Richard Kendall selected the exhibition *Degas: Images of Women* at the Tate Gallery Liverpool in 1988, and initiated the symposium of the same title that forms the basis for many of the essays in *Dealing with Degas*. Formerly a Senior Lecturer in the Department of History of Art and Design at Manchester Polytechnic, he is now a freelance art historian and writer who specializes in the work of Degas and his contemporaries. His other publications include works on Degas, Cézanne and Monet, and the catalogue, *Van Gogh to Picasso: The Berggruen Collection at the National Gallery*.

Griselda Pollock is Professor of the Social and Critical Histories of Art at the University of Leeds. She is also Director of the Centre for Cultural Studies. Co-author of *Old Mistresses* (Pandora, 1981) and *Framing Feminism* (Pandora, 1987), she has also written *Vision and Difference* (Routledge, 1988) as well as monographs on nineteenth-century art and a range of critical and theoretical writing on contemporary art and art history. She juggles her commitments to feminist theory and practice, writing and teaching with domestic responsibilities and passion for two children, Benjamin and Hester.

DEALING WITH DEGAS

Representations of Women and the Politics of Vision

Edited by
Richard Kendall and Griselda Pollock

Universe

Published in the United States of America
in 1992
by UNIVERSE
300 Park Avenue South
New York, NY 10010

ISBN 0-87663-628-8

CIP data for this book is available
from The Library of Congress

92 93 94 95 96 / 10 9 8 7 6 5 4 3 2 1

Selection and introductions © 1991
Richard Kendall & Griselda Pollock.
Essays © 1991 Linda Nochlin,
Hollis Clayson, John House,
Debora Bershad, Griselda Pollock,
Heather Dawkins, Richard
Thomson, Anthea Callen, Richard
Kendall, Heather Dawkins.

The contributors to this work assert
their moral rights to be identified as
the authors of their contributions.

Typeset by Harper Phototypesetters Limited,
Northampton, England
Printed in Hong Kong

Contents

List of Illustrations

18 Eugene Feyen, *The Honeymoon*, Salon of 1870, dimensions and whereabouts unknown

19 Charles Baugniet, *The Troubled Conscience*, 1864, dimensions and whereabouts unknown

20 Edgar Degas, *Woman with Lorgnette*, c. 1866, oil sketch on pink paper, 28 × 22.7cm, British Museum, London, L 179

21 Edgar Degas, *At the Racetrack*, 1868–1919, oil on panel, 46 × 36.8cm, Weill Bros Cotton Inc., Montgomery, Alabama, L 184

22 Edgar Degas, *At the Racetrack*, 1868–1919, pre-1959 restoration

23 Edgar Degas, *Manet at the Races*, pencil on light brown paper, 38 × 24.4cm, Metropolitan Museum of Art, New York (Rogers Fund)

24 Edgar Degas, *Woman with Lorgnette*, c. 1865, oil sketch and pencil, 31.4 × 18.5cm, Burrell Collection, Glasgow Museums and Art Galleries, L 268

25 Edgar Degas, *Woman with Lorgnette*, c. 1875-6, oil on cardboard, 48 × 32cm, Gemalde Galerie, Dresden, L 431

26 Mary Cassatt, *Woman at the Opera*, 1879–80, oil on canvas, 80 × 64.8cm, Museum of Fine Arts, Boston (The Hayden Collection)

27 Jacques Lacan, series of diagrams from *Four Fundamental Concepts of Psychoanalysis*, London, The Hogarth Press; New York, W.W. Norton

28 Mary Cassatt, *Marie Looking Up at the Mother*, 1897, pastel on paper, 80 × 66.7cm, Metropolitan Museum of Art, New York (gift of Ralph J. Hines), B 278

29 Edgar Degas, *Woman Leaving her Bath*, 1876–7, monotype, 16.1 × 12cm, Bibliothèque Nationale, Paris, J 176

30 Edgar Degas, Notebook 29, pp.31, 35, 1877–80, sketches, 25.1 × 34.5cm, private collection, Paris

31 Edgar Degas, *Woman Drying her Arm*, c. 1895-8, pastel, 70 × 70cm, The Louvre, Paris, L 1335

32 Edgar Degas, *La Toilette*, c. 1881, pastel, 63.5 × 48.8cm, private collection, formerly Lefevre Gallery, London, L 749

33 Edgar Degas, *Reclining Female Nude*, c. 1895, pastel, 48.3 × 83.2cm, private collection, L 855

34 Edgar Degas, *The Bath, Woman Seen from Behind*, c. 1895, oil on canvas, 65 × 81cm, private collection, L 1104

35 Jean-François Millet, *Two Bathers*, 1848, oil on panel, 28 × 19cm, Musée d'Orsay, Paris

36 Edouard Manet, *Olympia*, 1863 (Salon of 1865), oil on canvas, 130.5 × 190cm, Musée d'Orsay, Paris

37 William Bouguereau, *Birth of Venus*, Salon of 1879, oil on canvas, 300 × 218cm, Musée d'Orsay, Paris

38 Edgar Degas, *Woman Bathing in a Shallow Tub*, 1885, pastel on paper, 81.3 × 55.9cm, Metropolitan Museum of Art, New York (Havemeyer Collection, formerly collection of Mary Cassatt), L 816

39 Edgar Degas, *After the Bath, Woman Drying Herself*, later 1880s, pastel on several pieces of paper mounted on cardboard, 104 × 98.5cm, National Gallery, London, L 955

40 Edgar Degas, *La Boulangère*, 1885-6, pastel on paper mounted on cardboard, 67 × 52.1cm, The Henry and Rose Pearlman Foundation, on loan to the Art Museum, Princeton University, L 877

41 Draner (pseud. Jules Rénard), 'Chez M.M. les peintres indépendants', *Le Charivari*, 12 April 1879

Plates between pages 96 and 97
Plate

Acknowledgements

We would like to thank the staff of the Tate Gallery, Liverpool, for hosting the symposium at which most of the papers published here were first delivered. Special thanks to Anne McPhee for her tactful and charming organisation of the event.

Richard Kendall would also like to thank the Tate Gallery, Liverpool, for organising the exhibition *Degas: Images of Women*, especially Richard Francis, Lewis Biggs, Jemima Pyne and Penelope Curtis. A personal debt of gratitude is also owed to Mollie Sayer, whose wise counsel did much to sustain the enterprise.

Further, we would like to thank all the contributors for agreeing to have their work published, and for all their co-operation in the preparation of the manuscript and illustrations.

Candida Lacey and Ginny Iliff of Pandora Press merit particular gratitude and appreciation for having taken on the project and guiding us through the task of assembling and producing the book.

Dealing with Degas
Richard Kendall

Why Degas? Why, in a generation so extravagantly committed to the depiction of the female form, which numbered among its ranks Manet, Cézanne, Cassatt, Morisot and Renoir, has so much attention been directed towards Degas and all his works? Over the past decade, a fusillade of articles, books and research projects has been released in Degas' direction, sometimes from the bastions of art history but increasingly from the redoubts of psychology, social history and feminist studies. Amongst this barrage, the critical fire has tended to concentrate on a number of conspicuous targets, such as Degas' brothel pictures and his pastels of the female nude, and correspondingly to neglect the wider terrain of the artist's long and diverse career. Conversely, emphasis on Degas' female imagery appears to have distracted criticism away from many of his peers; Cézanne, who had a life-long obsession with the naked female figure, and who painted scenes of unparalleled sexual savagery, still awaits a comparable study. What is it about Degas' imagery and career that have so concentrated the minds of his critics? Why have Degas' laundresses, dancers and nudes been singled out for scrutiny, rather than Renoir's Odalisques or Cassatt's domestic idylls? And what are the origins of this debate in the circumstances and controversies of the artist's own lifetime?

A partial answer to many of these questions lies in the sheer quantity and diversity of Degas' female imagery. From the earliest days of his training to the final years of his career, Degas devoted more time and energy to the representation of the female image than to any other subject. More than three-quarters of his total output of paintings, drawings, pastels, prints and sculptures are images of women, sometimes depicted in the company of men or children, but more typically in isolation or surrounded by other women.[1] From the early and rather formal portraits of his female relatives to the laundresses and cabaret singers of the Impressionist years, and from the celebrated ballet-dancers to the ponderous late nudes, Degas aspired to an encyclopaedic representation of the women of his metropolitan world. Studies of women pervade his work, from the small scale of notebooks, etchings and

11

photographs to the grandest of his life-size canvases, while certain media (such as sculpture and monotype) were almost entirely devoted to the subject. So relentless was Degas' pursuit of the female image that it has been seen as obsessive or even pathological, and much curious attention has been directed at his childhood and the history of his personal relationships. [2] The death of his mother when Degas was only 14, his ambivalent attitude towards marriage and his contemporary reputation for misogyny, have all promoted speculation, though detailed biographical evidence is surprisingly sparse and often contradictory. Degas' works of art, on the other hand, and the context in which they were received, are often extensively documented, and a brief survey of both is perhaps appropriate as a preliminary to these studies of his female imagery.

A propensity towards female subject-matter is evident from the beginnings of Degas' career. During the 1850s, when he was studying to be an artist and practising his portraiture on readily available models, he produced a remarkable sequence of drawn and painted studies of his sisters, female cousins and aunts. Like most other apprentice artists of the day, Degas also learnt to draw from the nude model (both male and female) and later aspired to demonstrate his mastery of the human figure in grandiose canvases intended for public exhibition. In the early 1860s, Degas worked on a series of such pictures, several of which involve themes of sexual confrontation; in *The Bellelli Family* (plate 1), these tensions are implicit, while in *The Misfortunes of the City of New Orleans* (Paris, Musée d'Orsay, L124)* they are both explicit and violent. This latter painting, a brutal vision of rape and pillage in the Middle Ages, was accepted at the official Salon of 1865, but was effectively to mark the end of a youthful phase in Degas' imagery. It was his last venture into orthodox history painting, as well as an untypical attempt to express sexual violence in an overt, descriptive manner. From this time onwards, Degas was to find his subject-matter in the commonplace encounters of his own age, and in such pictures as the *Tableau de Genre* (Interior) (plate 2) he began to construct modern equivalents for the fancy-dress dramas of his youth. In company with Manet, Renoir, Monet and others, Degas turned his attention to the women and men of his own society, scrutinising the misfortunes and delights of the city of Paris in the new industrial age.

The tensions between tradition and modernity, and between personal sexuality and conventional decorum, are amongst the many defining polarities of Degas' art. Another is that of the public exhibition versus the private image, a distinction that was to become crucial for his evolving representations of women. With the exception of his Salon entries (which were largely ignored by the critics), Degas exhibited little before he reached the age of 40. [3] It was not until the 1870s, when he contributed

* L refers to the catalogue of Degas' work by P.-A. Lemoisne in *Degas et son oeuvre,* Paris, Paul Brame et C. M. de Hauke ed Arts et Métiers Graphiques, 1946-9. J refers to Eugenia Parris Janis, *Degas Monotypes,* Cambridge, Fogg Art Museum, 1968. BR refers to the supplement to Lemoisne: Philippe Brame and Theodore Reff *Degas et Son Oeuvre: A Supplement,* New York and London, Garland Publishing, 1984.

extensively to the Impressionist exhibitions, that a clear definition of his characteristic subject-matter began to emerge and a coherent critical response to his work can be identified. Confronted by Degas' images of ballet-dancers, laundresses, milliners and jockeys, many writers identified a paradox at the heart of the artist's work. On the one hand, they acknowledged his remarkable technical skills, notably his draughtsmanship and his disciplined observation, while on the other they recoiled from an awkwardness, even a brutality, which they found in his subject-matter. Describing a pastel of young girls at a dance examination, the novelist and critic Huysmans observed: 'What truth! What life! See how realistic these figures are, how accurately the light bathes the scene. Look at the expressions on their faces, the boredom of painful mechanical effort All these things are noted with analytical insight at once subtle and cruel'.[4] Here Degas is publicly identified with the project of Realism, with the veracity and freshness of vision that some of his colleagues had brought to the painting of landscape, and with the descriptive precision that Huysmans and his fellow-writers, such as Zola and the Goncourt brothers, had brought to the contemporary novel. Degas' images of working girls and labouring women, which accounted for the overwhelming majority of his submissions to the Impressionist shows, were to be seen as topical, documentary and instructive, a paradoxical conjunction of low life with high art.

While Realism might be presented as a responsible and even scientific pursuit for the writer or painter, it was more widely associated with lurid subject-matter and subversive morality. Degas, the son of a respectable banking family and increasingly reactionary in his own politics, appears to have cast himself in the role of detached observer, a patrician eye amongst the ugly and the beautiful. From the vantage point of his assumed objectivity, he felt able to tackle a wide range of themes that were socially ill-defined or frankly scandalous. Laundresses and shop-girls were widely involved in casual prostitution, and settings like the circus, the race-track and the café were all part of the notorious sexual market-place of the city. The 'analytical insight' noticed by Huysmans has, therefore, a double significance. Many reviewers emphasised the role of observation in the artist's work and Degas himself drew attention to its complexities, delighting in the reversals and metaphors of mirrors, binoculars and opera glasses (plate 3). But such objects, then as now, were also the province of the voyeur, and Degas' 'subtle and cruel' insight cannot be disassociated from the predominantly female objects of his attention. While some of the remarks most widely attributed to Degas, such as the claim that his pictures were painted 'as if through a key-hole', are often quoted out of context and without reference to their authenticity, it is also evident that his pictures are not simple acts of clinical observation.[5] Even his studies of the ballet, which have been so widely admired for their delicate colouring and subtlety of movement, are elaborately constructed and knowing configurations of gesture, pose and social ritual, and form part of a complex dialogue with a profession that was notorious for its sexual availability.

Degas' reputation as 'the painter of ballet dancers' began early in his career and

even became the subject of adverse contemporary criticism.[6] His predilection for female portraits, however, went largely unnoticed and certain other groups of works, such as the brothel monotypes and the sculptures of dancers and nudes, remained almost entirely hidden from public view. While some of these works were seen by individuals who visited the artist's studio, most did not see the light of day until Degas' death and never became part of a public or critical dialogue. In the middle years of his career, Degas' reputation depended largely on the paintings, pastels and drawings he showed at the Impressionist exhibitions and on his association with the Impressionist artists. Though a regular participant at these exhibitions, it was often noted that Degas appeared to be distinct from many of his fellow-exhibitors, not least in the context of his subject-matter. Degas' single-minded preoccupation with the female image might find some echoes in the work of Renoir, Cassatt, Morisot, Forain and others, but his exaggerated scorn for the practice of outdoor landscape painting, and for the improvised composition and rapid brushwork associated with it, further distanced him from his colleagues. Degas insisted that his own pictures were composed and executed entirely in the studio, however naturalistic their final appearance might be. His compositions were based on a laborious process of preliminary drawing, tracing and the integration of elements from other pictures, pursued in a setting where lighting and pose could be precisely controlled. In addition, the ballerinas, washerwomen and ladies of leisure depicted in Degas' work were often posed by professional models or friends, and such poses might be repeated for years or even decades in a continuing sequence of variations. In his working practice, as in his persistent visual quotations from the Old Masters, Degas stressed the artificiality of his art and the deliberation of the art-making process. His images of women are the result of this process and this attitude, a knowingly constructed dialogue between artist and public conducted by an individual who delighted in the paradoxes of this exchange.

During the 1880s, Degas was regarded by many as the dominant figure in the ill-defined circles of Impressionism. Though the persistent legends of Degas' private wealth are now largely discredited, there is evidence that his success in selling work enabled him to adopt a manipulative, almost playful attitude to collectors and gallery audiences. His exhibition in 1881 of the sculpture *Little Dancer Aged Fourteen*, one of the most celebrated of all his images of the female figure, was a calculated and theatrical intervention in the Realist debate, and it is tempting to see his submissions to a number of Impressionist shows in this same purposeful light. The series of pastels of the female nude presented in 1886, for example, was apparently intended to challenge the preconceptions of the critics, and has continued to generate controversy to the present day. A number of essays in *Dealing with Degas* refer to these pastels (see plate 7, figs 38, 40) and to the nature of the debate, but in the present context certain features of their public reception should be noted. First, Degas' entries in the 1886 exhibition were, even by his own standards, unusually dominated by the female image. Secondly, and perhaps more significantly, the numerous critics who

responded to the exhibition failed entirely to register this important fact; evidently Degas was so closely associated with the representation of women that such a feature could pass without comment. Finally, while the significance of the critics' responses is still the subject of debate, their terms of reference reflect an awareness of a change in Degas' art. As in earlier decades, there was admiration for the startling verisimilitude of his figures and for his rejection of the sentimental stereotypes of femininity. This time, however, there was also a recognition that Realism no longer accounted for Degas' art, that the languages of depiction, metaphor and allusion had been carried forward into new areas of complexity. [7]

The public and critical debate around Degas' images of women came to a virtual stand-still at this point in his working life. [8] For reasons that are not fully understood, and in stark contrast to his colleagues Monet and Renoir, Degas effectively withdrew from the public arena for the remaining quarter-century of his career. According to conventional wisdom, the artist became a virtual recluse and only reluctantly sold individual works to dealers and friends, disillusioned perhaps by the public and critical responses to his exhibited work. As the years went by, his imagery became more rather than less inscrutable, devoted to two or three reiterated themes that have little in common with the repertoire of his Impressionist phase. Laundresses, prostitutes, milliners and café-concert singers were left behind and Degas' studio was slowly engulfed in a new generation of female subject-matter; densely-coloured pastels of women at their *toilette* (fig. 45), ambitious canvases of the female nude (fig. 34) and endless drawings of models posed as ballerinas or bathers. With the exception of a few scenes of the race-track, Degas' fixation on the female figure was now complete. Tracing and reworking earlier pictures, he developed a new amplitude of line and an unexpected richness of colour, suggesting to some commentators the first stirrings of abstraction. It can be argued, however, that Degas' subject-matter never lost its hold; his heavy-limbed dancers and wearily bathing nudes are as insistent in their mortality as ever, echoing perhaps the artist's own advancing years and physical decline.

In later life, Degas appears to have found it convenient to hide behind a reputation for reclusiveness and misogyny. In reality he was a tenacious friend and a sympathetic supporter of young artists both male and female, from the abrasive Gauguin to the reactionary Forain and from the sophisticated Mary Cassatt to the unfortunate Suzanne Valadon. His dislike of uninvited visitors was real enough, however, and he developed a neurotic aversion to journalists and potential biographers. It was not until the artist's death in 1917 that a sudden and dramatic change in public awareness of his work took place. While the Great War was still in its final stages, and while shells continued to fall in the centre of the city, a series of massive auction sales of the contents of Degas' studio was held in Paris. For the first time, thousands of paintings, pastels, drawings and prints accumulated over his long career were put on public exhibition, many being bought by major museums and collectors. Reactions were by no means entirely favourable; even some of his close friends, like

Daniel Halévy, were startled by what they saw, describing some of the late pastels as 'powerful, but horrible' and some of the female nudes as 'cynical'.[9] In the immediate aftermath of the studio sales, Degas' monotypes of the brothel and his sculptures of the female figure also became known, and a number of major exhibitions and publications attempted to place such work before a wider audience. Though half a century was to pass before the first critical studies of Degas' female imagery appeared, the process of defining and assessing his achievement began in earnest.

This is not the place to attempt a summary of the changes in attitude to Degas and his art during the twentieth century, but certain symptomatic phases in this process can be usefully noted. The inter-war years might be described as the phase of the memoir, characterised by the publication of first-hand recollections of the artist by his former friends, models and admirers, and by a series of monographs written by critics and historians who had known the artist, to a lesser or greater extent, during his lifetime. These memoirs include informative texts by writers such as Paul Valéry and Daniel Halévy, colourful reminiscences by fellow-artists like Walter Sickert and Georges Jeanniot, and the celebrated account of the artist at work by one of his models, Alice Michel.[10] Though such texts vary considerably in their approach and their reliability, together they are largely responsible for the image we have today of Degas' attitudes, behaviour and personality, and as such have been widely quoted whenever his representations of women have been discussed. Significantly, such issues were generally avoided in the next phase of the historical process, which might be seen as the era of the catalogue. Initiated and overshadowed by the four-volume *catalogue raisonné*, *Degas et son oeuvre*, compiled by Paul-André Lemoisne and published between 1946 and 1949, this phase also saw the appearance of *Degas, Works in Sculpture: A Complete Catalogue* by John Rewald, and *Degas Letters*, edited by Marcel Guérin. Some two decades later, this process of compilation and documentation was almost brought to a conclusion in Eugenia Parry Janis' catalogue *Degas Monotypes*, Jean Adhémar and Françoise Cachin's *Degas: The Complete Etchings, Lithographs and Monotypes* and Theodore Reff's two-volume *The Notebooks of Edgar Degas*.

In the late twentieth century, we have become the beneficiaries of these pioneering works, as well as the heirs to their assumptions, omissions and whims. Following the age of the catalogue, many writers have moved into more speculative and critical territory, reflecting broader changes in the discipline of art history and more general shifts in theoretical and historical modes of thought. Looking back to such studies as Jean Boggs' *Portraits by Degas* and Reff's *Degas: The Artist's Mind*, a number of publications have explored the subject-matter of Degas' art and its relationship to the art of his contemporaries. Specialised exhibitions have examined Degas' techniques and the preoccupations of his early and mid-career, while historical research has taught us much about the social and economic context of the artist's imagery. It was not until the late 1970s, however, that the first evidence appeared of a debate that dominates much current thinking on the artist and provides the

central theme of the present book. Articles by Norma Broude, Eunice Lipton, Hollis Clayson and Carole Armstrong concerned themselves with the historical evidence of Degas' attitudes to women, his depiction of prostitutes and his approaches to the representation of the female nude, and a number of books and essays by these and other writers amplified the debate.[11] Further studies of Degas' pictures of laundresses, brothels, nudes and ballet dancers have since appeared, and such images are now routinely cited in the literature of social history, feminism and cultural studies. Suddenly, Degas' images of women are everywhere, fair game for the undergraduate essay and the doctoral thesis, for the scholarly tome and the colour supplement.

This shift in Degas studies and its corresponding transformation of our ways of talking and writing about his imagery is still far from complete. The historical role of the image, the functioning of language and the significance of art practice have all become issues within the broader debate, while new areas of research, such as Degas' use of photography and the work of his final years, have only recently been opened up. Many issues remain fiercely contested, and the sheer diversity of debate has perhaps led to a greater than usual variation in the quality and coherence of its components. The dangers of the specialist exchange have also been in evidence, in a number of heavily coded and almost hieroglyphic texts that seem destined to be, and are perhaps intended to be, accessible only to the privileged. It is beyond the scope of this introduction to attempt an assessment of the current debate, though the broad range of essays in *Dealing with Degas* conveys something of its animation and topicality. This publication also provides an opportunity to reflect on some of the larger issues behind this same debate. For whom is the debate intended? Is it of purely academic interest, or has it a significance for the artist, the art enthusiast and the gallery visitor? How does it affect our approach to the works of art in question? What questions remain to be asked, and what are the casualties of the new scholarly activity?

One of the most bizarre spectacles in recent years has been that of the specialist from the world of art history visibly ill at ease, or affecting a kind of hostile indifference, in a gallery surrounded by the very works of art which form the basis of their specialism. In some respects, this response is easily understood. The widespread promotion of works of art as the product of an ineffable 'genius', to be venerated from a distance and discussed in sepulchral tones, has become one of the marketing phenomena of our age, as well as a source of disaffection for many. Similarly, the media attention to sale-rooms and auction prices, and the mystique that is still attached to the artists' materials and processes, has perpetuated a kind of art gallery voyeurism which is quite unrelated to the depicted image. Even more problematically, an exhibition like 'Degas: Images of Women', which provided the original stimulus for the present volume, offers a further challenge in the form of subject-matter which some find disconcerting or even repulsive.[12] That these factors should be responsible for a reluctance to engage with works of art, and in some cases to set foot in such exhibitions, is however both new and troubling. In Degas' case, the situation is doubly

17

ironical. Amongst the differing responses to the artist's work during his own lifetime, a number singled out the ugliness of his models and the harshness of his pictorial effects, and it was some time before his output acquired the popularity that it has enjoyed, and continues to enjoy, in subsequent generations. Today, Degas 'the painter of ballet dancers' is one of the most celebrated artists of his generation, and the gulf between public perceptions of his work and specialist unease with the same objects verges on the spectacular.

The breakdown in the established relationship between the specialist and the object of their interest has a number of significances and consequences that go far beyond the response to a particular exhibition. At a mundane and rather *chic* level, tales are told of lecturers who are reluctant to use slides (or who grudgingly project one or two of their most dismal) and of academics with a preference for the unillustrated essay. In a wider sense, the shift towards theory and the invocation of new disciplines and methodologies has left the work of art with an uncertain status and a disquieting future. Not only has our 'joy in the text', and our individual response to the drama of the painted or drawn surface, been called into question, but the practice of direct scrutiny of particular objects, and groups or series of objects, has itself been seen as tainted. Notoriously, an earlier generation of art historians preferred to work from photographs rather than inaccessible works of art, but today we have no such excuse. Collections and exhibitions are better presented than ever before, the cleaning and restoration of works of art has reached new heights of audacity, and the technical understanding of pigments, media and surfaces has far exceeded that available to earlier scholars. Against the fashionable tide, it might even be argued that the confrontation with the art object, for all its finiteness and materiality, provides us with a limited, but perhaps unique, common ground for the increasingly prolix and disembodied exchanges that are conducted in its name. By the same token, critical studies which neglect the particularity of such works, or which choose to operate at a distance from them, run the risk of losing their footing. A number of such stumbles (and a few acrobatic collapses) can be found in the current Degas literature, and may suggest a more general malaise. Apart from the familiar mis-identification of techniques and media, and the failure to register and to take into account the scale of a given image, other solecisms appear to result from Degas' complex working methods. A recently published essay on Degas' brothel monotypes, for example, is based on the author's belief that they are 'crude, scribbled, smudged, murky forms', whereas the majority of these images are sharply defined and drawn with exceptional skill;[13] a widely-distributed catalogue has described an oil-painting of the ballet, without observing that it was repainted with the artist's fingers and thumbs more than a decade after the published date;[14] and a series of essays has dealt with a celebrated but small-scale image as if it were a finished picture, despite evidence of its preparatory nature.[15]

Another feature of Degas' imagery that demands a particularised approach is, paradoxically, his habit of working in series. Just as the mature Claude Monet

produced closely related canvases of Grain-stacks, Poplars and Water-lilies, so Degas in his later years would make ten or even twenty variants on a single theme, such as a group of dancers or a woman at her *toilette*. Again like Monet, Degas is known to have exhibited some of these pictures in thematic groups, and it is clear that for these artists and their early public, such works had an identity as a sequence, not just as individual images. At the same time, the tendency to generalise about such sequences, and to assume that what can be said about one grain-stack or ballet picture in a series can be said about them all, is to miss the point of the series procedure and perhaps of the functioning of works of art. By producing his work in sequences, and by encouraging the notion that they should be seen and exhibited as such, Degas explicitly drew our attention to the *distinctions* between his images, and the nuances of surface and subject that differentiate one image from its neighbour. Significantly, Degas' contemporaries appear to have understood this and the published reactions to a series of works such as the 1886 'Suite of Nudes' are remarkable for their variety and discrimination. Critics remarked on shifts of colour and tone, on variations of texture and finish, on the inclusion and exclusion of accessories, and on the subtle implications of a gesture, a space or an angle of vision.[16] Such attentive scrutiny has nothing to do with connoisseurship, with the uncritical adulation of genius, or with the seductive power of the art object. At its simplest, it is a process of identification, involving us in description and the making of visual inventories, in the definition of what is present and what is absent. Ultimately, it is the singularity of the object that is at stake, and a failure to identity this singularity is a failure to see (in every sense) the work of art. Absurd though the analogy might seem, the reluctance to engage with visual objects and the discomfiture of the specialist in the art gallery must be compared with the unwillingness of an imaginary literary critic to open a book or the distaste of a film theorist for the cinema.

Dealing with Degas offers a broad spectrum of approaches to this and other issues, ranging from the discretely focused study of a single work to the analysis of an entire phase in the artist's career, and from considerations of imagery to those of theory. Most of the essays are based on papers delivered at a two-day Symposium held in October 1989 at the Tate Gallery Liverpool, on the occasion of the exhibition 'Degas: Images of Women'. The decision to publish the Symposium papers was taken to provide a more leisurely and less highly charged opportunity to study the issues, and to bring new material and new insights to the attention of a wide audience. In the absence of the original exhibition, a number of illustrations of the artists's pictures have been included, though many readers may also choose to turn to the standard publications of Degas' work referred to in this introduction and to examples of his pictures in public collections. In addition, the text includes three unpublished or partly-published essays which amplify the coverage of the subject, and are intended to broaden the range and the usefulness of the book.

Notes

1. For a fuller discussion of these issues, see Richard Kendall, 'Degas: Images of Women', Tate Gallery, Liverpool, 1989.

2. See Benedict Nicolson, 'Degas as a human being', *Burlington Magazine*, no. 105, pp. 239-41; Norma Broude, 'Degas's misogyny', *Art Bulletin*, no. 59, 1977, pp. 95-107; Roy McMullen, *Degas, His Life, Times and Work,* London, 1985.

3. Between 1865 and 1870, Degas exhibited eight pictures at the Salon, including four studies of women. In the years before the First Impressionist Exhibition of 1874, he also showed a small number of canvasses at dealers in Paris and London.

4. Joris-Karl Huysmans, 'L'exposition des indépendants en 1880', *L'Art Moderne*, Paris, 1883.

5. This much-quoted remark can be found in George Moore, 'Memories of Degas', *Burlington Magazine*, February 1918, pp. 64-65, though it should be noted that in its original context Degas insists that his models 'are honest, simple folk, unconcerned by any other interests than those involved in their physical condition'.

6. Eugène Véron, 'Cinquième exposition des indépendants', *L'Art*, no. 21, 1880; quoted in Charles Moffett, *The New Painting*, Geneva, 1986, p. 322.

7. See Martha Ward, 'The rhetoric of independence and innovation', in Moffett *op. cit.*, pp. 431-34; Richard Thomson, *Degas: The Nudes,* London, 1988, pp. 135-51.

8. A second group of pastels of the female nude was shown in 1888 at Bousson and Valadon, but produced little critical response; see Thomson, *op. cit.,* p. 132. Degas' only other significant exhibition during his lifetime, at Durand-Ruel's in 1892, consisted entirely of landscapes.

9. Daniel Halévy, 'A Edgar Degas', *Le Divan*, no. 61, September-October 1919, p. 209.

10. Full references to these and all other texts mentioned can be found in the bibliography in Jean Sutherland Boggs *et al*, *Degas*, Paris, Ottawa and New York, 1988-9, pp. 614-20.

11. A summary of this literature can be found in the bibliography of the *Degas: Images of Women* catalogue; see note 1 above.

12. The exhibition took place at the Tate Gallery Liverpool from 21 September to 31 December, 1989. A modified version was shown at the Burrell Collection, Glasgow, from 15 January to 25 February, 1990.

13. Charles Bernheimer, 'Degas's brothels: voyeurism and ideology', *Misogyny, Misandry and Misanthropy,* Howard Bloch and Frances Ferguson (eds), London, 1989, pp. 158-86.

14. *The Passionate Eye: Impressionist and Other Master Paintings from the Collection of Emil G. Bührle, Zurich*, 1990, no. 33.

15. Several recent discussions of Degas' *Women with Binoculars* and its variants have

disregarded the existence of a much larger fragment which indicates that Degas intended (and perhaps executed) a large-scale composition based on this subject; see *Atelier Edgar Degas (3me Vente): Catalogue de tableaux, pastels et dessins*, no. 37 (ii), *Deux Jockeys – Femme à la lorgnette*.

16. For examples of the critical reaction, see the essays by Anthea Callen, Heather Dawkins and Richard Kendall in this volume.

Degas/Images/Women; Women/Degas/Images: What Difference Does Feminism Make to Art History?

Griselda Pollock

The occasion for which most of the papers assembled here were written was historic. An exhibition of a modern master, Degas, taking place in a prime cultural institution, the Tate Gallery Liverpool, is nothing but business as usual. But to find an exhibition that admitted Impressionist painting had social meanings, and that these might be related to the gender of both artist and those represented, was revolution indeed. Art historians usually only offer us the opportunity to celebrate art's apparently obvious pleasures. On this occasion aesthetic concerns were bracketed; we were asked to think about the paintings, pastels, drawings and sculptures as 'images of women'.

Much used in the 1970s, the phrase 'images of women' was for the early feminist movement the first, crudely drafted means of recognising that art objects had ideological meanings which affected us as we lived our lives. Of course, the majority of women do not visit art galleries and do not feel themselves defined by paintings of women by Leonardo, Michelangelo, Raphael, Manet, Monet, Degas, De Kooning and so forth. Feminist analysis, however, revealed an ideological continuity between High Art with its erotically available nude Venuses, or saccharine and devoted Madonnas, and mass culture's versions of femininity that crop up everyday in *Penthouse* or *Woman's Own*.

Art ceremonially displayed in élite institutions is not innocent in the social games of power. Deeply implicated in social and economic relations, the aesthetic 'aura' of art and genius lend legitimacy, and inevitability, to hierarchies of race, gender, class and sexuality. Art history has helped to convince us of the unassailable beauty of art and the unquestionable greatness of genius, both of which have given spurious authority to beliefs in women's limited function as objects of men's desire and servants of their domestic and genealogical needs. But in this case, art history and its institutional base seemed to ask some questions about the relations between representation and sexuality.

The title of the exhibition, 'Degas: Images of Women', however, expressed a contradiction. It implied a feminist agenda which its phrasing none the less subverted.

22

The three terms form a self-evident and natural entity, rehearsing the normative tropes of art history, the artist, the image, the reference. The phrase confirms an ideological 'order of things': men make art by looking at women. Man is the subject, woman the object, and art the product of that hierarchical exchange.

Feminism is the very condition for the exhibition, the conference that accompanied it and for the book which is the permanent result of the event. It is the women's movement which placed questions of sexuality and representation on the agenda for cultural analysis. But feminism is not to be understood as a neatly defined *approach* or a new *perspective* which simply gives gender a priority in the analysis of the iconographies of art, or versions of the social history of art. Feminism is a practice of constant theoretical provocation. It criticises and deconstructs its own formulations as it struggles against the dominant systems of meaning. One hegemonic theme is the conflation of woman with image – 'pretty as a picture' we say; 'how do I look?' we ask. The corollary is the identification of men and the right and power to look, of masculinity and the gaze.

In 1969 John Berger coined a famous phrase which seemed very powerful and insightful at the time: 'Men act: women appear. Women watch themselves being looked at.'[1] Berger identified one of the most pervasive myths of our culture. Woman seems the natural object for the eroticised gaze of men. Woman is thus sex, embodying it for men, titillating it in men, bearing the burden of punishment for men; woman is a saturatedly sexual term. By the same token, man enjoys a kind of universality. He is the eye, a powerful metaphor in the west for knowledge, liberated from the body by means of his *enjoyment* of a *mastering* gaze.* Feminist analysis has massively extended this argument with the aid of Michel Foucault's work on the systems of surveillance and discipline in modern society which root the political use of the gaze in a massive array of social apparatuses and institutions. Deborah Bershad's paper in this volume locates the preoccupations with, and difficulties of, looking as exhibited in Degas' work within this framework.

By naming this structuring opposition of men's appropriation of the gaze, feminists began to undermine that mastery. Thus masculinity is stripped of its transcendence and implicated in a sexual politics around looking and its objects. Woman, hitherto the sign of sexuality, contaminated and defined by her body, can now be understood as functioning specifically as the sign of *masculine* sexuality. Masculinity projects out its particularity on to the figuration of woman's body. Thus an 'image of woman' is not about a woman. It is a representation, whose signifier may be a female body. Its meaning, however, is the formation of masculinity within specific class relations. Woman signifies not a given difference from man, but difference for men within a phallocentric culture.

* Enjoyment has a colloquial meaning of pleasure. It also has a legal meaning, synonymous with possession as in enjoyment of rights of property. Husbands using women's bodies sexually conjoin the two meanings.

23

To go beyond the tactical importance of naming the structures through which Woman functions as a devalued category and 'natural' object of men artists' looking, feminist theory turns *its look* on masculinity, making it an object of interrogation and analysis. Women are attempting to find a *voice* in which to speak of, and from, the position of women, speaking 'femininity', as a complex psycho-sexual and social position, thus contradicting the notions that Woman is an enigma, that is, unknowable, or merely a body, impervious to the mind and the spirit, creativity and all those higher functions men have reserved as their special, defining prerogative.

We search for theories and methods which will create a way to displace the binary opposition which structures the questions of gender. How can we speak about difference which is so powerful in the definition of us as sexual and gendered subjects in a way which does not merely confirm the inevitability of the dominant versions of it? The point is not to say women are the same; that there is no difference. But we are trying to alter the values attributed to the terms in a particular system, in the first place, by stringently identifying them. Progress beyond critique, however, involves a kind of theoretical 'moving back' to the psychic-symbolic processes through which a sexual division is perpetrated on us, so as to understand the conditions of its formation and thus redefine the results. We are not excavating the history of subjectivity to find the true, essential woman, but rather to realign the signs so that the specificity of persons, identities and the larger groups, such as sexes, to which they are assigned, can be differently spoken. It is for this reason that the battle for feminism is so much a contest around language, terms of analysis, methodologies and a political assessment of their effects.

The exhibition 'Degas: Images of Women' was exemplary in this respect, both a site of confusion about the challenge of feminism to the normal procedures and interests of art history, and a site of conflict when the full force of feminist intervention reveals the continuing allegiance of that art history to a masculinist enterprise. It is time to trace some of the steps and arguments which make an exhibition, a conference, a collection of papers entitled 'Degas: Images of Women' both so important and so problematic. I shall do this by prising open the syntagm of the exhibition's title, term by term.

I Degas

It seems obvious to organise an exhibition around what an artist makes. Indeed, *the* subject of art history is the named individual creator of art. His vision, intentions, ideas, in a word, his genius, bring the works into existence and determine the explanation of them.[2] If we ask art history what works of art mean, we will be told that they reveal to us the artistic personality, in this case named Degas.

The second paragraph of the catalogue for the exhibition opens thus:

Given the nature of the artist's obsession, it is surprising to discover that this is the first exhibition to explore the subject of Degas' depiction of women.[3]

24

Degas did not depict women. He was an obsessional. His repertoire of topics was increasingly limited and boringly narrow: more and more dancers and naked women bathing. Yet his obsession was not actually with women. For in that assembly of works that is an exhibition or a catalogue or a monograph, there are no women present. There is a lot of Degas, splattered all over the canvases and pieces of paper covered with oil or pastel. These marks generate a fantastic or fictional space which the spectator encounters as 'a picture'. The picture is a physical thing, handmade and then experienced by viewers as a material object existing in space. But it is also a screen upon which the viewer reads imaginary bodies in fantasy scenarios.

Feminists ask: Whose imaginary? Whose fantasy? Art History will answer admiringly: Degas'. For the only imaginary art history acknowledges and celebrates is that of the possessive individual – the artist. The picture is the artist's property in both the sense of its being his possession, and the sense of its revealing his unique character, his properties. If the 'images of women' are Degas', they are, by that token, Degas. Through a loving identification with an all-male canon of artists, the art historian vicariously enjoys the mastery of the artist so carefully constructed and doggedly protected by its traditional methods.

It is all too easy for an exhibition about Degas' images of women to conclude with a revised and restored evaluation of the artist. Like any classic text, the exhibition opens up an area of risk, taking on the most insistent criticism addressed to this oeuvre, namely misogyny and cruelty (see Heather Dawkins' paper, 'Managing Degas' in this volume, pp. 133-45), only to find new and up-dated ways to value Degas. Repeatedly in the conference proceedings the *ambiguity* of Degas' representations of female bodies was identified and, to an extent, fetishised. In the postmodern era to be a little incoherent is a plus. Yet Degas' creativity, and his interest for art historians, remains based upon his economic and aesthetic uses of the bodies of working class women, however ambiguously these images ultimately read. What has changed?

Semiotics provides another way to understand art history's celebration of the artist. Language has been defined as a dual structure, *langue* (language as a general system) and *parole* (speech). For there to be speech, there must be a general and socially produced system of rules governing the combinations of sounds and units to produce meaning. Yet for there to be a system, there must be a community of speakers whose speaking practices institute and realise the system of the language. The model can be applied to art history whose dual structure comprises the artist as the *langue*, the deep and defining system for art works, which are the individual acts of *speech*, the event which realises the structure, namely artistic personality, the nature of genius. In semiotics, the two levels are a simultaneity, only theoretically distinct. For the art historian, however, the artist is imagined as coming before the artmaking, 'expressing himself through art works'.[4] So the major form of art historical writing is the monograph, an illustrated biography of a life with a beginning (early years),

a middle period (maturity) and an end (old age and death). Art historians assemble catalogues of art works into chronological and stylistic sequences from which they then derive a unifying artistic personality which gives them meaning as symptoms of the biographical life of the artist. The named individual artist gives this assembly coherence, confers value and *authority* which excludes other considerations of what art works mean and how they come to exist, considerations of a social, historical and public character for instance, based in relations of gender, race, class and power.

There is another dual structure at work in art historical discourse, which can only be identified from an Archimedean point outside its discursive and ideological universe. The individual artist acts as the *parole*, or speech in an ideological system. For despite over twenty years of pressure, art history still polices and celebrates its all-male canon. This less overt second system or *langue* of western art history is the privileging of masculinity in the ideal form of creative self-possessed individuality.

When feminists intervene in this territory defined by art history, we do not reject all commentaries on individual artists or art works. Instead of privileging the unique artistic subject who functions as sign of a hegemonic masculinity, we relate the work as a practice to a different *langue*, the structure of the social and the historical. Hence it is important to locate the historical conditions and contexts of artistic practices. In the following papers, there are examples of the many faces of current feminist cultural analysis, with different theoretical and methodological emphases. The specificity of the artistic practices under scrutiny is scrupulously interrogated to yield a many faceted view of cultural production. But these papers operate within a common assumption. These works can only be read as events within the social field of cultural meaning. The specificity of their articulation as products of this one man's studio lends precision to our understanding of the cultural politics of class, race, gender and sexuality; it is not a means of individualising or isolating art as an autonomous sphere of creative agency. Reference to the structures of the family, of public or commercial bathing practices, of the way in which what has been named the 'bourgeois imaginary' represented social relations through obsessions with bodies, with dirt and hygiene, to the relations between classed and gendered subjectivities – these are the necessary relations within which to comprehend the genesis and to read the effects of the images being examined. The purpose of feminist analysis is to identify painting and drawings as social images in ways which do not inevitably lead us back to the celebration of art history's singular, creative subject, the artist in general, Degas in particular, and, as always, Man.

II Images

The currency of the term 'images' in art history is a measure of the impact of semiotics and social histories of art. Image – a social category – immediately suggests a more social phenomenon than art or artwork's personal and aesthetic connotations. The phrase 'images of . . .' was initially used by women, lesbians and gay men, and cultural or religious traditions marginalised by the west, to draw attention to recurrent

patterns of oppressive representation. It helped to identify 'stereotypes', clichés and fixed ideological categories. But there are still theoretical problems with it.

As a feminist analysing art and its cultural uses and effects, I can no longer subscribe to the phrase 'images of women'. In 1977, I wrote an article entitled 'What's wrong with ''images of women''?'[5] in which I questioned its viability as a means of feminist analysis. Influenced by semiotic theory, I argued that meanings are not innate or given in the nature of things. Meaning is an effect, produced by signs. Signs, composed of a phonic or graphic element and a reference to a concept, signify only through relations of difference within a signifying system. Instead of 'images of women', a semiotic analysis would therefore argue that Woman and Man, as signs of the concepts masculinity and femininity, are produced as terms in a language system, having meaning only in relation to each other because of their difference as sounds or graphic forms, and not because they refer directly or positively to given persons or identities.

Semiotics proposes that there are no positive terms, no innate meanings, which language merely labels or expresses. Instead, meaning is produced by the differences between signs at the level of the graphic or acoustic signifiers (spoken and written words).[6] What gives the sign systems their coherence and cogency is not what they refer to but the network of reference within which they function. Social and ideological understanding of the world is produced by the mutual support of several sign systems and discourses which accumulate around certain nodes, and these come to be so familiar and obvious that we take them for an unmediated or merely reflected truth about the world.[7] 'Woman', produced in discourses of biology, medicine, psychology, the law, the family, history, cultural practice, advertising and so forth, comes to function as one such node. So multiplied and thoroughly spoken, written, pictured, defined, investigated, the sign comes to appear 'natural', reflecting directly that essential being, Woman.

The phrase 'images of women', collaborates with that 'reality effect', implying that women are a given, known category of which we make images.[8] Under this rubric images are appraised good or bad reflections of what is taken to be real women. They are judged truthful or false *images* of what already exists outside representation, which thus has meaning outside the system of signs by which meaning is *produced*. Instead of relating images back to an already fully formed and inherently meaningful world, semiotics suggest that our understanding of the world, our effective relation to it is mediated by this grid of signs which forms a whole field of representations and ideologies in which concepts of sexual difference (and their signs, Man/Woman) are produced. Cultural representations are thus productive points of definition of the historically specific arrangements of social relations and agents. The phrase 'images of . . .' however, allows us to accept, as given, what images are of, and focus only on the individual artist's or producer's manner of imaging. Thus the trope, 'Degas: Images of Women', invites us to focus on the 'Degas-ness' (the artistic signature) of the images, not on the process, conditions and effects of representation

as a particular, socio-historical construction of masculinity/femininity through the activity of artistic practice.

The stress on images as bearing social meanings, and indeed as having meaning only in a field of social semantics, has proved a powerful means of feminist ideology critique. But in the last decade theoretical refinements in our analysis of culture and sexual difference have extended the debate. It is the purpose of this introduction to explore some of that theoretical journey from the mere indictment of the ideological effect of 'images' in relation to the social experiences of women, to the analysis of the processes of sexuality and sexual difference in which 'images' figure in a field of fantasy and symbolic power.

III Women

A semiotic approach questions the obviousness of Woman. Does the word mean a person defined by a biological capacity to bear children in her body, that is, a sexual anatomy? Or is Woman the cultural sign for a system in which the reproduction of the society (its population) and the regulation of its sexualities for that purpose are variously organised? Woman is not a entity but a linguistic sign in a language system. It refers not to a person but a position in what anthropologists call a kinship system.[9] This does not imply that there are not people of the 'female persuasion'. And it would be plain silly to suggest that our experiences of sexuality and childbearing are not powerful determinants of a particular social as well as psychic formation. But there is an important difference between finding terms in which to speak of these events and meanings for the social group to which they are specific, and making these events and meanings the total definition of that social group. We have to acknowledge the specificity of women's sexualities, and they are plural and varied, but women are both more than and less than those sexualities. In representation, however, the sign 'Woman' signifies that marking of our bodies by sex (or rather sexual use) alone. Woman does not signify our sexualities, but our place in what Gayatri Spivak named the 'uterine economy'.[10] Woman signifies nothing but difference from men, and use from them within the political economy of sex.[11]

The priority of sex/gender inscribed through the term Woman screens off significant differences between the people who live under the sign Woman, differences which are material and determining in terms of class, race, culture, generation, sexuality, disability and so forth. It matters, for instance, in analysing the meanings of representations to specify all forms of power in play. Thus the predominance of both working-class women as models in Degas' art practice, and the representation of bodies coded to read as proletarian or petit-bourgeois in the products of that practice, is an equally important factor as is the inflection of class relations by those of gender and sexuality.

But it is insufficient to replace the abstract category Woman with the more concrete social collectivity, women. As feminist historians have argued, the category *women* is also unstable and unreliable. It smuggles in a universal condition, women, whereas

the meanings of the collectivity *women* have altered historically and vary culturally according to the constellation of factors of class, race and sexuality. In terms of western history, Denise Riley has shown that the identification of women exclusively with sex only begins in the seventeenth century. It is massively extended and confirmed in the form of bourgeois ideologies of domesticity and maternity, in the medical notions of hysteria, corroborated in demography, sociology, psychiatry and politics in the nineteenth century. Thus the immersion of women in their sex is a relatively recent historical development, but it had very different effects for women in different economic and national situations. [12] Feminist historians insist therefore on precise historic distinctions in the 'enunciations of femininity' which were enmeshed in concurrent and equally historical enunciations of class, race and sexuality. [13] These insights radically revise our understanding of what an 'image of women' might be *of,* pointing firmly towards the social structures and public discourses in their historical specificity.

IV Images of Women

There are, however, different temporalities in this reconceptualisation of women as a historical construction. What we commonly think of as history is the linear time of a narrative of a sequence of events, activities, or artworks which can be extended by incorporating a richer field of social factors and determinants. As many papers collected here reveal, historically informed interrogation of the particular configurations of class, gender and sexuality in the later nineteenth century in France produces unexpected and unfamiliar readings of representations of the feminine body as social history is expanded by attention to the politics of sexuality. The work of Hollis Clayson and Anthea Callen in this volume (see pp. 66-79 and 159-85) reveal the impact of feminism in this field of social history.

Anthropological history suggests yet another temporality, longer, epochal duration which lives on through myth and image as permanent presents for a culture, which is none the less prey to the constant erosions and modifications of concrete social practice in any particular historical moment. Furthermore, there are the temporalities of the unconscious, a sedimented layering of memories, constantly reworked by the current figuration of the psyche. Freud argued that deposits of daily experience are shaped by archaic memories structured in earliest infancy. Psychic time, as Freud's case studies revealed, interweaves both monumental and linear times. For instance, an analysand patient reports a dream, in real time, as a remembered story of actions and events unfolding in sequence. The analyst proceeds to break open the narrative to expose the other scene, the unconscious, which inserts itself into the characters, events and even the words, thickening the thin line of the manifest dream story. The interpretation of the dream exposes the presence of different stages of the patient's life, memories and significant repressed emotions coded in a displaced and condensed fashion within the linear narrative initially reported. This model of interpretation translates well into that of visual images, which have a privileged relation to psychic

time. An image is both a static fantasy visualisation, dense with many levels of signification, and an invitation to narrative, linking these elements linearly, in terms of what is present within the frame, and archaeologically in terms of vertical links and cross-references which operate with little reference to obvious or manifest appearances.

Psychological formations are not beyond or outside history. The social conditions of childrearing and the regulations of sexuality are historically specific and shape the patterning of the psychic forces, as Linda Nochlin argues in her analysis of the family in the works of Degas (see pp. 43-65), or Anthea Callen proposes in defining class specific concepts of the body within a 'bourgeois imaginary' (see pp. 159-85). Psychological and social histories converge on 'images of women' which is an historically produced tautology. Embedded in nineteenth-century ideologies of femininity and its function in consumption and display, Woman became conflated with spectacle and image. Its impossible terms were also forced together in the conflicts and contradictions of psycho-symbolic formation of bourgeois sexualities. Hence the paradox. Woman, synonymous with beauty, seems the obvious sight for art. But far from being good to look at, Woman is potentially a truly dreadful sight. [14] It takes a massive investment in what Freud called the surplus of aesthetic pleasure, art or beauty, to negotiate the terrors of looking at an 'image of woman'.

According to psycho-analytic models of the complex formations of human sexuality the representation of the female body bears a contradictory load. At once the representative of the maternal body, the powerful nurturer and guarantor of an infant's existence, Life, it is subsequently inscribed with the anxieties generated in the inevitable sequence of separations and losses demanded by social Law, compliance with which alone makes us speaking and sexed subjects. In Freudian accounts, the female figure comes to signify for, and on behalf of masculine psyches, the most fearful of all anxieties, that of the mutilation and dismemberment threatened by disobedience to the Law. [15] Yet this signification is perpetually haunted by a trace of another body, moment, or place, comfortingly signifying the abolition of all difference and distance demanded by the Father – that space is the fantasy Mother.

Feminist uses of psychoanalysis of necessity have been cautious since its narratives often confirm a dominant version of the hierarchy of sexual difference in the very attempt to analyse it as a precarious and contingent process. It is unnecessary to lend the story further credence by rehearsing its major elements here. Key feminist revisions allow psychoanalysis to function as a political weapon in the deconstruction of that dominant regime. [16]

Psychoanalysis has been taken up as an anti-biological or anti-naturalist theory of human formation. Against theories of development which see human babies organically maturing according to biologically prescribed genders, psychoanalysis suggests that trauma or threatened catastrophe is necessary to force the human infant into the social mould of a symbol-using, that is, a speaking and sexed subject. Semiotically interpreted psycho-analysis sees in the psychic formations of the child

similar processes to those by which language as a whole is formed. A primary condition for both is the play of presence or absence. The psychic adventures of human infants introduce them via accumulated separations to alienation in a world of symbols which is language. Two major effects are produced: fantasy and symbolisation. The one reorganises the conditions and materials of life to deal with the often threatening impact of humanisation and socialisation by negotiating communication via symbolic tokens, language; the other generates substitutes and scenarios to compensate for the rift which opens between infant and world.

Symbolisation
Birth marks the first separation for an infant which hitherto has lived in a totally undifferentiated sphere. Immaturity extends that inability to differentiate between the world and itself; the infant is a mess of chaotic sensation. Without difference, there can be no meaning, no consciousness. The child has no way to establish boundaries between an inside and outside, a self and a world. Humanisation – the making of a social yet individulated subject – depends on a forced introduction to difference by means of spatial, temporal and emotional distancing. Food provides an initial site for the emergence of signification. Pain at its absence, pleasure in repletion are gradually associated with an object, the breast, appearing at times of need, but also failing to be present. Of course, as certain optical skills and cognition of primitive forms emerge, the child links food to object to person creating a gap on the closure of which its being – survival – depends. The terrors of absence – its mother's, meaning its own death – experienced starkly by the unformulated child map slowly on to psychic mechanisms which defend the infant, hence the development of symbolisation. For instance, the child invests things with the values or powers associated with the mother, necessary for survival yet independent of the child. Thus playing with a toy can be a means of gaining, in fantasy, control over the process of absence/presence which the mother's autonomy forces upon the hapless infant. This primitive symbolisation involves the transfer of an emotional investment from immediate circumstances to metaphoric, metonymic, symbolic actions which have no direct, or reflective relation to the meanings they produce. At first the shift is from one thing, mother, to another, a toy. Eventually the shift will be to a totally symbolic system where the substitutes are conventional and systematic – signs, words.

Fantasy and Desire
The processes involved in tending to a child's biological needs, feeding and cleaning, generate emotional and psychological bonds which then precipitate the child into a sequence of separations and losses which pave the way for its entry into the culture's symbolic system. But at a price. Again food is exemplary. The breast provides both necessary nourishment and also a surplus of pleasure beyond the satisfaction of biological need, a drive acting as a formative component of what will become sexuality. But because this pleasure is located outside its satisfaction, need has to be formulated

as a demand addressed to something/someone who has the power to satisfy but also to fail, indeed to be absent. In the appalling gap which opens because of the possibility of a failure to fulfil demand, desire is forged as an absolute demand for unconditional love, a fantasy of unity to combat the intolerable discovery of destined separation. In the way life impels the child into recognition of difference, what we call memory invents its opposite: fantasy and desire are generated but forced to live fantasmagorically on the underside of the symbolic system of language, the verso of consciousness, the unconscious, only formed when entry to the symbolic establishes a rule of repression. The human subject bears as its defining character the process of its formation. We are split subjects, suspended over the perpetual play of the division, unconscious/conscious. The temporality or social immediacy of langauge is always disrupted by the temporality of the unconscious, fantasy and desire.

This account so far is genderless – and indeed all subjects are formed through such processes. There is a coincidence between our subjection to difference, in the symbolic form of language, and its sexualisation, that is, in becoming speaking subjects, we are sexed, for we must recognise and accept gendered nominations, she versus he and all the social patterns of masculinity and femininity these imply, father/mother, husband/wife, brother/sister (each term of which carries differential socially determined values, roles and possibilities).

Freud's, and later Lacan's, accounts often elide difference and sexual difference by the centrality in their theories of castration and the Oedipus complex. Kaja Silverman has used psycho-analytic theory against the psycho-analysts, including Freud himself, to prise open the conflation of the process of subjectivity with the process of sexuality, that is, the very centrality of the evocative term 'castration' to the Freudian account reveals a refusal to relate this moment back to any of the 'other divisions which occur prior to the registration of sexual difference'.[17] If everything is allowed to hinge only on castration, with its overly anatomical associations, men, who have penises to lose, appear not to be afflicted by lack. Feminists insist that although the Oedipal moment is a culturally crucial moment, its effectivity rests on the other moments of division and separation which are not gendered but common to all subjects. The focus on castration gives undue and absolute significance to the sexing of the subject which then is read back as the end towards which all preceding processes drive. What has been a psychic process is then collapsed back on to bodies and biologies: anatomy is destiny. Since women's bodies appear anatomically to lack an organ, Woman becomes synonymous with lack in a highly visual scenario upon which Freud based his arguments.[18] But we are all subject to many psychic moments of lack in the process that begins with birth. Furthermore, what those who become boys because of it, learn at the Oedipal moment, is both that they are forever separated from the maternal body and they lack the phallus. It is the Father who has power (the phallus), and hence polices access to the Mother. The Oedipal story as Freud and company invented it, and western bourgeois families institutionalised it, can be read as a defensive, masculinist

representation, distancing men from the lack which forms all human subjects by making feminine bodies the exclusive and visual bearers of deficiency.* The major cultural apparatuses are not patriarchal, therefore, because they are dominated by men; it is rather that they service masculine fantasies and needs in the conflicts that human subjectivity and its predominant forms of sexual difference generate. A prime site for this servicing is the proliferation and aestheticisation of 'images of woman'.

Kaja Silverman does not suggest that the pleasure of cinematic viewing is the re-enactment of men's mastery over their fear of castrated woman. She defines it as a constant projection of masculinity's own subjective lack which is *figured by the image of woman*. Thus what an image of woman is of is masculinity's lack.

> Once again, classic cinema engineers this projection for him. Through its endless narrativisation of the castration crisis, it transfers to the female subject the losses which afflict the male subject. It also arms him against the possible return of these losses by orchestrating a range of defensive operations to be used against the image of woman, from disavowal and fetishism to voyeurism and sadism. In this way the trauma which would otherwise capsize the male viewer is both elicited and contained. [19]

Such arguments apply to both the making and the viewing of visual images in other cultural domains. Degas' practice is exemplary with its obsessive, repetitious re-enactments of sadistic voyeurism narrativised in bathing scenes, with its fetishism of its own means of aesthetic production and transformation of the model's body, which in social exchange he debased and abused (see Heather Dawkins' work on the experiences of models in his studio in this volume, pp. 202-17), and which in aesthetic practice he punished and tortured.

In writing such sentences I do not disguise the partisanship of my viewing. As a woman viewer I am forced to take up the proferred sadistic masculine position and symbolically enact the violence of Degas' representations, or identify masochistically with the bizarrely posed and cruelly drawn bodies. The female viewer, argues Kaja Silverman, is, by means of this 'anatomisation of her lack' in cinema 'excluded from symbolic power and privilege.' [20] Women watching films encounter images of women endowed with few words and carefully orchestrated 'looks', mostly directed at themselves or at men. But feminism as a point of identification has made it possible to think against the grain, to seek, as Heather Dawkins does, for

* This defensive division of the sexes can be extended in terms of class power, imperialism and race. How intense is the machismo and insistence on feminine inferiority in cultures where the men learn that their masculinity is lacking power (money, status, control over material life and so forth) through relations of class, colonialism and racism which create lack of power, public status, control over material life.

other identifications against these fantastic bodies of the heterosexual and bourgeois masculine imaginary. This counter-identification has to be produced by our own interventions at the level of the signifier, in what we write.

This argument leads in several directions. One is the writing of different stories. In the reappraisal of art and literature made by women, we can produce different 'images of women'. There are non-fetishistic and non-voyeuristic ways of looking and representing women which do not perpetually affirm women as lack but celebrate their plentitude and pleasure. My own paper (see pp. 106-30) attempts to counterpose Mary Cassatt's figurations of women looking to those by Degas to explore *her* passion for and obsession with women. But such reactive and positive insistence on the special character of women, their experience or fantasy, cannot alone dismantle the system of symbolic power and privilege. The always considerable tactical power of counter-history threatens to remain only a inversion – a reversal of the terms of the binary opposition and not its overthrow.

The other possible strategy has been developed in feminist appropriations from the many threads and debates which collectively constitute post-structuralism. These challenge the seeming inevitability and weight of the current system of symbolic power by reading it as a precarious process permanently struggling with the elements which constitute it, the contradictions it cannot contain but must try to 'manage'. (See pp. 133-45 for Heather Dawkins' careful reading of the attempts of art history to manage the fissures rent in its fabric by the fascination and horror of 'Degas'.) The symbolic system arranges these elements and processes into a specific regime, but they exceed that arrangement and form the basis both of its constant renovation and its possible revolution. [21] Psychoanalysis can be used as a story which only has one ending: phallocentricism. By attending to its own ideological closures and reading it against the grain, it offers an analysis of a more contingent and fluid arrangement of sexuality in which femininity can be examined, not as the negative cipher of a dominant and normalising masculinity, but as a complex socio-psychic formation, equally but specifically an effect of the process of human subjectivity.

A feminist reading exposes the manufacture of sexual difference. We can tell this story without retrospectively naturalising the end point, the current hierarchy of difference. In that way, feminists are at once turning their gaze on the formations of masculinity, and unpicking their own formation within femininity. We are identifying, often with love and compassion, the crises, the contradictions and the cost of human subjectivity. The effect of women speaking this knowledge can only be transgressive and transformative.

V Conclusion

Under the current regime, men claim mastery over the production of signs and meanings. Art history has established an array of methods to support and celebrate that mastery. Feminist interrogation of the formations of masculinity within this regime of sexual difference, as it articulates with racial as well as class power, reads

the images the system produces as *masculine projections* and *fantasies* which replay masculinity's drama of loss, lack and the defences formed against them. Women are absent, unrepresented and unsignified. Yet the *image of woman* is a recurring and seemingly necessary visual device by means of which masculinity defends its fantasies of power and rehearses its desire. We therefore wish to displace the 'image of woman' and instead we work to signify a *presence* for women, to produce a discourse to counter the visual figuration of their *absence* through 'images of women'. Presence for women is at the level of the signifier, our words, our analyses, our points of view. But it must also include us in the histories and temporalities of which we write, the historically formed creatures of psychic as well as social time. Anthea Callen investigates a bourgeois masculine imaginary in which social difference is articulated in figurations of the body, conflations of sight and touch, dirt and sexuality, contamination and social oppression (see pp. 159-85), while my paper on Mary Cassatt (see pp. 106-30) indicates the strategies by means of which Cassatt can be said to signify feminine desire in her distinctive interruptions of current tropes in the representation of modern women.

The title, 'Degas: Images of Women' is both tautologous and heavily ideological. Appearing to recognise questions feminism has placed on our agenda it merely confirms a sequence of culturally over-determined relations not between men and women, Degas and women, but between masculinity and representation, between representation and power. Where does this leave women studying art and its histories? Speaking dirty.

Naming these structures of power involves transgressing the social codes of femininity. To go on and on about sexuality and castration is not just irritating because English-speaking audiences are culturally antipathetic to theory and psycho-analysis in particular. I am reminded of Virginia Woolf's lecture to the National Society for Women's Service on 'Professions for women' in 1931. She tells the simple tale of a woman who wanted to write articles but became a murderer. Writing, for instance, a review of a novel by a famous man, she was haunted by a phantom who disturbed and tormented her and whispered in her ear: 'My dear, you are a young woman. You are writing about a book that has been written by a man. Be sympathetic; be tender; flatter; deceive; use all the arts and wiles of our sex. Never let anybody guess you have a mind of your own. Above all, be pure.'[22] Virginia Woolf tells us this phantom was the Victorian model of femininity, The Angel in the House. She turned upon the Angel and strangled her. If she had not, the Angel would have taken the heart out of her writing. But it was a hard struggle to kill the Angel because she was a phantom, something planted in women's heads, made part of the process of becoming and living as women in the historical moment of extreme over-feminisation typical of the nineteenth-century bourgeoisie. Woolf suggests that it was the particular experience of Edwardian women who had to battle with this High Victorian phantom.

But for feminists today there is still a mighty struggle to name the power against

which we fight for the right to speak. We are seen as rude and aggressive, making unnecessary personal attacks on art historians or lacking deference to artists who are men. Our language is condemned as either crude or vulgar, or difficult and inaccessible. Those papers collected here inspired by feminism reveal the difference that feminism makes. They are not revisions to art history, but in necessary contest with its deep structures, values and the interests it serves. As is clear from the diversity of feminist theories and methods on offer in this collection, the psycho-analytic mode is not the only mode of feminist analysis. Undoubtedly an important partner in the ideological and historical analysis of cultural practice, it is the theory most resisisted for it generates the maximum discomfort through its insistence on the other scene, on the role of fantasy. This is not a covert way of saying it is true, for the issue with feminism is not the right way or the correct theory, but the use of resources which empower us to proceed with a constantly changing process of critique, deconstruction and analysis. In the end what matters is where we speak from and for whom we speak. It is, as Heather Dawkins argues (see p. 215) a matter of identification and that is not only psychological, but political.

The feminist art historian is as much captured within the regimes of knowledge called art history as her colleagues, men and women alike. Therefore we may address similar objects, this pastel or drawing, that document. The question perpetually posed as we work is: 'With whom do I identify?' Furthermore, what possible shift in conventional identification with the masculinism of art history's favoured tropes of art and artist are established by what we write and say? Thus it is not a matter of women condemning Degas as a misogynist artist, or revising that label by another more sympathetic reading. His reputation and status are of no importance. Let revisionist art history do that job. To write or speak or read as a feminist is to go beyond questions of good and bad images, good or bad artists, men-oriented or women-oriented art and art history. It is to put sexual difference on the line as the topic. To see it as a social, historical and psychic process at work as much in the art historical practices as in the art practices about which art history writes.

This collection is symptomatic of the encounter between art history and feminism. There are different strands of feminism represented coupled with differently conceived historical projects, methods of research, methodologies and theories. There are also differing degrees of understanding of the intervention feminism represents. The reader cannot approach such a collection merely as a series of academic papers. They are themselves the products of the struggles around representation and sexuality taking place today, in both artistic and academic practice. While the occasion was the collective look of scholarship at historical objects assembled under the rubric 'Degas: Images of Women', the questions really posed were 'What am I looking at and for? What knowledge does my look desire? Who am I when I look at this?' Displacing the ideological naturalism of the trope 'Degas: Images of Women', we are 'Dealing with Degas' to generate a different ordering of the politics of vision: *Women/Degas/Images*.

Notes

1. John Berger, *Ways of Seeing*, London, BBC, and Penguin Books 1972, p. 47.

2. I use the masculine pronoun advisedly, since art history finds it hard to imagine the coincidence of creativity and femininity. See R. Parker and G. Pollock *Old Mistresses Women, Art & Ideology*, London, Pandora Press, 1981.

3. Richard Kendall, *Degas: Images of Women*, Liverpool, Tate Gallery, 1989, p. 6.

4. See R. Barthes 'The death of the author', first published in 1969, in S. Heath (ed.) *Image-Music-Text*, London, Fontana, 1977, p. 145.

5. G. Pollock 'What's wrong with ''images of women''?' *Screen Education* 1977, no 24; reprinted in R. Parker and G. Pollock *Framing Feminism Art and the Women's Movement 1970-85* London, Pandora Press, 1987. See also 'Missing women: rethinking what's wrong with images of women', in *The Critical Image* ed. Carol Squiers, Bay Press and Harvester Press, 1990.

6. For instance d-o-g differs from h-o-g at the level of sound or shape, not because these particular sets of sounds have any direct or motivated relation to four-footed canines or snuffling pigs. Signs are not motivated, i.e. related to the concepts they signify; they are *arbitrary*, linked by conventions within each linguistic community and culture. For a introduction to this linguistic theory see J. Culler, *Saussure*, London, Fontana, 1976.

7. 'It is this mutuality which summons up the powr of the real: a reality of intertext beyond which there is no-sense. What lies 'behind' the paper or 'behind' the image is not reality – the referent – but reference: a subtle web of discourse through which realism is enmeshed in a complex fabric of notions, representations, images, attitudes, gestures and modes of actions which function as every-day know-how, 'practical ideology', norms within which and through which people live their relation to the world.' J. Tagg, 'Power and Photography' in *Screen Education*, 1980, no. 36; reprinted in *The Burden of Photography*, London, Macmillan, 1988, pp. 99-100.

8. The phrase is from Roland Barthes, as 'The reality effect' in *The Rustle of Language*, Oxford, Basil Blackwell, 1986.

9. See Gayle Rubin, 'The traffic in women' in Rayner Reiter *Towards an Anthropology of Women*, Boston, Monthly Review Press, 1975; E. Cowie 'Woman as sign' *m/f* 1978, no. 1. They draw on the work of Claude Lévi-Strauss, who was influenced by Saussure and semiotics and who argues that kinship patterns are like a social language which communicate meaning not by words but by the exchange of women between communities.

10. Gayatri Chakravorty Spivak, 'French feminism in an international frame', reprinted in *Other Worlds Essays in Cultural Politics,* London and New York, Methuen, 1987, pp. 134-54.

11. The phrase is Gayle Rubin's; see Note 9.

12. D. Riley defines this process as the 'long march of the empires of gender over the entirety of the person', and elegantly argues for an historicisation of the

category 'women' in 'Does sex have a history?' in *'Am I That Name?' Feminism and the Category of 'Women in History'*, London, Macmillan, 1988.

13. See Angela Davis, *Women Race and Class*, London, The Women's Press, 1984 for a powerful account of the different way black women have lived, negotiated, and defined the social meanings and psychological investments of 'woman, women and femininity'.

14. L. Mulvey, 'Visual pleasure and the narrative cinema', *Screen*, 1975, vol. 16, no. 3; reprinted in *Visual and Other Pleasures*, London, Macmillan, 1989.

15. The Law is the social rule which separates the biological from the social family. The Law sets the limits to our sexual objects and defines the socially accepted regulation of sexual gratification. In the bourgeois family the Law is operative, demanding that the infant give up its prime object, the mother and accept a substitute – in the case of a male child, another woman, in the case of a female child a composite of a man who will, by having a phallus, become a father and make her a mother and give her a baby. The particularity of the western bourgeois family's submission to the Law which sexes its agents for the reproduction of society is complicated by the intimacy and eroticised relations of immediate family members, especially mother and child, and by the authority directly exerted by the father in the day-to-day life of children. The Law, as the prescription of acceptable sexual relations and the proscription of the immediate family as candidates, operates in different cultures through various mechanisms. The bourgeois family of the Freudian account heightened the stakes and the pain by intensifying the family relations, only to make the prohibitions more fearsome. The significance of the castration threat enacted against small children's autonomous sexual pleasures, as well as their attachments to their parents, has to be read in a historically specific context. It is within this situation that the image of woman comes to signify; the threat of castration seems serious because there appear to be castrated people. The mother, once powerful and dependable, is revealed through social and cultural rather than physical means not to be all powerful. Since social power is associated with men, the phallus symbolically represents what the mother lacks. Memories of her power and significance invest her body in fantasy with the phallus, of which she has subsequently been deprived. Aggression towards that which threatens the child's diminishing sense of omnipotence and ability to give itself pleasure, in fact the representative of the Law (the father), is transferred on to the Mother. The 'image of woman' is a composite of this fantasy body – powerful and therefore threatening, powerless and also threatening to extend that powerlessness to those who identify with her form. To submit to the Law is to accept a symbolic mapping of the body – either identifying with the body of power, empowered by the phallus for which the penis will function as metonym, or identifying with the Mother. For the masculine subject that other body signifies powerlessness and a perpetual threat of becoming like it. For the feminine subject, the issue turns out quite differently,

as my paper subsequently tries to argue.

16. ibid. p. 1.
17. K. Silverman, *The Acoustic Mirror: The Female Voice in Psychoanalysis and Cinema*, Bloomington, Indiana University Press, 1988, p. 15.
18. For a powerful critique of the over-visualisation of sexual difference, see Stephen Heath, 'Difference', *Screen*, autumn 1978, vol. 19, no. 3.
19. Silverman, op. cit. p. 31.
20. ibid.
21. J. Kristeva, 'The system and the speaking subject', in *The Kristeva Reader*, ed. T. Moi, Oxford, Basil Blackwell, 1986.
22. V. Woolf, 'Professions for women', first published in 1931, in *Women and Writing* introduced by M. Barrett, The Women's Press, London, 1979, p. 59.

SECTION I:
IMAGE, NARRATIVE AND THE QUESTION OF AMBIGUITY

A House is not a Home:
Degas and the Subversion of the Family

Linda Nochlin

In a brothel, both
The ladies and gentlemen
Have nicknames only.
W. H. Auden

I first started thinking about Degas and the subversion of the family when I noticed, after the removal of *The Bellelli Family* (plate I) to the Musée d'Orsay, the existence of half a small dog scooting out of the painting to the right. I had never noticed this detail before the painting was moved – it is very hard to see in most reproductions – and none of the scholars who have discussed *The Bellelli Family* have taken account of its presence.[1] The dog must have been a last minute addition; it does not appear in the final Ordrupgaard sketch of about 1859 (L 64). It is possible that Degas' main reason for putting it in his painting was a formal one, to fill up an awkward empty space in front of the figure of Gennaro Bellelli who otherwise might seem outbalanced by the three-figured group on the left. Yet a formal intention does not nullify a signifying result: the way the dog works in the construction of meaning in the painting. With a kind of airy, heedless, cheeky *je m'en foutisme*, entirely at odds with the almost desperate seriousness of the painting as a whole, this canine hind part works to undermine all the solemn balance and traditional formality of Degas' monumental, tensely harmonised, family-group structure with a wave of its fluffy tail. The dog's vector is, in the extreme, centrifugal; as such, it might be opposed to the reassuringly anchoring position of Porto, the Newfoundland, wholly present – indeed, literally part of the family – in the more cheerful and relaxed representation of a bourgeois family group in Renoir's *Mme Charpentier and her Children* (Metropolitan Museum of Art, New York) of 1878.

Yet it is not really the dog I wish to talk about – Degas, incidentally, is said to have hated dogs – but rather the relatively covert contraversion it figures in the portrait of *The Bellelli Family* of what one might call conventional bourgeois – specifically upper

bourgeois – family values such as those represented in the *Charpentier Family* portrait and many others of the period. Now, one could point to *The Bellelli Family* as a special case; indeed it is one, if only in the sense it was the representation of an unhappy family. Degas was well aware of the strains existing between the husband, Gennaro Bellelli, and wife (his father's sister, Laura, his aunt) when he embarked on his ambitious project in the late 1850s. At the same time, he evidently wanted the portrait of the Bellellis to be a major painting with a dignified structure and a sense of traditional universality as well. The tensions proliferating among the artist's lofty intentions; his sense of the specific and the contemporary; his conscious and/or unconscious awareness of animosity between the couple; the perhaps unacknowledged strength of his feelings for his aunt and hers for her nephew; these, and the consequent insertion of the signs of dissension and instability into the superficially harmonious fabric of his representation, are what make the portrait interesting and disturbing to the modern viewer. *The Bellelli Family* (originally referred to simply as 'Family Portrait' when it was first exhibited in the Salon of 1867)[2] is as much a painting about the contradictions riddling the general idea of the high bourgeois family in the middle of the nineteenth century as it is a family portrait *tout court*.

The Bellelli family portrait, then, must be read not merely as a family document but also as a representation of 'The Family', its structure inscribing those tensions and oppositions, characteristic of certain familial relationships in general, and the relationships existing in this family in particular, at a concrete historical moment. At the same time, the painting must be seen as inscribing those unifying codes of structural relationship – hierarchised according to age and sex, homogenised in terms of class and appearance – governing the ideal of nineteenth-century bourgeois family existence.

Within the complex web of inscriptions constituting the Bellelli portrait, both temporal and spatial considerations play their role. For Degas has presented the family diachronically as a hierarchical continuum of generations: grandfather René, then the parents, followed by Giuliana and Giovanna; and, as the presence of the recently deceased grandfather is indicated simply by an image on the wall, so the presence of the unborn next generation is merely hinted at in the costume and stance of Laura. This notion of a generational historicity is heightened by nuances of style and structure: references to a specifically aristocratic tradition of portraiture, that of van Dyck and Bronzino for example, and the willed balance and geometric ordering of the composition, suggest that it is not just to any old past that the young artist wishes to connect his family.

Yet the high tone of this reference to family continuity is interrupted or complicated by synchronic tensions. The stately procession of inheritance and succession is interrupted and called into question by contemporary and specifically psychological disharmonies characteristic of the high bourgeois family of Degas' own time and the Bellelli's particular family drama. Interestingly, these tensions are, in pictorial

terms, represented not merely by the slumped figure of Gennaro and the over-erect one of Laura, but perhaps even more acutely by the figure that both separates and connects them, the awkwardly and unstably posed Giuliana.

Strains there were many in the Bellelli family. The scenario of the Bellelli relationship reads like the outline of a contemporary nineteenth-century novel, one by Balzac, or, later, by Zola; or perhaps it simply reveals the source of both the painting and the novels – *pace* Roland Barthes – in contemporary discourses of the family which position this institution as a problematic as well as an ideal social construction. [3]

Laura Degas had married Gennaro Bellelli as a 'last resort' at the advanced age of 28, for her domineering father (standing guard on the wall behind her in the painting) had found all preceding suppliants, including one that she truly loved and wanted to marry, insufficiently rich or distinguished to accede to the hand of this young woman who was herself both rich and beautiful. 'On a particularly distressing occasion', says Roy McMullen in his biography of Degas, 'an Englishman who had failed to measure up to the requirements . . . had lost his temper and denounced the whole proceedings as "more like a business negotiation than an affair of the heart".' [4]

The Bellellis' was evidently a loveless marriage, and at the time Degas was engaged in painting the portrait – first sketching in Florence, where the Bellellis lived in rented quarters, then painting the large canvas back in Paris – Laura Bellelli, whom he loved and who was startlingly open with him about her marital problems, was desperately unhappy with her husband. In 1859 and 1860, she wrote to Degas about her misery, describing her sad life with a husband whose character was 'immensely disagreeable and dishonest' and declaring that 'living with Gennaro, whose detestable nature you know and who has no serious occupation shall soon lead me to the grave'. In another letter, she refers to the 'disagreeable countenance' of a bitter and always idle Gennaro, and declares that he has no 'serious occupation to make him less boring to himself'. [5]

Given the outspoken distaste of the wife for the husband, the pregnancy discreetly evoked in Degas' painting should perhaps be read not merely as the dignified suggestion of future generations carrying on the Degas-Bellelli family tradition, but as evidence of a quite different situation. From a certain vantage point, Laura Bellelli's gently expansive form may be viewed not merely as a representation of woman's predestined role as procreator, but as the subtle record of an outrage, an act committed on her body without the love or respect of the perpetrator – an act that has come to be defined as marital rape.

Yet there is still another set of facts about the family represented here that demands still another kind of reading of the painting: this reading is what one might designate as a political one. Despite the surface stability of the family group, and the suggestion of elegance and settled comfort in the setting, this is a painting of a family in exile, a family which had wandered and been uprooted several times in the course of its existence. The Bellellis were living in a rented, furnished flat in Florence because

Gennaro had been exiled from his native Naples and, indeed, had been condemned to death *in absentia* on account of his role in the local 1848 Revolution and his subversive political activities on behalf of Cavour, who wished to expel the Bourbons and create a greater Italy by uniting the Kingdom of the Two Sicilies with Piedmont.[6] Gennaro and his wife had fled to Marseilles, then to Paris, then to London, and in 1852 had settled with their two children in Florence. This, then, is the painting not merely of a family, or of an unhappy family, but of a family torn from its native habitat. Is it merely coincidental that in his notebooks of 1858 in Florence, Degas records a plan to depict Mary Stuart's heart-broken departure from France in 1561, based on an incident in the Seigneur de Brantôme's *Vies des dames illustrés*? This was to have been a sentimental history painting that Degas describes in the following terms, no doubt drawn from his source: 'Without thinking of anything else, she leaned both her arms on the poop of the galley next to the tiller and began to shed huge tears while continually rolling her beautiful eyes toward the port and the land she had left, and while repeating over and over again, for nearly five hours and until night began to fall, the same doleful words: "*Adieu*, France".'[7] It is not too far-fetched to speculate that the painter conceived of his aunt as a modern Mary Stuart, melancholy in her isolation and exiled, inconsolably, from friends and family in Naples.

Yet, interesting though this painting and this family may be, it is not just *The Bellelli Family* that I will be concerned with in this text, but rather the intersection of the particularity of the Bellelli story with the signifying structure of the painting, and the relation of both to the more general and consistent practice of fragmentation and centrifugality characteristic of Degas' representations of family groups. This is a practice that contrasts strongly with the more unified, harmonised and centripetally focused representations of the subject by more conventional painters of the period. Finally, I will examine the relation of all of these issues to the problematisation of the discourse of the family in the second half of the nineteenth century in France.

To begin with, *The Bellelli Family* may be contextualised as one of a number of Degas' images in which gender opposition, tension or outright hostility is a major issue, in works such as the *Young Spartans* of 1860-62 (National Gallery, London, L 70), *The Interior* of 1868-9 (also called *The Rape*, plate 2) or *Sulking* (fig. 16) in which a yawning space between the gendered opponents and/or fragments or centrifugal composition constructs a disturbing sense of psychological distance or underlying hostility between the figures in question.

It is, oddly enough, precisely in the representation of *family* scenes – just where one would most expect a pictorial structure suggesting 'togetherness' – that Degas most strongly emphasises apartness and disjunction. In the striking portrait of his aunt Stefanina with her two daughters of *c*.1876, for example (*Portrait of the Duchessa de Montajasi with her Daughters Elena and Camilla*, fig. 1), the black-clad matron stares stolidly ahead at the viewer, while the two young women, perhaps playing the piano

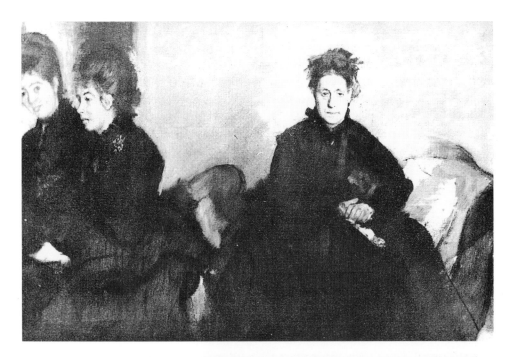

Fig. 1 *Above* Edgar Degas, *Portrait of the Duchessa de Montajasi with her Daughters Elena and Camilla, c.* 1876, oil on canvas, 60 × 98cm, private collection, L 637.

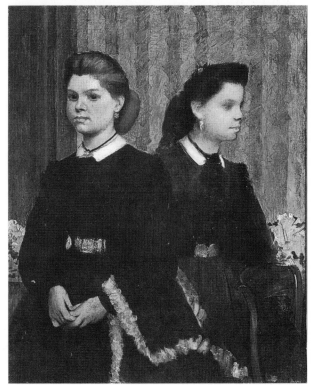

Fig. 2 *Right* Edgar Degas, *Giovanna and Guiliana Bellelli, c.* 1865–6, oil on canvas, 92 × 73 cm, County Museum of Art, Los Angeles, Collection of Mr & Mrs George Gard De Silva, L 126.

and relegated to the bottom left margin of the painting, focus their attention away from her, out of the painting altogether.[8] In his painting of the *Place de la Concorde* of 1876 which was destroyed (L 368), the Vicomte Lepic, his two daughters and their greyhound are all centrifugally deployed, the fragmentation and disjunctiveness of the composition made even more evident by the presence of a sliver of an onlooker in the left hand margin and the vast empty space of the *Place* itself in the background. This is a daringly decentred composition, inscribing in visual terms the fragmentation and haphazardness of experience characteristic of the great modern city, but with the added poignancy that the point is made with parent and children, rather than with mere passing strangers.

In the double portrait of the Bellelli sisters (fig. 2), the two girls turn their backs on one another, and in the portrait of Degas' close friend, Henri Rouart with his daughter, Hélène, of 1871-2, the child perches uneasily on her father's knee, looking grimly out at the spectator as he looks dully to the left (private collection, New York, L 424). The other members of the Impressionist group, Berthe Morisot, for example, or Mary Cassatt, often turned to members of their own families or to those of friends as subject matter, and it is rarely a question of sentimental heightening of family feeling in their work. Rather, it is Degas' insistence on separation and disjunction, a formal structure of indifference, as the very hallmark of the family portrait, that is so striking.[9] The wistful sense of uneasiness emanating from the artist's portrait of his orphan cousin and her uncle, *Henri and Lucie Degas* of *c*.1876 (Art Institute, Chicago, L 394) is a function of the same sort of psychic and compositional disjunction that marks Degas' representations of family members generally.

Even in the one work, *At the Races in the Countryside*, (plate 4), in which Degas has apparently created a pastoral image of *haut-bourgeois* family felicity, a composition representing his old friend Paul Valpinçon, his wife and their infant son, Henri, a group as cuddly and engaging as any sentimentalist of the family could want, the family unit depicted is, in a sense, a fraud. For the mother-figure at the heart of this family group, emphasised by her white dress and the solicitously adjusted white umbrella over her head, is *not*, in fact, the happy mother at all but rather the hired help, the wet nurse, who, like the fashionable bulldog perched on the edge of the carriage, is simply one of the necessary accoutrements of the high bourgeois domestic economy. The *soi-disant* family group disguises the presence of an intruder: that of the so-called *seconde mère* who is the actual provider of nourishment to the son and heir.

It would be easy to reduce Degas' uneasy representations of the family to the projection of some sort of personal neurosis on his part which one could attribute to the early loss of his mother, the surplus of bachelor uncles and marriages of convenience in his family, or to poor communication with his father, but that would be to miss the point.[10] The family was a theme considerably debated during the second half of the nineteenth century in France among men of Degas' class, and specifically within the group of sophisticated men of letters who were his friends and associates.

After the Commune, the problematisation of the family was stimulated by the nascent discipline of sociology, which took on this institution with a vengeance, positioning the Commune as a disaster occasioned by the weakening of family authority and the resultant triumph of anarchy and greed among the lower orders. This was the interpretation not only of authorities on the Right – Catholic or Royalist – but, most especially, of right-thinking Republicans of *juste-milieu* tendencies, sociologists like Henri Baudrillart, member of the Institute and author of the influential *La Famille et l'Education en France dans leur Rapports avec l'Etat de la Société*, published in 1874. [11] In this important study, Baudrilart lays emphasis on the bourgeois family as the chief pillar of the state, a bulwark against the chaotic and uncontrolled energies and desires of the masses, and on the necessity for the middle-class family to instil the virtues of industry, honesty, loyalty and self-sacrifice in its members – through the instrumentality of its female members above all.

Often, in the wake of the bourgeois trauma represented by the Commune, the need for vigorous political control within the state was equated with the need for increased state intervention in the affairs of the family, that is to say, the working-class family. Such intervention became an important element of the modernisation processes in the nineteenth and early twentieth centuries, as Jacques Donzelot revealed in his now classic study *La Police des Familles* of 1977. [12] This demand for the policing of the poor family was almost always accompanied by a parallel demand for self-policing, for internalised education in self-control and repression of impulse on the part of the superior levels of society.

Yet of course I am making it sound as though the family were itself a fixed, known entity, rather than a formation in the process of construction during the course of the nineteenth century. While a great deal of ink was spilled in defining family norms – rather different for different classes to be sure – and positing family ideals, the modern family, that entity we tend to think of as relatively fixed and permanent, put in place within the individual by such structuring devices as the Oedipus complex and the super-ego, and socially positioned as the private sphere, in opposition to the public one of politics, was still a formation in the process of coming into being during the period when Degas was painting.

Mark Poster, in his book *Critical Theory of the Family* (1978) sets out the most accurate, complex and nuanced model of bourgeois family structure available, making clear and raising to the level of critical consciousness just those features of family relationship and ideology that Degas and his contemporaries – and perhaps many of us as well – take as inherent to family structure, but which in fact are historically and class specific. [13]

To summarise Poster's model of the nineteenth-century bourgeois family:

> The bourgeois family by definition is located in urban areas . . . Family planning first began in this group. In everyday life, relations among members of the bourgeois family took on a distinct pattern of emotional intensity and privacy

. . . Sexuality among this class, until recent changes, is one of the more astonishing features of modern history. Like no other class before, the bourgeoisie made a systematic effort to delay gratification. This led to sexual incapacities for both men and women. . . . Among the bourgeoisie, women were viewed as asexual beings, as angelic creatures beyond animal lust. When internalized, this image of women led to profound emotional conflicts. . . . Prostitution was required by bourgeois males . . . because the ''double standard'', which originated with this class, made sexual fulfillment impossible for both spouses.

Bourgeois marriage bound the couple forever. Social and financial interests tended to predominate in these alliances . . . as the soundest reason for marriage. Yet there was a contradictory drive in bourgeois youth towards romantic love. The strange thing about the sentimental pattern of the middle class is that romantic love rarely outlasted the first few years . . . of the union. 'Happily ever after' meant living together not with intense passion but with restrained respectability.

Relations within the bourgeois family were regulated by strict sex-role divisions. The husband was the dominant authority over the family and he provided for the family by work in factory or market. The wife, considerably less rational and less capable, concerned herself exclusively with the home. The major interest of the wife for a good part of the marriage concerned the children: she was to raise them with the utmost attention, a degree of care new to family history. A new degree of intimacy and emotional depth characterized in relations between parents and children of this class. A novel form of maternal love was thought natural to women. Women were not simply to tend to the survival of their children, but to train them for a respectable place in society. More than that, they were encouraged to create a bond between themselves and the children so deep that the child's inner life could be shaped to moral perfection. . . . As it eschewed the productive function, the bourgeois home also divorced itself from external authority. Within the family's clearly defined boundaries, authority over the relations of parents and children was now limited to the parents alone.

With new forms of love and authority, the bourgeois family generated a new emotional structure. Child-rearing methods of this family were sharply different from those of the earlier aristocracy and peasantry. During the oral stage, the mother was deeply committed to giving her infant tenderness and attention. . . . During the anal phase, the same constant attention continued accompanied by a sharp element of denial. The child was compelled to exchange anal gratification for maternal love, denying radically the pleasure of the body in favor of sublimated forms of parental affection.

Ambivalence, according to Poster, the central emotional context of bourgeois

50

childhood, must be seen as a direct creation of the bourgeois family structure. In fact, he maintains, the secret of the bourgeois family structure was that, without conscious intention on the part of the parents, it played with intense feelings of love and hate which the child felt both for its body and for its parents in such a way that parental rules became internalised and cemented in the unconscious on the strength of both feelings, love and hate, each working to support and reinforce the other. Love, as ego-ideal, and hate, as super-ego, both worked to foster the attitudes of respectability. In this way, Poster maintains, the family generated an 'autonomous' bourgeois, a modern citizen who needed no external sanctions or supports but was self-motivated to confront a competitive world, make independent decisions and battle for capital.

Poster summarises the formative structure of the bourgeois family and the resulting sharp differentiation of gender roles as follows:

> The emotional pattern of the bourgeois family is defined by authority restricted to parents, deep parental love for children and a tendency to employ threats of the withdrawal of love rather than physical punishment as a sanction. This pattern, applied to the oral, anal and genital stages, results in a systematic exchange on the child's part of bodily gratification for parental love, which in turn produces a deep internalization of the parent of the same sex. Sexual differences become sharp personality differences. Masculinity is defined as the capacity to sublimate, to be aggressive, rational and active; femininity is defined as the capacity to express emotions, to be weak, irrational and passive. Age differences become internalized patterns of submission. Childhood is a unique but inferior condition. Childhood dependency is the basis for learning to love one's superiors. Passage to adulthood requires the internalization of authority. Individuality is gained at the price of unconsciously incorporating parental norms. . . . The bourgeois family structure is suited preeminently to generate people with ego structures that foster the illusion that they are autonomous beings. Having internalized love-authority patterns to an unprecedented degree by anchoring displaced body energy in a super-ego, the bourgeois sees himself as his own self-creation, as the captain of his soul, when in fact he is the result of complex psycho-social processes. [14]

In comparison to this psycho-analytic thematisation of the formation of the family under capitalism, Jürgen Habermas' positioning of the modern nuclear family as the historically emergent institution constituting private relations within what he terms the 'life world' (existing in opposition to the public, or political sphere of this world at the same time that it is linked to, and mutually dependent upon, the official economic sphere of the so called 'system world'), emphasises very different features of bourgeois family structure within the social, economic and political context of modernisation. [15] Degas' representations of the family, it seems to me, cannot be

fully understood or interpreted without taking account of this process and the ways in which the family assumes a new and important role in relation to the other institutional orders of capitalism. Neither can such representations be understood without an awareness of the important ideological role played by idealist pictorial or literary constructions of the family in which the mutual interlinkage of the family and public life, the family and the economy is occluded in favour of a vision of the family which envisions it as a pure opposition to the world of getting and spending, an oasis of private feelings and authentic relationships in a desert of harsh reality. The complex construction of the bourgeois family was marked in all its phases by non-sychronous features, by failures and contradictions as well as by triumphs. For example, in Degas' time, for the upper bourgeoisie in general, the older notion of the extended family and its interests, and of marriage as a strategic cementing of economic, social and political alliances coexisted with very different, more 'progressive' notions of romantic love, freely chosen spouses, the primacy of the individual couple and their mutual interests, and so forth. [16]

I have gone into such detail in establishing an identifying model of the nineteenth-century bourgeois family because I believe it is impossible to deal with the representations and critiques problematising this institution in the literary and artistic discourse of the time without some familiarity with various theories of the family and its historical formation under capitalism. Certainly, sharp criticism of the bourgeois family and its defining hypocrisy constituted one of the favoured themes of the naturalist writers of Degas' time and circle. In these texts, it is the difference between appearance – of decorum, mutual interest and above all of unimpeachable respectability – and reality – sordid, exploitative, corrupt – that constitutes the favoured topos, rather than what might be characterised as the Freudian figure of ambivalence. Zola's *Pot-Bouille* of 1884, for example, is just such a searching and serious critique of the corruption infecting bourgeois family relations. [17] In *Pot-Bouille*, the opposition between respectability, which is the appearance, and corruption, which is the reality, is figured in the contrast Zola establishes between the family areas and the servants' quarters of a Parisian apartment house, a setting the author characterises as a 'bourgeois chapel'. But in the centre of the house is the servants' staircase and inner court. Here, in this place that Zola calls 'the sewer of the house', all is dank and redolent of stale odours. The servants shout malevolent gossip and vulgarities from window to window. 'The facade of respectability that conceals the vulgarity of the servants' court is an analogy for the strict moral facade and inner corruption that characterise every family in the house.' [16] *Pot-Bouille*, according to Demetra Palmari, constitutes a serious and devastating condemnation of bourgeois morality from the vantage point of a progressive social critique couched in the language of naturalism. From this vantage point, the failure of the family lies in the fact that although this institution is supposed to uphold the highest moral standards, it does not serve this function at all. 'Though the family is a central element of their lives, its members have virtually no affection for one another and are

continually trying to escape its oppressive bonds, at the same time that they cling to its emotionally lifeless form, for it is the societal justification of their moral code.'[19]

In those pre-Freudian days, Zola's analysis of the problems besetting the bourgeois family fastens on the contrast between appearance and reality, between masquerade and truth as the besetting evil; that is to say, hypocrisy rather than internalised ambivalence is positioned as the motor of family interaction. Love – spontaneous, natural, unfettered – on the other hand, rather than being seen an inherent part of the 'problem' of the bourgeois family, the most potent, internalised weapon of family control, is idealised as the (rarely available) 'solution'.

This topos of appearance versus reality, of glittering performance versus sordid *coulisse*, of masquerade as the livery of bourgeois respectability, is one favoured not merely by serious naturalists like Zola, but by the light-hearted, cynical, worldly men of letters of Degas' time and ambience as well. As such it constitutes an important sub-genre of the entire discourse of prostitutionality of the period, a genre focusing on the difficulty of distinguishing between respectable women and prostitutes.[20] Of course the Goncourts resort to the topos again and again, both in their novels and in the pages of the *Journal*,[21] but the apotheosis of the genre, constructing a critique of bourgeois family values through a witty, parodic literary structure rather than a naturalistic, moralistic one, is in fact the creation of Degas' close friend and fellow *habitué* of the *coulisses* of the Opéra: Ludovic Halévy, author of the *Famille Cardinal* series (fig. 3). Degas created over thirty illustrations, mostly monotypes, for the series of interrelated short stories dealing with the Cardinals: Monsieur, Madame and the two 'petites Cardinals', Virginie and Pauline, who are members of the *corps de ballet*.[22] Degas evidently admired the Cardinal stories, relishing their charm and cynicism, despite the fact that Halévy rejected his prints as illustrations for the collected volume, *La Famille Cardinal*. When Halévy later published the more moralising, sentimental novel, *L'Abbé Constantin*, Halévy notes Degas' negative reaction in his diary, saying: 'He is disgusted with all that virtue, all that elegance. He was insulting to me this morning. I must always do things like Madame Cardinal, dry little things, satirical, sceptical, ironic, without heart, without feeling . . .'[23]

What Zola hypostatises as tragedy, Halévy deconstructs as farce. It is simply taken for granted that the 'family values' represented by an upwardly mobile lower- or lower middle-class family with two dancing daughters are farcical – hypocritical and corrupt – and that the desperate need for respectability that apparently motivates the Cardinal parents in their ambitions for their lovely and desirable daughters is laughable rather than pathetic. Social critique, if it is present at all, is directed against the lower-class victims rather than the worldly men who supply these young women with material benefits in return for sexual favours: this social arrangement is simply taken for granted. Its acceptability – and worldly humorousness – is underscored by the fact that the tales of the Cardinals' peccadilloes are always narrated by the author himself; Halévy figures as the observer-narrator of *La famille Cardinal,* and Degas, rather too conspicuously for the author's taste, perhaps, introduces his friend

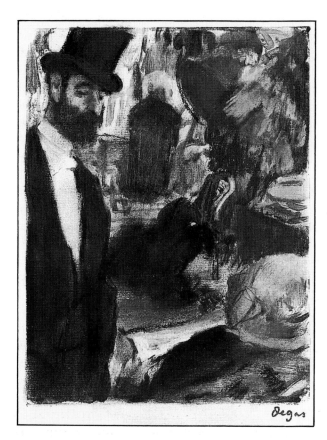

Fig. 3 Edgar Degas, *Ludovic Halévy Meeting Mme Cardinal Backstage*, La famille Cardinal series, 1876–7, monotype with red and black pastel, 21.3 × 16 cm, Staatsgalerie, Stuttgart, J 212.

as a recognisable portrait in many of his illustrations (probably created during the 1870s and early 1880s).

The Cardinal stories are constructed as a series of paradoxes, in which the family is figured in the form of its parodic debasement, and in which the mother enacts the role of the loving, concerned – ever-vigilant – procuress and the father that of the strict but respectable pimp, who from time to time, because of his political ambitions, refuses to let his daughters darken his door. These paternal political ambitions serve to define the ridiculous M. Cardinal as a sort of M. Prudhomme of the left, for *La Famille Cardinal* is a parody of the radical politics of the lower orders as well as of their search for respectability. M. Cardinal is represented as a genuine member of the Commune, a parodic Communard, M. Prudhomme as Communard. He is a militant atheist whose cocotte-daughters, having set him and his wife up in *confort coussu* in a suburban cottage, buy him busts of Voltaire and Rousseau as a birthday present, while their lovers provide him with fireworks and refreshments for the radical fête he has organised in the village in hope of becoming its radical mayor.

The two Cardinal daughters are hardly described at all. Their charms are a matter of suggestion, indicated by the reactions of their male admirers and the high price

their sexual services fetch on the *coulisse* market. They are obvious fluff-heads, alternately dumb, tangled up in their own silly spontaneous erotic impulses, and extremely astute about making domestic arrangements that pay well and leave them free to pursue their unslakable but innocent lust for pleasure and possessions. Both Colette's *Gigi* and Anita Loos' *Gentlemen Prefer Blondes*, as well as the comedy films of Marilyn Monroe, are presaged in these adorably silly young creatures. In the case of these 'naturally' predatory girls, Halévy implies, education – one of the cornerstones of bourgeois family aspiration – would be a drawback rather than an advantage. When Pauline Cardinal, now a *poule de luxe* ensconced in the lap of luxury, wishes to break some appointments with her wealthy lovers in order to visit her mother in the country, she has her lady's maid write to the gentlemen in question rather than doing so herself. When Mme Cardinal expresses shock over her bad manners, Pauline replies: 'Hermance writes better than I do; she's been a governess in a great family; she never makes a mistake in spelling. But as for me! It's a little your fault, mamma. You were much more anxious to teach me dancing than spelling.'

'Because I thought it was more useful and I was right.' Mme Cardinal replies. 'Would you be what you are if it hadn't been for the ballet? And see what spelling brings you to – to be your lady's maid.'[24]

Bourgeois virtue, far from being rewarded, is in fact punished in this paradoxical mode of family satire. What you would expect the right-thinking, respectable mother to demand is never quite what Mme Cardinal in her role of procuress-mother is up to in her search for 'respectable' – actually, high-class prostitutional – connections for her daughters.

Family feeling, that demand for harmony and mutual support usually seen as central to the respectability of the family as an institution, is wittily demeaned by such paradoxical figuration. When for example, Virginie's rich and aristocratic lover, the Marquis, discusses domestic arrangements with M. and Mme Cardinal, suggesting that he will pay the parents a little pension and set up house with Virginie on Boulevard de la Reine-Hortense, M. and Mme Cardinal are overcome with horror. This is not because the Marquis wishes to live in sin with their daughter, as one might expect, but because he wishes to set her up separately from them – outside the bosom of her family – and pay them off with a measly pension. M. Cardinal walks out in a huff, saying that nothing can induce them to part from their Virginie, leaving Madame to negotiate with her daughter's would-be keeper:

So it was agreed, between the Marquis and me, that he should hire a large apartment, large enough for the whole of us. At first the Marquis proposed to take us all into his house, but I told him Monsieur Cardinal would never agree to that; and I seized the opportunity to describe M. Cardinal's character; that he was a great stickler for honour and respect and consideration before everything; that we must save appearances at any cost; that, to do that, two doors and two staircases were necessary, so that there shouldn't be any

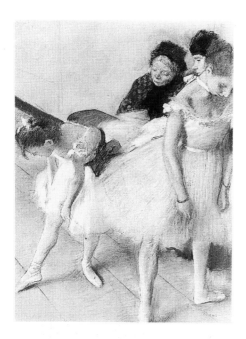

Fig. 4 *Left* Edgar Degas, *The Dance Examination,* *c.* 1879, oil on canvas, 63.4 × 48.2 cm, Denver Art Museum, L 576.

Fig. 5 *Right* Edgar Degas, *The Name Day of the Madam,* 1876–7, pastel over monotype, 26.6 × 29.6 cm, Musée Picasso, Paris, L 549.

disagreeable meetings at unseasonable hours.

The Marquis understood it all as well as could be; the very next morning he began his search for apartments, and by noon they were found. That's where we're living now – Rue Pigalle. . . . We are very comfortable there. . . . Salon and dining-room in the middle; at the right, our rooms; . . . at the left, Virginie's and the Marquis's. Two doors and two staircases. The Marquis did his best to induce M. Cardinal and me to take the rooms on the main staircase side; but M. Cardinal refused, with his usual tact. Tact is his strong point, you know. We took the servants' staircase.[25]

In still another incident from the same story, Mme Cardinal and the Marquis almost come to blows as to who is entitled to give the ailing Virginie her footbath.

He seized the tub but I held on. He pulled and I pulled; half the boiling water fell on his legs and he gave a yell and dropped it. Then I ran through the door to my Virginie. 'Here, my angel, here's your footbath!' And I looked the Marquis straight in the eye and said: 'Just try to tear a mother from her daughter's arms, will you, you grinning ape! You abandon your children, but I don't abandon mine!'[26]

This is of course cynical, *boulevardier* mockery of 'family values', underscored by the shrug, wink and nudge of the worldly narrator, who shares the complicitous semiology of the *homme du monde* with his audience. This audience included Degas, who, in

works like *The Dancing Lesson* of *c.*1874 (The Metropolitan Museum, New York, L 397) or *The Dance Examination* of *c.* 1879 (fig. 4), also called *Dancers at their Toilette,* may well imply, subtly of course, that the ubiquity of the dancers' mothers behind the scenes has certain questionable overtones and that apparent chaperonage actually disguises its opposite. The difference between the outright procuress-mother, like Mme Cardinal, and the generic stage-mother is not a pronounced one in the eyes of the sophisticated backstage gentleman of Degas' time, and indeed, the mother represented in *Dancers at their Toilette* bears a suspicious resemblance to Mme Cardinal in the monotype series dedicated to Halévy's stories.

Degas' climactic subversion of family values, however, occurs not in the realm of backstage shenanigans established by the Cardinal family prints, but in a setting of overt transgressiveness: in the brothel, the family's forbidden opposite, in a pastel over monotype, *The Name Day of the Madam* (fig. 5). This image, too, is related to a literary strategy of moral paradox, specifically that employed by Guy de Maupassant in his *nouvelle* of 1881, *La Maison Tellier,* in which prostitutes play the role of *grandes dames* at the first communion of the madam's niece, and where the comic tears

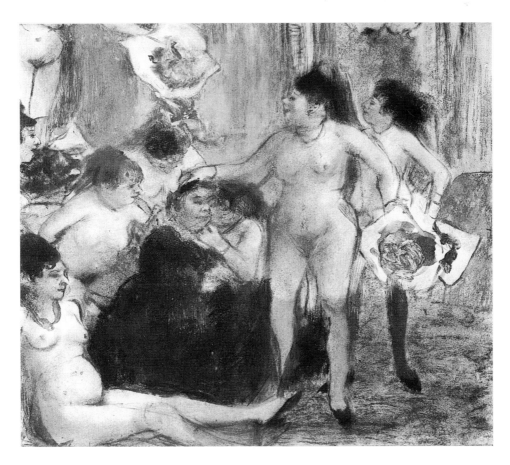

of sentimental whores create a moment of genuine emotion in the little church in Normandy where they have gathered for the celebration. 'The convention', writes Edward D. Sullivan in his analysis of this work, 'to be sure, is the convention of farce and develops the conceivable consequences of the singular proposition of a bawdy house closed because of a first communion.'[27] Right from the beginning, however, Maupassant emphasises the 'family atmosphere' of the brothel in question: the Maison Tellier is constructed as a site of warmth, good fellowship and even of respectability. 'There were always about six or eight people there, always the same, not cut-ups, but honourable men . . . and they took their chartreuse teasing the girls a little or else they talked seriously with *Madame*, whom everyone respected. . . . The house was familial, very small, painted yellow. . . . *Madame*, born into a good peasant family . . . had accepted that profession absolutely as she would have become a milliner or a seamstress . . .'[28]

Degas, although he too relies on the figure of reversal in his *Name Day of the Madam*, pushes things a bit further. It is not the image of respectability he wishes to construct, but its opposite. In one reading, this might be construed as a grotesque reversal of the notion of family piety, the madam, the 'mother figure' of the piece inscribing a notion of maternal abjection, to borrow Kristeva's locution. The whole brothel setting with the naked girls pressed together, proffering both their sexual charms and their congratulatory bouquet, creates a sense of family values displaced: the house is certainly a home in terms of warmth, of the pressing together of bodies in a fleshly intimacy impossible to the chilly decorum governing the behaviour of a 'real' bourgeois family like the Bellellis, but it is nevertheless a house of scandal, of debasement. Perhaps it is irony which is the figure at issue here, as Victor Koshkin-Youritzin suggests in his extremely suggestive article entitled 'The Irony of Degas'. Characterising this, among all the bordello monotypes created by Degas, as a 'serious and poignant aspect of irony', he points out that this seriousness can only be appreciated to the full if 'one recalls the entire body of Degas' work, especially the many family scenes (Bellelli, Mante, Lepic, etc.) with their piercing sense of isolation. Very simply', Koshkin-Youritzin concludes, 'is there not a rather exquisite irony to the fact that here – not in a private home or polite social gathering, but a mere bordello – one finds probably the fullest expression of human warmth, inter-relationship, and general happiness to be found anywhere in Degas' work – and moreover, perhaps the only specific example of human *giving*?'[29]

It is unexpectedly enlightening to examine Degas' whole series of Brothel Monotypes from the unexpected vantage point of the problematic of 'family values' as it was constituted in the later nineteenth century (*In a Brothel Salon*, 1876-7, fig. 6).[30] It seems to me that Degas' strategies *vis-à-vis* the representation of the family are best read against the foil of their apparent opposite, the brothel, the one functioning as the parodic supplement of the other. The family as the site of alienation and disconnection; the brothel as the last refuge of living warmth and human contact; or the family as the place where women are sold for money as in the brothel, but

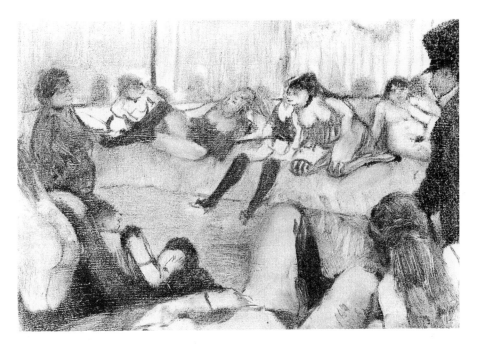

Fig. 6 Edgar Degas, *In a Brothel Salon*, 1876–7, monotype, 15.9 × 21.6 cm, Musée Picasso, Paris, J 82.

Fig. 7 Edgar Degas, *The Fireside, c*. 1876–7, monotype, 42.5 × 58.6 cm, Metropolitan Museum of Art, New York, J 159.

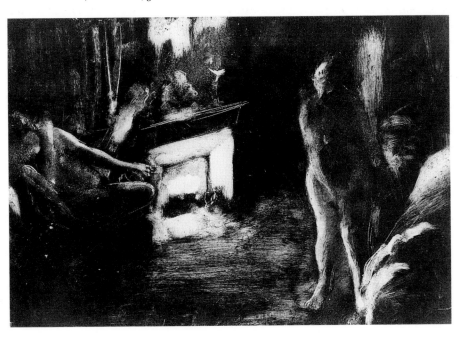

with greater hypocrisy, under a veneer of social virtue, and above all, bourgeois respectability: these are the topics suggested by Degas representations.

The Brothel Monotypes are too often considered as a unified group of works, inscribing a single discourse of prostitutionality and transgressiveness. Yet as a group, they are far from unified, ranging from alienating, caricatural coarseness and animalism (see, for example, *Deux Jeunes Filles*, J 81; *Au Salon* J 82 or *Waiting* [*L'Attente*] [first version], J 64), to representations of relaxed conviviality among women on their own or women with a male client, or women enjoying each other's bodies (see *Sieste au Salon*, J 18, *Femmes Nues*, J 118, *Two Women*, J 117, *Conversation* J 106), to a kind of melting bodily unification, a dark, dreamy, fingerprinted figuration of flesh finding satisfaction in flesh, inscribed in compositions in which centripetality – in one case, around a hearth (*The Fireside, c.* 1876-7, fig. 7) – is often the controlling compositional feature, formal blending, dissolution of borders, and material unity the strategic constructive principles (see, for example, *Le Repos*, J 73, or *Un Coin de Salon en Maison Close*, J 71). Boundaries and oppositions are obfuscated in these amazing prints, suggesting an almost palpable yearning for that ultimate, even pre-Oedipal, unification with the object of desire – a total and fantasmic satisfaction of the flesh – utterly forbidden by bourgeois family codes, and any others that we know of for that matter. [31]

In Degas' most typical works, for example *The Dancer with a Bouquet* of 1878 (also known as *Ballerina and Lady with a Fan* (Rhode Island School of Design, Providence, L 476), the figure of relationship – of 'togetherness' – is always stipulated as a purely formal one, constituted here by the way tutu and fan echo and re-echo each other as formal entities, not as signs of human connection. The 'closeness' is specified as that of shapes on paper or canvas, certainly not that of individual psychology or communitarian solidarity: on the contrary, it is precisely the social and psychological *distance* between the dancer on the stage and the elegant spectator in the box that is at once elided here, and at the same time evoked by the formal echoing, even overlapping, of the semi-circular shapes that bind them in a totally fortuitous rapport. This refusal of conventional psychological connection, of traditional narrative, constitutes for us an essential part of Degas' modernity: his making strange of human relatedness; his insistence on isolation, disjunction and unexpected 'meaningless' conjunction as the norms for the pictorial construction of contemporary social existence. His refusal of the clichés – and the presumed hypocrisy – of the discourse of the family and of women in general seems like one aspect of this modernity. It is only in this sense, I believe, that one can speak of some of Degas' representations of women as 'positive', in that they call into question the notion that the family is the natural site of feminine existence by means of unconventional structures of composition and expression, rejecting the standard codes and pictorial conventions of the time, even those informing many of the engaging family representations of his Impressionist colleagues.

Pursuing the implications of this negative dialectic even further, Degas went so

far as to locate the purported virtues of the bourgeois 'home' in the 'house', so to speak, on the very site – both seductive and repellently grotesque – of the family's transgressive Other. In so doing, he undermined the oppositional authority of both as imaginary spaces of moral distinctiveness.

Notes

1. Richard Thomson, for example, in his article ' "Les Quat'Pattes' ': The image of the dog in late nineteenth-century French art', *Art History*, vol. 5, no. 3 (September, 1982), p. 327, mentions the fact that Degas 'included dogs in his portraits on several occasions' but does not mention the one in the Bellelli Family; he focuses on the more prominent pedigree hound represented in the artist's (now destroyed) *Place de la Concorde*, and on other Degas works.

2. For the history of the portrait, its exhibition, and the identification of its subject, see the excellent analysis in the exhibition catalogue, *Degas*, Jean Sutherland Boggs, *et. al* (eds), Grand Palais, Paris; National Gallery of Canada, Ottawa; The Metropolitan Museum of Art, New York, 1988-89, cat. no. 20. The painting is dated 1858-67. (This catalogue will be referred to as *Degas*, 1988-89 in subsequent references.)

 For the classical analysis of the painting and Degas' relation to the family see Jean Sutherland Boggs, 'Edgar Degas and the Bellellis', *Art Bulletin*, vol. 37, no. 2 (June 1955), pp. 127-36. Also see the revision of that article in H. Finsen (ed.), *Degas og familien Bellelli/Degas et la famille Bellelli* (Exhib. Cat.), Ordrupgaard, Copenhagen, 1983, pp. 14-19.

3. The ambiguity of the concept of the family at the time Degas painted the Bellellis is indicated by the fact that, during the 1860s, the 'interior of the middle-class home became the prevailing metaphor for a refuge where authentic feelings could be safely acted out'; yet at the same time, 'strained relations between the sexes – within marriage and without – provided the theme for countless novels, plays, illustrations and paintings of this period.' For a discussion of both these aspects of the representation of the family interior, especially in the visual arts, see Susan J. Sidlauskas, 'A "perspective of feeling": The expressive interior in nineteenth-century realist painting,' Ph.D Dissertation, University of Pennsylvania, 1989, pp. 80-81 and 101. For a consideration of the theatrical representation of theme of dissension within the 'modern' family, see Charles Edward Young, 'The marriage question in modern French drama', *University of Wisconsin Bulletin*, vol. 5, no. 4, 1912. I will be dealing with the problematics of the family and its representation in considerable detail below.

4. Roy McMullen, *Degas: His Life, Times, and Work*, Boston, Houghton Mifflin, 1984, p. 52.

5. *Degas,* 1988-9, op. cit., pp. 81-82.

6. McMullen, *Degas,* op. cit., p. 53.

7. McMullen, *Degas,* op. cit., p. 66.

8. For information and further interpretation of this painting, see *Degas*, 1988-89, cat. no. 146.

9. Compare, for example, Degas' *Giovanna and Giuliana Bellelli* with Morisot's *Two Seated Women* ('The Sisters') of *c.*1869 or Degas' *Count Lepic and his Daughters* of 1871 (Bührle Collection, Zurich, L 272) with Morisot's *Julie Manet and her Father* to see the difference. The same point might be made in the case of the representation of fathers and sons with a comparison of Mary Cassatt's *Alexander Cassatt and his Son, Robert* of 1884 with Degas' *Henri Rouart and his Son Alexis* of 1895-8 (Neue Pinakothek, Munich, L 1176).

10. The term 'uneasy' applied to Degas' images must inevitably recall Eunice Lipton's memorable study: *Looking into Degas: Uneasy Images of Women and Modern Life*, Berkeley/Los Angeles, University of California Press, 1986.

11. Henri Joseph Baudrillart, *La famille et l'éducation en France dans leurs rapports avec l'état de la société*, Paris, Didier *et cie*, 1874.

12. Translated into English as *The Policing of Families*, R. Hurley (trans.), New York, Pantheon Books, 1979.

13. Mark Poster, *Critical Theory of the Family*, New York, Seabury Press, 1978. The bourgeois family model differs significantly from earlier aristocratic and peasant ones, coming into being only with the rise of capitalism.

14. Poster, *op. cit.*, pp. 169-78 *passim*.

15. For an excellent analysis of the Habermasian schema and a critique of his social theorisation of the family in terms of his neglect of the importance of gender roles in both the private sphere and within the economic world, see Nancy Fraser, *Unruly Practices: Power, Discourse and Gender in Contemporary Social Theory*, Minneapolis, University of Minnesota Press, 1989, pp. 113-43. As Fraser points out, 'Habermas's account offers an important corrective to the standard dualistic approaches to the separation of public and private in capitalist societies. He conceptualizes the problem as a relation among four terms: family, (official) economy, state, and public sphere. His view suggests that in classical capitalism there are actually two distinct but interrelated public/private separations. One public/private separation operates at the level of 'systems', namely, the separation of the state or public system, from the (official) capitalist economy, or private system. The other public/private separation operates at the level of the 'lifeworld', namely, the separation of the family, or private lifeworld sphere from the space of political opinion formation and participation, or public lifeworld sphere. Moreover, each of these public/private separations is co-ordinated with the other. One axis of exchange runs between private system and private lifeworld sphere, that is, between (official) capitalist economy and modern restricted nuclear family. . . . The roles of worker and consumer link the (official) private economy and the private family, while the roles of citizen and (later) client link the public state and the public opinion institutions' (pp. 124-25).

16. Still further contradictions are offered by the fact that the older modes of

conceiving of the family in some way coincided quite well with capitalist aims of cementing Gemeinschaft with Gesselschaft and making the family work together with larger public and capitalist institutions to further the objectives of productivity: i.e. the notion that stable, well-disciplined family units 'worked' better. And yet such coherence goes against another notion, familiar especially to readers of English social history of the mid-nineteenth century, of the family as the very opposite and redemption of the cold, impersonal, competitive public arena of money-making, an oasis of private feeling and altruism, run by the 'angel of the house' as an antidote to the harsh market-place which constitutes the public, masculine world.

17. I borrow heavily here from the excellent analysis of the novel by Demetra Palmari, 'The shark who swallowed his epoch: family, nature and society in the novels of Emile Zola', published in the collection of essays entitled *Changing Images of the Family*, V. Tufte and B. Myerhoff (eds), New Haven and London, Yale University Press, 1979, pp. 155-72.

18. Palmari, *Changing Images*, p. 164. This author focuses on a single family represented in the novel, the Josserands, who, in their obsession with obtaining a good *parti* for their daughters, echo the situation recounted of Laura in the Bellelli chronicles. Says Palmari of the Zola's Josserands:

> The daughters must be married, and the search for husbands is the mother's obsession, for marriage is the basis of their moral system and world view. In truth, marriage is itself a mask of morality, for it is usually a façade for adulterous intrigues.
>
> The Josserands are prepared to do anything to marry off their daughters, and the girls care little about the choice of husbands, for their paramount concern is to be married. Berthe's mother lies about her daughter's dowry and steals a small inheritance from her retarded son in order to enlarge the sum. Pushed into an extreme position – the mother admits she would go so far as to commit murder to get her daughter properly married – she reveals herself as a victim crippled by society who in turn victimizes and oppresses her daughter. . . . The plot is a maze of illicit liaisons for which marriage and family are a thinly respectable facade. It ends with a final allegorization of the servants' court. "When it thawed, the walls dripped with damp, and a stench arose from the little dark quadrangle. All the secret rottenness of each floor seemed fused in this stinking drain"'' (pp. 164-65).

19. She continues: 'It is a code so rigid and hostile to all that is natural – all that is spontaneous in humanity – that it is completely unenforceable. In creating such rigid moral standards society becomes not a protector but an enemy of life, love and honesty. Ideally, it is the family that provides order against external chaos, but to do so it must be allowed a degree of flexibility and naturalness.

Too great rigidity in this . . . itself engenders chaos. Love and spontaneity reappear because these aspects of life cannot be eliminated, but they are garbed in their dark manifestations – as exploitative sexuality, brutal confrontations, violent outbursts – more disruptive, disorderly, and threatening to the social order than they would have been if allowed a proper place to begin with'. (Palmari, *op. cit.*, pp. 165-66, *passim.*)

20. The Goncourts, for instance, are obsessed with this issue. See T. J. Clark, *The Painting of Modern Life: Paris in the Art of Manet and His Followers*, New York, Knopf, 1985; Alain Corbin, *Les filles de noce: Misère sexuelle et prostitution aux 19e et 20e siècles*, Paris, 1978; Hollis Clayson, '*Avant-Garde* and *Pompier* images of 19th century French prostitution: the matter of modernism, modernity and social ideology', in B. Buchloh *et al.* (eds), *Modernism and Modernity: The Vancouver Conference Papers*, Nova Scotia, Nova Scotia College of Art and Design, 1983, pp. 43-64); and most recently, Charles Bernheimer, *Figures of Ill Repute: Representing Prostitution in Nineteenth-Century France*, Cambridge, Mass., Harvard University Press, 1989, for important discussions of the discourse of prostitutionality. Clark and others have seen the confusion between respectability and prostitutionality as central to the construction of the social problematic of later nineteenth-century France.

21. See, for example, their anecdote of the adorable and apparently respectable middle-class mother and daughter glimpsed in the park – the very models of domestic and filial virtue – whom they later find out are notorious whores specialising in serial fellatio: first mother, then daughter performing the act in the comfort of the client's own home. (I regret to say I can no longer locate the exact reference to this incident which I read many years ago in the complete edition of the Goncourt Journals, *Journal: mémoires de la vie littéraire*, 1851-1861 – 1892-1895, Académie Goncourt (eds), Paris, Flammarion, 1935-36, 9 vols. Attempts to track the story down in abridged versions of the *Journals* have been fruitless.)

22. For the complex publishing history of both the *Cardinal* stories and Degas' relationship to this publication, see 'Degas, Halévy, and the Cardinals', in *Degas*, 1988-89, cat. nos. 167-169.

23. McMullen, *Degas*, p. 353.

24. Ludovic Halévy, 'Pauline Cardinal', in *La famille Cardinal,* Paris, Calmann Lévy, 1883, pp. 62-63.

25. Ludovic Halévy, 'Madame Cardinal', in *La famille Cardinal,* pp. 19-20.

26. ibid., p. 32.

27. Edward D. Sullivan, *Maupassant: The Short Stories*, London, Arnold, 1962, p. 43.

28. Guy de Maupassant, 'La Maison Tellier', in *Oeuvres complètes,* vol. 6, Paris, Louis Conard, 1908, pp. 1-2. Indeed, as Emily Apter has pointed out, 'the *maison close* (literally "closed house") [is] . . . a subversive catachresis, yoking the bourgeois notion of "home" to the morally tainted connotations of "closet" sexuality.' ('Cabinet secrets: fetishism, prostitution, and the fin-de-siècle interior', *Assemblage*,

no. 9, June 1989, p. 8).

29. Victor Koshkin-Youritzin, 'The Irony of Degas', *Gazette des Beaux-Arts,* no. 87, 1976, p. 36.

30. For the series of Brothel Scenes, dated to *c.* 1879-80 or 1876-77, see *Degas,* 1988-89, cat. nos. 180-188; the earlier dating is preferred here. Also see Eugenia Parry Janis, *Degas Monotypes*, Cambridge, Mass., Fogg Art Museum, 1968. Individual examples from the series will be referred to in terms of Janis' catalogue numbers, as 'J'.

31. I am, however, wary of exonerating Degas' complicity in the scopophilic practices of his time on the basis of the self-revelation of the medium constituted by these prints, as have, to some degree, Carol Armstrong and to a lesser one, Charles Bernheimer. (See Carol Armstrong, 'Edgar Degas and the representation of the female body', in *The Female Body in Western Culture,* S. R. Suleiman (ed.), Cambridge, Mass., Harvard University, 1986, pp. 223-42; and Charles Bernheimer, 'Degas' brothels: voyeurism and ideology', *Representations* no. 20, Fall 1987, pp. 158-186). I turn for the critique of this strategy of recuperation through formal practices to Constance Penley's negative assessment of structural materialist film practice and its attempt to subvert the identificatory modality of the apparatus by constantly revealing its presence as a transgression which ultimately identifies with the Law. 'The use of self-reflexive aesthetic strategies is, of course, almost the definition of avant-garde practice. . . . [the use of] ''filmic material processes'' as subject matter: celluloid scratches, splicing tape marks, processing stains, fingerprints, image slip, etc. . . . But if we take Metz's thesis that the primary identification is with the camera, then we must immediately question the ''objectivity'' of the strategy of showing the spectator these ''protheses'' of his own body, of his own vision, because it is quite likely that this could *reinforce* the primary identification, which, as Metz argues, is the basis of the construction of a transcendental subject.' Penley continues: 'Side by side with the axiom of self-reflexivity is the emphasis on these films as epistemological enterprise.' But, as she points out, 'in its extreme form the desire to know slips from epistemology into epistemophilia, the perversion of the desire to know. This perversion involves the attempted mastery of knowledge and the demonstration of the all-powerfulness of the subject.' (C. Penley, 'The avant-garde and its imaginary', *The Future of an Illusion: Film, Feminism and Psychoanalysis,* Minneapolis, University of Minnesota, 1989, pp. 18-19.) The same criticism could be offered of Degas' attempt to remove his work from the established codes of pornographic representation of his time through strategies of self-reflexivity. Both Armstrong and Bernheimer deal intelligently with the complex and, admittedly, ambiguous issues involved; I am not suggesting there is an absolutely correct position on this issue: on the contrary.

The Sexual Politics
of Impressionist Illegibility

Hollis Clayson

Around the time of Edgar Degas' *Women in Front of a Café, Evening* (plate 5, a pastel-enhanced monotype of 1877), commentators of all kinds reported that bands of predatory, lower-class women were regularly invading the *grands boulevards*, pride of fashionable right-bank Paris. The two passages quoted below, for example, describe this phenomenon:

> Nowhere are the Nymphs of the pavé to be seen in greater force than on the Boulevards. As soon as the lamps are lit, they come pouring through the passages and the adjacent rues, an uninterrupted stream, until past midnight. The passages Jouffroy, Opéra and Panoramas, on wet nights swarm with these women. At the cafés on the boulevards, particularly on the Blvd. Montmartre, the muster, always, is considerable. Only glance at one of these creatures, and you will be entrapped in a moment until you have the moral courage to resist.[1]

> For it's no longer the night, the evening, *from the lighting of the gas lamps until eleven o'clock* when the *hetaïres* operate. It is all day. It's not in the remote neighbourhoods that they search out their booty, it's in the most lively center of Paris.
>
> Between noon and midnight, pass by the left sidewalk of the rue du Faubourg Montmartre – you see that I'm precise – you will encounter twenty, thirty, forty girls between fifteen and eighteen – there are some who are twelve! – hatless, *décolletées*, provoking, shameless, brushing up against you with an elbow or a shoulder, barring your way while telling you things in the loudest voice that would make a rifleman blush. Where do they come from? It is easy to tell from their demeanour; they walk dragging their feet, bothered by high-heeled shoes that they are not accustomed to, encumbered by corsets that they haven't worn for long. It's the riffraff from the *bals de barrière* who, enticed by impunity, have descended upon Paris.[2]

Moralists, journalists, social observers, and policemen as well as writers of special-ized guides to sex in Paris produced such statements. The majority of them were written between the late 1860s and 1889, and they vary in tone and purpose but tend to fall into two general categories. One variety, like the first passage quoted, light-heartedly celebrates a nocturnal movement of energetic and attractive young women who arrive on the boulevards when the gas lamps are lit in order to establish their beach heads in the neighbouring cafés. The other kind, exemplified by the second text, judgmentally describes a contamination of the neighbourhood by a squalid street *racolage* that lasts all day, practised by grim, aggressive vulgar young girls. But certain 'facts' are shared and repeated by reports of both kinds: certain sections of the boulevards brimmed with opportunities for sexual commerce (especially but not only in the evening), the girls came from 'elsewhere', and the boulevard Montmartre (bracketed by the rue Drouot and the rue du Faubourg Montmartre) was the most thoroughly contaminated section of the *grands boulevards* network.

Degas' *Women in Front of a Café, Evening* appears to have a great deal in common with the written accounts of 'invasion'. The print and both texts quoted share certain key factual information: neighborhood, time of day, type of people and their activity, since the pastel shows prostitutes at a café on the boulevard Montmartre in the evening.[3] An important matter therefore is determining just what kind of connection to draw between the verbal reports of the invasion and this apparently closely-related picture of the same subject. We want to avoid advancing the unsatisfactory proposition that the texts 'explain' Degas' artwork just because their contents happen to match. This essay seeks, in fact, to interrogate the two contradictory aspects of Degas' pastel: its facticity on the one hand and its ambiguity on the other, aspects of the work that have both been emphasised in the art historical literature. Modernists have tended to emphasise the picture's open-endedness, ambiguity, indecisiveness, evasiveness, illegibility, non-anecdotal, anti-narrative quality, and have proceeded to use those qualities to characterise, to explain *and* to praise the picture, while the empiricists take for granted that the picture is an accurate description of a corner of modern life. I am interested in realising two related objectives: problematising the picture's truthfulness, and rethinking any ascription of social value to ambiguity in a picture of women prostitutes.

It is revealing to discover that nineteenth-century and present-day commentators alike have not been entirely sure what story Degas' small picture has to tell. (In order to include it in his twenty-two piece display in the 1877 Independent Exhibition, the third such group show, Degas borrowed it from his friend/artist, Gustave Caillebotte.) Reviewers of Degas' work in the 1877 show found *Women in Front of a Café, Evening* to be especially truthful, and, though their comments remained quite general, the critics tended to assume that the 'realistic' prostitutes in Degas' picture were relaxing rather than working.

Georges Rivière, friend and partisan of the Independents, recorded his view in *L'Impressioniste* (his own journal). Like Edmond Duranty, Degas' close friend and

author of *La Nouvelle Peinture* (1876), Rivière believed that Degas was as concerned with narration in his work as he was with aesthetic issues. 'M. Degas,' he wrote,

> How best to speak about this essentially parisian artist, whose every work contains as much literary and philosophical talent as it does expertise in drawing and the science of coloration?. . . . Here are some women at the door of a café in the evening. There is one who clicks her fingernail against her teeth, saying: 'Not even that,' which is a poem in itself. Another rests a large gloved hand on the table. In the distance, the boulevard with its gradually thinning swarm. Again it is an extraordinary page of history. [4]

Rivière wanted to find a straightforward social physiognomics of class and profession in Degas' pictures which was not there, as we shall see, so he had to make do with Degas' 'language of bodily impropriety and gestural innuendo', to borrow Carol Armstrong's excellent phrase. [5]

Without referring to specific aspects of the artwork, other critics of the 1877 display joined Rivière in stressing the realism and truthfulness of Degas' handling of the appearance and character of prostitutes. Alexandre Pothey, writing in *Le Petit Parisien*, referred to the women as 'painted, blighted creatures, sweating vice, who recount to one another the doings and gestures of the day.' [6] Pothey situated the central figure's gesture in the context of the women's off-hours commentary, but kept open the possibility that it duplicates a typical work gesture. [7]

The authors of several very recent, socially-oriented art historical studies of this particular work, more willing than their nineteenth-century predecessors to do close formal analysis, ran into snags when they attempted to act upon their conviction that Degas was engaged in social description. Members of the 1988 Degas Exhibition Committee were convinced that the picture represented prostitutes at their leisure. Their somewhat elusive entry reads: 'the subject, prostitutes chatting on the boulevard, was undoubtedly sensational, but no less so than its rendition'. [8]

Robert L. Herbert unveiled the most elaborate and precise storyline in Degas' 1877 print by considering Degas' depiction of prostitutes at a boulevard café to be a kind of snapshot of the practice of prostitution in this *quartier*. [9] In Herbert's view, the picture and its referent are hand in glove in mimetic collaboration, and the subject is definitely prostitutes at work.

In her review of Herbert's book, Kathleen Adler singled out his discussion of Degas' *Women in Front of a Café, Evening* for special attention and comment. She takes him to task for producing 'a rather unsubtle narrative reading of this work'. [10] She advises that 'one should hesitate before ascribing such detailed, anecdotal intentions to Degas, whose work seems instead to consistently embody a modernist, anti-narrative impulse'. [11]

On balance, then, Degas observers have not interpreted the picture as a narrative with much consistency. I want to show that the reason no one has been able to decide once and for all whether the prostitutes in Degas' picture are working or relaxing

– soliciting customers or chatting – is because: first, the 1877 picture straddles and elides the iconographic categories established by other artworks on the subject of 'boulevard women', and secondly it uses an idiosyncratic, allusive syntax of body and gesture.

My argument will go like this: we have tended to think that the descriptive open-endedness and narrative indecisiveness of a picture like this one are the admirable modernist means that allowed Degas to find innovative form for commodified women. (And to the degree that it *is* descriptively accurate, that is a progressive characteristic.) I hope to show that, on the contrary, Degas's blurring of boundaries serves to fix, to secure an identity for prostitutes with considerable ideological certainty. Indeed, in this picture, we can see ambiguity *enabling* fixity; and we will observe that formal openness and illegibility have a specific (and not very appealing) sexual politics.

Degas' ascription of a particular bodily impropriety or scurrilousness to boulevard prostitutes (discussed below) embodies a broader cultural pattern of anxiety about, and interest in, sexually deviant women in later nineteenth-century Paris.[12] Prostitution was especially interesting and appealing to avant-garde male 'painters of modern life' because prostitutes marked the point of intersection of two widely disseminated ideologies of modernity: the modern was lived and seen at its most acute and true in what was temporary, unstable and fleeting, and the modern social relation was seen as more and more frozen in the form of the commodity. In the 1870s and early 1880s, prostitution occupied an over-determined place at the point of intersection of these two ideological structures. Hence the two seemingly antithetical qualities of modernity central to the avant-garde could be resolved in the figure of the prostitute.

The prostitute was at the centre of the period's obsessions and fears for another reason as well: her ostensibly deviant sexuality. The logic of the commodity helped to produce the obsession with the prostitute in nineteenth-century Paris, but so did the logic of male desire and the increasing male fear of unrestrained female sexuality.

The various accounts of women aggressively putting themselves on display were in part descriptive. They targeted increasingly open forms of sexual commerce that characterised the urban erotic economy in the years following the Commune. In his *The Garbage of Paris (Les Ordures de Paris)* published in 1874, Flévy d'Urville complained that 'women no longer wait to be admired, they exhibit themselves'.[13]

But such ideas were, at the same time, fantastic, embodying as they do chimerical, neo-regulationist disquiet about the takeover of Paris by clandestine prostitutes. Alain Corbin has rightly observed that the two principal focuses of later nineteenth-century outrage about female sexuality were closely linked. He understands that the fear of the clandestine prostitute and the concern about the sexual recklessness of decent women were two sides of the same coin:

The impression of invasion by the *insoumise* [unregistered prostitute] very obviously translated the terror inspired by any thought of sexual liberalization

among the bourgeoisie. The line of demarcation between adultery, moral libertinism, debauchery, vice and prostitution was less clear than ever before. [14]

In the 1870s and 1880s, many Parisian men saw deviants/deviance moving toward the centre of their city's life, threatening to upset the social and sexual balance of power. There is an accusatory tone in neo-regulationist discourse. It appears as though the prisoners in the panopticon have got loose, that the 'weapons' trained on them are without disciplinary effect. But the analogy of jailbreak is inadequate unless we also imagine the escaped convicts seducing the guards while the warden looks on, powerless. Such were the contents and objects of the fear and anger in question, and they point to one of the central contradictions of the philosophy underlying the regulatory apparatus: the sexually deviant woman was needed by the sexually hungry man. She was, however, frequently characterised as the instigator of increased male demand; indeed the women were believed to have converted male need into male desire. As a consequence, the women were seen to have increased the demand for illicit sex across the social map, converting men from sexual *misérables* into sexually ardent victims of disobedient temptresses.

Turning now to other figurations of invasion, we will discover that the visual material, like the written accounts, has its orthodoxies: the installation of marauding women in cafés dominated the interest of virtually all artists who treated the theme.

Caricaturists working for urbane illustrated papers like *Le Monde Comique* frequently used the figure of the solitary, female café invader settling where she did in order to attract men. No other motive is ever attributed to such a woman's occupation of a café table. In *Parisian Fantasies* by Gillot of 1878–79 (fig. 8), a waiter is shown helping the calculating woman to settle in a spot that should favour effective solicitation. 'Glue yourself right here', the *garçon* advises her, 'it's a good spot.' In Ancourt's *On the Boulevard* of 1875–76 (fig. 9), the joke about the parasitic café woman turns upon the parallel between the opening of the hunting season and her quotidian hunt for men. Hadol's ingenious *L'Araignée du Soir – Evening Spider –* of 1875–76 (fig. 10) overtly links a solitary aperitif-drinker to sexual ensnarement.

There are also images by painters of the avant-garde of this topic that show that the coding for 'such women' was in force across a range of representational practices. Although the woman in Degas' pastel-enhanced monotype, *Woman in a Café* of 1877 (fig. 11), has no spider web, the heavily made-up and gaudily dressed figure is surely on the look out for a man, or is using the café as the rendezvous point for an illicit assignation. Edouard Manet's painting titled *The Plum (La Prune)* of 1877–78 (fig. 12) is semantically open-ended by comparison to the Degas seen in fig. 11. Manet's painting includes all the ingredients of the usual social coding for the indecent café woman, but in it the codes are muffled and stalemated, certainly not refused. While Manet's picture does not actively contribute to the reinforcement and dissemination of ideas concerning the moral dubiousness of women on their own in cafés, neither does the picture escape agreement with the dominant ideology on this matter. Manet serves himself cake and eats it, too.

Fig. 8 *Above* 'Here glue yourself here, it's a good spot.' Gillot, Parisian Fantasies, *Le Monde Comique*, 1878–9.

Fig. 9 *Above right* ' ''Hunting season opens the 29th'' . . . Goodness! If I had to wait until then . . .' Edward Ancourt, On the Boulevard, *Le Monde Comique*, 1875–6.

Fig. 10 *Right* 'Five o'clock! The Absinthe hour. Penelope has spread out her web.' Paul Hadol, Evening Spider, *Le Monde Comique*, 1875–6.

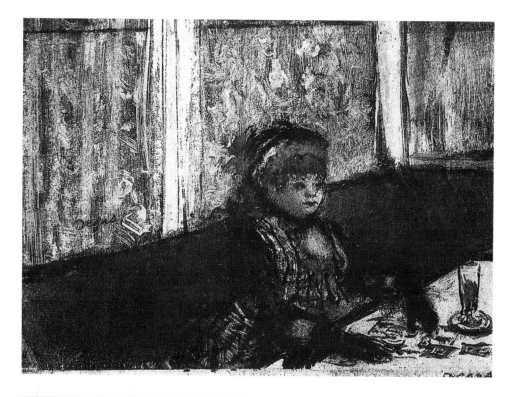

Fig. 11 *Above* Edgar Degas, *Woman in a Café*, 1877, pastel over monotype, 13.1 × 17.2 cm, private collection, L 417.

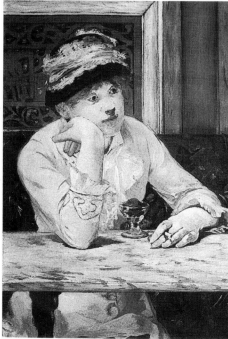

Fig. 12 *Left* Edouard Manet, *The Plum*, 1877–8, oil on canvas, 74 × 49 cm, National Gallery, Washington DC.

Fig. 13 'Pauline would have a beer with us –
call her.'
'Can't you leave her alone! She's
attending to her "affairs" . . .'
Paul David, Women of the Boulevard, *Le Monde
Comique*, 1874–5.

The stigma of impropriety that adhered to almost any woman on her own in
a café was erased in pictures that show more than one woman sharing a café table.
By and large, the rule seems to have been – at least in the realm of representation
– that the predatory lamp was lit only when the marauding woman was on her own.
When friends were together, they were understood to be socialising and relaxing.
In Paul David's *Women of the Boulevard* (*Boulevardières*) of 1874–75 (fig. 13), for example,
the woman in the distance ('Pauline') had planned to knock off 'work' to have a
bock (beer) with her identically dressed friends, but had another 'affaire' to attend
to. Her trio of friends in the foreground are clearly having a beer as a respite from
work. Likewise in many vanguard pictures. Although, for example, the women in
Degas *At the Café* 1877–1880 (fig. 14) are not necessarily prostitutes, they are shown
to be introverted and innocent during this moment of all-female, café-based
socialising.

In view of the taxonomy generated by this brief overview of representations of
'invasion', Degas' *Women in Front of a Café, Evening* (plate 5) would appear to fit in
the second category of picture: an image of play rather than work, a representation
of prostitutes taking their ease, having a drink, resting their feet, getting caught
up with one another – especially since a man is shown hurrying past them. Upon
close inspection, however, the pastel is instead a picture that crosses the boundary
between genres, and blurs certain of the usual distinctions made between pictures
of prostitutes-at-work and pictures of prostitutes-at-rest. Let us examine aspects of

the picture's structure. While the arrangement of the four women encourages us to 'read' the picture as an image of casual relaxation set on a café terrace, certain key details inflect and complicate that first impression. For example, the two women on the right are seated and appear quite firmly planted at a small round table, but only one drink is before them. The impermanence and irregularity of their occupation of the café terrace are thereby suggested: only one woman has actually ordered a drink. The other one is soon to be on her way, or has just arrived. And the woman at the far right does not sit up to the table; she appears to have rapidly taken her position without having bothered to rearrange herself according to conventional standards of etiquette. The women are together on the terrace all right, but not for long because they obviously arrive and depart at irregular intervals.

Within the isocephalic frieze of women – the two on the right seated and the two on the left on the go – diversity has been maximised. The positions of the four heads create an alternating rhythm, a series of reversals: facing right, left, right, left. The women at either edge of this series face into the centre, closing it off as with parentheses, a sure sign of Degas' signature and the compositional complexity and control. Because the heads alternate in direction, there is the appearance of randomness in the moment observed ('just a glimpse'), but this arrangement cannily establishes a disconnection

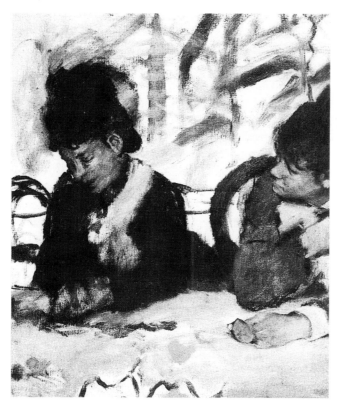

Fig. 14 Edgar Degas, *At the Café*, *c.* 1877–80, oil on canvas, 65.7 × 54.6 cm, Fitzwilliam Museum, Cambridge, L 467.

between the four women, and the suggestion that this is not a proper café party, just an *ad hoc* assembly. This is certainly the point of the solitary drink and the animation of the woman with the brown sleeves (the figure overlapped by the roof support).

Their positions, each different from the next, further connote the group's lack of decorum and indifference to the world surrounding them. Their disconnection from their immediate milieu is underscored by the disappearance of the dark-suited man in the middle distance whose angled body indicates the hurriedness of his movement off to the right, away from these women and their space.

But Degas establishes the appearance of an animated conversation kept up in spite of the fact that the women are coming and going. The briskly moving figure appears to chat animatedly before moving on or settling down. The central figure in bright blue leans heavily and rudely into her vernacular gesture, while the women at the two sides are both sullen and self-absorbed, impolitely so, with eyes downturned.

All in all, this way of picturing boulevard prostitutes obviously differs from other images of the subject. One difference is that these figures appear to relax, to bustle off to work, and to be at work – all at the same time. By mixing these pursuits and by joining together the genres used to depict them, Degas suggests indirectly that, for the prostitute, work and leisure are not mutually exclusive; especially not on the terrace of a boulevard café, the locus of work and play for a woman in this line of work. Another outcome of the blurring of the borders between the standard types of boulevard prostitute picture is that it allows Degas to propose that the commodified woman remains just that, at work and at play. Stopping work is not shown to alter her moral or occupational status. Prostitution is not what she does; it is, according to the terms of the picture, what she *is*.

This outlook is reminiscent of that which predominates in the same artist's so-called brothel monotypes of about the same date.[15] A precise link between the 1877 picture (plate 5) and the brothel prints is the use of a thumb-in-the-mouth gesture by one of the conversing prostitutes. The gesture appears in *Waiting* (*L'Attente*) (fig. 15), one of the prints in the series owned by Pablo Picasso. It is the woman shown second from the right who employs the decisive gesture used by the woman in blue in the 1877 pastel-enhanced monotype.[16]

In *Waiting* (*L'Attente*), four varieties of simultaneously relaxed and enticing bodies are lined up. As usual with the transgressive syntax of the body used in these prints, it is hard to differentiate the natural/inner-directed positions from the staged/outer-directed poses. What concerns us here is that within the specialised framework of brothel display and inveiglement, the woman who mouths her thumb is likely mimicking (and probably offering to perform) fellatio. While Degas surely did not set out to refer to such a sexual act directly in the public 1877 pastel, he certainly relied on the thumb-in-mouth gesture to enforce the scurrilousness and even masculinity or mannishness of the street prostitute.[17]

With the deployment of the hand gesture by the woman in blue, Degas uses one

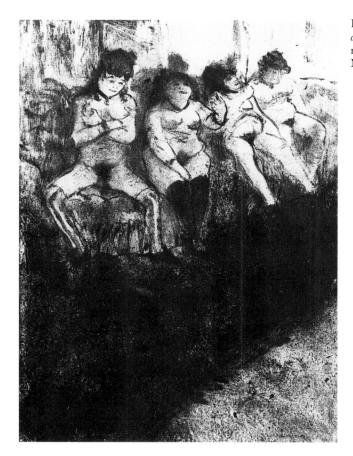

Fig. 15 Edgar Degas, *Waiting*, *c*. 1876–7 or *c*. 1879–80, monotype, 21.6 × 16.4 cm, Musée Picasso, Paris, J 65.

of his most familiar 'sociological' devices. He frequently uses what he takes to be characteristic professional gestures – think of the milliners, the ironers and the dancers – which function both denotatively and connotatively, as anecdote and as allusion. The function of this particular gesture is to refine a definition of the character and the deportment of the street prostitute: the gesture declares that this is a vulgar, mannish woman. I use mannish here in the sense of a compromised or coarsened femininity. Femininity and sexuality are to be held at odds and the feminine body reads as de-feminised through unfamilial and non-domestic sexual practices. These women are therefore doubly coarsened by virtue of their low social status and de-feminised gender condition; they have undergone a fall from refinement and delicacy by using their bodies in this way. Vulgar (class-loaded) and masculinised (gender-loaded) seem, then, to interact here for Degas as a means of delineation and denigration.

While the picture is certainly elliptical and noncommital compared to the average anecdotal boulevard cartoon, I want to argue that it is *deceptively* disengaged and remote from an interpretation of its subject. We have already suggested that Degas'

76

conflation of the two-standard iconographic categories for portrayals of this subject has the effect of freezing these women in the identity of prostitutes. And the key gesture forcefully connotes the sexual daring of a prostitute's line of work as well as the woman's general crudity. The gesture therefore brings the subject of sexual commerce into a picture of leisure in an unmistakable and somewhat uncomfortable way. The central figure's gesture works as a displaced, risqué, and explicit substitute for the vulgar *raccrochage* practised by the working prostitute (which oftimes incorporated the mimicking of oral sex as in *Waiting* (*L'Attente*). The gesture, I am suggesting then, indirectly summoned up an image of things prostitutes actually did with their bodies. At the same time, Rivière's not irrelevant reading of it as a complaint about a stingy payment also makes the gesture into a powerful sign of the prostitute's venality. The multiple connotations of the gesture made by the woman in blue fix her character by alluding to specific aspects of a deviant woman's behaviour and character. The action also helps to specify and confirm the indecent things that other aspects of her (and her friends') appearance had already made known.

Because the picture straddles and elides the iconographic categories established by other artworks on the subject of boulevard women, we have been able to show that the picture cannot be pinned down to being *either* a picture of prostitutes working to solicit customers *or* a depiction of prostitutes taking time off. But a key objective of this essay has been to show that the absence of univocal anecdote *is not* the same thing as detachment, vagueness or ambiguity. Indeed, now we can confidently jettison the standard assumption that imprecise story-telling or blurred handling of painted detail necessarily encodes the intellectual or moral detachment of an artist. It appears that in his elliptical way, Degas has attributed a somewhat brutal and brutalising set of characteristics to Parisian café prostitutes. But saying that still does not exhaust the picture, for although Degas has attempted to contain the social and sexual force and threat of 'such women', the difficulty of doing so conclusively has left its traces in the picture. The action, centrality, and luminous blue colour of the featured woman seem at the same time to secure an indomitability, a power for her: she seems to be saying 'fuck you' – to the world, to men, to the woman across the table, to the viewer.

It must be clear by now that I do not wish to associate the picture with any uncompromisingly progressive position, but neither in the end do I want to hitch it to a monolithic reactionary outlook. The picture betrays Degas' effort to dominate and stave off his subject matter, but it is surely not the figuration of a world comfortably or completely controlled by a secure masculine perspective. The pastel plays out a contradictory dialectic of fascination and disgust.

Acknowledgements

The present essay grew out of a talk I gave at a session of the Association of Art Historians Meeting in London in April 1989. My thanks to Tamar Garb and Briony Fer for the invitation to speak there, and to Griselda Pollock for asking me to contribute to this book. I want sincerely to thank Nancy Ring, Alex Potts, and Griselda Pollock for their stimulating and indispensable ideas about Degas' *Women in Front of a Café, Evening.* I used them all.

Notes

1. Anon., *Paris after Dark, Night Guide for Gentlemen*, 13th edition, Paris, n.d. (c. 1870), p. 19.

2. Georges Grison, *Paris Horrible et Paris Original*, Paris, 1882, pp. 296–97. The translation is mine as are all the others that follow. Other reports that helped to constitute the 'discourse of invasion' are discussed in Chapter 3, Part 2 of my forthcoming book, *Painted Love: Prostitution in French Art of the Impressionist Era* (Yale University Press).

3. In P. A. Lemoisne, *Degas et son oeuvre*, Paris, 1946, vol. II, no. 419, the work is subtitled 'Un café, Blvd. Montmartre'. Tag (Theresa Ann) Gronberg ('Femmes de Brasserie', *Art History* vol. 7, no. 3 (September 1984), p. 333) has identified the category of café depicted by Degas as a *boîte à femmes*.

4. Georges Rivière, 'L'exposition des impressionistes', *L'Impressioniste*, 1 (6 April, 1877), reprinted in Lionello Venturi, *Les Archives de l'Impressionisme*, Paris, 1939, vol. II, p. 313.

5. Carol Armstrong, 'Duranty, Degas, and the realism of the third republic', paper given at the Nineteenth-Century French Studies meeting, Evanston, 1987.

6. Alexandre Pothey, 'Beaux arts', *Le Petit Parisien* (7 April, 1877), reprinted in Venturi, op. cit., pp. 303–4.

7. Other 1877 reviews are discussed in Chapter III, Part 2 of my forthcoming book (see note 2).

8. Jean Sutherland Boggs *et al.*, *Degas*, New York, The Metropolitan Museum of Art, 1988, entry no. 174, p. 289.

9. Robert L Herbert, *Impressionism: Art, Leisure, and Parisian Society*, New Haven and London, 1988, pp. 44–46. He writes (p. 45):

> They [boulevard Montmartre prostitutes] find their clients among the men who are out shopping or going to and from nearby theaters. These women, like the two at left in Degas's composition, come and go from the terraces where they watch out for clients; they change places frequently out of impatience or to put themselves in more advantageous positions. Often they sit and wait, as Degas's other two are doing. The one in the center has her thumb to her teeth, either to indicate boredom, or perhaps, to vent her disappointment. . . . The dark form of the man moving off to

the right is a clue to the street commerce these women engage in, or at least a hint of it. . . . The woman who is leaving to the left might well have been given a discreet sign by this man. . . . of course, we cannot insist on a knowing exchange between Degas's two figures, but the presence of a male passer-by is an essential element of this pastel. Degas makes us into an investigator, seated on that terrace, sizing up various clues in order to understand what is going on about us

10. Kathleen Adler, 'Nineteenth-century studies', *Art in America*, vol. 77, no. 1, January 1989, p. 27.

11. Adler, ibid, p. 27. Further on in the same review, Adler shows an inclination (much less pronounced than Robert Herbert's) toward settling upon a storyline for the picture, or at least toward circumscribing the picture within the field of work as opposed to play. She writes (p. 27), '[the] inclusion of prostitutes such as those represented here by Degas obviously implies the existence of male customers even if, in this case, the gesture of the center figure, thumb to mouth, seems to suggest that business is slack.' Adler also judiciously and effectively questions Herbert's assumption that the normative present-day viewer of Degas' picture is male.

12. This paragraph summarises the main theme of my forthcoming book, op. cit.

13. Flévy d'Urville, *Les Ordures de Paris*, Paris, 1874, p. 12.

14. Alain Corbin, *Les Filles de noce: Misère sexuelle et prostitution aux 19e et 20e siècles*, Paris, 1978, p. 43.

15. The monotypes are generally dated *c.* 1879–80 but the 1988 Degas exhibition committee (Boggs *et al.*, op. cit., p. 106) redated them to *c.* 1876–77. Chapter II of my forthcoming book discusses the brother monotypes in detail.

16. Thanks to Richard Thomson for calling my attention to the gesture in *Waiting* (*L'Attente*) in his *Degas: the Nudes*, London, 1988, p. 106.

17. In Honoré de Balzac's *Père Goriot* (early 1830s), Vautrin used the same action to dismiss categorically a worthless person (*Le Père Goriot*, New York, Charles Scribner, & Sons, 1928, p. 173). Thanks to Gloria Groom for the reference, and to Lisa Tickner and Patricia Simons for their suggestion that I think about the mannishness of the gesture.

Degas' 'Tableaux de Genre'
John House

In Degas' work from the early 1870s onwards, there is a consistent contrast between the roles ascribed to men and women. Male figures, where they appear, are presented as individuals, even in the few genre paintings where they are unaccompanied by women, such as *Portraits in a Bureau* (*New Orleans*) of 1873 (Musée des Beaux-Arts, Pau, L 320) and *Portraits at the Stock Exchange* of 1878–9 (Musée d'Orsay, Paris, L 499); Degas stressed the individuality of the figures in these paintings by calling them 'portraits' when he first exhibited them, though their informal groupings of variously occupied figures bear no relation to the conventions of contemporary portraiture.

Today, we know the identity of the models for most of the figures in these pictures, but this knowledge would not have been shared by most of their original viewers at the Impressionist group exhibitions of 1876 and 1879. More specifically, Parisian viewers would have had no idea of the identity of Degas' relatives depicted in the New Orleans cotton bureau. However, the titles of the paintings, and the way in which the male figures are treated, emphasise that they are there as individuals; all have their distinctive facial features, social identity and professional role.

By contrast, apart from a few more conventional portraits, the female figures Degas painted from the early 1870s onwards are presented as types, identified primarily in terms of their activities; and these activities are not individual and specific to a single woman, but (explicitly or implicitly) shared by a whole group – members of the corps de ballet, or laundresses, or simply women bathing. Their faces are rarely seen in full, and never given features which sharply differentiate them from their companions; where they are characterised, this is done through physiognomical stereotypes which typecast them, rather than showing them as unique individuals. [1] Likewise their gestures are not individualised, but are closely tied to the activity shown – dancing, ironing, etc. – or else are subconscious, implicitly semi-animal reflexes like scratching or yawning or slumping in exhaustion. [2]

The contrast between male and female figures is most vivid in a number of

paintings, mostly of the early- to mid-1870s, in which both appear in the same picture; the male audience watching the dancers on the stage, or the dancing master coaching the corps de ballet. It has recently been argued that Degas' treatment of ballet-masters subverts male authority.[3] However, despite the informality and asymmetry of the grouping of the figures in these pictures, the masters are always placed in unequivocally pivotal positions, around which the movements of the dancers are orchestrated; and also, as men, they alone are given a full individuality – that central prerequisite of authority within bourgeois patriarchy.

The contrast between male and female figures is established still more vividly in the two versions of *Ballet of Robert le Diable* of 1872 and 1876 (Metropolitan Museum of Art, New York, L 294, and Victoria and Albert Museum, London, L 391). In these, there is a clear differentiation between the individualised men in the audience and the anonymous dancers in nun's costume. But the key female presence is physically absent – the implicit woman in the box out of the picture to the left, towards whom the male figure in the stalls gazes through binoculars. In a stock situation like this, woman's role as object of this gaze is so passive, so taken for granted that the female figure need not appear at all.[4]

There is, though, a small group of paintings dating from around 1867–73, in which gender roles, and woman's role in particular, are treated very differently; these are the subject of the present essay. They are not a coherent or consistent group, nor do they form a distinct phase in Degas' career; other pictures showing the stock gender contrasts were done in the same years. However, the pictures I will discuss have certain shared characteristics which set them apart from contemporary images of modern social life: they show social interchange between men and women; the relationships between the figures are hard to interpret unequivocally; and the female figures in them are distinctively individualised. In various ways they challenged the ways in which such images were conventionally interpreted, and through this they called into question certain underlying assumptions about modern society – about its coherence and legibility, and more specifically about the distinct spheres of male and female activity.

The two principal pictures in this group of paintings both have very uncertain titles. The canvas known as *Bouderie*, inadequately translated as 'sulking' (fig. 16), was apparently given this title by Degas; he described the other picture only in the most neutral terms as *Interior* or 'my tableau de genre' (plate 2). Neither picture was exhibited until much later, though the scale of *Interior* (it measures 81 × 116 cm) suggests that it was conceived with a view to exhibition at the Paris Salon.[5]

Because the pictures were not exhibited, they aroused no public comment at the time of their making. However, a contemporary text gives a useful indication of the criteria applied to pictures of this type in the late 1860s; this is Castagnary's extended discussion of the two paintings which Degas' friend Manet exhibited at the Salon in 1869, *Le Déjeuner* and *Le Balcon*:

81

Fig. 16 Edgar Degas, *Bouderie*, *c.* 1872, oil on canvas, 32.4 × 46.4 cm, Metropolitan Museum of Art, New York, L 335.

In looking at this *Déjeuner*, I see, on a table where coffee has been served, a half-peeled lemon and some fresh oysters; these objects hardly go together. Why were they put there? Just as M. Manet assembles, simply for the pleasure of astonishing, objects which should be mutually incompatible, so he arranges his people at random without any reason or meaning for the composition. The result is uncertainty and often obscurity of thought. What is the young man in the *Déjeuner* doing, the one who is seated in the foreground and seems to be looking at the public?. . . . On the *Balcony* I see two women, one of them very young. Are they sisters? Is this a mother and daughter? I don't know. And the one has seated herself, apparently just to enjoy the view of the street; the other is putting on her gloves as if she were just about to go out. This contradictory attitude bewilders me. A feeling for functions, for fitness are indispensable. Neither the painter nor the writer can neglect them. Like characters in a comedy, so in a painting each figure must be in its place, must play its part, and so contribute to the expression of the general idea.[6]

For Castagnary, then, in a well-put-together picture details should relate intelligibly to the whole, as should the actions of the figures depicted; and the relationships between these figures should be clear. All elements should contribute to the 'general

idea', which should be evident to the viewer. This implies that the viewer's position in relation to the scene should also be clear – both physically (witness Castagnary's anxiety about the boy in the *Déjeuner*), and in social and ethical terms, so as to be able to place the scene by grasping the 'general idea'. These criteria can be summed up in terms of various types of legibility, ranging from detail, gesture and expression to compositional organisation, overall theme and 'plot'.

This was not simply a matter of artistic convention; the ready legibility of images was one of the key means by which society ordered itself and established control over its constituent elements. In their conventional uses, these devices – the placing and expression of figures, and the use of details – were basic mechanisms by which visual representations were ordered and their meanings controlled; they were the keys to legibility. At the same time, under the strict censorship of the 1860s,[7] one of the principal means of expressing opposition to dominant social norms was by challenging these normative patterns of reading and understanding images.

By Castagnary's criteria, the two pictures by Degas are as puzzling as the Manets. In *Bouderie* there are a number of very explicit details: the window-counter at top left, the racing print, and the rack for ledgers at top right; these are all associated with banking, business, gambling – in themselves a consistent set. But the puzzle lies in their relationship to the central subject, the figures; there is no way in which these insistent details can be integrated into a consistent reading of the whole. Evidently, too, the relationship between the two figures is ambiguous – the female turned to us, the male turned away. There is clearly some sort of break in communication between them, but we are offered no clue to interpreting it. Like the details in the background, their gestures and expressions invite a narrative explanation but at the same time thwart the attempt to read them.

The *Interior* invites a narrative reading still more forcibly, but thwarts the attempt even more strongly. Discussion of the painting has been complicated by two things: by the apocryphal title *The Rape*, first applied to it in 1912, wholly without Degas' sanction; and by the question of whether it illustrates a passage from a contemporary novel.

Various possible literary texts had been suggested for *Interior* – from a novel by Degas' friend Duranty and from Zola's *Madeleine Férat* – before 1970, when Theodore Reff proposed that its 'principal literary source' was a scene from Zola's *Thérèse Raquin*.[8] Many writers since then have uncritically accepted this theory, but it has been questioned, first by Roy McMullen in his excellent biography of Degas, and more recently by Carol Armstrong.[9]

The scene in question is the wedding night of Thérèse and her lover, Laurent, who have together murdered her first husband:

Laurent carefully shut the door behind him, then stood leaning against it for a moment looking into the room, ill at ease and embarrassed. A good fire was blazing in the hearth, setting great patches of golden light dancing on the ceiling

and walls, illuminating the whole room with a bright and flickering radiance, against which the lamp on the table seemed but a feeble glimmer. Madame Raquin [Thérèse's aunt] had wanted to make the room nice and dainty, and everything was gleaming white and scented, like a nest for young and virginal love. She had taken a delight in decorating the bed with some extra pieces of lace and filling the vases on the mantlepieces with big bunches of roses . . . Thérèse was sitting on a low chair to the right of the fireplace, her chin cupped in her hand, staring at the flames. She did not look round as Laurent came in. Her lacy petticoat and bodice showed up dead white in the light of the blazing fire. The bodice was slipping down and part of her shoulder emerged pink, half hidden by a tress of her black hair.[10]

Despite the many comparatively trivial points at which text and picture do not match, Reff argues that Zola's description 'corresponds in almost all respects' with the picture, and 'must surely be considered Degas' principal literary source'.[11] However, Reff also notes several things in the picture which do not appear in the text, but without questioning whether these in effect contradict his whole theory. Some of them seem of central importance: the fact that it is clearly a single bed; the emphasis on the open sewing box on the table; the top hat on the chest at back left; and the corset discarded on the floor. None of these is in any sense compatible with Zola's story. They cannot simply be attributed to artistic licence within the 'Thérèse Raquin illustration' theory; they invalidate the theory itself.

The strange combination of elements in the picture makes it most unlikely that there is still another potential literary source for it, as yet undiscovered. Yet Interior, and Bouderie as well, do deploy the obvious means of generating readings and possible meanings: the placement of the figures; their expressions and gestures; and their attributes and surroundings. A closer examination of the conventional uses of these devices will show the ways in which Degas' pictures challenged accepted norms and called into question the values for which they stood.

Conventionally, surroundings and attributes were used to locate a scene socially; individual, emphasised details might be a pointer to a more specific reading, such as a narrative. The use of this sort of clue was a vexed issue in the circle of Degas and Manet at the time. Antonin Proust remembered Manet's mocking interpretation of just such a detail in a picture by their mutual friend Alfred Stevens: 'Alfred Stevens had painted a picture of a woman drawing aside a curtain. At the bottom of this curtain there was a feather duster which played the part of the useless adjective in a fine phrase of prose or the padding in a well-turned verse. "It's quite clear", said Manet, "this woman is waiting for the valet".'[12] The picture in question is titled The Morning Visit; so the duster did play a part – to indicate the time of day; but, to Stevens's annoyance, Manet jokingly upgraded it into a fully fledged pointer to a potential sentimental narrative.

Such alertness to the significance of attributes as pointers is particularly relevant

to *Interior*. The most potentially loaded sign, the corset on the floor, is given no special prominence, in contrast to the sewing box on the table, and we know that this box was further emphasised during the execution of the painting. A friend of Degas' (perhaps Tissot) wrote a critique of the then-unfinished canvas, which included: 'The sewing box too conspicuous, or instead not vivid enough.'[13] Degas chose to make it still more prominent. But what should we make of this? That it is the key to a narrative – and a quite different one from Zola's? Or that it is merely a colour accent in the composition? It seems more likely that the emphasis given to so apparently trivial an item is a subversion of the stock procedures of reading pictures; there are similar subversions in many pictures by Manet, for instance, the armour on the chair in *Le Déjeuner*, which Gautier playfully tried to read as the key to a narrative in his review of the 1869 Salon, by asking: 'But why these weapons on the table (sic)? Is it the luncheon before or after the duel? We don't know.'[14]

The displacement of the figures to the margins of the canvas in *Interior* takes up a type of centrifugal composition which had been used by painters of historical genre such as Delaroche from around 1830 onwards, and had been given fresh drama by Gérôme in canvases like *The Death of Caesar* (1867; Walters Art Gallery, Baltimore). Deliberate decentring such as this is not uncommon in Salon painting of the later 1860s, but Degas' *Interior* is exceptional for the period, in using such an arrangement to evoke physical and psychological distance between two figures in a private space.[15]

The distance between the figures is inseparable from their poses and expressions, which must be examined in relation to nineteenth-century theories about the interpretation of facial expression and bodily movement. The 1860s was a period of active debate about this. The study of physiognomy had been central to academic art training since the late seventeenth century, and had been codified by the Swiss theorist Lavater in the late eighteenth century; writers in the 1860s were seeking to give a more scientific and experimental basis for their studies, but Lavater's much reprinted textbook remained the yardstick against which later critics measured themselves.[16] Degas' interest in these questions is demonstrated by comments in one of his notebooks from this period: 'Make the academic *tête d'expression* into a study of modern feeling; it's Lavater, but Lavater made more relative, in a sense – sometimes with signs of accessories.'[17]

These comments have often been quoted in discussions of *Interior*, but in practice theories of physiognomy, gesture and expression give no very clear entry to the picture. The pose of the female figure relates to stock images of pensiveness and melancholy, but we can see little of the face; and the male figure's stance, leaning back with hands in pockets, offers little rhetorical sign language. Moreover, Degas seems to have diminished the expressive force of the female figure as his plans for the picture evolved: a preparatory drawing shows more of the face, and heightens the frisson of the pose by revealing the breast;[18] another drawing (fig. 17), very possibly an initial idea for *Interior*, shows a similarly half-dressed figure in a far more dramatic pose, suggesting that at this stage Degas may have envisaged an overt confrontation

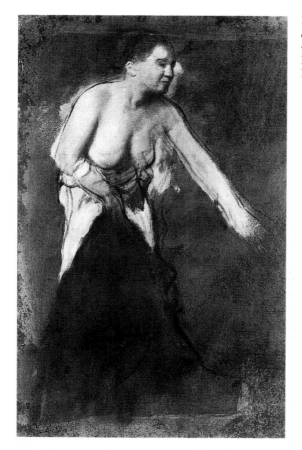

Fig. 17 Edgar Degas, *Female Figure*, *c*. 1868, essence on brown paper, 47 × 30 cm, Oeffentliche Kunstsammlung, Kunstmuseum, Basel, L 351.

between the two figures.

In 1867 Degas' friend Duranty published an essay 'On physiognomy' which helps to locate Degas' apparent wariness of using languages of gesture and expression in *Interior*.[19] In part, the essay is an argument for just the 'Lavater made more relative' that Degas was seeking: Duranty insists that a person's profession and circumstances have an important effect on their physiognomy. At times he seems to endorse physiognomy's claims to the status of a science and as a key to human feelings. But he treats with some scepticism the claims of other recent theorists that the hands are a key to character; in *Interior* Degas denies himself this insight in the male figure, with hands thrust in pockets. For Duranty, the expression of the mouth is more revealing, but Degas makes little use of this, either, in *Interior*.

However, from the start of his essay Duranty reveals misgivings about the whole subject. He admits the possibility of aberrant individuals whose appearance eludes all systems of classification, and speaks of the powerlessness of the police in the face of such individuals, since the police operate by stereotypes. In his final paragraph, with seeming impatience, he declares that the perceptive individual can understand

more than any system can teach: 'The best advice to give to those who want to recognise a man or men, is to show much spirit and shrewdness in unravelling their complexities, since words are lying, action is hypocritical and physiognomy is deceitful.' At this point in his career Degas may well have had similar misgivings about the claims of 'science'.[20]

It is particularly interesting that Duranty's criticisms of physiognomy are couched in terms of the limitations of police methods. This suggests how closely methods of classification were associated with structures of control, and presents the unique individual as a transgressive force who threatened the whole fabric of authority. The paradigm of Duranty's man of spirit is the Parisian boulevardier – Baudelaire's *flâneur*, the passionate observer in the crowd – whose insight allows him (the *flâneur*, ranging freely in public, is by definition male) to transcend the straitjacket of classification.[21]

Robert Herbert has recently proposed the detective's eyes as a paradigm for the detached, investigative vision he sees as characterising 'naturalism' such as Degas'.[22] However, Duranty's essay suggests the limitations of this model: the *dégagement* of the man of spirit lacks the detective's goal-oriented vision, but it also shows a passionate *curiosité* which ranges far beyond the detective's investigations, and lays bare the stereotypes upon which they are based.[23]

Duranty's insistence on the uniqueness of the exceptional individual, who transcends the classifications of the physiognomists, is very relevant to Degas' pictures: the protagonists in them are presented as individuals. The male figures in both and the female in *Bouderie* have distinctive features; the pose of the female in *Interior* conforms to stereotypes of female passivity and anonymity, but the figure's individuality is implied in a different sense, as a protagonist in the illegible emotional interplay before us; it is not a social ritual but a particular drama.

In two ways the pictures run right against the standard patterns of contemporary modern life genre painting: virtually always the women in the stock images are wholly typecast, in their facial features and their activities; and men scarcely ever appear at all, though their existence is often implied. In this respect Manet's *Le Balcon* is very comparable to Degas' paintings, though it carries little hint of psychological interchange. Images of male-female relations are very rare in scenes of contemporary life before the mid 1870s; one of the rare appearances of a male figure is in Eugène Feyen's *The Honeymoon* of 1870 (fig. 18), where male and female conform to the most stereotyped contrast of gender roles, even at this tender moment: the male is writing at a desk, implying professional activity or brain work, while the female sits embroidering – preoccupied with the *arts d'agrément*.

Images of flirtations or trouble in relationships, when they appeared, were generally translated into historical dress, often of the Directoire period (the late 1790s), as in Tissot's *Un Déjeuner*, a *risqué* scene of public flirtation shown in the 1868 Salon. Also shown at this Salon was Victor Giraud's *The Husband's Return*, an image of a woman caught *in flagrante delictu*, again set in Directoire costume; in this gigantic canvas, measuring about 12′ by 6′, the shot lover, young, handsome and grossly

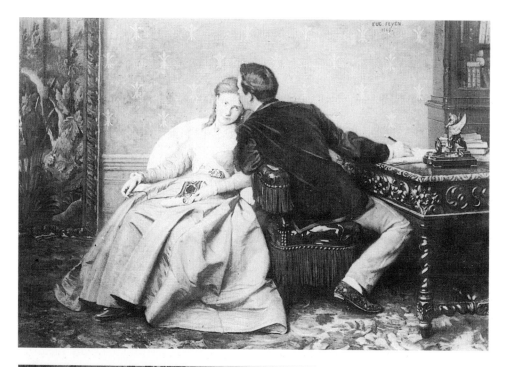

Fig. 18 *Above* Eugene Feyen, *The Honeymoon*, Salon of 1870, dimensions and whereabouts unknown.

Fig. 19 *Left* Charles Baugniet, *The Troubled Conscience*, 1864, dimensions and whereabouts unknown.

over-dressed, lies expiring at the foot of a staircase, pleading to the vengeful, black-clad middle-aged husband, who looms over him, up the stairs, supporting the swooning wife.[24] In modern dress scenes, hints of intrigue and immorality appeared only in scenes containing one or more women alone, where their gestures, and often the titles of the pictures, allow the spectator to imagine what cannot be seen in the picture itself, as in Charles Baugniet's *The Troubled Conscience* (fig. 19).

The virtual absence of male figures is a significant factor in modern life genre paintings. Explanations of various sorts can be proposed for this. For many theorists, the male figure, and in particular modern male dress, were incompatible with the beauty which art should seek; commentators, too, pointed out the lack of intimacy in French marriages.[25] However, the question of individuality seems a central issue. In conventional representations, contemporary women were assigned typecast roles, re-enacting standard social and domestic rituals; men by contrast defined themselves as individuals, in terms of their professional activity, and male artists seem to have been reluctant to present male figures in stock roles within the domestic spaces where alone they had legitimate interchange with women. *Interior* and *Bouderie* were both transgressive through the presence of male figures; *Interior* is problematic, too, in the drab surroundings and the woman's partial undress, *Bouderie* in the individuality of the female figure, shown in a space associated with male professional activity.

The female figure in *Bouderie* looks directly at the viewer (at the male viewer: in this period the construction of the spectator was fundamentally male-gendered; there was no autonomous notion of female viewing). The challenge of this eye-contact directly implicates the viewer in the scene and destroys the barrier between the two worlds. Manet's *Déjeuner sur l'Herbe* of 1863 (Musée d'Orsay, Paris) seems to have been the first modern life painting to do this, but there the model's nakedness adds a *frisson* wholly absent in *Bouderie*. At the salon of 1868 Charles Marchal explicitly used such eye-contact in his *Phryné* to evoke the idea of the luxurious courtesan, together with stereotypes of physiognomy, gesture, expression and attributes, in contrast to the demure profile of his *Pénélope*, the dutiful wife, shown at the same time. In his review of the exhibition, Marius Chaumelin explicitly associated the contrasting directions of the gazes with the moral contrast between these two images.[26]

In *Bouderie*, though, the clothing and demeanour of the female figure make no such association with immorality. Likewise Manet's *A Young Woman* (now known as *Woman with a Parrot*; Metropolitan Museum of Art, New York), shown with the Marchals at the 1868 Salon, challenges this stereotype, showing a woman privately and informally dressed in a house coat, but wholly without the inviting gesture and voyeuristic appeal of Marchal's *Phryné*. Manet's figure, like that in *Bouderie*, is distinctively individualised.

Degas' fascination at this period with the idea of eye-contact with a female figure placed within the picture appears most vividly in *At the Racetrack* (fig. 21) and the many related studies he made of the motif of a woman looking at the viewer with binoculars. One of these studies (fig. 23) shows that he associated this motif in some

sense with Manet – a drawing showing Manet at the races, with the same female figure rapidly outlined on the left.

In *Interior* and *Bouderie*, Degas seems deliberately to have challenged the standard contemporary processes of encoding meanings in pictures. In this respect there are clear parallels with Manet, but Degas tackled the theme of psychological interrelationships several years before Manet.[27] In one sense the pictures come at the end of a sequence in Degas' work, for his paintings of historical subjects of the late 1850s to mid 1860s had mostly focused on tensions between men and women.[28] But at the same time they are among his first paintings to engage uncompromisingly with themes from contemporary life.

What contexts should we propose for them? It would be a mistake to discuss them primarily in personal terms, as some writers have done – in relation to Degas' supposed difficulties with women.[29] Pictures like these were conceived for some sort of public forum and as interventions into contemporary artistic and social debates; it would be damagingly limiting to reduce them to by-products of the artist's private life. Moreover it would be anachronistic to claim that Degas conceived their subjects as metaphorical expressions of his own anxieties; such notionally confessional imagery only emerged at the end of the nineteenth century in the work of painters such as Munch.

In some respect the imagery of sexual disharmony was very topical. The 1860s witnessed a spate of social debate about adultery and the breakdown of the family in the face of materialism and consumerism, but the main focus of these debates was the world of high fashion and luxury.[30] In the arts, plays like Victorien Sardou's *La Famille Benoitton* (1865) and *Maison Neuve* (1866) were paralleled in painting by the work of artists such as Toulmouche and Baugniet (see fig. 19). Degas' *Bouderie* hints at this world, with its references to banking and horse-racing, but the scenario is far from luxurious. In *Interior* the surroundings are markedly simple – a far cry from Baugniet's world; its setting clearly does bear a far closer relationship to the world of Zola's early novels to which it has been linked – to the humble inns and rented lodgings which his socially unstable characters frequent.

But, as we have seen, Degas' pictures reject the legibility and coherence of plot on which Zola's novels, like paintings such as Baugniet's, depend. In a sense these vivid but illegible images are a declaration of the difference of painting from literature. In later years Degas often reiterated his scorn for the uses that *littérateurs* made of painting, and his belief in the power of images without words.[31] Paintings like Baugniet's, with their titles, invite verbal glosses, narrative readings; in a sense *Interior* and *Bouderie* also ask to be viewed like this, since they too seem to present a dramatic situation, but their details, poses and expressions fail to deliver the expected resolutions. Many years later, Degas was told that a major museum had refused to buy *Interior* because of the immoral circumstances depicted; apparently Degas said: 'But I'd have furnished a marriage licence with it.'[32] This comment should be seen not as a hint that the painting does, after all, have a precise storyline, but

rather as a mockery of such types of judgment and of the use of narrative titles and literary glosses.

These paintings engaged in many ways with both social and artistic debates, and challenged many stereotypes – both dominant social values and the normative conventions of picture making. Parallels for these challenges can be found in the work of Manet. In Manet's subversion of conventions there is some consistency of concerns and targets: a recurrent interest in challenging patterns of classification and reading led him to focus on illegible social situations, often placed in settings with ambiguous or equivocal associations, or on the margins between private and public spheres. This in turn can be linked with certain types of radical urban opposition to the regime of Napoléon III and to the repressive early years of the Third Republic. Manet's challenges to structures of classification can also be seen as a challenge to the authorities who rooted their power in those structures and legitimised it through them. [33]

No such consistent pattern emerges in Degas' work, either in the imagery he chose or the way he treated it; and yet the complexities of the paintings I have been examining show an acute and critical awareness of the same network of issues. Perhaps we can make some sense of this by invoking biography – not by seeking out a 'private' Degas, but rather by looking at the ways in which his friends and contemporaries perceived the man and his work. The images we find are paradoxical and contradictory. To some he appeared as a man from high society and a decadent – but Berthe Morisot's mother saw him as a sympathiser with the Communards in 1871; some found him a charming companion, but others found his wit cold and distancing; he presented himself as an aesthete and a man of ideas, but he was already an obsessive experimenter with artistic materials and techniques; and some saw his art as realist, others as the fruit of imagination and fantasy. We should not seek to synthesise these views in search of an 'essential Degas'; these are not images of a real Degas, but rather constructions of 'Degas', though in turn they may relate to his own strategy of self-presentation. [34]

The paintings I have examined admit the possibility of individual female experience, in contrast to Degas' imagery from the mid-1870s onwards, which typecasts women and defines them by their professional activity or, with the bathing women, in terms of some notion of essential femininity. The change in his subject matter coincides with a vital shift in his compositional techniques, towards the habitual high viewpoint and oblique angle of vision of his pictures of urban entertainments, and later to the so-called keyhole viewpoints of many of the bather pictures. These all impose an overall control, and interpose distance and barriers between artist and subject. The *tableaux de genre* do not have these barriers, but evoke a more direct encounter with their subjects, in social rather than professional contexts. It is no coincidence that, before he died, Degas erased the figure of the woman with binoculars from *At the Races*, since, more than any other, this image threatened the distancing that he so carefully cultivated in his later work. [35]

Degas, before he adopted these distancing devices, was perhaps a less coherent, less resolved artist; but, perhaps more than later, he was also an artist singularly closely engaged with the social and artistic milieu in which he worked.

Notes

1. See Douglas W. Druick and Peter Zegers, 'Le réalisme scientifique, 1874–81' in Jean Sutherland Boggs *et al.*, *Degas*, New York, The Metropolitan Museum of Art, 1988, pp. 203–11; and Anthea Callen, 'Anatomy and Physiognomy: Degas' Little Dancer of Fourteen Years', in Richard Kendall, *Degas: Images of Women*, Liverpool, Tate Gallery, 1989, pp. 10–17.

2. Edmond de Goncourt in 1874 described Degas' detailed knowledge of the different movements made by women ironing (*Journal 13 February 1874*, 1989 edn, II, p. 570).

3. Eunice Lipton, *Looking into Degas*, Berkeley and Los Angeles, University of California Press, 1986, pp. 110–3.

4. The standard pattern is shown in Renoir's *La Loge*; it appears too in many graphic illustrations and caricatures, notably Grandville's *Venus at the Opera* (1844), in which the heads of the gazing males are reduced to a set of gigantic eyes (reproduced in Judith Wechsler, *A Human Comedy: Physiognomy and Caricature in 19th Century Paris*, London, Thames & Hudson, 1982, p. 102). For Mary Cassatt's witty reversal of this stereotype, see Griselda Pollock's essay in the present volume (pp. 106–30).

5. For details of the pictures, see the Paris 1988 exhibition catalogue (op. cit.), pp. 143–8; the title *Bouderie* was given to the former, presumably by Degas himself, when he deposited it with the dealer Durand-Ruel in 1885; he deposited the latter with Durand-Ruel in 1902 with the title *Intérieur*. A painting by Delort with the title *Bouderie* was published by the dealer Goupil in photographic reproduction in the 1870s; it is a fairly unproblematic image of a lovers' tiff, showing a woman in Renaissance dress turning away from her male companion, seated alongside her on a bench.

6. *Le Déjeuner*, Bayerische Staatsgemaldesammlungen, Munich; *Le Balcon*, Musée d'Orsay, Paris. Castagnary, in his *Salons (1857–79)*, Paris 1891, I, pp. 364–5. On these pictures, see *Manet*, catalogue of exhibition at Grand Palais, Paris, 1983, pp. 290–4 and 302–7, and John House, 'Manet's Naiveté' in *The Hidden Face of Manet*, published in *Burlington Magazine*, April 1986, pp. 7–8, and 'Social Critic or Enfant Terrible: The Avant-Garde Artist in Paris in the 1860s' in *Actes du XXVIIe Congrès international d'histoire de l'art*, Strasbourg, forthcoming 1991; although generally known as *Déjeuner dans l'atelier*, the former picture was titled simply *Le Déjeuner* on its first exhibition.

7. On the press and censorship, see Pierre Guiral, 'La Presse de 1848 à 1871' in *Histoire générale de la presse française*, directed by Claude Bellanger and others, Paris 1969, and Robert Justin Goldstein, *Political Censorship of the Arts and the Press in Nineteenth-Century Europe*, London, Macmillan, 1989; for a most interesting

discussion of the implications of censorship for painting, see Leila M. Kinney, 'Genre: A Social Contract?' in *Art Journal*, Winter 1987, pp. 267–77.

8. The principal account of *Interior* is by Theodore Reff, 'My Genre Painting' in *Degas: The Artist's Mind*, London, Belknap Press, 1976, pp. 200–38; I am indebted to this for much information, though I disagree with many of its conclusions.

9. Roy McMullen, *Degas: His Life, Times and Work*, London, Secker & Warburg, 1985, pp. 158–61; Carol M. Armstrong, 'Edgar Degas and the Representation of the Female Body' in Susan Rubin Suleiman (ed.), *The Female Body in Western Culture*, Cambridge, Mass., Harvard University Press, 1986, p. 228; it will be discussed in more detail in Carol Armstrong's important forthcoming book on Degas.

10. As quoted by Reff, op. cit., p. 205.

11. ibid.

12. Antonin Proust, 'Edouard Manet (Souvenirs)' in *Revue blanche*, 1 March 1897, pp. 202–3; Proust's description corresponds exactly with the painting sold as *La Visite matinale* at the Galerie Royale, Brussels, 7 December 1923, lot 51 (formerly collection A. Sarens).

13. Reff, op. cit., pp. 225–6, first published this letter; the original French text appears in the Paris 1988 exhibition catalogue, op. cit., pp. 144–5.

14. Théophile Gautier, 'Le Salon de 1869' in *Tableaux à la plume*, Paris 1880, p. 285.

15. This is a frequent device in late nineteenth-century painting notably in the work of painters such as Munch.

16. For discussions of mid-nineteenth century interest in physiognomy, see Wechsler, op. cit., and Elizabeth Anne McCauley, *A.A.E. Disdéri and the Carte de Visite Portrait Photograph*, New Haven and London, Yale University Press, 1985, pp. 167–72.

17. Notebook 23, p. 44, in Theodore Reff, *The Notebooks of Edgar Degas*, Oxford, OUP, 1976, I, p. 117.

18. Reproduced in Reff, op. cit., p. 213.

19. Duranty, 'Sur la physionomie', *Revue libérale*, 25 July 1867, pp. 499–523.

20. On Degas and science, see the essays by Douglas Druick and Peter Zegers, op. cit., and by Anthea Callen, op. cit.

21. Baudelaire's vision of the *flâneur* was formulated in his essay 'Le Peintre de la vie moderne'; Janet Wolff, 'The Invisible *Flâneuse*: Women and the Literature of Modernity' in *Theory, Culture and Society*, vol. 2, no. 3, 1985, discusses the paradoxical status of woman in discussions of public spaces and their relationship to notions of modernity.

22. Robert L. Herbert, *Impressionism: Art, leisure and Parisian Society*, New Haven and London, Yale University Press, 1988, on the detective, pp. 43–4, quoting Victor Fournel's detective-like characterisation of the *flâneur*, who uses physiognomy as his guide; on Degas, pp. 45–57 (for readings of *Interior* and *Bouderie*, see pp. 50, 56).

23. *Curiosité* is one of the key qualities posited by Baudelaire for the *flâneur* in 'Le Peintre de la vie moderne' in Baudelaire, *Ecrits sur l'art*, Paris 1971, II, p. 144.

24. Tissot's picture is reproduced in Christopher Wood, *Tissot*, London, Weidenfeld

& Nicolson, 1986, plate 36; Giraud's picture was bought by the State at the Salon, and is in the Musée Fabre, Montpellier; it is described by Marius Chaumelin, 'Salon de 1868: V' in *La Presse*, 29 June 1868.

25. For the unsuitability of male dress for representation in fine art, cf. e.g. Marius Chaumelin, 'Salon de 1868, VI' *La Presse*, 12 July 1868; on marriages, cf. Hippolyte Taine, *Notes sur l'Angleterre*, Paris, 1872, 1885 edn, pp. 95, 103.

26. *Phryné*, now lost, engraving reproduced in T.J. Clark, *The Painting of Modern Life: Paris in the Art of Manet and His Followers*, London, Thames & Hudson, 1985, p. 114; *Pénélope* in Metropolitan Museum of Art, New York; Chaumelin, 'Salon de 1868, III' in *La Presse*, 11 June 1868.

27. Manet's first such subject was probably *Argenteuil*, Salon of 1875 (Musée des Beaux-Arts, Tournai).

28. For instance *Scène de guerre au moyen âge* (Musée d'Orsay; exhibited at the Salon of 1865); *La Fille de Jephté* (c.1859–61, Smith College Museum of Art, Northampton, Mass.); *Petites filles spartiates* (c.1860–2, National Gallery, London).

29. For a recent example of such personal readings, see Richard Brettell's discussion of *Young Spartans* in *Degas in the Art Institute of Chicago*, Art Institute of Chicago and Harry N. Abrams, 1984, pp. 32–5; such a reading is also among those proposed by Reff, op. cit., pp. 215–16, in discussing *Interior*. The late 19th century cliché about Degas' misogyny lies at the base of such readings; for an attack on this viewpoint, see Norma Broude, 'Degas' ''Misogyny''' in *Art Bulletin*, March 1977; Broude's article does, however, retain the assumption that Degas' images of women can primarily be read in terms of his own personal attitudes and feelings.

30. Debates about the morality of the world of high Parisian fashion were brought to prominence by the *Opinion de M. le procureur Genéral Dupin sur le luxe effréné des femmes*, delivered in the Senate on 22 June 1865, published in Ernest Feydeau, *Du luxe, des femmes, des moeurs de la littérature et de la vertu*, Paris, 1866; Feydeau's book attacked Dupin's views from the point of view of the fashionable *boulevardier*, but similar condemnations of the fashionable urban lifestyle were widespread (e.g. Monsignor Dupanloup, *La Femme studieuse*, Paris, 1869, reprinting essays of 1866 and 1867).

31. For Degas' opposition to literary painting, cf. e.g. his comments to Georges Rivière and George Moore, quoted in McMullen, op. cit., p. 288.

32. Roger Fry told this story to Quentin Bell, quoted Reff, op. cit., p. 206 and p. 328, note 35; the museum in question was probably the Metropolitan Museum of Art, New York.

33. See House, op. cit. (*Actes du XXVIIe congrès*).

34. The best discussion of the ways in which Degas was perceived by those who knew him, and the contradictions in their perceptions, is in McMullen, op. cit.

35. On the rediscovery of this figure when the picture was cleaned, see Benedict Nicolson, 'The recovery of a Degas race course scene', *Burlington Magazine*, December 1960, pp. 536–7.

Looking, Power and Sexuality: Degas' *Woman with a Lorgnette*

Deborah Bershad

From 1867 to 1877 Edgar Degas produced a number of studies and sketches of an unusual, indeed almost bizarre image.[1] Each work depicts a young woman, dressed in varying walking costumes, who holds a pair of binoculars or opera glasses to her eyes with her right hand, while her left hand supports her right elbow. (figs 20, 24, 25). William Wells, in an article that appeared in 1972 in *Apollo*, related these works to a painting by Degas which is entitled *At the Racetrack: The Jockeys* (fig. 21).[2] Wells reported the discovery of a similar female figure under several layers of paint that were removed from the race track scene. He also made the suggestion that the model for these figures was Lydia Cassatt, referring to the name 'Lyda', inscribed at the top right-hand corner of one of the oil sketches (plate 3). Wells' query 'Who was Degas's Lyda?' – the title of his article – formulates the problem of the existence of this image as a search for a prototype, in this case, a model. A more appropriate question might be 'Why was Degas' Lyda?', a question I hope to address.

The importance of this image to Degas may be deduced by both his detailed treatment of the four oil studies of this figure, and by his original intention to place the figure in a markedly central position in the oil painting *At the Racetrack: The Jockeys*. Yet this figure of a woman who confronts us so directly with her binoculars is difficult to reconcile with Degas' other racetrack paintings and sketches. His two paintings *At the Races in the Countryside*, dated 1870–3 (plate 4), and *At the Races* (Paris, Musée d'Orsay, L 461), dated 1877–80, are the only other racing scenes in which the spectators are placed in the foreground. However, in both works we can look beyond the foreground to the smaller background scenes of horse-racing. The spectators are to one side of the scene, and our gaze is unblocked by the direct look of another. Two somewhat earlier works, *Before the Races* (Paris, Musée d'Orsay, L 262) and *False Start* (Yale University Art Gallery, L 258), both dated to 1869–72, are illustrative of Degas' usual approach to the track – his concentration on the jockeys. Degas deals with the subject of the spectator by placing the small figures in the stand, either behind

the jockeys or to the side and back of the jockeys. From an examination of these and other track and racing scenes it seems clear that Degas was, for the most part, concerned with depicting scenes on the track, scenes that he or other spectators might have seen from the stands, or even across from the stands. By omitting the spectator, what Degas omits from his conception of the races is the clear sense of class distinctions at the races, as well as the aura of sexuality surrounding the track, two phenomena which were both apparent to, and reported by, his contemporaries.

I should point out that these omissions were even more striking in the 'high art' of the period, that is, in the Salons of 1861–73. Throughout this period there were only fifteen paintings shown at the Salons which depicted the racetrack. Of these, nine depicted steeplechase scenes, a clear concession to the Anglomania of the period. [3] In painting scenes of the track Degas seems to have been, in most of his works, conforming to a marginal but persistent tradition of painting. By concentrating on the jockeys and their mounts Degas retained that connection with hunting scenes which seems to have made the steeplechase and even the track acceptable in very limited quantities to the Salon judges. Although such an analysis makes the problem of the 'Lyda' series even more complex, it may indicate one of the reasons why Degas felt compelled at a later date to paint the female figure out of *At the Racetrack: The Jockeys* (fig. 22). Since Degas' work was accepted at the Salon from 1865–70, it seems more than likely that he was familiar with the hierarchisation of subject matter, and that he was aware of where his paintings would stand in relation to other images of equestrian sports. It is doubtful that this image of a woman with binoculars, an image of a woman that brings into question just who is the spectator in the painting-spectator relationship, would have been viewed by Degas as compatible with more traditional images of both women and racing.

How then can we explain this seemingly strange image? Rather than move from the realm of 'high art' to the realm of 'popular imagery' in a search for sources and influences, it seems essential to take into account the racetrack as not merely a subject for painters, but as a social situation whose characteristics were changing dramatically in just those years in which Degas began to paint it.

According to an article in *L'Illustration*, 14 June, 1873:

> Fifteen years ago no one bet at the track. Only the owners of horses and members of the Jockey Club bet large sums on the heads of horses. Today the furore of betting has become general, and is known even among the humblest classes of the Parisian population. . . . It was around 1860 that the track became *à la mode*. It attracted a mob. . . . With the mob came the bookies. But they still acted within a restricted domain. . . . Most [betters] were members of the *Betting* or *Salon des courses*. . . . The bets that were made at this time were a minimum of 5 louis. They were based on one's word. . . . Thus we see in some degree the understanding among men of the same world. . . . Little by little strange and diverse elements were introduced in the *Ring*. This English

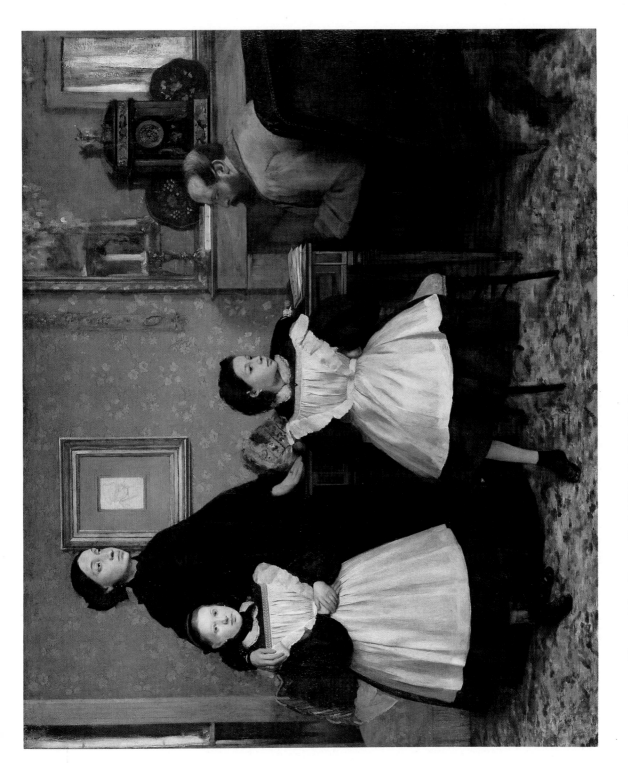

Plate 1 Edgar Degas, *The Bellelli Family*, 1858–67, oil on canvas, 200 × 250 cm, Musée d'Orsay, Paris, L 79.

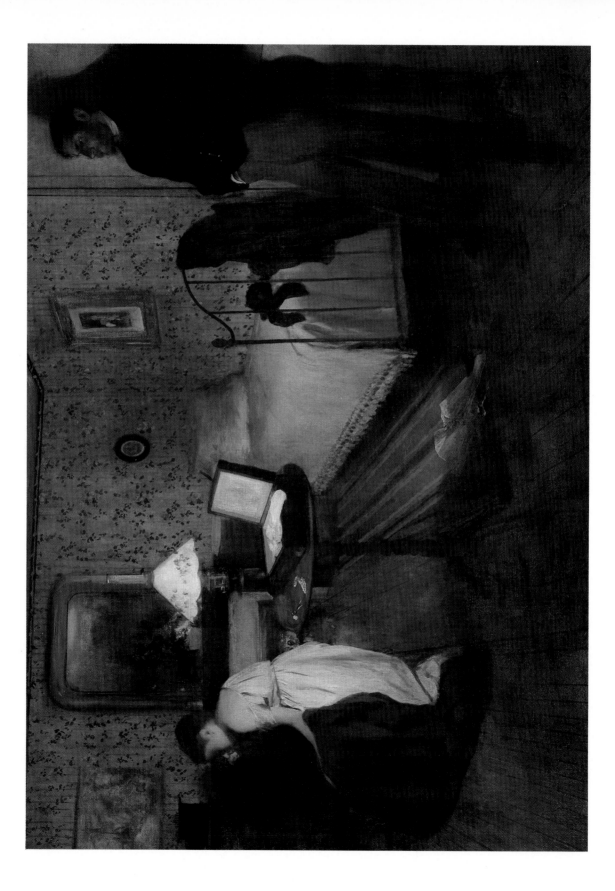

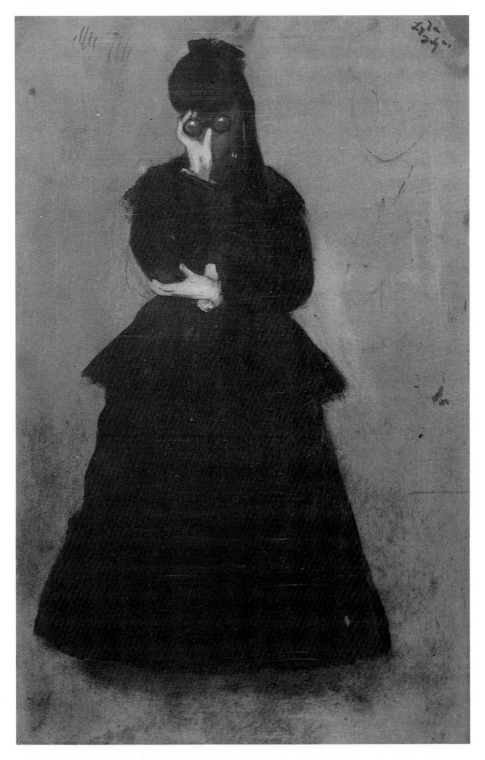

Left Plate 2 Edgar Degas, *The Interior, c.* 1868–9, oil on canvas, 81 × 116 cm, Museum of Art, Philadelphia, L 348.

Above Plate 3 Edgar Degas, *Woman with Lorgnette* [Lyda], *c.* 1869–72, oil sketch on paper glued to canvas, 35 × 22 cm, private collection, Switzerland, L 269.

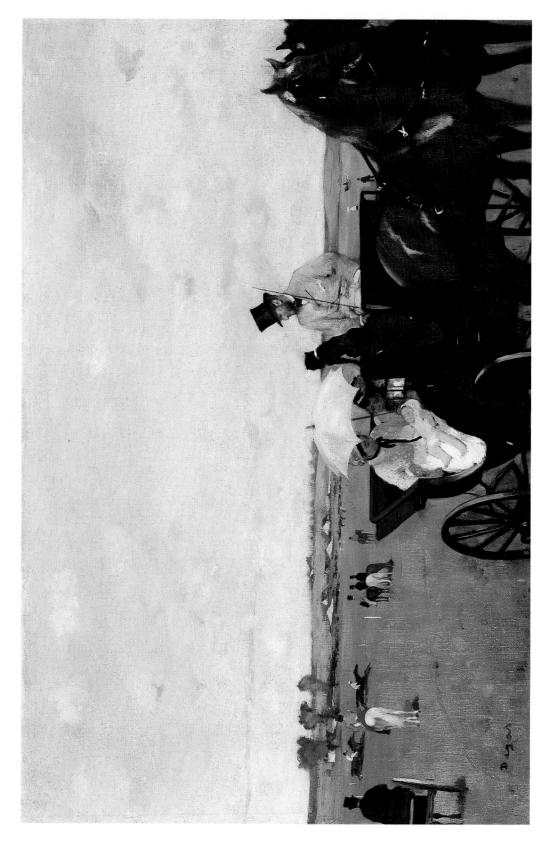

Plate 4 Edgar Degas, *At the Races in the Countryside*, 1869, oil on canvas, 36.6 × 55.9 cm, Museum of Fine Arts, Boston, L 281.

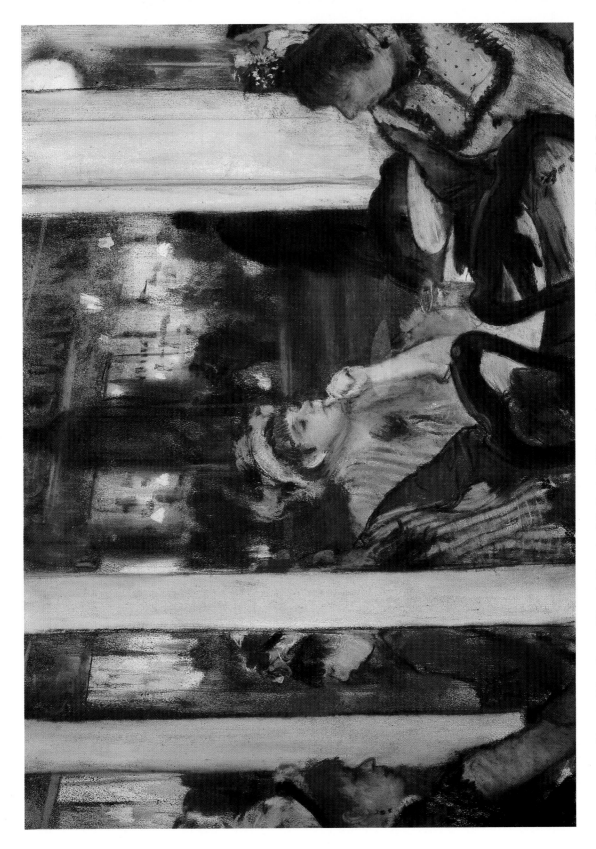

Plate 5 Edgar Degas, *Women in Front of a Café, Evening*, 1877, pastel over monotype, 41 × 60 cm, Musée d'Orsay, Paris, L 419.

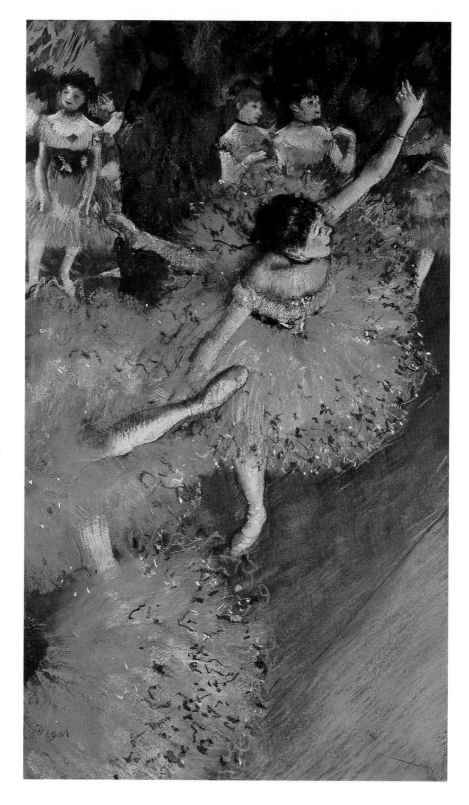

Plate 6 Edgar Degas, *The Green Dancer, c.* 1880, pastel and gouache, 66 × 36 cm,
Thyssen-Bornamisza Collection, Lugano, Switzerland, L 572.

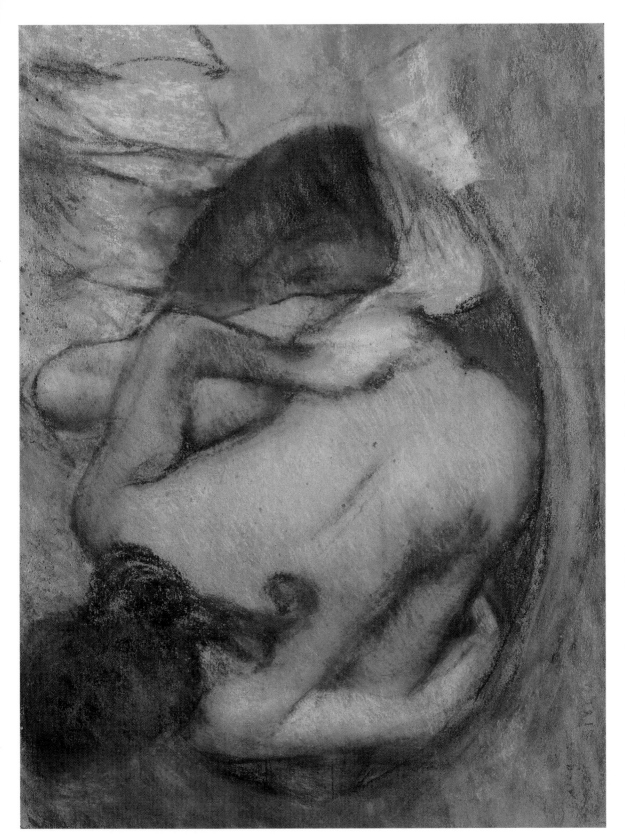

Plate 7 Edgar Degas, *The Tub*, 1884, pastel 45 × 65 cm, Burrell Collection, Glasgow Museums and Art Galleries, L 765.

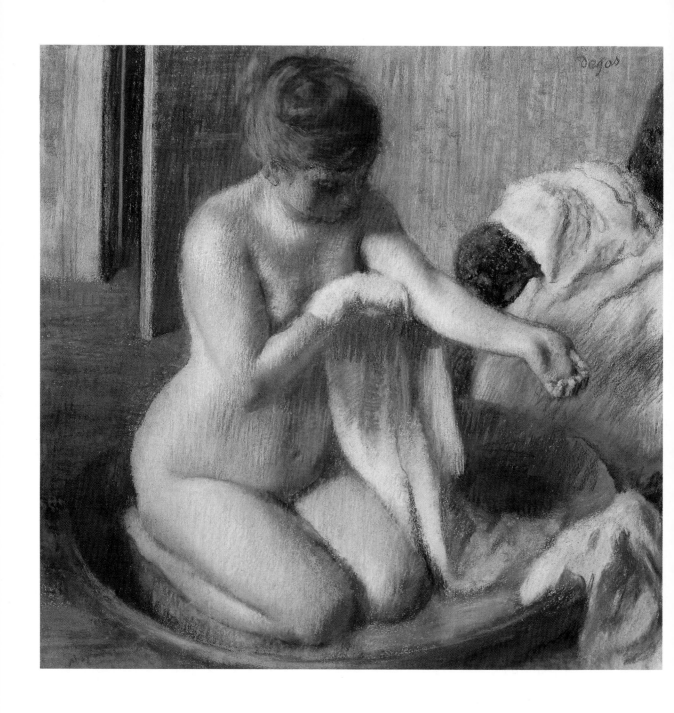

Plate 8 Edgar Degas, *Woman in the Tub*, *c.* 1886, pastel, 69.8 × 69.8 cm, Tate Gallery, London, L 738.

word . . . indicates the circle formed by the bookies who took and gave on horses. They began to take bets of 50 francs, then 20 francs, 10 francs . . .[4]

What this writer so discreetly objects to is more forcefully condemned in an earlier article from the same paper, dated 15 March, 1873:

Finally, we must regret the nourishment given to the fever of the game [horse-racing], we must deplore that the appeal of gain without work attracts to the tracks the multitudes whose position and profession render them absolute strangers to the horse . . .

The track of Longchamps in the Bois de Boulogne had only recently been completed in 1857, and was inaugurated on 26 April of that year. The four stands alongside the track which were on either side of the Emperor's pavilion were erected by the Jockey Club. The western stand which flanked the pavilion was reserved for the Minister of Agriculture, Commerce, and Public Works, the Prefect of the Seine, the Prefect of Police, the Municipal Council, and the members of the most exclusive clubs of Paris. The eastern stand was set aside for members of the Jockey Club, with a special compartment reserved for ladies. By 1862 it was possible to reach the park by carriage and horseback, by foot, by rail, tram, omnibus and steamboat.[5] However, the mixture of classes that such a variety of transportation might have afforded was initially restricted by the rule that public conveyances were not allowed to cross the park.[6] Despite this restriction, the track began to attract crowds of people, possibly because of the betting, but also, certainly, because of the size of the stakes, from 3,000 to 14,000 francs.[7] The *Salon des courses*, which required an application for admission, gave way to 2–, 5–, 10– and 20–franc mutuals, sums, incidentally, which guaranteed the accessibility of the thrill of betting to all but the poorest of Parisians.[8] By 1867 the mixing of classes at the track was already a subject for satire. For example, in Cairon's *Les Gens de Paris*[9] a bourgeois family at the track, attempting to move up in society, is ridiculed by the rich 'cocottes and gandins', previously the sole frequenters of the course.

Thus the period from 1857 (when the track first opened) to 1869 saw a dramatic change in both the number and variety of class of people who attended the races.[10] It is precisely this change that Degas does not record in his racetrack scenes. And it is the sense of the track as a stomping ground for prostitutes which Degas appears to avoid as well. Not all the women who attended the races were prostitutes. As I noted earlier, part of the eastern stand was reserved for ladies:

. . . The chairs are placed between the stands and the track: this narrow strip is like an immense salon. . . . The fanatics are in the stands. . . . The women condemn themselves to this torture. They are conscious of being looked at, they know and feel themselves being admired. This thought sustains them.[11]

Both professional and amateur alike were apparently appraised in a similar fashion, as this poem which appeared in *L'Illustration* on 16 April, 1870 indicates:

> . . .
> What nymphs are seen here,
> Lovers serve as pages
> They often surround their carriages,
> And we know we'll see, in the setting sun,
> The course of Cythera at Longchamps.
>
> . . .
> For one would search in vain
> For four Lucretias at Longchamps.
>
> Who would be the greater coquette,
> The Lady or the grisette,
> The wife of a simple clerk
> There finds that she has friends . . .
> That is what we see at Longchamps.

I don't wish to imply that every woman who attended the races went in hope of a sexual encounter. Saint Albin, in his 1890 treatise on the track, gives us another type of La Parisienne – the sportswoman:

> But here is the true sportswoman; *lorgnette* slung across her back, programme and pencil in hand, she goes, comes, questions, fusses, collecting on the wing all the gossip. . . . The race begins; this professor of sport does not want to miss a step of her favourite. She clambers up on a chair like a warbler on a branch; her lorgnette trained on the moving and multi-coloured group . . .[12]

With this information in mind we might be inclined to identify Degas' 'Lyda' with the sportswoman vividly described by Saint Albin. Both hold *lorgnette* and neither are seated in the stands. However, in Degas' *At the Racetrack: The Jockeys*, the riders are behind the woman, and are thus not the subject of her curiosity. But there are other reasons why one would use a *lorgnette* at the track. Perhaps Degas' woman with a *lorgnette* is inspecting the spectators. Our own experience of the image, the recognition that this flat painted image is looking at you, would thus overlap with a starting point for a narrative about the racetrack: a woman with a *lorgnette* looking at the spectators.

I use the term *lorgnette* rather than *jumelles* or binoculars for several reasons. The majority of sources that I referred to used *lorgnette* in the context of both the track and the theatre, not too surprising since the word *jumelles* was not used to mean an optical instrument until 1825, being then defined as a double *lorgnette*.[13] By utilising

the word *lorgnette*, it is also possible to retain the term's significant connection to the verb *lorgner* – to look at with the aid of an instrument, [14] or, more importantly, to ogle. In a dictionary of slang published in Paris in 1808 the phrase *lorgner une femme* appears. [15] Looking in this instance becomes something that is done to women, something that has sexual overtones. It seems fitting that the verb *voir*, to see, came to mean sexual intercourse by 1864. [16]

Yet even without this equation of the look with sexuality, the track was sexualised. The words that refer to activities at the track had double meanings. *Course*, the track and race, meant sexual intercourse, while *monter*, to mount, meant masturbation or intercourse. [17] Courtines, the racetrack, was synonymous with courting, through Anglomania. [18] The very language that Degas or any other Parisian would have used to describe common activities on the track, or to describe areas that comprised the track, was laced with sexual connotations. Thus when Zola depicts the confusion on the part of the spectators between Nana the woman and Nana the horse, he is simply extending and playing with contemporary trains of thought.

The track, then, as a site for sexual pleasure was explored by means of slang, caricatures and various forms of journalistic reportage, and through novels like Zola's *Nana* (1880) and Flaubert's *Sentimental Education* (1870). However, although Degas' work has often been placed in the realistic camp, and discussed in relation to the work of such writers as Zola and Flaubert, his images of the track in the decade under discussion avoid the sexual issues raised. Or do they?

In *At the Racetrack: The Jockeys* (fig. 21) we are shown a woman in an unspecified area of the track. There is no stand behind her nor railing before her to indicate exactly where she stands. If we look at another painting by Degas entitled *At the Racecourse* (1878, Paris, Musée d'Orsay, L 461), we can see how Degas could, in a very simple manner, depict a woman whose position on the track was evident. The type of chair on which this woman sits was placed before the stands or in the paddock, two areas which were forbidden to prostitutes. [19] Closer to the earlier work are two paintings dated to 1882–5. In contrast with the 1878 painting neither of these works provides us with any explicit information that would help us to understand these women's positions in society. Without any architectural structures in the background, it is possible to conclude that the women stand somewhere in the area before the stands and across the track. This area, the public enclosure, was the 'favourite resort of sporting characters', [20] and accommodated carriages and people on foot. This seems to be the most likely area for these women, and for the woman with a *lorgnette*. Positioned across the track she would have a clear view of the stands. But if she were in the public enclosure what sort of woman would she be? Not a lady of Degas' class; otherwise she would be seated in or near the stands. Zola's novel *Nana* is an excellent example of how strictly the lines were drawn between respectable women and prostitutes. Although Nana momentarily transgresses those lines, her seat is with the other prostitutes – in the public enclosure. [21] However, I remain uneasy about too readily confining 'Lyda' to the public enclosure.

For one thing, the jockeys and their horses are behind her. Since she is not in the paddock, which was surrounded by trees and the stands, she might well be at the starting-point of the track, which was not too heavily wooded on either side of the course.

In all probability, cogent arguments could be made supporting both her respectability and her dissolution. And perhaps this is what we should attend to. The ultimate ambiguity of her position on the track. The potential reading of this image as the sister of a beloved friend, or as a prostitute. Perhaps the detachability of the image from its surroundings indicates that we should consider it as a *shifter*, as defining the position of the viewer even while it reverses that position, deriving meaning from its context, although not context-bound. The four detailed oil sketches indicate that for Degas this image had its own significance, resonance apart from its context.

Yet can we divorce this image from the context of the track? And can we argue not only for its independence, but also for other contexts, other usages? It might be objected that where else save at the track would a woman, dressed in a relatively simple *toilette*, use a *lorgnette*. One answer would be at the theatre. Apparently, in the early 1860s, the period in which Degas began to paint track scenes, full dress was not worn at 'any place of amusement in Paris, except at the Grand Opera and the Italiens'. [22]

Significantly, Parisians did not attend the theatre merely for the show, but to see and be seen by others. A short story by Halévy is quite eloquent on this point. A young woman records in her diary:

> . . . I was more intent on the effect that I produced, for I felt myself the focus of the opera glasses of the group of young men who surrounded the Prince. [23]

Again, another scene from *Nana* indicates that opera glasses were used to see not just the stage, but the audience as well:

> Other women sat languidly fanning themselves, while young gentlemen, standing up in the stalls, their waistcoats open, gardenias in their buttonholes, pointed their opera glasses with gloved fingertips. [24]

Despite several images of both men and women with opera glasses by Renoir, Gonzalez, Cassatt and Degas, it seems that it was a convention that men looked and that women were looked at. [25] The theatre, like the track, was a place where it was permissible to look. It became a setting saturated with sexual meanings. [26] From the plays, comedies and dances, characterised by a visiting American as 'brilliant displays of immodesty', [27] to the interaction between actors and audience, the underlying theme is sex. The following is an entry from the *Journal* of the Goncourt brothers, dated 1 March, 1862:

Went to the opening night of *Rothomago* at the Cirque. . . . In the boxes there was quite a pretty array of prostitutes. It is wonderful what a centre of debauchery the theatre is. From the stage to the auditorium, from the wings to the stage, from the auditorium to the stage, and from one side of the auditorium to the other, invisible threads criss-cross between dancers' legs, actresses' smiles and spectators' opera-glasses, presenting an overall picture of Pleasure, Orgy, and Intrigue. It would be impossible to gather together in a smaller space a greater number of sexual stimulants, of invitations to copulation . . .[28]

Perhaps these 'invisible threads' are not only threads of desire but also desiring looks.[29] Degas painted one such look in his *Ballet of Robert le Diable*, dated 1872 (New York, Metropolitan Museum, L 294). His friend Hecht, seated in the orchestra section of the theatre,[30] looks away from the stage and up towards the side of the theatre. He apparently gazes upward at the occupant of a *loge*, situated at the front, left-hand side of the theatre, a *loge* like the ones drawn by Degas in the early 1880s. In the *Ballet of Robert le Diable* we look at a man looking at someone or something inaccessible to us.[31] In Degas' *Ballet from the Opera Box* (1878, Paris, Collection Wagram, L 476) we look past a woman at the dancers on stage. Our glance affords us the information of our own look, which takes her in, as well as the knowledge of what she looks at. In both works our role as spectator is clearly defined. However, in *At the Theatre*, dated to around 1880 (France, Private Collection, L 577), the line between spectator and image breaks down. The hands in front of us might be our own, the ballet before us might be real. What confronts us is a commentary on painting as seeing, on the artist as spectator, and on the role of the spectator in relation to a work of art. Is it possible that the *Woman with a Lorgnette* is also such a commentary?

It is no secret that Degas was concerned about his eyesight. After 1871 his letters are full of references to his eyes and his problems with them. Having explored briefly some of the ties between looking and sexuality, can we afford to see Degas' complaints as separate from their societal context? After all, questions have already been raised concerning Degas' sexuality and his possibly unwitting avoidance of overtly sexualising and objectifying imagery of women.[32] The link between sexuality and looking would indicate that Degas' complaints about his inability to see may have been complaints about his inability to be a sexual entity in a socially acceptable fashion. What this inability implies might be better understood if looking is viewed as not simply a neutral category tinged with sexual innuendo, but as a means of gathering information about, and thus power over, the world and its components.

In his book *Discipline and Punish*, Foucault discusses the 'panopticon' of Jeremy Bentham, the model for a perfect disciplinary apparatus. This architectural form, with a hidden central observer, would allow a single gaze to see everything around it. Foucault sees the panopticon as the diagram of a mechanism of power reduced to an ideal form. Power because surveillance is used as a method of control. According

to Foucault, surveillance in the mid-nineteenth century breaks down into a network of individuals, whose law is the norm, the average, the correct. [33] This development parallels and informs his understanding of the history of sexuality; [34] if looking is an act of control so is the development of sexuality as an area of study. Foucault argues that the concept of sexuality, as a field for scientific investigation, became a form of societal control through the positioning of norms. I would add that looking, in the mid-nineteenth century, became a part of the discourse on sexuality, a commentary that aided in defining public values. Looking remained an act of control. That this was recognised on some level might be contended from the caricatures of photographers in this period that drew analogies with executioners. [35] The thirst for knowledge was the thirst for power, and could be partially channelled through the act of looking.

Looking, after all, is a physical sense that is not commutative in the way that touching is. The physical act of looking could thus be utilised to assist in the solidification of roles, since, as a metaphor for power, looking disallows the possibility of sharing. Looking could divide the world into passive and active, weak and strong. Looking could therefore serve as a metaphor for male sexuality, as in their non-commutability sexual pleasure and looking were male domains.

Looking appears to have been sanctioned as a public act, occurring in public places. Whether there were any restrictions on looking as a private act is unclear, though towards the end of the century at least one woman's trousseau included nightdresses with a lace-trimmed slit along the front of the gown, minimising any chance of exposure during sexual intercourse. [36] Perhaps the lines between public and private looking were contiguous with those between public and private women, between prostitutes and 'respectable' women.

In any event, the separation between public and private domains was an important aspect of this period. The norm of public opinion became an element in the struggle for power, whether individual or governmental. [37] Certainly the creation of public places of amusement should be seen in the context of the recognition of the dispersal of power to individuals in society. This is not a simple case of bread and circuses. If the connection between looking and power is a valid one, these areas of public entertainment, of release and pleasure, were also areas in which class and sexual relations were acted out, rehearsed and performed, but not solely on stage.

We could easily see Degas' woman with a *lorgnette* as an icon of this period, as a means of expressing in condensed form the common interest in looking. But this would be an avoidance of the problem of Degas' own difficulties with looking. The substitution of looking for 'normal sexuality' was by the end of the nineteenth century categorised as a perversion. Perhaps Degas felt like a voyeur. Or perhaps he was simply uncomfortable with his role as an observer and recorder of images. Perhaps he saw his role as similar to that of the 'detective camera', which used photographic equipment for surveillance. If Degas' interest in motion and time is seen as evidence for a desire to know, a desire for power, what is the ultimate difference

between the painter and the detective who photographs, who searches out images, records them and judges them against a norm?

Valéry says that Degas owned a *lorgnette* that he used at the track, and that the images that he saw through the *lorgnette* looked small, 'like a *Meissonier*'.[38] Did this experience of looking exemplify for Degas his relationship as an artist to society? An unanswerable question. I would hesitate to ascribe any specifically personal significance to this image, since my concern has not been to look back through this image to Degas. I have attempted to situate this image in a broader context of images and behaviours, and to point out some of the motivations for the practices that I have examined. And yet although I refuse to draw a straight line of causality between this series of images and the social and personal history surrounding it, I hope that I have sketched out a wavering trajectory of interconnection that in the future may be more firmly tied to artistic production.

I would simply like to close with this point. By placing a woman in such a confrontative pose, Degas reverses the standard depiction of women as accessible objects, rather than subjects, as acted upon, rather than active. Degas places her in a role defined by his society as masculine, while at the same time he questions the viewer's role in relation to the image. Who or what is being watched?

Acknowledgement

I would like to take this opportunity to thank Griselda Pollock for selecting this article for publication, and Eunice Lipton for bringing it to her attention. The work was written a decade ago for a graduate seminar on Edgar Degas. I have not edited it for publication because to my mind it exemplifies a past place and time.

Notes

1. All dates are from P.-A. Lemoisne, *Degas et Son Oeuvre*, four volumes, Paris, P. Brame et C. M. de Hauke et Arts et Metiérs Graphiques, 1946–1949.
2. William Wells, 'Who was Degas's Lyda?', *Apollo*, 1972, no. 95, pp. 129–34.
3. The percentage of equestrian sport paintings up to 1873 never rose above 0.9%, reaching that level only in 1864, 1867 and 1869. These figures are based on titles of paintings as listed in the official Salon catalogues of 1861 to 1873. They are intended as rough indices of the status of this particular category of painting.
4. All translations from the French are mine unless otherwise indicated.
5. See W. Galignani's *Galignani's Guide to Paris*, London and Paris, William Tinsley, 1862.
6. Chroniqueuse [Olive Logan], *Photographs of Paris Life*, London, 1861, pp. 287–88.
7. Galignani, op. cit.
8. Some of the lowest paid workers, such as seamstresses and lacemakers, earned only two or three francs a day. However a teacher could earn 14 francs a day, and a department store employee could earn 70. Marcel Frois, *Les Blanchissages et les Blanchisseries*, Paris, 1896, p. 102, and Theodore Zeldin, *France 1848–1945*,

vol. I: *Ambition, Love and Politics*, Oxford, Oxford University press, 1973; cited in Eunice Lipton, 'The laundress in late nineteenth century French culture: imagery, ideology and Edgar Degas', *Art History*, September 1980, p. 301.

9. Claude Antoine Jules Cairon, *Les Gens de Paris*, Paris, Michel Levy, 1867, pp. 238 ff.

10. 'They (the veterans of the turf) pretend that the track has become vulgar. If the track had not become vulgar, the receipts would diminish fatally, and it is the receipts which permit the diverse societies of the track to maintain a superb budget . . .' A. de Saint Albin, *Les Sports à Paris*, Paris, Librairie Moderne, 1889, p. 29.

11. A. de Saint Albin, *Les Courses de Chevaux en France*, Paris, Bibliotèque du Sport, 1890, p. 320.

12. ibid, p. 381–82.

13. Paul Robert, *Dictionnaire alphabétique et analogique de la lange française*, Paris, Société du Nouveau Littré, 1973, p. 148.

14. ibid, p. 311.

15. D'Hautel, *Dictionnaire du Bas-Langage*, Slatkine Reprints, 1972; [reprint of 1808 edition], p. 87.

16. Alfred Delvau, *Dictionnaire erotique moderne*, Slatkine Reprints, 1968; [reprint of 1891 edition], p. 373.

17. ibid, p. 120, 264–65.

18. Jean Galtier-Boissière and Pierre Devaux, *Dictionnaire historique, etymologique et anecdotique d'argot*, vol. XXXVII, Paris, La Crapouillet, 1948.

19. Emile Zola, *Nana* (1880), translated with an introduction by George Holden, New York, Penguin Books, 1972, pp. 363–69.

20. Galignani, op. cit.

21. Zola, op. cit.

22. Chroniqueuse, op. cit., p. 161.

23. Ludovic Halévy, *Autumn Manoeuvres*, M. K. Ford (trans.), New York, Books for Libraries press, 1970, p. 199.

24. Zola, op. cit., p. 27.

25. See, for example, 'Mariette', in Halévy, op. cit., p. 117, and Zola, op. cit., p. 33.

26. The comments of Octave Uzanne in *The Modern Parisienne*, New York, G. P. Putnam & Sons, 1912 [English translation of 1894 French edition] are quite illuminating in this respect. On the actress: 'As she has no private means and must appear beautifully dressed on stage, although on a small salary, she has . . . to remember that she is a woman, and must supply the defects of her purse by making use of her sex.' (p. 146). On middle-class prostitutes: 'At the theatre, where they arrive late in order to be as conspicuous as possible, they attract the eye by eccentricities of dress. They go out after every act, put off and on wraps of gaudy colours, talk loudly, laugh noisily, and play conspicuously with opera-glasses and fans' (p. 190).

27. J. D. McCabe, Jr., *Paris by Sunlight and Gaslight*, Philadelphia, 1868, p. 674.

28. E. and J. de Goncourt, *Pages from the Goncourt Journals*, R. Baldrick (trans.), London, Oxford University Press, 1978, pp. 68–9.

29. Especially as the translation 'spectator's opera-glasses' is an approximation of the phrase 'regards des lorgneuses' or glances of those who look with curiosity or desire.

30. An area usually reserved for men in the larger theatres (Galignani, op. cit).

31. A construction very similar to Cassatt's *At the Opera*, or even to Renoir's *The Loge*.

32. This problem has been discussed by N. Broude in 'Degas's ''misogyny''', *Art Bulletin*, March 1977, and by E. Lipton in 'Degas' bathers' the case for realism', *Arts Magazine*, May 1980, and in 'The laundress in late-nineteenth century French culture: imagery, ideology and Edgar Degas', *Art History*, 1980, vol. 3, no. 3.

33. M. Foucault, *Discipline and Punishment*, A. Sheridan (trans.), New York, Vintage Books, 1979.

34. M. Foucault, *The History of Sexuality, Volume I: An Introduction*, R. Hurley (trans.), New York, Vintage Books, 1980. Interestingly, this book was originally published under the title *La Volonté de Savoir*, Paris, Editions Gallimard.

35. See the lithographs by Platier and Grevin in M. F. Braive, *The Photograph: A Social History*, New York, McGraw-Hill, 1966. In addition, see Daumier's series of lithographs on photographers, many of which are indicative of the fear and hostility surrounding the photographic process.

36. P. Waldberg, *Eros in la Belle Epoque*, New York, Grove Press, 1969, p. 39.

37. E. J. Hobsbawm in *The Age of Capital*, London, Abacus 1975, indicates the events of 1848 established the public in France as a force in society.

38. P. Valéry, *Degas, Manet, Morisot*, New York, Pantheon Books, p. 69.

The Gaze and The Look:
Women with Binoculars –
A Question of Difference
Griselda Pollock

I Seeing a Drawing

In the semi-religious gloom of the Grand Palais in Paris housing a major retrospective exhibition of Degas, I was startled by a tiny drawing of a woman looking directly at the spectator through a pair of field glasses, *Woman with a Lorgnette* by Edgar Degas (fig. 20). [1] Feminist theory has argued that there is a hierarchy of gender in Western culture's looking – men look; women are observed. Is a woman looking, therefore, *ipso facto* a transgression? Why would a man like Degas make an image so apparently threatening? Small, delicately brushed on pink tinted paper, a possibly pregnant woman stares at the viewer. Enchanting rather than perverse, the drawing seemed to unsettle the established terms of feminist analysis.

Into my mind came Dorothy Parker's famous dictum, 'Men seldom make passes at girls who wear glasses', used as an epigraph by Mary Ann Doane in her theorisation of female spectatorship. [2] As symbol of a woman's claim to the look, the woman with glasses is part of a general logic discerned by Doane in Hollywood cinema. Doane argues that 'in usurping the gaze she poses a threat to an entire system of representation'. [3] Women who insist upon looking are always excessive. Linda Williams has analysed women's look in horror movies: [4] 'The woman's active looking is ultimately punished. And what she sees, the monster, is only a mirror of herself – both woman and monster are freakish in their difference, defined either by 'too much' or 'too little'. [5] The collapse of the feminine into the monstrous is echoed in Degas' disturbing drawing of a woman's face partly obliterated by the mechanical aggression of the binoculars protruding like the eyes of a monstrous bug.

It is not improbable to note correspondences between the sexual structures of looking in cinema and early modernist painting. A sexual imbalance determined the latter at both social and psychic levels. Nineteenth-century consumer capitalism generated new urban forms and spaces in which socially sanctioned voyeurism became the privilege of bourgeois men as '*flâneurs*'. Moreover, the bourgeoisie mapped its rigidly divided ideology of gender on to the social spaces of the spectacular modern

106

city. Thus masculinity enjoyed the public domain as the field of power, expressed by visual mastery, while femininity was associated with the interior, where Woman was guarded from intrusive scrutiny and made the object of an intimate, possessive regard.

Feminist theory has identified and tried to depose the binary opposition structuring bourgeois representation around gender. Often, however, feminist analysis remains trapped within it. Femininity is conceived and re-evaluated relatively, that is to say, as difference from masculinity, thus maintaining the opposition. From a post-structuralist perspective, masculinity and femininity are terms in a system, however, not the reflection of a given difference. They are products of *processes of differentiation* which are articulated through language but which are formed in a complex but irreducible interplay between social and psychic formations. We need to re-examine, therefore, how difference is produced and what that process means. This paper is such an attempt to read the trope of the gaze as a question of difference, that is to say questioning its conditions and its effects in both producing and displacing the divisions we call 'sexual difference'.

In the Grand Palais I was looking at *Woman with a Lorgnette*, being drawn to it enough to go on thinking about it, sufficient to propose it as the topic of a paper. The question, however, should not be 'What was I looking at?' but 'What was I looking for?' What

Fig. 20 Edgar Degas, *Woman with a Lorgnette, c.* 1866, oil sketch on pink paper, 28 × 22.7 cm, British Museum, London, L 179.

knowledge and understanding, what pleasure does my look as a feminist scholar *now* desire? How is it that a drawing by this artist – of all artists – should pleasure me and sustain such repeated, concentrated looking back at her looking at me? What is it that I suspect lies beyond the visible? How does it speak across the gender of its maker and the form of its figure to my desire?

II Women: A Magnificent Obsession?

The drawing and its related oil sketches and painting regularly attract art historians. [6] The catalogue to the exhibition 'Degas: Images of Women' in Liverpool was no exception. Richard Kendall used the British Museum drawing as one of three illustrations to the opening pages of the introductory text. A strange choice, for the theme of the essay and the exhibition both emphasise Degas' look at women. One of the major tropes of Degas literature is the preoccupation with vision and eyesight. Indeed the title of Richard Kendall's essay in the catalogue is, and note the possessive, 'Degas' discriminating gaze'. Degas signifies the active gaze, curious, obsessive but discriminating, and of course, self-possessing. But the reader is confronted with a sketch of a woman looking, intently assisting her scrutiny of some object in her direct line of vision by means of binoculars. As we stand before the little drawing we are placed as the objects of that look, drawn near by magnification to a drawing which keeps its distance by being so diminutive (it is 28×22 cm). Something so delicate could never threaten. It might even be a source of comfort and pleasure.

Richard Kendall also writes of a woman with an active gaze: 'The only individual to approach Degas's obsessional, life-long relationship with the female image was, paradoxically, a woman: the female painter much depicted by Degas himself, Mary Cassatt.' [7]

This sentence is quite shocking. It admits that Degas was an obsessional, though the admission is quickly domesticated. But how much more interesting, outlandish, yet how just, it is to suggest that we think of Mary Cassatt's work also in terms of a life-long obsession.

That women artists so often represent women typically invites scorn. It merely confirms that seamless identity between woman as producer (artist) and woman as subject (image) under the rubric of an innate femininity which encircles both as mere symptoms of this inescapable otherness and insufficiency. What Kendall has written explodes the feminine stereotype. [8] Instead Mary Cassatt is posed as the subject of desire, looking at women not because that is all she was socially constrained to do, but because she was obsessed, desiring, curious, pleasured and made anxious by doing so. This is an important revelation for which I am profoundly grateful.* Cassatt's desire is the central theme of this paper and the works by Degas

* In the end, the text brings Cassatt safely back to her place as yet another inscription of Degas himself by reference to his depictions of her. Cassatt is one of these female images he obsessively pursued.

will function as necessary objects of investigation on a journey to enunciate the feminine desire that traverses the history of Cassatt's work and my own as a feminist.

III Looking at Degas Looking: Varied Opinions

The drawing I saw at the Grand Palais is one of a group of oil paintings/drawings/sketches dating from the mid-1860s–1870s, which have been collectively linked to a project for a painting *At the Racetrack*, begun in the late 1860s which was never finished (fig. 21). This canvas was repainted many times during Degas' life-time and was found in the artist's studio on his death in 1917 (fig. 22). It entered art history when it appeared in a sale in 1960 and was cleaned at the National Gallery. [9] This restoration removed sixteen layers of paint and recovered the original conception of the picture, dating from the late 1860s (fig. 21). In the foreground are two figures, a dandified race-goer, and a woman looking straight ahead through field glasses. This figure is the topic of several works, from a faint pencil sketch (fig. 23) to several worked up studies in oil which are dated well into the 1870s (figs. 20, 24, 25, plate 3).

In her book *Looking into Degas*, Eunice Lipton has written about the painting *At the Racetrack* (figs. 21, 22), focusing on the woman with binoculars:

> Standing frontally, iconically and staring out through binoculars, this woman is an imposing personage whose monumental form and act of bold looking

Fig. 21 Edgar Degas, *At the Racetrack*, 1868–1919, oil on panel, 46 × 36.8 cm, Weill Bros-Cotton Inc, Montgomery, Alabama, L 184.

Fig. 22 Edgar Degas, *At the Racetrack*, 1968–1919, pre-1960 restoration.

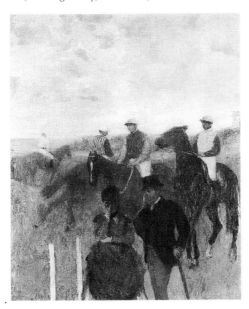 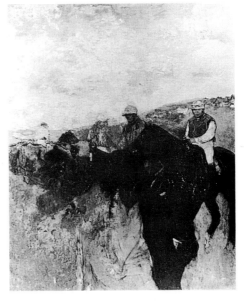

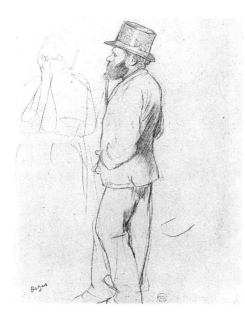

Fig. 23 *Left* Edgar Degas, *Manet at the Races*, pencil on light brown paper, 38 × 24.4 cm, Metropolitan Museum of Art, New York (Rogers Fund).

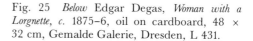

Fig. 24 *Below left* Edgar Degas, *Woman with a Lorgnette*, *c*. 1865, oil sketch and pencil, 31.4 × 18.5 cm, Burrell collection, Glasgow Museums and Art Galleries, L 268.

Fig. 25 *Below* Edgar Degas, *Woman with a Lorgnette*, *c*. 1875–6, oil on cardboard, 48 × 32 cm, Gemalde Galerie, Dresden, L 431.

expressed tremendous power, power which at that time was by definition male. [10]

Eunice Lipton suggests that this is a transgressive image. The bourgeois codes of femininity identified respectibility with domesticity and chaperoned public appearances in opposition to women associated with the streets, pleasure and money signified as sexuality and figured as prostitution.

It is in this field of anxiety about sexuality – represented in the relations of looking and being seen in public space – that Lipton locates the threat which the image evokes. Of a related work, Lipton writes:

> Degas's *Woman with Binoculars* [fig. 25] could be taken as that fear embodied and exaggerated. One can speculate that he removed her from *At the Racetrack*, both because she was potentially horrifying to bourgeois sensibility. None the less that she lingered in his mind is suggested by several small sketches depicting her alone. [11]

Undoubtedly Lipton is correct about the social conditions in which a woman's steadfast gaze in public was a threat. But the passage again returns the woman as social image, to him – the artist's mind. [12] Paradoxically, that is where 'she' – the image – belongs, as a figment of fantasy.

Another interesting and radical study of these works is Deborah Bershad's paper 'Looking, power and sexuality: Degas' *Woman with a Lorgnette*' (reprinted in this volume pp. 95–105). [13] Bershad categorically refuses to make that return of woman to man. She states that she does not want to look back through this image to Degas. Instead she locates the paintings in a series of images and behaviours which would indicate some of the motivations for the practices of looking which she examines. She writes of establishing a 'wavering trajectory of interconnection'. [14] But her most valuable point and her defining difference from the majority of Degas literature comes in this statement:

> We could easily see Degas' woman with a *lorgnette* as an icon of this period, as a means of expressing in condensed form the common interest in looking. But this would be an avoidance of the problem of Degas' own difficulties with looking. [15]

Bershad connects these difficulties with sexuality. Psycho-analysis is on her horizon, but she does not go on to take on its insights which refer us beyond sexual practices in all their heterogeneous forms, to the very difficulties of the formation of sexuality at all. But Bershad offers important evidence about a general cultural trajectory connecting sexuality to surveillance of woman in public. She insists on the title, *Woman with a Lorgnette*, for a lorgnette derives from the verb *lorgner*, to look at with the aid of an instrument, that is, to ogle.

Bershad uses a Foucauldian model to implicate Degas' troubled looking and sexuality with the desire for social regulation. Foucault's work on sexuality and surveillance has been a powerful instrument in overcoming the preoccupations within art history with the creative subject, the artist. But Foucault's work on discipline and surveillance tends to replicate the truism of a sexually divided society and its familiar formula: men's surveillance disciplines women. The whole point of these drawings is precisely the interest they register in someone looking at the spectator, thus in the spectator's *being the object of a gaze.*

But the painting and drawings interrupt that gaze. The instrument for enhancing vision also conceals the eyes. In their biography, Robert Gordon and Andrew Forge admit the aggression of Degas' images, but they also stress its paradox:

> By her direct stare, her symmetrical frontality, the severe pyramid of her dress, and the menacing concealment of her face, she becomes one of his most aggressive images. His preoccupation with looking and with all that looking could mean is for once stated in a way that is not oblique, but unnervingly direct. The power of looking and the power of concealment are linked in a single image. [16]

The conjunction of the power of looking and the power of concealment makes the image the site of constant movement, shifting positions, contradictory processes and conflicting impulses which, although tied back relentlessly to him, Degas, alerts us to the need to investigate what the process of investment and compulsion to repeat such a figure might be.

IV Looking into Cassatt Looking

But, after all, the 'woman with binoculars' about which I really want to write is not by Degas at all. Mary Cassatt's *Woman at the Opera*, dated variously to 1879 and 1880 (fig. 26), has been a constant companion in my journeys into feminist knowledge. Each writing finds something unexpected which makes possible another reading. Historically and theoretically, it can be analysed anew by being put into dialogue with the works by Degas.

Reversing the typical arrangements of woman as preferred object of an appraising, masculine look (Renoir, *La Loge*, 1874, Courtauld Institute Galleries, London, for instance), the painting takes as its theme the dialectics of looking, sexuality and gender in the spaces of the modern city. Women's vulnerability to intrusive scrutiny whilst out in public is exposed through the witty pun of the painting's spectator being mirrored by a figure in a distant loge with his binoculars trained on the woman in black. Because this woman looks away, and her eyes are not invitingly offered to the viewer but are masked by her lorgnette, she becomes not an object but the subject of the look. [17]

There is, of course, an active/passive division within the economy of the visual.

Fig. 26 Mary Cassatt, *Woman at the Opera*, 1879/80, oil on canvas, 80 × 64.8 cm, Museum of Fine Arts, Boston (The Hayden Collection).

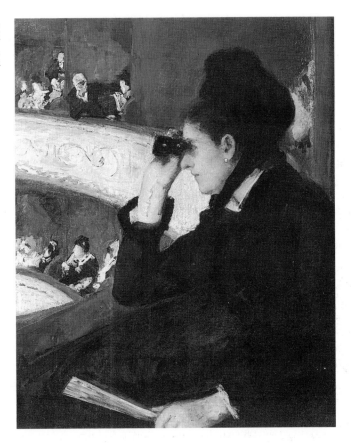

The problem is that we too easily map that division absolutely on to masculine and feminine positions which are then equated with social men and women. Thus Cassatt's painting is read as an inversion of the Renoir within a binary opposition of artists of different genders and social experience. The theorisation of sexuality and the gaze derived from psychoanalysis opens the prospect of a more dialectical understanding of the dynamic which generated this, as well as Degas' paintings. Masculinity or femininity are effects which share some part of the journey the human infant must travel to attain social subjectivity. On that common field, the production and negotiation of sexual difference, we can mark out a theoretical difference which does not reproduce women's lack and negative place within existing accounts of its formation. Psychoanalysis, critically re-read by feminist interest, provides some preliminary maps.

V Looking and the Subject's History: Some Theories

Freud argued that in the component drives of sexuality in the infant, that is, well before the human infant is in any sense inscribed within a sexual regime or gendered body image, pleasure in looking (scopophilia) is matched by pleasure in being the

113

object of a gaze (exhibitionism). [18] There is a further narcissistic investment in being the object of another's look. Indeed the still unformulated subject of these drives is volatile – moving easily between, and simultaneously enjoying, both active and passive postures.

Freud argued that there are many moments or structures in the formation of sexuality which only at a late stage polarise around gendered terms. Sexuality is not a given, innate, biological content or force, but a psychic structure, produced by the mapping of component drives on to the social systems of kinship at a psychic level. [19] The component drives of sexuality are without aim or object and are initially indifferent to perceptual reality. But they are progressively captured and ordered within a system of meanings culminating in the crisis known as the Oedipal Complex, which orders the subject according to a patriarchal logic signified, according to Lacan, as the Law/Name of the Father. This generates what is known as the Symbolic which designates masculinity and femininity as contradictory positions. But, in the systems of representation governed by this regime, both psychically and in culture in general, femininity is appropriated as an outside point – an otherness – which signifies on behalf of masculinity. In the Symbolic, Woman is designated as image, that is, the almost exclusive repository of formative exhibitionism, while masculinity appropriates the activity associated with scopophilia. [20]

The trope, 'woman-as-image' becomes the bearer of the fear of a 'lack in being' (Freud called this castration anxiety) which is projected out from the masculine psyche because it threatens the narcissistic integrity of the masculine subject as whole and masterful. In fact all masculinity is formed in lack; the male subject has to submit himself to the law and forego desire for his mother (and father) in order to become a tenant of the place of the father, that is, to take up a masculine position. The feminine subject also undergoes the force of the Law, and enters the symbolic. But this occurs on a different trajectory of symbolic lack *which is not signified by its projection on to the male body*, or an image of the male body as lacking, but occurs in a complex formation in relation to *the maternal body*. The normal psychoanalytical account only tells of the formation of masculinity, for which the image of woman is a psychic component of his castration anxieties. Feminist interrogations of such official sexism has led to our being able to represent the particularity of femininity so that it is no longer just the cipher of difference for masculinity, but a psychic formation of comparable complexity with its particular, different trajectories and signifiers of desire.

Psychoanalysis, therefore, suggests that there are several psychic pleasures and opposing dreads associated with looking. The subject who looks from the masculine position is fundamentally split between the contradictory oscillating pleasures of the pre-Oedipal moments, which are themselves not free from aggressions and anxieties, and the Oedipal scenarios in which there is evident danger in the look. Thus any looking will contain within it the traces of pre-Oedipal moments, other pleasures, moving away from the fixities of the masculine place, and its price, to archaic but still resonant fantasy positions where feminine and masculine subjects

share recollected pleasures, or rather retrospectively invented fantasies which are obsessed by the figure of the lost/repressed mother. There is a permanent oscillation between related but irreducible regimes – the Symbolic (a fixing into place according to a Law and a Paternal Authority) and what preceded it (the processes of psychic formation and their untidy traces dominated by a maternal figure). The latter remains active as the permanent, unconscious companion of the Symbolic because these processes are the pre-conditions of any Symbolic. [21] For psychoanalysis, the infant becomes a subject as it passes, historically, through several stages. This conception does not imply a narrative of development. For the adult subject is formed by an almost archaeological layering, where all the subject has passed through is complexly sited in the psychic representational system we name the unconscious. Thus the mobile pleasures of looking and being looked at which define one moment of human subjectivity are perpetually present to destabilise the symbolic fixing of such pleasures to an arrangement called man (look) and woman (object).

The symbolic can be defined as the ordering of sexual difference hinged upon its opposing terms 'man' and 'woman-as-image/lack'. We can then turn our gaze to other moments in the process of the making of those sexed and gendered subjects which precisely unhinge that division. This affords space to consider femininity as a particular, but not totally other, articulation of desire. Allowing difference to play across formations of desire and the gaze opens out the question of the pleasures serviced by apparently transgressive or perverse images of women looking, painted by both Cassatt and Degas.

VI The Subject in the Field of Vision: Other Theories

In analysing these pre-symbolic formations of the human subject, Lacan's mirror phase has been highly influential. For Lacan the subject is only formed in relation to the gaze of the Other. The metaphor he used involves a very young child being held up to a mirror. It sees an image, but it also sees someone looking at it. The image in the mirror looks at the child who is also watched by the adult who holds the child to the mirror. The child looks to this Other for confirmation of what it has seen, an image which it is told is his/hers. But the act also affirms that the child has *been* seen. In this relay of looks, in which it is predominantly an object, the child is forced to recognise its spatial separation, and thus a minimal form of difference, from the mother. The conditions for being a subject are partition from a unity with another. We become a subject only because we are confronted with and distant from an Other. What the image in the mirror or frame reveals is a figure isolated in space from the world of things and people with which it fancied it was in a continuum. The looks which pass between child, image, mother in the triangle around the mirror define a threatening cleavage, but there is also a pressure to resurface the gap, establishing looking both as an action laden with anxiety and as a means of potential comfort, a life-line of light across the cleavage. The one is perpetually shadowed by its Other, distance created and disavowed by the exchange of looks.

The problem with Lacan's argument, however, was that he appeared to assume some proto-subject already there to recognise the identity between the image and the body looking at it, the child itself. His subsequent Seminar XI, published as *The Four Fundamental Concepts of Psychoanalysis* (1977), returned to the problem in a way that did not rely on some act of recognition by the potential subject. Rather he suggested that the subject is constituted by a gaze that is exterior to it, in what Kaja Silverman has called the 'photo-session', the 'clicking of an imaginary camera which photographs the subject and thereby constitutes him or her'. [22]

This is Lacan's version:

> In the scopic field the gaze is outside. I am looked at, that is to say I am a picture.
>
> This is the function that is found at the heart of the institution of the subject in the visible. What determines me, at the most profound level, in the visible, is the gaze that is outside. It is through the gaze that I enter light and it is from the gaze that I receive its effects. Hence it comes about that the gaze is the instrument through which light is embodied and through which . . . I am photo-graphed. [23]

Silverman concludes that the subject's relation to visual representation involves both

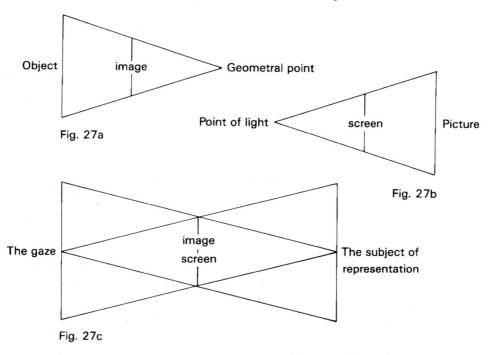

Fig. 27a

Fig. 27b

Fig. 27c

Fig. 27 From Jacques Lacan, *Four Fundamental Concepts of Psychoanalysis*, edited by Jacques-Alain Miller, translated by Alan Sheridan Smith, courtesy of the Estate of Jacques Lacan, The Hogarth Press and W.W. Norton Inc.

the subject who incorporates an image, and a subject appropriated as an image by and for the Other. The structure is thus triadic – subject, image (that is, what is present in the mirror), (m)other. This dialectic is elucidated by a series of diagrams in Lacan's text (fig. 27). The first (a) replicates the scheme of Renaissance geometrical perspective, which imagines viewing and the visual field as deriving from and returning to a punctiform point, the mastering eye/I. At this point the gaze and the I coincide. The I is mapped on to a purely perceptual grid. But Lacan wants to undercut the Renaissance myth of optics, geometry, perception and the subject. So he produces an opposite scheme which he illustrates with the famous story of the sardine can which wasn't looking at him (fig. 27b).[24] Here the subject of the first diagram is merely the seen object of another, indifferent gaze. This introduces a radical doubt, and a degree of suspicion, that if the other/world is not looking at the subject, there may be something else out there to see. The final resolution is the superimposition of both diagrams to produce the subject of representation at once occupying a place of imagined mastery *vis-à-vis* the visual field, and a point in the visual field of the other (fig. 27c). As Joan Copjec has argued:

> The second triangle diagrams the subject's mistaken belief that there is something behind the space set out by the first. It is this mistaken belief (this misrecognition) that causes the subject to *disbelieve* even those representations shaped according to scientific laws of optics.[25]

This split, *suspicious*, subject is the subject produced by the gaze. Mastery is then a project to tame this gaze of the other, to produce lures for it so that, in settling on the subject in the place of the eye/I, the gaze is tamed as the look, and thus supports the subject's illusion of control over the visual field as the field of its desire.

Between the two triangles is not the transparent window of Renaissance optics and art theory, and not even the mirror of Lacan's earlier formulations. It is an opaque screen, and it is, as Joan Copjec argues, the screen of semiotics. It is a surface already organised with meanings.[26] Picking up on Lacan's phrase photo-graph, she writes:

> *Graph.* Semiotics, not optics, is the science that clarifies for us the structure of the visual domain. Because it alone is capable of lending things sense, the signifier alone makes vision possible. There is and can be no brute vision, no vision totally devoid of sense. Painting, drawing, all forms of picture making then, are fundamentally graphic arts. And because signifiers are material, that is because they are opaque rather than translucent, because they refer to other signifiers rather than directly to a signified, the field of vision is neither clear nor easily traversable. It is instead ambiguous and treacherous, full of traps.[27]

The formulation 'images of . . .' perpetuates the Renaissance belief in the subject

as a stable point for vision, mastering the world by sight, his (sic) 'discriminating gaze' protected by and projected through a window on to a world translucently there. In Lacan's scheme this mastering subject of vision is an effect of a fantasy of control, signified by consciousness, which is, however, determined by and dependent on the other system, the unconscious. Consciousness (often signified in Cartesian logic by Sight) deceives. The conscious subject mis-recognises the world, and its place in it by virtue of being a subject constructed from outside, from the field of the other, through a gaze which is neither God nor the Mother, a singular, appropriable point, but which is diffuse and all surrounding. As Copjec argues, this makes the subject suspicious that there is always more than the subject can envisage. But the real irony is that this 'more' is nothing.

> For beyond everything that is displayed to the subject, the question is asked: what is being concealed from me? What in this graphic space does not show, does not stop writing itself? This point at which something appears to be invisible, the point at which something appears to be missing from representation, some meaning left unrevealed, is the point of the Lacanian gaze. It marks the absence of a signified; it is a point that cannot be occupied. The image, the visual field then takes on a terrifying alterity that prohibits the subject from seeing itself in the representation. 'That belongs to me' aspect [of the mirror phase] is suddenly drained from representation as the mirror assumes the function of a screen. [28]

Seeing enacts, therefore, a drama of loss and threat which the graphic arts can temper, which *framing* a visual field can momentarily master. But there is always the risk of an inversion of the triangles where the subject's illusory mastery dissipates, its centrality and fixity dissolve.

But even as Copjec re-reads Lacan, there is no suspicion of the issue of sexual difference pressing on the relation of the subject to the gaze as the lost object of desire. Ideas such as that of the suspicious subject – split but also doubting, the notion of the opaque, screen-like quality of representation – can be mobilised to theorise the differences which structure and are structured by paintings by Cassatt and Degas. They inhabit related yet distinct positions *vis-à-vis* the gaze as the locus of desire not just because one is a man and the other a woman. For these representations functioned within a historically specific configuration of subjectivities. What Lacanian psychoanalysis gnomically defines a 'nothing', an unattainable effect of our capture with the laws of human sociality under the Law of the Father, is being contested by women. That 'more' or 'beyond the screen' is not nothing, but the imagined locus of a social as well as psychic desire for more, for renegotiated social orders, for other managements of sexuality and subjectivity. Their imprecision as what we can now but suspect does not diminish their symbolic power in motivating a struggle against what is currently inscribed on those screens of representation. Resistance

politically is motivated by the mechanism of that suspicious subject Copjec brilliantly defines.

VII Modernity and Visual Pleasure

We are usually told, and the Tate exhibition catalogue was itself symptomatic of this, that Impressionist artists in their various ways made the act of vision central to their project. But the opposite is the case: as Bershad insisted, they made seeing complex, treacherous and opaque. [29]

Art historians teaching the early modern period will often quote the poet Baudelaire's important essay, 'The painter of modern life' (1863) which evoked an ideal of the modern artist voraciously consuming with *his* eyes the novel signs of the city, its goods on show in department stores, its women on display in the streets. [30] Artist as *flaneur* and man in the crowd enjoyed the seemingly insignificant 'pageant of fashionable life'. But do we recognise the desire, powerfully inscribed in Baudelaire's texts, to be seen – to be engulfed in the spectacle of the world, to be embraced by its all-seeing, dense space, both dangerous and protective, full of shocks but where the *flaneur* felt most 'at home'? Is there not some echo there of what Jacques Lacan identified as the Gaze as the object of desire? Thus we can invert a normative theory of men mastering the gaze by suggesting heretically that they also desire to be embraced by it.

Impressionists painted pictures of things Baudelaire itemised as icons of modern life. But these sights appeared to their contemporaries as devoid of meaning, aesthetic value and cultural importance. And they were in a way. Popular resorts of leisure and entertainment (race courses, ballet rehearsals, drives in the Bois, visits to café-concerts), details of the daily domestic life of the bourgeoisie, having lunch, washing children, playing cards were familiar if selective aspects of contemporary life, but what made them modern as art was the manner of the representation. As T. J. Clark has argued, the subjects in themselves were not *modern*, as revisionist art historians try to establish by their exhaustive archival reconstructions of these social habits and bourgeois customs. [31] The places and spaces of leisure were the conditions for a new kind of urban subjectivity. Representations were modern only when artists turned these sites into a sight, a spectacle, throwing them on to the dense opaque screen of a knowingly flat, painted surface. The most formalist aspect of modern painting, flatness, reads as the form of a psychic as well as social flight from meaning, an evasion or a stalemate. [32]

The 'New Painting' of Cassatt's and Degas' circle shared a muted, evasive and ambivalent quality with the perplexing and contradictory text Baudelaire published in 1863: 'The painter of modern life'. The Impressionists were seen by their contemporaries as wilfully refusing to endorse the accepted idioms for making paintings, completing an intellectually conceived and formally resolved picture. Instead they offered the public the allusive traces of mere impressions – which were systematically deceptive. What better way to signify your modernity than by offering

colourful, eye-catching paintings which provide a lure for the spectator's gaze only to rub the spectator's nose, at close range, in a mess of pigment, a lot of pastel barely configuring, which, when discerned offered ambivalent and often treacherous imageries? Early modernism was not so much about looking, as about new ways of mapping the field of the visual and the subject in visual representation which bear the charge of both the fascinations and anxieties of the field of vision. At its heart lay the difficulties of the subject of representation, the subject of the gaze, but that is always as question of difference, a matter of sexuality in both the psychic and social fields of vision.

VIII Historical Speculation: Two Hypotheses

I want to imagine how the Degas' pictures came into existence and then I want to suggest that Mary Cassatt's painting *Woman at the Opera* (fig. 26) is a considered response to Degas' studies of the *Woman with a lorgnette*. Dated to 1879–80 it is produced shortly after meeting Degas and joining the independent exhibiting group. As such we can read it as a commentary on the Degas, bringing out its suppressed subject – the figure being viewed through the binoculars, the figure who was caught looking.

The First Hypothesis

Imagine a man at the race course, scanning the sparse crowd with binoculars. He is ogling. He sees two figures. One he recognises. It is a professional rival, Edouard Manet. Later this figure is recorded in a drawing (fig. 23). A tentative outline marks a female companion and defines her as a woman who is using a lorgnette – the hands and the blank spheres of the binoculars are rapidly notated. These occluded eyes, the machine for looking and the hands will feature in many subsequent essays about this scene. But what do these element signify? The insistence but also the negation of vision? But whose vision? The drawing results from the vividness of a moment of being caught in the act of looking. Back at the studio, the man tries to recreate the situation and examine it, re-experience it, prolong it. Distance is abolished and the man controls the fragility of the moment. He can extend it as long as he wants. He can re-enact it whenever he fancies. He can also walk away.

Imagine the British Museum drawing being made back in the studio (fig. 20), the brush rapidly defining the shapes of the pregnant woman's dress but not delaying to fill in its uninteresting surfaces. What lay underneath the dress was not to be imagined if it is his pregnant sister Marguerite standing there. [33] Next imagine the plan to make a painting perpetuating the experience but justifying it within the narrative of a very modern Baudelairean scene, *At the Racetrack* (fig. 21). The painting never worked. All those years of worry from 1868 to 1917, and sixteen layers of paint, bear witness to some unresolved problem for the man. Eventually he abolished the woman with binoculars (fig. 22). She is painted out and attention returns to the man, Manet in the original sketch we are told; his brother posed for a later version.

They are either family or professional rivals. The original two-figure composition could not support the figure of the woman it was intended to house because it introduced another narrative. An Oedipal scenario is evoked by the triad of Manet, the woman and the watcher, Degas. Forgive a dedicated Freudian for not going into the primal scene at this point, but it's probably part of the problem that led to the effacement of the woman and the painterly aggression unleashed on the jockeys which characterise the final picture found turned to the wall and glued to another canvas because it was abandoned when its paint was still wet.

The studio provided a safe scenario for reliving and lingering over the memory of being looked at by a woman, initially experienced at the racetrack, in that public space of modernity (fig. 20). It is no part of my purpose to suggest what the private meanings of such a memory might have been. They are unavailable. But in the existence of the painting as traces of repeated re-enactment in the studio, figures on the screen of representation playing with viewing and being viewed we do have some basis for analysis of their effects within a public domain. [34]

The figure of the woman with binoculars appears in several versions (plate 3, figs. 24, 25). The later ones are full length. The greater distance is mediated by a lot of fuss about ruches and frills on the dress, or lace-edged overskirts. Effects vary. In the Dresden picture (fig. 25) the ghost of the standing male hovers in thin outline, reversing the relations of that early sketch of Manet, shifting the interest from man to woman. This masculine presence does not disrupt the impact of the heavily painted standing woman who is centred and dominant. The binoculars again attract the painter's skill and are now less bloody, with twin points of white highlight. But there is another version in a private collection (plate 3). The figure is all in black, full length on a lurid yellow/orange ground, an effect not a little sinister, but not so much as the sci-fi effects of a bog-eyed monster created by the binoculars extending from her face. The gentle femininity of the early British Museum drawing (fig. 20) has been collapsed into a monstrous image of excess and threat.

Repeated and varied, by turns gentle, elegant, winning, exciting or dangerous as this last fetishistic version, the point is not an 'image of woman'. The series was generated by an experience reworked as a memory become representation – of a gesture of looking, figured by a woman's face and hands, which in fact signified Degas' complex pleasures and fears of *being looked at*. In my imaginary scenario of the race-course which initiated the series of works, the man was surprised in his ogling by the chance discovery of someone looking at him. I am forced to quote to you Lacan paraphrasing Sartre on the Gaze and the voyeur's shame:

> If you turn to Sartre's own text, you will see that, far from speaking of the emergence of this gaze as of something that concerns the organ of sight, he refers to the sound of rustling leaves . . . to a footstep heard in a corridor. And when are these sounds heard? At the moment when he has presented himself in the action of looking through a keyhole. A gaze surprises him in the function

of voyeur, disturbs him, overwhelms him and reduces him to shame. The gaze in question is certainly the presence of others as such. [35]

While disassociating the gaze from the eyes and the look, this reference sets up a situation in which the pleasures of looking are threatened by being discovered ogling. I know the mention of a keyhole in a paper on Degas is irresistible, but I want to work in the opposite direction – not to accuse Degas of a voyeurism which the pictures enact – but in this instance to show how he used the studio situation to invert the dangers and threat of being discovered looking. The studio reverses the race course scene and returns him to the position of mastery. For what we, as the imagined and intended spectators, see is 'his looking at her looking'. *She* is surprised, discovered. And the effect is to reduce the shame associated with the paranoic moment of the ogler/voyeur discovered, by a fantasy of being able at all times to solicit the gaze of the Other, to be the picture which lures and tames it, to be its permanent and unique focus. Each work in this sequence handles the contradictory forces differently, with differing measures of success yielding different amounts of pleasure. The pleasure lies in the solicitation of the Maternal Gaze, the formative gaze, which is both distant and forever lost. But the possibility of repetition though art permits the artist to play Freud's famous game of *fort-da*. [36] The absence of the mother was symbolically mastered through a repetitious game with a toy, thrown away and recovered. The repeated act of drawing and painting, delineating and framing, is a device to capture the lost gaze. Perhaps this is why these pictures are so loved that they keep cropping up; why they arrest our attention. But attraction vies with repulsion as witness to impossibility. There is also the evident aggressiveness, the dreadful Medusa-like moment of being caught by a dangerous look, a threat associated in masculine psyches with Woman as bearer of lack, a threat which is displaced on to the always odd, sometimes horrendous, binoculars. [37]

The Second Hypothesis

Mary Cassatt responded to the most peculiar version, the vast blackened creature on the page, her face almost entirely obscured by the cavernous tubes with their opaque highlights (plate 3). What did Cassatt do with this scenario? She put it back into the modern world, at the theatre where femininity and modernity were allowed to mingle (fig. 26). But the theatre was not, for a bourgeois woman, the place to enjoy the *flaneur's* public privacy and authorised voyeurism. In public, women are perpetually the object of an all-seeing gaze – not just this man, or that man – but an impersonal and ubiquitous 'voyure'. Cassatt's sardonic tone in specifying that the gaze is merely some tiring fellow peering at you provides some defence against that constant menace. How else to read that the caustic brevity notating the man in the neighboring *loge*, embarrassingly eager to be noticed? Cassatt has not put into the picture just any spectator, but sardonically specifies the one who is the virtual but absent subject of Degas' work, the man intended to occupy the geometral point

of Lacan's diagram I (fig. 27a).

But Cassatt's painting implies another spectator within the painting, there in the box beside her matinée-goer. A logical necessity, the chaperone or companion in the box is the necessary guarantee of the respectability of the woman we can see. In the implied narrative she is also looking, seeing both the woman in the *loge* and the ogler. But as the unseen other, this fantasised space becomes the gaze of the other within which both figures and their relations assume meaning. This is also the place we the viewers are invited to share.

As viewers we can projectively identify with the main female figure, actively looking for something to see. We can also, empathetically identify with the gaze of the other because of the kind of proximity the painting's spatial system creates between viewers and the woma(e)n in the box. Because of that closeness this gaze does not master: mastery depends on a set distance. Rather it embraces and indulges the depicted female subject. Compositionally, therefore, we can read a specifically feminine logic in the painting's field of vision.

The feminine subject is equally the product of a scopic regime, which constitutes her in desire through separation from, and loss of, the Mother. Femininity is formed around loss of the Maternal space and look. Cassatt's paintings obsessively picture the presence of this look in images in which the look becomes almost tactile, embracing the figures. Evident in representations of mothers or nurses with small children, for instance *Marie Looking Up at the Mother* (fig. 28), the paintings are fantasises shaped in an adult feminine psyche. [38]

Cassatt's repeated representations of maternity can be read as other than regression to an inevitable, pre-Oedipal attachment to the mother. Such fantasies of unity with the mother, popular in some current feminist theories of femininity, are stamped with ideological notions which conflate women with a primordial femininity, Woman. As much as it intuits the presence of that comforting, constitutive gaze, *Woman at the Opera* registers the effect of the Symbolic; it inscribes distance between that all-seeing gaze and the main female figure, a dislocation between the gaze, her look and what she might be looking at [for]. Her look is directed to the space beyond the frame. Desire is written on the screen of representation by the suggestion of there being something else in the visual field which we, the viewers, cannot see. Her gaze is focused beyond the frame, even while ours seems tamed within it. We, the viewers, are thus 'discovered' looking at a picture which is not looking at us. [39]

The approval of this painting for its simple reversal of the hierarchies of looking – the woman becomes the subject of the look – now seems woefully inadequate. The composition strategically produces its protagonist as the subject of desire. Desire is figured by that something else, not there in frame, the more that is always suspected. And that desire is feminine in so far as it is not fixed in its object, not fixated upon 'woman-as-image'. [40] Formed within the Symbolic and desire, the feminine subject is, like the masculine, the subject of lack. But in the visual economy of femininity, an image of a woman does not figure that lack. Feminine desire is projected by a

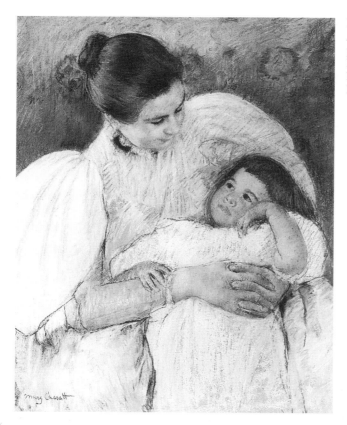

Fig. 28 Mary Cassatt, *Marie Looking Up at the Mother*, 1897, pastel on paper, 80 × 66.7 cm, Metropolitan Museum of Art, New York (gift of Ralph J. Hines), B 278.

representation of a woman looking beyond the frame, suspecting that there is more than the social world envisages for her. It is also indicated by the intimation of the gaze of the other, there as the invisible frame.

The pattern of looks in Cassatt's works are indeed obsessional and repetitious. We can identify at least two dominant modes. In many stagings of the relation between children and their nurturers, the gaze becomes a kind of touch in the almost physical embrace of the mother's look which is underlined by the enfolding of the smaller body in a monumental form. But at the same time there is a sense of separation so that the exchange of glances both intimates partition and offers a compensatory memory. (See for instance, *The Mauve Dressing Gown*, 1908, Washington DC, Private Collection, B 510.) Such imageries of mother and child are often embarrassingly dismissed, even by feminist critics, for banality and sentimentality. Cassatt may not have been a mother, but like us all, she had one, and I am suggesting that it was the vividness and significance of that mother-daughter relationship, socially so important within the bourgeois world of women, that incited the repetitions and intensities of these works. [41]

The other mode, then, involves an adult woman's look away to a point outside the geometrical field of western pictorial space, the look off screen in filmic terms,

for example, *Young Woman in Black* (1883, Baltimore, Peabody Institute, B 129). In the works by Degas the look was captured and tamed. His fictive spaces isolated a figure forever focusing on the putative spectator a veiled look.

Memories of infantile pleasure vie with post-Oedipal dread to produce the contradictions of these images of *Woman with a Lorgnette*. Cassatt's response to Degas exposed, through a humorous trivialisation, what that burden of masculine formation meant for women. By implied citation, masculine desire is framed and overwritten by an inscription of feminine desire which yearns beyond the frame. Cassatt acknowledges, but claims the power, of the threat of femininity signalled in the physical appearance of the woman in black, quoting it from the Degas, but investing it with the splits and psychic complexities specific to the formations of adult femininity. These cannot be contained within this image. Denied by the ubiquity of the trope of woman-as-image, woman image makers are perpetually driven beyond the scopic regimes of Western art.

IX Epilogue

The purpose of this paper has been to seek a way out of the relentless inscriptions of masculine desire in Western art and art history in order to invent ways to speak of, and from, a feminine place. Equally desiring knowledge, equally desiring certainties and secure objects for our scholarly gazes, we discover that the texts we have written are ourselves, caught in the act of peering into history, longing to see clearly yet having to admit that we are formed by what we find already written on the cultural screens of representation like art history. The representations we want to make as feminists are driven by our desire for that which seems outside current regimes of sense, ways of seeing art, doing art history, understanding the past.*

It has taken years to unpick my formation as an art historian and the required identification with its masculine regimes so that I might begin to glimpse something of the depth and meaning of Mary Cassatt's passion for women. Her works can only have meaning for those who will share the socially and psychically specific spaces

* I have to anticipate questions from art historians about Degas and the paintings. It will be an obvious defence against hearing the conclusion, ending with all that woman-talk. What, about Degas' paintings of women looking out of the frame, like *Woman Putting on her Gloves* (see cover, 1879, private collection) and the haunting *Portrait of Madame Jeantaud Before a Mirror* (1878, Musée d'Orsay, Paris, L 371)? And there are pictures by women artists of women looking at the viewer, a device used often in the portrait but rarely by Mary Cassatt. But my hypothesis offers no exhaustive explanation of uselessly vague categories such as Degas' images of women or Cassatt's images of women. Each work is a particular strategic intervention which involves a play of subjectivity in the complex fields of representation which are marked by difference at all its psychic and social levels.

But I must just mention the final reply to Degas in his life-long rivalry with the man at the race course. Manet had the last word in a thoroughly modern painting which dealt with both a woman looking in public and the ambivalence of the gaze. After Manet produced *The Bar at the Folies Bergère* (1881, Courtauld Institute Galleries, London), no wonder Degas painted out his female figure and turned his canvas to the wall.

proposed for viewers, and recognise in their longing looks off screen both a psychic loss constituting desire and a powerful resistance to the social lack defined as bourgeois femininity. The force of her works can be acknowledged today because they find an echo of the current struggle of feminism to answer Freud's famous question: 'What do women want?' – 'They want their own way'.[42]

Notes

1. *Degas* was shown at the Grand Palais, Paris, the Museum of Fine Arts, Ottawa, and the Metropolitan Museum of Art, New York between February 1988 and January 1989. I am grateful to Lisa Tickner for drawing this work to my notice at the show.

2. M. A. Doane, 'Film and the masquerade: theorizing the female spectator' *Screen*, 1982, vol. 23, nos. 3–4, pp. 74–87.

3. ibid. p. 83.

4. Linda Williams, 'When the woman looks', in *Revision: Feminist Essays in Film Analysis*, M. A. Doane *et al.* (eds), New York Greenwood, 1984.

5. This is Doane paraphrasing Linda Williams, Doane, op. cit., p. 83.

6. The works in this series are as follows: (a) *Manet at the Races* (New York, Metropolitan Museum of Art) pencil on light brown paper 38 × 24.4 cm; (b) *Woman with Fieldglasses* (London, British Museum) *c.* 1866 oil sketch on pink paper 28 × 22.7 cm, L 179; (c) *Woman with a Lorgnette* (Glasgow, Burrell Collection) *c.* 1869–72, oil sketch and pencil 31 × 19cm, L 268; (d) *Woman with a Lorgnette (Lyda)* (Private Collection, Switzerland) 1869–72 oil sketch on paper glued to canvas 35 × 22 cm, L 269; (e) *Woman with a Lorgnette* (Dresden, Gemaldegalerie) 1875–6 oil on cardboard 48 × 32 cm, L 431; (f) *At the Racetrack* (Montgomery, Alabama, Weill Inc.) 1868–1919 oil on panel 46 × 36.8 cm, L 184; Some of the works were known in Degas' lifetime and enjoyed a certain reknown. The Burrell drawing (c) was in the collection of critic Edmond Duranty until 1881; the painter Puvis de Chavannes owned the work (d) now in a private collection in Switzerland. Version (e), in Dresden was given to James Tissot who sold it in Degas' lifetime to the dealer Paul Durand-Ruel.
 See also, William Wells, 'Who was Degas' Lyda?' *Apollo*, February 1972, vol. XCV, no. 120 p. 130 on version (d), and on version (f) see B. Nicholson, 'The recovery of a Degas race course scene', *Burlington Magazine*, December 1960, vol. CII no. 693 pp. 536–37.

7. R. Kendall (ed.), *Degas: Images of Women*, Liverpool, Tate Gallery, 1989, p. 7.

8. See R. Parker and G. Pollock, *Old Mistresses: Women Art & Ideology*, London, Pandora Press, 1981, for a full discussion of this concept.

9. B. Nicholson, 'The recovery of a Degas race course scene', *Burlington Magazine*, December 1960, vol. CII, no. 693, pp. 536–37.

10. E. Lipton, *Looking into Degas: Uneasy Images of Women and Modern Life*, Berkeley, California University Press, 1986, p. 68.

11. ibid, p. 69.

12. This is the title of a major work on Degas by a leading modernist scholar, Theodore Reff, *Degas: The Artist's Mind*, New York, Harper and Row, 1976.

13. I am grateful to Eunice Lipton for bringing my attention to this paper and to Deborah Bershad for agreeing to allow us to include it here.

14. ibid. p. 103.

15. ibid p. 102.

16. R. Gordon and A. Forge, *Degas*, London, Thames and Hudson, 1988 p. 120. They are discussing the figure as a compilation of three versions, the full length oil sketch in the Burrell Collection, the half length from the British Museum and the full length with a tiny hint of a male figure from Dresden. The page layout with all three pictures on a double page spread heightens the effects by the repetition of the gesture. Intriguingly, the very next page reverses the striking and powerful effects of these three direct and mechanically aided gazes, by reproducing three prints by Degas of his friend Mary Cassatt and her sister Lydia in the Etruscan galleries at the Louvre. Here the woman looks away, eyes hidden by hat or book, or totally averted by a figure only seen from the back, pp. 122–23.

17. For a fuller discussion of this reading see G. Pollock, 'Modernity and the spaces of femininity', in *Vision and Difference*, Routledge, 1988, p. 76.

18. S. Freud 'Three essays on sexuality' [first edition, 1905], in The Pelican Freud Library, *On Sexuality*, vol. 7, London, Penguin Books, 1977.

19. For a useful discussion of this, see P. Hirst and P. Woolley, 'Psychoanalysis and social relations' in *Social Relations and Human Attributes*, London, Tavistock Publications, 1982.

20. The most closely argued analysis of this formation is the much quoted and often superficially read paper by Laura Mulvey, 'Visual pleasure and narrative cinema', *Screen*, 1975, vol. 16, no. 3, reprinted in L. Mulvey, *Visual and Other Pleasures*, London, Macmillan, 1989.

21. For some readers familiar with these formulations it might seem that I am confusing different theoretical traditions; the Freudian pair would be Pre-Oedipal and Oedipal, the Lacanian would be the Imaginary and the Symbolic. I think it is helpful to be a little cavalier here. I want to stress, like Mulvey, that there is a symbolic order, however illusory it is, which sets up man versus woman, look versus object. But that cultural apparatuses and practices pleasure and excite us by the temporary suspension of the fixities, and the narrativisation or displays of the more fluid and contradictory materials, positions and fantasies of which the symbolic is an always precarious management. This formulation clearly owes a lot to writings by J. Kristeva with her theories of process (pre-symbolic) and unity (symbolic) which she perceives in constant dialectic, present at all times. This helps to escape the tiresome narratives of typical Freudian and Lacanian theory which has an ideological function in its insistent teleologies

which drives its subjects towards the current symbolic solutions – i.e. the Law of the Father, the Primacy of the Phallus and the Repression of the Mother.

22. K. Silverman, *The Acoustic Mirror: The Female Voice in Psychoanalysis and Cinema*, Bloomington, Indiana University Press, 1988, pp. 161–62. I am deeply indebted to the important work of Kaja Silverman for the extension of feminist analysis towards both the new understanding of the gaze and masculinity and for the ways in which she enunciates her theories to insist upon women's desire and meanings.

23. J. Lacan, *The Four Fundamental Concepts of Psychoanalysis* [first edition, 1973], J.A. Miller (ed.), A. Sheridan (trans.), London, Penguin Books, 1979.

24. Lacan, op. cit., pp. 95–96.

25. Joan Copjec, 'The orthopsychic subject: film theory and the reception of Lacan', *October*, 1989, no. 49, p. 68.

26. 'It is crucial that we insist upon the social and historical status of the screen by describing it as that culturally generated image or repertoire of images through which subjects are not only constituted, but differentiated in relation to class, race, sexuality, age and nationality. The possibility of playing with these images then assumes a critical importance, opening up as it does an arena for political contestation.' K. Silverman, 'Fassbinder and Lacan: a reconsideration of gaze, look and image', *Camera Obscura*, 1989, no. 19, p. 76. This important paper offers further elaboration of Lacan's theory and stresses the place of the social within the psychic scheme.

27. J. Copjec, ibid., p. 68.

28. ibid., p. 69.

29. See also, T. J. Clark on Pissarro, TV programme for the Open University's *Modern Art and Modernism*, 1983, for a very fine presentation of the difficulties of seeing in Impressionist painting.

30. C. Baudelaire, 'The painter of modern life', in *The Painter of Modern Life and Other Essays*, Jonathan Mayne (trans.), London, Phaidon Press, 1964; see G. Pollock, 'Modernity and the spaces of femininity', op. cit., for a feminist reading of this text.

31. T. J. Clark, *The Painting of Modern Life Paris in the Art of Manet and his Followers*, London, Thames and Hudson, 1984. On revisionist social histories of, see for instance Robert Herbert, *Impressionism, Art, Leisure and Parisian Society*, London and New York, Yale University Press, 1988.

32. T. J. Clark, ibid., p. 15: 'I wish to show that the circumstances of modernism were not modern, and only became so by being given the forms called "the spectacle".' Modernism is not to be reduced to a matter of formalism; but the *forms* of signification can be ideological and historical.

33. The models are not really identified. It is a mere suggestion that this is Marguerite Degas, married in June 1865, pregnant in 1866. See also William Wells 'Who was Degas's "Lyda"?', *Apollo*, vol. XCV, no. 120, February 1972, p. 130, who

tried to suggest that the inscription on the Dresden painting, Lyda, referred to Mary Cassatt's sister Lydia. This is generally discounted.

34. For a discussion of this fantasy and the public realm, see Elizabeth Cowie, 'Fantasia', *m/f*, no. 9, 1984.

35. Lacan, *The Four Fundamental Concepts of Psychoanalysis*, op. cit, p. 84.

36. Freud found his grandson repeatedly throwing away and retrieving a cotton reel and announcing each moment: *fort*, i.e. gone, which signified the absence of the mother, and *da*, i.e. here, signifying her return. This represented a primary moment in which the child symbolically attempts to control the anxiety evoked by his mother's absence. There are many readings of Freud's account and of the game. See K. Silverman, *The Subject of Semiotics*, Oxford, Oxford University Press, 1983, ch. 4.

37. I am grateful to Heather Dawkins for a reference which is timely here: Alice Jardine cites a passage from an unpublished paper by Michèle Montrelay, describing a typical male fantasy: 'First, a central tube which cannot be the closed and satisfying container of an interior. It's not that the plan of the container is non-existent. Intestine, pipe, image of cavern, of dark, deep inner spaces, all that exists, but submitted to the forces of suction that empty them in the most painful fashion. Or else the void is already established. . . . On the surface – and isn't that characteristic of male sexuality – there's an eye.' A. Jardine, *Gynesis Configurations of Women and Modernity*, Ithaca and London, Cornell University Press, 1985, p. 70.

38. Limitations on illustrations prevent the kind of photo-essay this point requires. But reference can be made to Adelyn Breeskin's catalogue *raisonné*, *Mary Cassatt*, Washington, Smithsonian Institute, 1970, for illustrations of: *Emmie and her Child* 1889, (B 156); *Baby's First Caress*, 1891 (B 187); *Mother Looking Down at Thomas*, 1893 (B 225); *The Mauve Dressing Gown*, 1908 (B 510).

39. Film theory has argued that the apparatus of cinema captures our desire by matching it to the scale, space and figures which is defined within the screen. Off-screen space must always be carefully managed, as in shot reverse shot sequences and rules about eye line matching across related shots and 180 degree camera turns. These constitute the process of suturing the spectator's look to what the camera shows and thus to the narrativisation of space and figure. See Noel Burch, *Theory of Film Practice* [first edition 1969], London, 1973; and Stephen Heath 'Narrative space', *Screen*, vol. 17, no. 3, 1976. This argument is suggestive for current analysis of the relation of look to frame within nineteenth-century painting. It does not imply that any picture of a woman looking out of the frame signifies woman's desire. It is rather an identification of a structural convention upon which the ideological order of women's availability to figure men's desire functions; it also indicates the means of its disruption. Thus suggestion that there is offscreen space is a historically conditioned tactic for Mary Cassatt which none the less had significant ramifications in the resources of expression through

which to register the pressure of feminine desire as something that seems to be outside the existing *frameworks* of meaning.

40. I am referring back here to the discussion in Section VI of the way in which 'woman-as-image' became an over-determined sign of masculine fantasy, bearing the lack projected out from the masculine subject, and at the same time carrying the trace of the lost mother. In the varying economies of feminine sexualities, an image of woman may be an object of desire, and may indeed figure feminine desire. The point I want to emphasise is that, in a system which recruits the image of woman as a fixed object mastered by a masculine look, feminine desire will figure itself or find forms of representation as that which exceeds fixing, picturing, framing, containing, objectifying. Not because women are good and do not objectify, but because the social screens of representation negate feminine desire, deny it forms of representation. It is not to be represented by objects, but in relations. The struggle for women artists is not for positive alternative images, but to write on the screen of representation that which is culturally excluded, offscreen, the more that is always suspected, and is signified by men as there, yet empty, the enigma, the excess, the monstrous. I am not suggesting other positive feminine systems of representation, but the way meanings for feminine subjects can only be generated as a strategic negotiation of the historically specific fields of representation.

41. See Carol Smith Rosenberg, 'The female world of love and ritual: relations between women in nineteenth century America', in *Disorderly Conduct: Visions of Gender in Victorian America*, New York, Alfred Knopf, 1985.

42. I learned this from a children's book I was reading to my daughter, *Sir Gawain and the Loathly Lady*, retold by Selina Hastings, London, Walker Books, 1985. King Arthur meets a Knight who threatens to kill him unless he answers a riddle: 'What is it that women most want?' A hideous hag saves Arthur's skin by telling him the answer in return for one of his knights as her husband. Sir Gawain volunteers. Of course, the Loathly Lady becomes a beautiful woman, but will remain so only if Gawain answers her riddle. The answer is that she must do what she wants. What women most want is their own way – the pun is intended.

SECTION II:
THE BATHER SUITE:
POSITION AND PERSPECTIVE

Managing Degas

Heather Dawkins

In 1886 Degas exhibited a suite of nudes which are known to be only a small part
of his unusually extensive production of images of women bathing (fig. 29, plate
7). These images, of women washing or drying themselves, getting up or getting
dressed, caused much consternation among art critics in 1886; thus the most extensive
writing on Degas' work during his lifetime was formed. A textual event that has
been crucial in the formation of a literature on Degas, it set the terms for a debate
about Degas and misogyny which is still being waged – was Degas a misogynist
and his pictures evidence of his attitude to women, or could they be understood
in less disturbing ways? The pictures which provoked the debate on misogyny are
both complicated and contested sites of meaning and pleasure. It is not my purpose
to add yet another voice to the debate. Rather, I want to trace the way selected texts
'manage' the issue and consequently their strategies for securing pleasure and (sexual)
violence in relation to the pictures.

My reading of texts is what is called symptomatic. I am looking not only at what
was said and how, but at the intricate movements within a text, its repetitions, its
inconsistences, its contradictions, its relations to other texts, what it seems to avoid
saying and the conclusions and questions that can be drawn from its overall argument
as well as its component parts. It is really no more than a very close and attentive
reading which also asks how the reader is or is not being positioned by the text,
and what the reader is invited to identify with or project away from him/herself.
This kind of reading has been very useful to feminists who have found themselves
at odds with a culture so destructive for women; it offers a way of analysing how
that culture is produced and how other texts and other readers might be constructed.

Degas' exhibition of women bathing and the critics' responses to it forms a rare
moment in the nineteenth century – a moment when representations of women
by a man were challenged, albeit by men. The questions and issues of that crucial
moment resonate in the cultural matrix of contemporary feminism. The Women's
Liberation Movement has enabled the issue to emerge from the chaos of historical

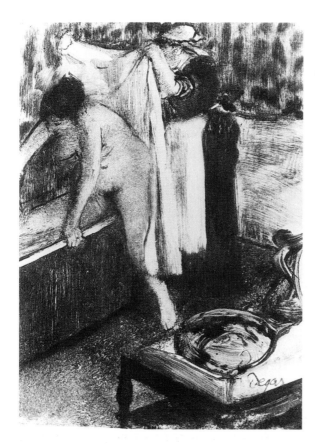

Fig. 29 Edgar Degas, *Woman Leaving her Bath*, 1876–7, monotype, 16.1 × 12 cm, Bibliothèque Nationale, Paris, J 176.

materials to appear within the discipline of art history, a masculinist discipline fundamentally ill-equipped and even at odds with the issue's relevance. This has induced rather complex attempts to deal with the debate; art historical writings that are usually more than attempts to preserve 'Degas' as an unproblematically pleasurable cultural product, though that is often their ultimate effect.

One of the most comprehensive attempts to date to look at the literature formed in response to the 1886 exhibition of nudes is Martha Ward's article, 'The rhetoric of independence and innovation'. She reveals that there were a number of options available to contemporary commentators to make sense of Degas' contribution to the Eighth Impressionist Exhibition and the apparent shift in his work. The women depicted in various states of undress were described not only as slatterns (poor, ugly and repulsive), but as animals, frogs, monkeys or cats[1] – or as fat prostitutes having the flesh of mammals and rented out by weight.[2] Whether these pictures were a malicious joke, a sincere expression of reality or a 'witty' commentary on the ranking of women in relation to the animal kingdom was open to debate. Were these images scientific, 'superior illustrations to a zoological treatise';[3] realist correctives to the deceitful conventions of academic nudes; or evidence that Degas must hate women

and abhor love?[4] There was little agreement on the meaning of this project. Certainly the most famous opinion, unpublished until 1889, is that of Huysmans:

> [Degas] brought to his study of nudes a careful cruelty, a patient hate. . . .
> He must have wished to take revenge, to hurl the most flagrant insult at his century by demolishing its most constantly enshrined idol, woman, whom he debases by showing her in her tub, in the humiliating positions of her intimate ablutions. . . . [He gives to her] a special accent of scorn and hate.[5]

It was to Huysmans' essay that Alice Michel, a working-class woman, 'replied' twenty years later; her response is analysed in another essay by me in this volume (see page 202). In the publications by men at the time of the 1886 exhibition, however, Degas was variously positioned as a misogynist, a feminist (see below), an objective observer of the inevitable but aesthetically unfortunate phenomena of women's bodies, or an astute debunker of the conventions of the academic nude, and as some have implied, a deconstructionist. These issues raised in the nineteenth century have been approached in recent art history by many writers – Eunice Lipton, Carol Armstrong, Hollis Clayson, Edward Snow, Richard Thomson and Charles Bernheimer.[8] The state of this literature is very uneven; there is little agreement on the analytical tools which could be used to pry open the debate on misogyny, its historical intertextuality, psychic over-determination and specific relationship to these pictures.

Most of the writings on Degas which lay or refute the charge of misogyny are not overly fascinated with Degas' life but with trying to explain or come to grips with the contradictions of pleasure and anxiety the writers experience in looking at his work. One writer has attempted to dismiss the misogynist debate altogether. Carol Armstrong's essay, 'Edgar Degas and the representation of the female body', disdains the issue raised by others for its sentimental fascination with Degas' life; she lumps together the arguments for and against his misogyny as 'two sides of one representational coin'.[7] Disregarding the debate in this way, however, is not convincing. While Armstrong is right to be suspicious of the hagiography in which art history often specialises, in the case of Degas, this kind of fascination and aggrandizement of the artist's life has precious little to work with, the biographical materials being so thin and insubstantial that it is impossible to fill out any kind of complex character for Degas. And in any case, art history's hagiography must be read symptomatically, not simply and summarily refused.

As forcefully as Carol Armstrong dismisses any interest in the debate on Degas' misogyny, it is a concern which persists as a subtext in her essay, not only in the kind of language she uses to discuss certain images but in her conclusion which, in a new twist to the literature, argues for what she names as a 'structure of celibacy' in the bathers. On reading her essay one is struck by the grotesque or macabre tone of some of *her* descriptions of the nudes.[8] It seems that the charge of misogyny, the

suspected cruelty attributed to Degas in relation to women or representations of women, haunts her prose in tortured evocations of images by Degas:

> Take the gesture of the arm again: where in Ingres's *Odalisque* and Cabanel's *Venus* it is lifted back to expose and stretch the line of the breast and continue the line of hip and waist, and where in the latter it is flung over the brow to almost hide, and in so doing to stress the flirtatious glance of the nude, in Degas' Bather the arm is angled over the face to cancel out the inviting glance, and though fully exposing the chest, it transforms the fleshy hill of breast into the bony angle of an awkward shoulder. The same is true of the arm on the floor, pushed against the chest so that a comparison of breast and elbow is forced. Flesh is turned into bone; movements of stretching and facts of contact become ones of torsion and pressure; and a gesture of exposure, ease and self abandonment becomes one of protection, discomfort and mortification. Added to this is the arrangement of hip and leg, pulled over to combine a side view with a front one, to transform a sensuous thigh into a straining rump and flank, to hide flatly both pubis and pelvis rather than to disclose them. Hands and feet have become unfinished stumps, lengths of titian hair a blunt rope of russet, the face a half obliterated skull. [9]

The language used to describe the body: 'flank and rump', 'unfinished stumps', 'half obliterated skull . . .' is not Carol Armstrong's alone, but is striking in this text because of her impatient dismissal of the continued debate over misogyny. She does not confirm the exact terms of the debate, but unintentionally confirms its relevance to any spectator looking at these images. The force of Armstrong's descriptions is secured by the comparison with such 'sweet' images such as Cabanel's which are still regarded in art history as harmlessly titillating if aesthetically silly. [10]

The sense of a violence done to these bodies has a long history in the writing on Degas' images; its relevance to the images must be taken seriously, especially considering the recent attempts to discover or construct an altogether different reading for Degas' bather images – their expression of an autonomous female experience. This radical movement in the Degas literature merits close consideration because it was entirely unrealisable in the nineteenth-century criticism. It depends on the viewer's identification with the bathers, and by this I mean a fusion of viewer and representation that allows viewers to claim that we know 'her' experience. It seems to have been impossible in the nineteenth century to identify with these imaged women in such a way, though it is clear that in this case we can as yet only speak for masculine viewers. [11] Take, for example, the 1886 criticism which labelled Degas as a feminist, not because he was showing women as they experienced themselves, but because he was able to define them knowledgeably:

> He is a feminist . . . and more feminist than the manufacturers of Venuses

and Ledas, if one understands by that the gift of seeing and defining woman (as certain type of women, if you wish) in that which most characterises her. [12]

Compare now the twentieth-century work of Edward Snow or Eunice Lipton. The latter's can be summarised as an assertion that the bathers are depicted as they would experience themselves:

> In addition, Degas's pastels have wandered so far from the conventional path of objectification that the women can actually be described as self-absorbed. Instead of depicting the nude in a specific brothel setting or as a Venus-like offering for an imagined male spectator. Degas presents her as she might experience herself. [13]

What are the textual conditions for such an identification with an image so that not only Degas, but 'we' have access to 'her' experience?

In both Eunice Lipton's recent book and her earlier article the historical changes in the practice of bathing are discussed in detail in order to confirm that, as nineteenth-century writers recognised, these were images of prostitutes: Degas would not have had access to a middle-class woman's toilette (even if he were married, Richard Thomson adds) and in any case middle-class women bathed only infrequently whereas prostitutes were required to bathe between clients. However, in Eunice Lipton's publications, this profession appears only to disappear; it is secured in relation to the images only to be abruptly dismissed. Instead, these images depict 'any woman':

> Because of the absence of explicit sexual gestures and complex narratives, and the presence of private pleasure, in the latter images the rooms seem ordinary – 'any woman's' room. And the prostitute has metamorphosed into any working woman, or even middle-class woman. . . . It is not possible to say precisely who this woman is, because she is not precisely anybody. [14]

It is important to realise that this passage proceeds directly from a discussion of the viewer's recognition that some of these images depict women's own experience while more other contorted poses represent women experiencing intense physical pleasure. [15] In this text a viewer cannot be positioned in a relation of identification to these visual texts without first circumscribing that positioning. It is thus no more thinkable that these are images specifically of prostitutes and so we identify *with* prostitutes (with specific experiences of their bodies or their intense pleasures) than it is thinkable that 'we' are positioned as the client. Identifying with 'women' is possible in the twentieth century (unlike, it seems, the nineteenth), but identifying with prostitutes, or being positioned as the client is not.

Edward Snow also constructs a feminine autonomy of experience and privacy

in the images with which the viewer and Degas can identify, but he must structure his argument differently from Eunice Lipton, well aware that he and Degas are masculine subjects and that this identification with women demands explanation. His argument includes a contrast and dependence between two seemingly opposite positions, two sorts of languages used in relation to the bather images.

In 'Painterly inhibitions', Snow begins by quoting a fascinating text by Jean-Paul Sartre, fascinating in itself and its relation to Snow's own text. It describes the long-term consequences of an early experience of identification wit his mother when a strange man, a 'blubbery mug' threatens them, making them a 'single frightened girl who stepped away'. Sartre writes:

> Even now, I have a feeling of pleasure whenever I see a serious child talking gravely and tenderly to his child-mother. I like those sweet friendships that come into being far away from men and against them. I stare at those childish couples and then I remember that I am a man and I look away. [16]

Edward Snow follows this by plunging into the misogyny debate, quoting what he calls the standard view of Degas' nudes, and this view is thus constructed as equivalent to the threatening 'blubbery mug' that, confusing as it is in Edward Snow's exerpt, seems to have forever changed Sartre's life. Thus we read the following quotation:

> . . . there is, with Degas, dried-up will power, and a line that cuts like a knife . . . The angular and flabby bodies squatting in the pale metal of the tub with its splashing water, render hygiene as sad as a hidden vice. He shows us meager forms with protrusive bones, a poor aspect, harsh and distorted, of the animal machine when it is seen from too near by, without love, with the single pitiless desire to describe it in its precise action, unrestrained by any sense of shame, and without the quality of heroism which might have been given to the all too clear eyes by a lyrical impulse . . . As soon as his sharp eyes surprise the thinness of elbows, the disjointed appearance of shoulders, the broken appearance of thighs, and the flattening of hips, he tells of all this without pity. [17]

But no, Snow asserts, on the contrary:

> One can only defend oneself from the half-truths of criticism like this by looking at the paintings, and noting the delicacy and hesitancy of Degas' approach, the tenderness with which he creates for his nudes their own body, their own privacy, their own space, and the protectiveness with which he insists upon measuring and respecting the distance that separates him from them. What these canvasses witness is not misogyny but its poignant, complex inverse: the artist's need to absent himself from the scene constituted by his gaze, his attempt to come to terms with sexual desire by transforming it, through art, into a

reparative impulse. It is as if these images are offered to the women themselves rather than to the audience that beholds them.[18]

Snow constructs Degas and himself along the lines of Sartre in *The Words*, projecting out aspects of masculinity which cannot be admitted in the union of protector and the feminine but which is nevertheless crucial in structuring that union. Present if only in order to be projected, sexual aggression is a cornerstone in this relation to the feminine. Sartre, learning to fear the masculine aggressor in a momentary identification with his mother, because the protector. The 'blubbery mug' stares at this mother but speaks to him; he is for a moment a frightened girl but then a protector, an active or masculine position, whose pleasure in the union with the (m)other is thus intensified. Structurally similar to the Sartre passage, 'Painterly Inhibitions' argues that Degas denies his own presence in the scene constituted by his gaze and that this denial enriches and intensifies the sense of erotic fulfilment in the canvases of the bathers. Yet we know that Degas not only constituted the scene by his gaze but through his position as an artist in relation to a woman who is paid to model naked in some very difficult poses. However, according to Edward Snow, this is heterosexual masculine desire at its best, not at its most debasing.

Like Lipton's argument which had strategically to suppress the prostitute to construct an identification, Snow must manage the proximity of heterosexual masculine desire and violence. However, as in Carol Armstrong's essay, the management of the anxiety of looking (an anxiety which is symptomatic in the descriptive violence demonstrated above) does not quite succeed. A second strategy can be seen in both texts, where the look – of Degas or of the viewers – is written out of existence. In Snow, this is no more than an underlying theme, that it is as if the images or women do not exist for an audience, and explicitly not for a masculine sexual presence.[19] In Carol Armstrong's essay very elaborate arguments are constructed first to suggest that Degas declares the look 'as a kind of pressure, a violence inflicted on the body like a rape or a subtle torture'[20] and then to suggest that one pastel denies the existence of a place for the viewer, even disembodies the viewer.[21] Thus Degas succeeds in problematising the gaze. In the interests of space, I will not go into the intricacies of her thinking, which I have put in its simplest terms but would like to point to what seems to me to be a crucial question. For there to be a picture, a visual text, there must be a viewer – what necessitates that the viewer or the audience or the masculine gaze be denied, however momentarily? For it is the viewer's gaze, and Degas' historical gaze, which we need, crucially, to come to terms with.

It is these gazes and their gendered and sexual specificity which have fractured the writing on Degas, and which have called for strategies of management. The unease, discomfort, even sadism of looking that is historically apparent in the writing on Degas does not at all preclude aesthetic or sexual pleasure, but these contradictory effects must be managed. For the management of pleasure and anxiety is precisely

the lot of representations of women's bodies in a heterosexual and masculinist economy of desire.

Why would someone want to paint women washing and drying themselves, often from untypical viewpoints, in poses that are awkward, contorted and contrived, and in proportions that are manifestly exaggerated? Why would he want to paint a woman washing or drying while a maid arrives with a cup of tea or a towel, over and over again? And not only represent this repeatedly but consider constructing a special system of tiers in his studio in order to be able to represent the scene from highly specific and spectacularly precarious points of viewing. [22]

Curiosity does not explain it. Degas' investment is prolonged, repetitive, determined, deliberate . . . yet enigmatic. What we are dealing with is a psychically over-determined fascination. As such it remains enigmatic, for it refers to at least three temporal spaces, one of which cannot be known, one of which is only a promise and one which has yet to be effectively approached. [23]

The psychic or historical past, Degas' childhood, which structured his traumas and psychic necessities is entirely unknowable. We may be able to elaborate childrearing practices which constructed certain splits in masculine heterosexual desire, but I am referring to a more idiosyncratic pressure, which is irretrievable and yet somehow available to us in Degas' sustained and prolonged engagement with his pictures of bathers. There is also the impossible promise of gratification which compels Degas to repeat these poses, these gestures, these points of view, these sculptures, with the apparently conscious desire of wanting to rework, and rework and rework . . . We are then left with the historical present which provided Degas with the materials and practices with which to work this fascination and which are specifiable but fragmentary and contested by historians. Here one can think of a range of literatures and histories that have yet to be brought to bear on 'Degas': the prostitutional complex in the nineteenth century, transformations in looking, the gendered practices and gazes of modern art, the scientific deployment of the gaze, the hysterisisation of women's bodies, the artistic practices which inscribed certain constitutiencies of heterosexual masculine desire . . . I have no doubt that 'Degas' would emerge from this study in an entirely new configuration – one that would have to cope with the contradictory effects of his images as well as the imbrication of his artistic practices with techniques and relations of power and heterosexuality. By way of provisional conclusion we can take one crucial aspect of Degas' historical present that has been complete overlooked in the literature about him and his work.

The Historical Present

By the time Gustave Geffroy's reviews of Degas' contribution to the Eighth Impressionist Exhibition appeared, the bathers had already been written about in rather scathing terms, as, for example, 'in perfect bad taste and totally lacking artistic qualities' or as having a 'ferociousness that speaks loudly of the scorn of women

and the horror of love'. [24] However, Gustave Geffroy suggests that if there is a spirit of loyalty (a sense of brotherhood perhaps) which forces one to look, these eyes first of all offended by colouration and 'attitude' (which could be translated as pose, expression, attitude and/or point of view) will quickly make an about face as sincerity and truth appear. Gustave Geffroy very knowledgeably sets up a whole different argument for Degas' work, while producing a certain kind of identification with Degas. In doing so he offers a clue to these works' social significance and conditions of existence that has been completely overlooked in the literature about them. Very simply, Geffroy constructs Degas as 'scientific man' facing reality without preconceptions and attempting to transcribe it:

> Anxious/uneasy about lines that one doesn't try to arrange, that one doesn't even search to see, he wanted to pain the woman who doesn't know she is looked at, as one would see her, hidden by a curtain or through a key hole. [25]

Gustave Geffroy thus introduces the famous and voyeuristic dynamics of viewing so taken for granted in the literature but in the context of a detached and sexually disinterested gaze that is the inverse of sexual coercion referred to in Degas' comment that he would have painted Susanna and the Elders had he not been a modern man. [26] But this is just one part of a larger reference for Geffroy. For he introduces the little known Degas by saying that he:

> Knows like no one else, the arabesque of the human form, the ceiling and circumference of the theatres of music and dance, the vestibules and rooms of a turkish bath, the gallery of a certain modern building or the sitting room of a house built yesterday. He would have known how to describe there in particular the animal grace of the girls of the opera, and the elegant thinness of the race horses, the look of a woman worker at her trade, the costume and undress of the woman of today. [27]

Now for those who are intimately familiar with Degas' *oeuvre*, this list of places and things that Degas excels in must seem a bit strange, though it has been passed over without comment. Most of it rings true – but what did Geffroy mean when he noted Degas' intimate knowledge of the vestibules and rooms of the turkish baths? Could he be referring to the small and very unimpressive sketches of a turkish bath in one of the notebooks, *c.* 1880 (fig. 30)? I rather doubt it as they were not known publically and are neither artistically nor anatomically noteworthy. Yet I think we must enquire about Geffroy's comment, for his review is one of the most detailed on Degas' work.

It is here that the Degas literature can provide no further help, for it has not been able to come to terms with the customs and complexities of nineteenth-century bathing and the contradictory, confusing and inconsistent morality around hygiene.

141

Fig. 30 Edgar Degas, Notebook 29, pp. 31, 35, 1877–80, sketches, 25.1 × 34.5 cm, private collection.

General rules about who did and didn't bathe, how, and how frequently, collapse in confusion when held up to scrutiny; statistics about who was in possession of which bathing paraphenalia gloss over crucial details. Turkish baths, however, are already specific. Though we may think of something fairly exotic, that exoticism is understated in the medical definitions of a turkish bath as a steam bath in which one passed through successively hotter rooms followed by a massage, flagellation with birch branches, a lathering in aromatic soap, a rubbing down with a massage glove or aloe, and lukewarm shower before being left wrapped in hot sheets, to sweat. [28] Sketches by Degas indicate something of this ilk but do not necessarily elaborate more completely a connection between the exhibited bather pictures and Geffroy's review.

The pictures exhibited in 1886 did not mesh in any simple way with Geffroy's turkish baths as they show only the very poorest or most economical of bathing situations: five pictures feature cuvettes, the round, shallow basins with sloping sides that used little water and could be cheaply bought, and two pictures were of outdoor bathing or dressing, a custom that had been the target of repeated and ineffective legislation in Paris from the middle of the century (plate 7, fig. 38). However, these kinds of pictures in Degas' *oeuvre* are both preceded and far outnumbered by pictures of women bathing in a manner much higher up the social scale – stepping in and out of bath tubs, often in the company of a maid.

In listing the sites in which Degas had already demonstrated his expertise, it is indicative that Geffroy divided his turkish bath into the vestibule and rooms. For the lack of clean specialised bath houses were deplored by the respectable classes in Paris in the 1870s and 1880s as the dream of cleanliness and luxury gave way to sordid 'realities'. Architecturally more common was the bath house that was divided into two very distinct spaces, the first orientalist and exotic and serving only as the façade for much more ordinary bathing establishments where one would find the *baignoires* or bath tubs, maids and simple furnishings of Degas' pictures.

The meaning of Geffroy's assertion, then, in an otherwise accurate review of Degas, that he was an expert on turkish baths, is not crystal clear in relation to the exhibition but can be made sense of in a larger context of Degas' bathers and is of paramount importance in signalling the public spaces of bathing. This meaning will focus if we consider that Geffroy's review was also the first published discussion about Degas' pictures in voyeuristic terms, that this was a woman who did not know she was being watched, that it was as if the onlooker was hidden by a curtain or looking through a keyhole. And here again we can draw out a relationship to public baths and illicit sexualities, but illicit sexualities as practised by men belonging to the upper and supposedly respectable classes. For at least one public bath in the 1880s rented rooms to amateurs by the week and the month – but not for bathing. Equipped with a small and skilfully hidden peep hole one could watch women bathe, with or without them knowing it. According to Gustave Macé, two former ministerial officers and a justice of the peace were caught engaged in such a hobby – though at this point I cannot ascertain whether charges were laid against this particular

bath house or its amateurs. Whether or not police and judicial records can be traced, Gustave Macé's text indicates that Degas' fantasy and peculiar points of view may have been not only shared as fantasy with his critics or buying public, but enacted in a monetary exchange, an historically specific form of voyeurism. [30]

Geffroy's initially puzzling comment thus opens on to public bathing practices and illicit looking, but this should not be taken to exclude or negate a relationship to the critic's references to prostitution; illicit sexual activities, whether homosexual or heterosexual, were endemic to bath houses; illicit pleasures are checked by the identification with Scientific Man in Geffroy's text, by Investigatory Man in Macé's . . .

We know that Degas' work was, and continues to be, understood in contradictory and antagonistic ways. I have tried to show some recent textual strategies that displace, project or attempt to deny the difficulties of these images, and thus attest to the necessary for then management. Those difficulties involve questions of the politics of looking and representation as well as the treacherous ground of psycho-analysis and sexuality; attempting to construct 'Degas' as a site of unproblematic pleasure will prevent our ever knowing what is, or was, at stake.

Acknowledgement

Grateful acknowledgement is made to the Social Sciences Humanities Research Council of Canada Doctoral Fellowships for funding my research.

Notes

1. See Martha Ward, 'The rhetoric of independence and innovation', in *The New Painting, Impressionism 1874–1886*, The National Gallery, Washington, 1986, pp. 430–34, for an overview of the animal metaphors.
2. Henri Fèvre, 'L' Exposition des Impressionnistes', *La Revue de Demain*, Tome 1, nos 3–4, May–June 1886, p. 154.
3. Gustave Geffroy, cited in Martha Ward, op. cit., p. 432.
4. Martha Ward, op. cit., pp. 430–34.
5. J. K. Huysmans, cited in Eunice Lipton, *Looking into Degas: Uneasy Images of Women and Modern Life*, University of California Press, 1986, p. 182. Lipton implies that this was written at the time of the exhibition, while Daniel Halévy footnotes it as published in 1887. See Daniel Halévy, *My Friend Degas*, London, Rupert Hart-Davis Ltd, 1966.
6. See Richard Thomson, *Degas, The Nudes*, London, Thames and Hudson, 1988; and Charles Bernheimer, 'Degas's brothels, voyeurism and ideology', in *Representations*, no. 20, Fall 1987.
7. Carol Armstrong, 'Edgar Degas and the representation of the female body', in *The Female Body in Western Culture: Contemporary Perspectives*, Susan R. Suleiman (ed.), Harvard University Press, 1986, p. 225.
8. The violence in this description is strengthened by the comparisons of a work by Degas with painting by Ingres and Cabanel, work generally understood as

completely benign. It is worth noting that the comparison here is rarely possible, that the reclining nude being considered is seldom found in Degas' *oeuvre*. Significantly, Degas avoided inviting comparison with the 'erotic' academic tradition; Armstrong's work suggests why.

9. Carol Armstrong, op. cit., p. 233.

10. The implications of psycho-analysis have not been taken up for imagery outside the avant garde, any more than they have been taken up for Degas. See John Ellis, 'Photography/pornography/art/pornography' in *Screen*, vol. 21, no. 1, Spring 1980, for a lucid and useful (though not historically accurate) summary of the questions that psycho-analysis raises in relation to looking and women's bodies.

11. Griselda Pollock's essay, 'Modernity and the spaces of femininity' in her book *Vision and Difference*, London, Routledge, 1988, revolutionises the literature on modernity by analysing the politics and construction of the look in the painting of modern life. She is able to retrieve the inscription of femininity in the paintings by Mary Cassatt and Berthe Morisot and thus elaborate the historical specificity of looking as a woman.

12. Cited in Martha Ward, op. cit., p. 433.

13. Eunice Lipton, op. cit., pp. 180–81.

14. Eunice Lipton, op. cit., p. 182.

15. Eunice Lipton, op. cit., pp. 177–78.

16. Jean-Paul Sartre, cited in Edward Snow, *A Study of Vermeer*, University of California Press, 1979, p. 24.

17. ibid., pp. 25–26.

18. ibid., pp. 27–28.

19. ibid., pp. 26–27 and 30.

20. Carol Armstrong, op. cit., p. 234.

21. Carol Armstrong, op. cit., p. 240.

22. *Degas*, Paris, Edition de la Rénuion Musées Nationaux, Ottawa, National Gallery of Art, New York, Metropolitan Museum of Art, 1988, p. 314.

23. Elizabeth Cowie, 'Fantasia', in *m/f*, no. 9, 1984, p. 84.

24. Labruyère, *Le Cri du Peuple*, 17 May 1886, p. 2; and Octave Mirbeau, *La France*, 21 May 1886, pp. 1–2, respectively. Gustave Geffroy, *La Justice*, 26 May 1886.

25. Gustave Geffroy, op. cit., (second page of unpaged paper).

26. Daniel Halévy, *My Friend Degas*, Middletown, Wesleyan University Press, 1964, p. 119.

27. Gustave Geffroy, op. cit., (second page of unpaged paper).

28. Theodore Reff, *The Notebooks of Edgar Degas*, Oxford University Press, 1976, vol. II, Notebook 29, pp. 29, 31, 33, 35.

29. Bonami, 'Vocabulaire de bains: Nouveau dictionaire de santé', 1888, cited in Julia Csergo, *Liberté, Egalité, Propreté*, Paris, Albin Michel, 1988, pp. 345–46.

30. Gustave Macé, *La police parisienne: Mes Lundis en prison*, Paris, G. Charpentier, 1889, p. 167.

On Narrative and Metamorphosis in Degas

Richard Thomson

Degas scholarship remains rather imbalanced, despite the plethora of publications on the artist's work over the last half decade. Much research has been undertaken on his early career as a student, copyist, history painter and remarkable portraitist. Great emphasis has also been placed on his mid-career, from the mid-1860s to the mid-1880s. This phase coincides with Degas' public career. During this period he belonged within recognisable groups of artists; he exhibited regularly; a body of contemporary critical writing about his work exists. And this period saw him grappling with issues of modernity; Degas and his contemporaries confronted the modern city and the debates about gender and class, perception and representation, which the urban world threw up. However, despite the evidence of the 1988–9 retrospective,[1] which did much to show the grandeur and ambition of Degas' late work, his production after 1890 has been little studied and interpreted. After about 1890 Degas exhibited only casually; critical writing about his work became more disparate, though the recording of anecdote and table-talk burgeoned; he kept most of his ambitious work in the studio and made much in his rhetoric about being private, obsessed with his activities in the *atelier* and disdainful of the contemporary world.

In this essay I want to begin to ask some questions about this apparent imbalance. To what extent is his late work, after 1890, a retreat from, or a subversion of, his previous pictorial concerns? Or is there less disjunction than we imagine? Was it rather a case that Degas adapted his means of representation, so we have to assess a process of development rather than an abrupt caesura, a change of language? Take these two variants of a single pose (plate 8, fig. 31). The first was made in the mid-1880s, though it does not seem to have been among the *suite* of pastels of the female nude which Degas submitted to the last impressionist exhibition in 1886; the second was made about a decade later. The earlier image is more deliberately 'naturalistic'; Degas was concerned to manipulate the medium, the better to approximate to skin and other surfaces. The model has been given facial features; she is allowed an identity. The later image is more sharply coloured and the strokes of the pastel begin to take

on an independence from the forms they represent. The model appears as an anonymous female figure; her pose and action are the same as in the earlier work, but her lack of identity serves to reduce what one might call the social function of the figure. The legibility, the 'naturalism', of the earlier pastel was contrived to give the spectator the illusion of a naked human figure involved in a specific, plausible activity; an activity, moreover, the purpose of which is rooted in the social sphere. The devices of naturalism – tactility, physiognomy, detail – are curtailed in the later variant; we still 'read' a woman drying her arm after washing, but the business of analysing her activity, reading her social role, is increasingly contradicted by the insistence of the surface. The closer range of tones, the evident reworking of contours, the striations and gestural marks which make little attempt to suppress the play of the hand, deny the illusion of naturalism and seem to insist that this image is an invention, a studio confection, an exercise in form, colour and touch.

How are we to decode the languages of these images? How are they to be read? It has been suggested by several writers[2] that Degas' view down on the figure implies the spectator's dominant position, and Degas often used the device ambiguously, as he did here. For what is the implied identity of the spectator? Man or woman? Husband, lover, maid or friend? I have suggested elsewhere that Degas' echoing of the pose in the upholstered furniture may be an invocation – conscious or not – of a patronising pun on women's bodies common in contemporary literature and caricature.[3] If viewpoint and metaphor – and both involve male-orientated

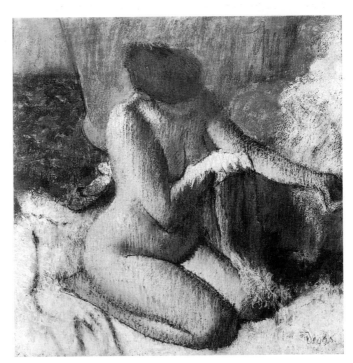

Fig. 31 Edgar Degas, *Woman Drying Her Arm, c.* 1895–8, pastel, 70 × 70 cm, Louvre, Paris, L 1335.

assumptions about power and control – were devices implanted in this image in the mid-1880s to encourage particular readings, do they apply to the later variant?

Let us leave those questions open and rapidly run through some of the key pictorial devices Degas seems to have used in his 'naturalist' work of the late 1870s and early 1880s. Then we can gauge how they were brought into play or repudiated in the late work. In *La Toilette* (fig. 32) shown at the 1880 Impressionist exhibition, there is active formal play between the figure of the corsetted woman and the water-jug on the table. Of course, such a jug was a plausible accessory in a *scène de toilette*, but did Degas include it simply to set the scene, to function as a likely accessory to a narrative? Or is there some kind of metaphor at work – deliberately or residually – with the volume of the jug implying uterine associations of the kind it has been suggested that Ingres deployed in *La Source* (1856: Paris, Musée d'Orsay)?[4] We are on the borders of psychological speculation here, which I am very wary of crossing, but one should stress that, in the complex world of Degas' images, formal, pictorial concerns act in a very close conjunction with the articulation or inference of meaning.

One of Degas' primary concerns in the 1870s, it seems to me, was how to imply narrative, how to suggest a relationship or exchange – perhaps inexplicit or ambiguous

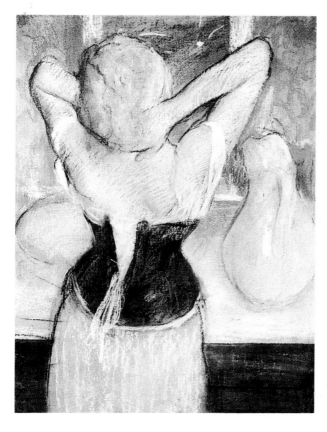

Fig. 32 Edgar Degas, *La Toilette*, *c*. 1881, pastel, 63.5 × 48.8 cm, private collection, formerly Lefevre Gallery London, L 749.

– between the figures in the fiction of his compositions. He also seems to have sought means by which to implicate the spectator, so the image acts less as a theatrical *tableau* from which we are physically disjoined but more as a pictorial simulation of how we see, perceive and make social judgements based on our visual observations in the modern city. In *Woman Putting on her Gloves* (see cover, *c.* 1879, oil on canvas, 63.5 × 48.3 cm, private collection, L 438) we are given certain clues. We are shown a smartly dressed middle-class woman, dressed in her outdoor or walking clothes, so she is a visitor to this interior. Degas represents her leaning attentively forward, rather tense, and awkwardly fingering her gloves. But to whom is she listening? To man or woman? One person or many? Why is she there? The sketchy quality of the door concentrates our attention on this single woman within the room and encourages us to look in, to speculate. Here a pictorial decision – to leave the door-frame and the spectator's fictive space approximate – serves to assist the subtle implications of narrative.[5]

Degas also developed formal means to convey attitudes about class and gender appropriate to a man of his upper middle-class status. In *At the Milliners* (1882, Metropolitan Museum of Art, New York, L 682) two women are appropriately ordered by such standards. The *bourgeoise* to the left is stereotypically coquettish as she adjusts her bonnet; she is mistress of the space with her confident gestures. By contrast, the shop assistant stands in absolute symmetry, unnaturally disciplined and controlled as she holds other hats, and is literally effaced by the mirror.[6] Her semi-obliteration by the mirror was, I would argue, not merely a pictorial decision to contrive an element of chance in the image in order to promote a fiction of the spectator's glimpsed, momentary perception of this scene. For that carefully managed 'chance' operates as a regulator of the social hierarchy. Perhaps it is worth pointing out that Degas was here being obedient to the habits of seeing and representing of his gender, class and generation. Jean-Léon Gérôme's *Moorish Bath*, for example, albeit *orientaliste* rather than *naturaliste*, works in much the same way; the female nude is subservient to the spectator; she fulfils contemporary, European assumptions about harem women, while the faceless servant is subservient to her. (One might add that Gérôme did not necessarily consider his putative spectator to be exclusively male. He dedicated one of the three versions of this painting to his daughter Madeleine, no doubt considering that the image's implicit assumptions about sexuality and social control were appropriate for her.)[7]

Patriarchal assumptions about class and gender came into play in Degas' images of women bathing, such as the pastel-over-monotype lent by Caillebotte to the 1877 Impressionist exhibition (Musée d'Orsay, Paris, L 422). The maid is again symmetrically posed; she is effaced, and still. Her mistress, on the other hand, is active, mobile and dominates her own space. But Degas was far from programmatic in his representations. In a slightly later pastel of the same subject – a maid proferring a towel as her mistress emerges from the bath (*c.* 1885, Ny Carlsberg Glyptotek, Copenhagen, L 706) – it is the *bourgeoise* who, cropped by the frame, loses her identity and dominance. The decision was presumably made because Degas elected to concentrate on the maid,

posed by the actress Réjane, in the symmetry he felt apt for representing servants.[8] One might at this juncture make another point about Degas' devices at mid-career. For he often used women to play roles in his images. In this pastel Réjane 'acts' a maid; in *L'Absinthe* (*c.* 1875–7, Musée d'Orsay, Paris, L 393) another actress acquaintance, Ellen Andrée, plays a prostitute; the patrician Senator's wife Mme Dietz-Monnin was made to perform with a lack of gentility and restraint in *Portraits after a Masked Ball* (*c.* 1878–9, Art Institute, Chicago, L 534).[9] In making these female models play roles – willingly or otherwise – Degas was effecting a social transformation, reversing the portrait painter's usual practice; he was making such women appear in the fiction of his images as something they were not in lived social experience.

This process could go further. Among a group of portraits of Hélène Rouart made in the mid-1880s, one pastel shows her dressed in robes which give her the look of a Tanagra figurine. She all but ceases to be an identifiable young Parisian *bourgeoise*, daughter of Degas' prosperous industrialist friend Henri Rouart, and becomes metamorphosed into an anonymous, ancient Greek maiden. Dillian Gordon has suggested that Degas played on the notion of 'La Belle Hélène',[10] and he seems to have enjoyed this kind of playful allusion to, or adaptation of, the languages and meanings of high culture. This can also perhaps be traced in *Miss Lala at the Circus Fernando*. A preliminary sketch for the composition includes both acrobat and audience below (1879, private collection, BR 79). Later versions, however, show just the acrobat. Perhaps this change can be explained by Degas' realisation that as we 'watch' Miss Lala's spectacular performance – she was hauled up to the circus roof clinging on to a rope by her teeth – the spectator's gaze would follow her up; and thus could not simultaneously see the fellow spectators beneath. Degas' decision to trim his composition was thus made to control the spectators' reading of the image, to make it a more 'accurate' simulacrum of our perceptions. But should *Miss Lala* be interpreted solely in such 'naturalistic' terms? I have argued elsewhere that the image was an application to a modern circus subject of a traditional composition for an Assumption or Ascension.[11] One might take as an example the *Assumption* painted between 1864 and 1867 for the Eglise de la Trinité by Elie Delaunay, to whom Degas had been close as a student in Italy during the late 1850s.[12] Delaunay's *Assumption* has a similar relationship between spectators below and spectacle above to the early version of *Miss Lala*, which is also an exaggerated vertical design. It may be that *Miss Lala* sprang from a pictorial decision to use a traditional configuration with a vertiginous figure for a modern subject; perhaps it became a playful critique of Delaunay's solution, in which we look *at* rather than *up to* the Virgin. Degas would have realised the false perception of that, and modified his composition accordingly. This is a speculation made in passing; my point is that Degas' most ambitious articulations of 'naturalism', of pictorial artifices intended to convey our perceptions of the modern urban world, might be shot through with allusion to traditional compositions and he can playfully adapt or metamorphose them to suit his purposes.

After 1890 Degas' figure subjects – with the rare exception of some portraits –

were exclusively women. His main preoccupations were the bather, usually alone, sometimes with a maid or in a group imagined in a schematic 'outdoors', and the dancer, generally offstage and more regularly related to other figures. Activity, pose, and generalised setting are plausible enough in many of these images, but what one might call the 'social' element is considerably diminished, it seems. There is little or no dialogue, contact, or exchange between the figures; the women are represented as anonymous, their faces given only cursory features; likely paraphernalia and objects are minimised, not brought to the viewer's attention. Colour and touch are emphasised, and the poses or compositions limited in number and frequently repeated, as if the woman/model was only of interest as a malleable form and no longer as a social being, living in a shifting world, performing social functions within different environments and in contact with other people. Much of the Degas literature encourages the reader to consider Degas' concerns after 1890 as primarily aesthetic, pictorial, even using terms such as 'abstract'.[13]

I would like to set out some arguments for a more complex analysis, by returning to those key devices of the mid-period and assessing their survival or adaptation in the late work. Some images do apparently continue the earlier systems of meaning. *Breakfast after the Bath* (private collection, L 724), a pastel of the mid-1890s, might be construed like a work of twenty years previous; its narrative is apparently clear. The maid brings a hot drink to her mistress, and – according to my earlier readings – the structure and poses sustain the class hierarchy: the maid is in profile, regimented, disciplined, subservient, while the mistress commands the space, filling it with her energetic movements. And yet the touch, the handling of the pastel, seems in places to float free from the forms one expects it to describe. This is particularly true of the body of the nude; it almost appears as if she is standing behind a veil. Carol Armstrong has read this effect as subverting the conventional painterly encouragement of a male viewer's interest in the female body by refusing to elide or harmonise the fictional surface of the body and the tangible surface of the *matière*.[14] Does such an image thus articulate one set of conventions – about class and role – and deny another – about a controlling gaze? Are image and means at odds with each other? Perhaps we are helped by recalling a once close colleague of Degas, also an artist who concentrated on the female nude and who during the 1890s consistently repeated and revised a stock of poses. Gustave Moreau celebrated repetition in an untitled text, written late in life to defend and explain his work: '. . . *cette éloquence plastique admirable, enfin trouvée, il faut toujours le redire* . . .'[15] He exhibited *Salomé* (Armand Hammer Foundation) at the Salon of 1876, a highly detailed painting which lent itself easily to Huysmans' 'naturalistic' account of its jewelled décor and encrusted surfaces. But Moreau's *réprises* of the motif, it seems, lose their concordance of touch and image. His linear patterns, even to an extent his colour areas, operate with a certain independence from the main structures of the image.[16]

Degas' repetitions might be seen to work in a similar way. For example, he made two versions of *Reclining Female Nude* (*Femme Nue Couchée*), the first pastel in the mid-1880s

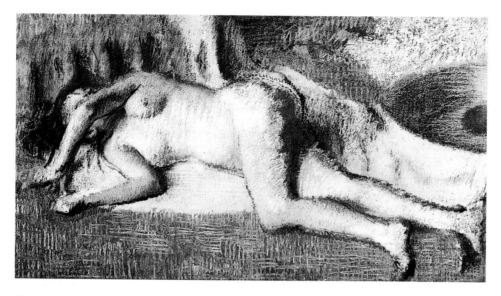

Fig. 33 Edgar Degas, *Reclining Female Nude*, *c.* 1895, pastel, 48.3 × 83.2 cm, private collection, L 855.

(Musée d'Orsay, Paris, L 854) and the second (fig. 33) about a decade later. The later variant is more patterned, and the touch divorced from the objects and surfaces it describes. Yet perhaps this is not so much an exposure of the conventions for emphasising the sensuous objecthood of the female nude as, say, a simple concern for pattern (particularly in the floor), a retreat from detail, a new awareness of the independence of light from form, or (in the figure) a covering of mistakes. [17] If anything is subverted in the pose of the two versions of *Reclining Female Nude* it is narrative. Why should the woman be posed lying on her flank upon a towel spread on the floor? It seems implausible in the apparently banal privacy of a domestic chamber. Perhaps her arm raised to cover her face intimates some reason: has she tumbled? Has she been struck? Pose and environment here seem to contradict each other; the one is startling, eccentric, perhaps pathetic, while the other is ordinary and mute. Perhaps one begins to explain these contradictions when we recall a pose from the *Scène de Guerre au Moyen Age*, the painting Degas exhibited at the Salon of 1865 (Musée d'Orsay, Paris, L 124). In this image of man's violence to women, despite the apparent polarisation of genders – female victims to the left, male persecutors to the right – Degas used his models interchangably. At least one preliminary drawing, for a sprawling woman to the lower left of the composition, looks as if it might have been made from a male model, to which Degas added imaginary breasts, [18] while a study for the man shooting an arrow on the right was drawn from a female model. [19] For Degas, it seems, the human body was a resource to be metamorphosed at will by the artist's imagination. Thus if one accepts that the vulnerable, even defensive, pose for the *Reclining Female Nude* has its ancestry in the *Scène de Guerre*, and links that

152

with the device of placing the spectator in the dominant position looking down on the female figure, then she appears increasingly not as a 'motif', not removed from an imagined social function, rendered anonymous by Degas' purely pictorial concerns; not just as a vehicle for pattern or colour; not as a denial of tactility, of the male fantasy of possession. Rather she appears as a fragment of a narrative, a moment in a story – at which we can only guess – that has left her vulnerable, forced into submission below us. [20] Here, then, a work of the mid-1890s seems to be constructed to read much as a work of two or even three decades previously.

However, in other images the structures of narrative seem to go awry, perhaps deliberately so. In *The Bath, Woman Seen from Behind* (fig. 34), a painting of the mid-1890s, some of the devices seem to operate as I have described them. So the maid is rendered anonymous and shoved subserviently into an upper corner. Yet the nude is in an extraordinary position, which seems uncomfortable and most implausible for having one's hair combed. Perhaps this extraordinary image might be explained as a bather climbing or stepping up, such as we find in an early Millet painting of two bathers (fig. 35), which was bought by the Luxembourge Museum after the artist's death

Fig. 34 Edgar Degas, *The Bath, Woman Seen from Behind, c.* 1895, oil on canvas, 65 × 81 cm, private collection, L 1104.

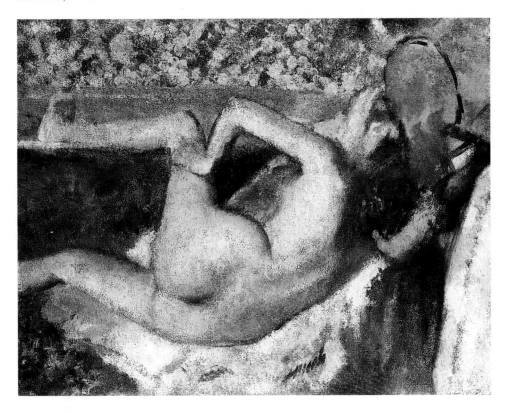

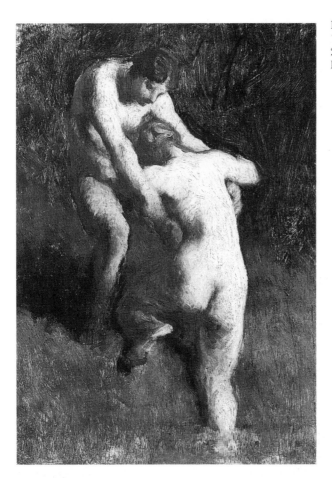

Fig. 35 Jean-Francois Millet, *Two Bathers*, 1848, oil on panel, 28 × 19 cm, Musée d'Orsay, Paris.

in 1875. Degas, for reasons we can only surmise, elected to turn an apparently plausible vertical figure on to its side, jolting the spectator's sense of likelihood and stressing the invention, indeed the dominance, of the artist. This is not to demonstrate that the Millet served as a precise prototype, but to draw a visual analogy, to suggest that in some cases Degas did not care to imply or resolve narrative. He might settle for an awkward transformation or articulation of pose, or contrive the 'mystery' which he told Jeanniot a painting should be able to conjure up.[21]

Perhaps we underestimate the element of fantasy in the late work of Degas, in images such as *The Bath*, and consider him too tied to the model. Perhaps nowhere in his fascination with the fantastic, with metamorphosis, so evident as in his landscapes of the 1890s. One might tend to read a pastel-over-monotype such as *Landscape with a Cliff* (private collection, J 283) in terms of Monet's paintings of the Normandy cliffs, but it may be a play on a strangely physiognomic rock formation famous enough to have been illustrated in the popular scientific magazine *La Nature*.[22] Whether Degas had seen this cliff-face or simply illustrations of it we cannot be

sure, but his landscape seems to have savoured the capricious elision of human physiognomy and natural form. It certainly appears that he transformed representations of the female body into landscape forms. I have shown elsewhere how beneath an image of a coastal landscape can be traced the structure of a seated female nude; it seems Degas took a drawing related to a mid-1880s image of a woman having her hair combed and metamorphosed it into a landscape.[23] What is one to make of such a transformation? We know Degas enjoyed the caprice of metamorphosis; in 1890 he and the sculptor Bartholomé travelled from Paris to Burgundy by trap, and at some point during their journey Degas painted black stripes on their white horse, the 'zebra' amazing the peasants through whose villages they passed.[24] In the sixteenth and seventeenth centuries artists working in the Mannerist tradition had enjoyed similar visual games, with artists such as Joos de Momper disguising bodies and faces beneath landscape forms.[25] Degas may have been exploring an accredited form of old masterly fantasy. But Degas' landscape/woman of the early 1890s goes further than the metaphors he had implied earlier in his career, those allusions to jugs or upholstered furniture as in some way equatable with the female body. For the woman's body *becomes* the landscape; the fusion of woman and nature is complete.[26] Freedom from the descriptive constraints of naturalism, one might argue, freed Degas' imagination; the female body became to the artist a completely controllable object, able to be metamorphosed at will.

One salient aspect of Degas' late career was the constant reference to past art in his table-talk. This was not new – he had referred to Mantegna and Veronese in the 1870s[27] – but it does seem to have become more consistent. If the old masters, the great tradition, played a larger part in his mind during the 1890s than they had two decades before, might one not also expect this to manifest itself in his work more frequently than occasional clandestine and subversive references in images such as *Miss Lala*? Only recently have scholars begun to take such remarks as '*Dire qu'en autre temps, j'aurais peint des* Suzanne au bain' ('To think that in another age I would have been painting Susanna and the Elders')[28] to be more than mere nostalgia and to trace hints of traditional subjects in his late work. Towards the end of the 1890s Degas drew a number of studies of a female nude which worked variations on the same fundamental pose. This pose clearly interested him significantly, as he refined and reworked it in more than a dozen variants, including a sculpture.[29] The pose shows a female nude on the defensive. She is not only vulnerable in her nakedness, but rendered more so by her body language. In drawings such as the sheet at Princeton (*Bather, c.* 1895, University Art Museum, Princeton) she covers her genitals in fear, or shame, or self-defence. In such studies the figures' only context is the pose, so one is uncertain quite how to read their function in a narrative. Is the figure to be read as shrinking from a general threat, or actually cringing from an immediately oppressive physical presence? Is she peering out from a hiding place, watching those of whose gaze or intentions she is fearful? These are disturbing images, the mood of threat heightened by the urgent torsion of the body. We do not know exactly for

155

what these studies were intended. They may just have been studies in their own right of a vivid and emotive pose, or studies for the sculpture. More probably they may have been made for an ambitious picture, to involve other figures to whom the woman seems to respond. This picture could have been a *Susannah and the Elders* or perhaps a *David and Bathsheba*. It could equally have served for a modern narrative subject. But whether a historical or genre subject, narrative relationships were implicit.

A large, strange drawing in the Musée des Art Décoratifs may help us to get closer to Degas' intentions (*Baigneuses*, c. 1896). Degas' frightened pose has a ghostly presence to the lower right, and the women who surround her could be modern bathers or Diana and her nymphs. All seem to flinch or respond to something at the upper left; Gary Tinterow has suggested the scene may represent Diana turning Callisto into a bear. [30] Degas' treatment of his intently researched pose also involved other variations. In the sculpture, for instance, [31] the woman is made to clasp her stomach, and might even be pregnant; the posture could be one of pain rather than response to an exterior threat. And the pose was deployed again for a straightforward, quotidian bathing scene, the woman holding the edge of the bath as she steps in; [32] Diana could be transformed into domesticity. For the elderly Degas, woman remained a subject he could manipulate at will. He still used women to play roles in his pictures, and an individual pose – a player in his repertoire, one might say – could act in classical tragedy or domestic documentary, and could, by slight variations of gesture or body language, take on different emotional or psychological states.

Why did Degas return to classical or traditional subjects during the 1890s? One can only sketch approaches to an answer here, but one might be a conscious return by Degas to subjects on which he had been trained and had expected to found his career. Colleagues such as Gustave Moreau and Jean-Jacques Henner continued to paint *Susannahs* and *Dianas* during the 1890s, and – perhaps even more poignantly than Renoir or Cézanne – Degas now felt that such subjects, rather than those from the modern world, allowed him most satisfaction. Probably he was aware that by the end of the century young artists such as Maurice Denis and Henri-Edmond Cross were taking on classical or 'idealist' subjects, that there was something of a *rappel à l'ordre* in contemporary art, a return to the elevated traditions of the French school. This could be linked – in ways too complex to develop here – to the revival of the Right in French politics of the 1890s. At the time when France was polarised by the Dreyfus Affair, one might hold up the crude equation: Classicism meant Order meant allegiance to the Right. Perhaps it is of no coincidence that the subjects which the fervently anti-Dreyfusard Degas seems to have had in mind – *Susannah and the Elders, Diana and Callisto* – are narratives of espionage and exposure, secrecy and betrayal.

These are speculative propositions, of course, put forward in an attempt to broaden the still limited debate about Degas' later work. My central thesis is that Degas' work after 1890 is concerned with far more than the studio concerns with which analysis usually ends, describing his complex technical procedures, his *reprises*, his extraordinary chromatics and textures. These all have their importance, but their

fascination should not allow us to detach the late work from Degas' earlier concerns. Degas' late images of women are often still ordered around the controlling social structures of class and status for which he had found representative means in the 1870s: mistresses dominant, maids subservient; the female nude viewed from above, implying the spectator's dominant, male position. He added, at times, an implication of threat or even violence not to be found in his work since the 1860s. Thus in both kinds of image his female subjects are made to act within a narrative – albeit sometimes garbled or elusive – implied by the pictorial structure; they remain 'social' to some degree. And yet in another sense one feels that Degas' late images of women are denied the active, purposeful individualities they had in his mid-career, as ballet-dancers, laundresses or *bourgeoises*. Woman became for him a vehicle, an embodiment of a movement or emotion, a series of forms mutable into other forms or associations, a cipher to play in the roles created for her by the 'old master'.

Notes

1. Jean Sutherland Boggs *et al.*, *Degas*, Paris, Grand Palais, Ottawa, National Gallery of Canada, New York, Metropolitan Museum, 1988–9.

2. *Inter alia*, George Shackelford, *Degas: The Dancers*, Washington, National Gallery of Art, November 1984–March 1985, p. 24; and recently Richard Thomson, 'Les poses chez Degas de 1875 à 1886: lecture et signification', in *Degas inédit, Actes du Colloque Degas, 18–21 April 1988*, Paris, 1989, pp. 211–23.

3. Richard Thomson, *Degas: The Nudes*, London, Thames & Hudson, 1988, pp. 143, 146.

4. E. van Liere, 'Solutions and dissolutions: the bather in nineteenth century French painting', *Arts Magazine*, vol. 54, no. 9, May 1980, p. 108.

5. Richard Kendall, *Degas: Images of Women*, Tate Gallery Liverpool, 1989, no. 10; Richard Thomson, 'Liverpool Tate Gallery. Degas: Images of Women', *Burlington Magazine*, vol. CXXXI, no. 1041, December 1989, pp. 864–65.

6. Thomson, op. cit., 1989, p. 217.

7. George Ackerman, *The Life and Work of Jean-Léon Gérôme*, London, 1986, p. 236, nos. 240, B-1, B-2. The latter is dedicated to Madeleine Gérôme; Providence, Rhode Island School of Art and Design.

8. H. Rostrup, 'Degas og Réjane', *Meddelelser fra Ny Carlsberg Glyptotek*, no. 34, 1977, pp. 7–13; Thomson, op. cit., 1988, p. 207.

9. Richard Brettell and Suzanne Folds McCullagh, *Degas in the Art Institute of Chicago*, Chicago, Art Institute, July–September 1984, no. 47; Richard Thomson, 'Notes on Degas's sense of humour', in *Degas, 1834–1917*, Richard Kendall (ed.), Manchester, 1985, pp. 9–19.

10. Dillian Gordon, *Edgar Degas: Hélène Rouart in her Father's Study*, London, National Gallery, April–June 1984, p. 8; reprinted in Kendall, *Degas: Images of Women*, 1989, pp. 19–20.

11. Richard Thomson, *The Private Degas*, Manchester, Whitworth Art Gallery,

Cambridge, Fitzwilliam Museum, 1987, pp. 91–92.

12. *Jules-Elie Delaunay, 1828–1891*, Nantes, Musée des Beaux-Arts/Paris, Musée Hébert, 1988–9, pp. 161–5.

13. Boggs *et al.*, p. 481.

14. Carol Armstrong, 'Edgar Degas and the representation of the female body', in *The Female Body in Western Culture. Contemporary Perspectives*, S. Rubin Suleiman (ed.), Cambridge, Mass., Harvard University Press, 1986, pp. 223–42.

15. P.-L. Mathieu (ed.), *L'Assembleur de Rêves. Ecrits complets de Gustave Moreau*, Fontfroide, 1984, p. 156.

16. See, for example, P.-L. Mathieu, *Gustave Moreau: Complete Edition of the Finished Paintings, Watercolours and Drawings*, Oxford, OUP, 1977, nos. 160, 161; Musée Gustave Moreau, Paris, nos. 211, 222.

17. A similar 'disembodied' handling of pastel can be found in the work of Georges Jeanniot, for instance, *Femme se peignant* (1892: Paris, Musée d'Orsay; RF41657). Degas' *Portraits of the Artist's Friends* (1885; Providence, Rhode Island School of Design) has substantial scumblings of white pastel casually applied over worked areas, apparently to cover problematic passages.

18. Paris, Musée du Louvre, Cabinet des Dessins; RF 12274; Boggs *et al.*, op. cit., 1988–9, no. 57.

19. Paris, Musée du Louvre, Cabinet des Dessins; RF 15522; Boggs *et al.*, op. cit., 1988–9, fig. 56.

20. Thomson, 1988, op. cit., p. 205. For other accounts of this pose see Armstrong, op. cit., 1986, pp. 230, 233–5; no. 275.

21. Georges Jeanniot, 'Souvenirs sur Degas', *Revue Universelle*, LV, no. 15, 1 November 1933, pp. 281, 301.

22. Pontus Hulten *et al.*, *The Archimboldo Effect*, London, Thames & Hudson, 1987, repr. p. 210.

23. Thomson, 1987, op. cit., pp. 110–11.

24. Paul Lafond, *Degas*, Paris, H. Floury, 1918, vol. I, p. 139.

25. For the most recent discussion of this phenomenon see Pontus Hulten *et al.*, op. cit., (1987).

26. Similar elisions of the female body and landscape can be found elsewhere during the 1890s; see for instance Mucha's illustration on p. 32 of Robert de Flers' Ilsée, princesse de Tripoli, Paris, 1897; repr. A. Bridges (ed.), *Alphone Mucha. The Complete Graphic Works*, London, 1980, repr. p. 92.

27. Edmund and Jules de Goncourt, *Journal. Mémoires de la vie littéraire*, R. Ricatte, (ed.), Monaco, 1956, vol. 10, p. 164; entry of 13 February 1874.

28. Daniel Halévy, *My Friend Degas*, London, Rupert Hart-Davis, 1966, p. 119.

29. See Boggs *et al.*, op. cit., under no. 348.

30. ibid., 1988–9, no. 348.

31. ibid., 1988–9, no. 349; R. LIV.

32. For example, L. 1155.

Degas' *Bathers*:
Hygiene and Dirt – Gaze and Touch

Anthea Callen

> Woman then stands in patriarchal culture as signifier for the male other, bound
> by a symbolic order in which man can live out his phantasies and obsessions
> through linguistic command by imposing them on the silent image of woman
> still tied to her place as bearer of meaning, not maker of meaning.
>
> (*Laura Mulvey, 1975*).[1]

This essay was originally conceived not as a conference paper, but as part of a
forthcoming book.[2] Ideally, it needs to be seen as one of a series of closely
interconnected essays which examine how, in later nineteenth-century France, the
discourses of art and science were combined in a new visual language. Through
representations of, in particular, the female body, this visual language was crucial
to the generation of modern conceptions of gender.

As a feminist art historian I am concerned with how and why patriarchy *pictures*
femininity and masculinity in order to contain women and to empower men. Debates
over the meanings of visual images in much 'new' art history have tended to privilege
history, especially social history, or theory – for example Marxist or linguistic theories
– often disregarding the visual components of art. In our logocentric culture, analysis
of the word and a belief in the ability to decode written texts have, in recent years,
generally become taken for granted.

My project, however, is to develop *visual* analysis as a deconstructive tool. I am
working on ways of theorising the visual which do not treat images as adjuncts,
illustrative of a given history or theory, but which *start from* visual representations and
deploy histories and theories to help reconstitute the visual meanings. The meanings
of pictures are not, of course, constituted simply through narrative devices or subject
matter *per se*, but in many highly complex and subtle ways. Just as linguistic structure
and syntax are open to analysis, so too – in its own way – is the grammar of art.
Medium, composition, *mise-en-page*, spatial organisation, pose and gesture, colour,
light and shade, mark-making processes – indeed the whole physical object – must

be taken into account, if the ideological structures they enshrine are to be understood.

In this text, I shall focus on a group of pastels by Degas, *Bathers*, of which six were exhibited at the Eighth Impressionist Exhibition in 1886.[3] In my book, I write about this group of pictures using a number of different approaches, all of which connect art and science: pictorial space; anatomy; representations of flesh; hysteria; viewpoint and voyeurism; discourses of dissection and prostitution. For this study I shall concentrate upon the interacting discourses of hygiene and female sexuality, and of gaze and touch. Since the processes of objectification are intrinsic both to the production art and to its consumption as 'art-object' under the scrutiny of the (male) spectator, art is exemplary for the study of the gaze. Feminist analysis has implicated the gaze in a particular sexual politics in which female sexuality is objectified before the empowering scrutiny of man. I want to qualify and complicate this regime by charting other paths which cross over the field of the gaze, the body and the terrain of their interaction – the image – wherein the very tactility of the art-made body and the physicality of its pastelled surface suggests not just a disembodied gaze, but the proximity of tangible bodies: the touch as well as the gaze are channels for contamination. My analysis here of Degas' *Bathers* examines the question of *touch*, linking it to the concept of the *gaze*. I compare ideas of touch as physical contact (as manifest in contemporary ideas of bodily hygiene and disease), with touch as *touche*, the mark-making process which physically constitutes Degas' pastels. I also explore the relationship between touch and gaze, both as pictorial and as social processes.

I Degas: Images of Women

When I first saw the list of contributors to the *Degas: Images of Women* Conference I was impressed by the number of women art historians who were speaking. It had not occurred to me so immediately to consider the extent to which Degas scholarship is currently dominated by women, indeed by feminist art historians. So why do we do it? This question came up at the Association of Art Historians' Conference in Spring 1989, not specifically in relation to feminist scholarship, but rather to the current obsession with Degas *per se* – for there has been, in the last ten years, a general explosion of interest in Degas' work. My answer at the time highlighted the opposing aims of feminist and mainstream art history: whereas the latter celebrates the canon, feminist art history aims to deconstruct it. I argued that there were the historical parallels between the backlash against feminism in Degas' time and that which women now face – in attempts to contain feminists' practical and ideological disruptions of the status quo. In his own time, Degas' work gave visual constitution to fears of the feminine and of female sexuality. Mainstream art history's new productivity is evidence of a deep cultural need to re-articulate these anti-feminine discourses. Degas scholarship may be the field of battle, but the issues at stake involve the lives and liberties of real women.

In all the mainstream scholarship, what I find most striking is the degree to which

real meaning, real spectator discomfort has, over the past hundred years, been erased from readings of Degas' images of the female nude. This is apparent in the ease with which such images are displayed, discussed and given unquestioning aesthetic approval. This cannot simply be attributed to social change and certainly not to 'enlightened progress' during the period. It discloses the need to paper over any conflicts which might expose fissures within bourgeois ideology and, more fundamentally (since its effectiveness depends upon its invisibility), the very existence and mechanics of that dominant patriarchal ideology. Feminist bids to open up such fissures, by reconstructing and deconstructing the sense of disquiet with which Degas' nudes were received/perceived, and to return to the agenda the genuine problems posed by these works, are crucial to understanding, and undermining, the ways patriarchy functions.

It is vital to draw attention to the extraordinary process of 'sanitisation' which has made it unproblematic to celebrate intimate, obsessive, disturbing pictures of naked prostitutes hanging on the walls of polite bourgeois drawing rooms or public galleries. The mainstream art-historical discourse itself has played a central role in this exercise, by constructing a safe, aestheticising language which mediates between the raw images and the consumer, building up protective accretions of words which diffuse the impact of the visual language. Indeed, the very proliferation in recent years of words pouring off the presses, and from exhibitions with their accompanying heavy-weight tomes of reassuringly scholarly text, points to a crisis which suggests mainstream art history's need to 'sanitise' Degas' images has become – in the face of feminist incursions – at once more urgent and more difficult.

II Degas: Woman as Transgressor

All borders are dangerous. If left unguarded, they could break down, our categories collapse and our world dissolve into chaos. (*Robert Darnton, 1984*).[4]

Particularly during the 1870s and 1880s, Degas' obsession with woman in his work made visual the anxiety of bourgeois patriarchy over the problematic existence of Parisian women on the borderlines between the domestic and the public spheres of modern life. The growth of the bourgeoisie and of its wealth had brought with it an expansion in the service industries. As in our own time, this was mainly women's work. It was from these new or expanding service industries that Degas' *Parisienne* subject matter primarily derived. Thus, by the last years of the Second Empire, women began to displace men as employees waiting in bars and cafés, their role often slipping over into casual or organised prostitution.[5] The expansion of the Paris fashion industry resulted in growing numbers of women working in this and allied trades, like millinery, and their retail outlets.[6] The rise of off-the-peg consumption and the department store also offered women new and lucrative employment – and thus greater freedoms – as well as creating an environment in which the *bourgeoise* could move unchaperoned.[7] By the 1850s, the demise of the male dancer was all

but complete, and professional dance – both ballet and popular – was dominated by female performers. As Alex Potts has pointed out, 'Something had gone wrong with the image of the male – he connoted so strongly the idea of master in the prosaic world of war, government, administration . . . and finance that he was seen to be incompatible with pleasure and phantasy. This was the sphere of the female performer.'[8] The laundry trades, too, underwent dramatic expansion from the July Monarchy on, with the increasing bourgeois demand for clean linen.[9] Although the number of regulated brothels declined after the Second Empire, unregulated prostitution was an expanding trade, servicing a predominantly bourgeois clientele.[10]

In each of these trades, women performed activities associated with the feminine role prescribed for women within the private sphere of family life, but in the public sphere and for financial gain. Their need to earn in order to survive meant that working women embodied the contradictions inherent in the bourgeois discourse of the family. Participating in these highly visible trades, women not only transgressed the *ideological* limits which defined the domestic. They also eroded the *physical* boundaries of public and private in the course of their daily labours. Where domestic work screened the woman from public view, the milliner's shop or the café – almost extensions of the boudoir or dining room – were neither wholly public nor wholly private spaces. The work-spaces of washerwomen and ironers exposed themselves to public scrutiny, while delivering goods – whether fashion or laundry – involved moving from workshop to street to the bourgeois customer's residence. The dancer shifted from dressing rooms and corridors closed to all but select admirers, to the Opéra Foyer – a semi-public setting – to the public spectacle on the stage, and back again. So too in prostitution, where clients were often solicited in the public sphere, but where the consummation (consumption) normally took place in pseudo-domestic privacy.

Boundaries are cultural conventions. They are external projections of the psychic need to distinguish inner from outer, that distinction between the self and others signified by the human skin. Boundaries serve to define edges and contact, the points at which things meet, touch and separate. They are about the demarcation of objects in space, the distinction of social, geographical and psychological terrains.

Although they did form part of a broader patriarchal concern over the policing of social boundaries, transgressions of woman's prescribed role and space provoked a heightened degree of anxiety. This is confirmed in the explosion of discourses on woman at all cultural levels – in the popular press and novels through to criminal anthropology, medicine and art. Since masculine 'order' was defined by opposition to female 'chaos', containment of the female was deemed essential to the survival of that order. Disruption posed a threat both to the internal psychic order, and to the external patriarchal order. Transgressions required but – due to the scale of the project and to conflicting social and ideological needs – inevitably eluded, policing. The preoccupation of nineteenth-century ideologues with the containment of women, their bodies and their sexuality, has been widely acknowledged. Degas' work is no

exception. In his subject matter and its very repetitiveness, in his pictorial structures, and in the public reception, Degas' work constitutes this same fear of, and desire to control, a female subject which resisted fixity.

III The Politics of Hygiene: Gaze and Touch

The 1880s represented a watershed in the scientific understanding of contagion and the spread of disease, thanks to the discovery of microbes and bacteria in the work of Louis Pasteur. [11] However, concern over public hygiene and disease already had a long-standing place in the discourses of environmental medicine and urban renewal. Already, by the late eighteenth century, the benefits of cleanliness had become inscribed by the bourgeoisie with moral values, and were seen as synonymous with virtue and respectability. Particularly from the 1830s on, cleanliness became one of the prime signs by which the bourgeoisie distinguished themselves as socially and morally superior to the 'great unwashed'. Under the July Monarchy, debates over hygiene were no longer restricted to the public sphere, but justified intrusion into the private domain, to survey conditions and to inculcate salubrious habits: [12]

> Disinfecting poverty meant not only giving . . . [the poor] vigorous health, an increased aptitude for work and for war, but further ridding it of its 'barbarism', making it internalise the norms which would subordinate it to the dominant agencies and behaviour (hygiene, sobriety, sedentariness, order, family values, thrift), without which it could never truly live [those norms], as a result of always subsisting on the economic margins and their cultural consequences. [13]

The disinfection of the urban environment and of the urban masses (public and personal hygiene) were two facets of the same bourgeois project which, in its very classification of salubrity, defined and structured social difference.

The bourgeois preoccupation with personal hygiene was not simply to protect the individual from disease. Just as important was the need to establish social difference from those whose lack of personal hygiene connoted not merely physical, but moral degeneracy – which was in itself perceived as contagious. The 'great unwashed', then, presented as great a threat to the health of the bourgeois *social* body as to its *physical* body. The maintenance of distinction – in its several senses – demanded the cultivation of signs of difference: cleanliness *required* dirt to give meaning to difference. Avoidance of physical or social contact with 'inferiors' was an essential prerequisite of superiority. Despite crowding in Central Paris, personal physical distance could more readily be maintained in Haussmann's squares and parks, on the new broad boulevards and elegant balconies. These sites made the urban poor more 'visible', and also provided the bourgeoisie with the ideal public space for displaying the visual signs of their distinction. Space served to separate bodies, light to render them visible. [14]

163

As with the problem of women's transgression and its control, the multiplication of discourses around the problem of disease testified to the extensive scientific scrutiny required in its containment and eradication. However, the contradictions resulting from, on the one hand, the horror of filth and disease and, on the other, the need to observe it in order to cure it, gave a disturbing ambivalence to looking, to the gaze. Stallybrass and White consider the increased regulation of *touch* at this period to be a direct consequence of this ambivalence over the gaze:

> For even if the bourgeoisie could establish the purity of their own gaze, the stare of the urban poor themselves was rarely felt as one of deference and respect. On the contrary, it was more frequently seen as an aggressive and humiliating act of physical contact.[15]

The gaze was thereby conflated with touch. The gaze of the lower classes, like their touch, was experienced as an act of aggression. The paradigmatic bourgeois gaze, on the other hand, was the gaze of surveillance deployed to master the aggressive gaze of the lower classes. Surveillance by bourgeois agencies of social control – from the *police des moeurs* through to medical hygienists – also signified touch. The shock of Manet's *Olympia* lay precisely in the artist's explicit reference to the touch of the *déclassée*, as signified by the Olympia's gaze (fig. 36). The spectator's gaze is met, defiantly held and returned by the Olympia; he cannot avoid engagement

Fig. 36 Edouard Manet, *Olympia*, 1863 (Salon of 1865), oil on canvas, 130.5 × 190 cm, Musée d'Orsay, Paris.

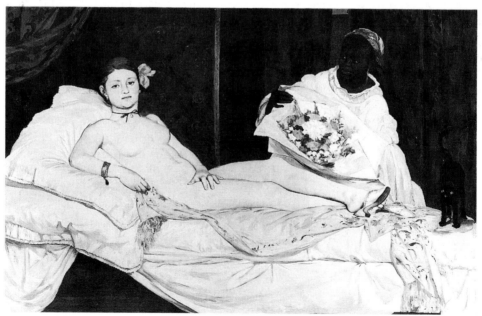

with the connotations of her look. The work's exhibition in the Salon of 1865 thus made tangible, in this assertive eye-contact, a disquietingly tactile exchange which was normally censored from public discourse. The removal of the painting from the 'eye-line' soon after the Salon opening bears witness to the power of the inscribed gaze and the official need to 'silence' it; re-hung high above the spectator's level the eye-contact was broken, and its discursive impact defused.

Stallybrass and White equate gaze and touch with the dual concepts of desire and revulsion. They argue that the dialectic between these poles underlay the structuring of social relations at this period. In what ways is this dialectic constituted in Degas' work, and how does it function?

IV Degas' *Bathers*: Gaze and Touch

Looking at a painting or drawing, the spectator's tactile sensations are of necessity indirect, mediated by the gaze: the sense of touch is constituted in the gaze. At times, this is made explicit – for example in Cabanel's *Birth of Venus* (Salon of 1865, oil on canvas, Paris, Musée d'Orsay), where touch is 'illustrated' by a narrative convention. The hand of the furthest cupid stretches towards the nude's arm, offering the spectator vicarious contact with the flesh.[16] At others, metaphor provides a more subtle device, as in the juxtaposition of fabric or fur to female flesh. However, in Degas' pastels we are dealing with touch on two levels, for there is also *touche*, the sensual mark-making process which constitutes the picture itself. For the spectator, the artist's touch reads not simply as a complex of representational conventions which signify meaning, but also as a tangible visual record of a physical process. One of the reasons why it is so crucial to examine art-objects 'in the flesh' is precisely that, in reproduction, the sensuality is lost. Confronting the object, the spectator – through memory, through association – relives the physical history of the mark-making which produced the image; the eye retraces the movements of the hand. The visual sensation is a metaphor for – or a sublimation of – actual bodily contact.

Degas' pictorial methods expressly privilege *touche*, and the sensual activity of the gaze. This is achieved by several means, including pose and *facture* which I shall discuss here. Several critics commented on the lack of eye-contact with the figures in Degas' *Bathers*: he positioned his models expressly to avoid visual confrontation with the spectator. He reinforced the device of the averted eyes by exploiting poses which connote unselfconsciousness on the models' part. In most representations of the female body, self-consciousness is signalled, if not by eye-contact, by poses which 'display' the body to a privileged spectator. The body is objectified for uninterrupted consumption by a male spectator, whose presence is thereby assumed (see fig. 37). The conventions of display in the discourse of the nude in western art include maximum exposure of the body surface – the figure is generally seen from full front or rear views, spread out, iconic, and – where supine – tipped up towards the spectator. In spite of these devices, female genitals have suffered a remarkably complete censorship in western art.[17]

165

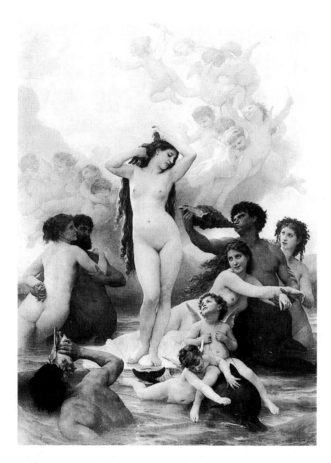

Fig. 37 William Bougu-ereau, *Birth of Venus*, Salon of 1879, oil on canvas, 300 × 218 cm, Musée d'Orsay, Paris.

Degas' work disrupts these conventions of display. The spectator's confrontation with the *Bathers'* bodies is neither relieved nor mediated by familiar pictorial conventions of nudity. The pictured bodies inscribe no discourse of complicity to orchestrate the spectator's pleasurable consumption of them; the implicit intrusion of a male viewer into the privacy of a female space is thus encoded. Spectating is made uneasy – a silent, voyeuristic soliloquy. Rather than an open, iconic spread of the bodies, their hunched compactness refuses the spectator a familiar terrain, forcing the eye to wander undirected over Degas' textured surfaces. In the *Bathers*, the dynamics of engagement with the spectator appear, at first sight, to be insistently constituted at the formal level, and not through a complicity between spectator and subject matter sanctioned either by pictorial convention, or by familiar narrative structures (plate 7, figs. 38, 39). However, I would argue that the meanings inscribed in Degas' novel pictorial devices can be understood *not* by endless comparison with 'traditional' pictorial conventions, but by stepping outside the tautology of art history. For it is, rather, in scientific discourses that clues to the discursive modernity of the *Bathers* can be found.

The critic Gustave Geffroy noticed how Degas had viewed his model from all angles, from high and low, obliquely. Even within individual drawings, multiple viewpoints on the figure and on the setting are often combined. Pictorial logic and a unifying gaze, which could be guaranteed by using perspective and classical anatomy, are thus fragmented. This results in distortions of space, anatomy and proportions which literally dis-locate the spectator. Taken on a purely practical level, this fragmentation can be attributed to two related aspects of Degas' technical procedure. First, his practice of working close up to the model, where it cannot be taken in 'at a glance', results in a fragmented perception of the figure. The artist must constantly move his head and shift his viewpoint to take in the whole figure; thus distinct cones of vision on the figure must be amalgamated to form a single image. Degas consciously exploits this phenomenon, producing 'composite' figures which do not conform to a classical conception of the bodily unity.

Secondly, fragmentation results from Degas' techniques of piecing, tracing, transferring and cropping his compositions: his *bricolage* techniques. Several studies could be combined during the various stages towards a definitive image – a final

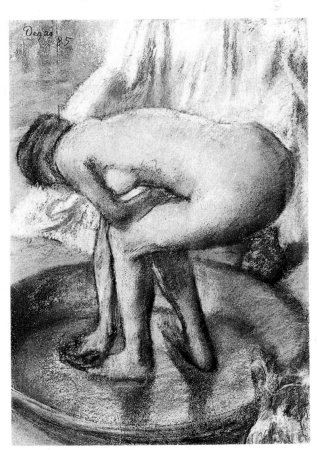

Fig. 38 Edgar Degas, *Woman Bathing in a Shallow Tub*, 1885, pastel on paper, 81.3 × 55.9 cm, Metropolitan Museum of Art, New York (Havemeyer Collection, formerly collection of Mary Cassatt), L 816.

167

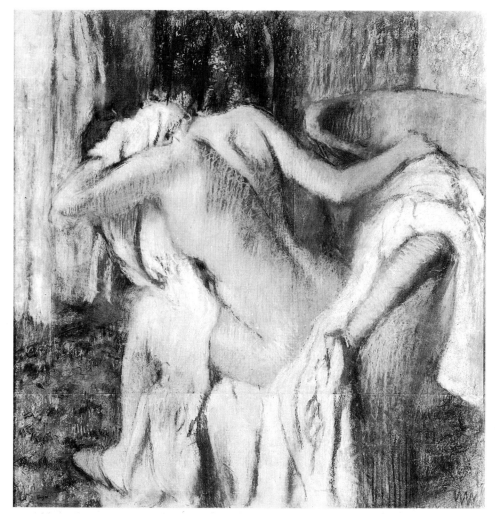

Fig. 39 Edgar Degas, *After the Bath, Woman Drying Herself*, later 1880s, pastel on several pieces of paper mounted on cardboard, 104 × 98.5 cm, National Gallery, London, L 955.

mise-en-page itself often modified by cropping or adding extra fragments. Spectating retraces Degas' handling; the moving eye follows the energetic rhythms of hatched line and the erratic shifts of broken contour. The dis-located gaze travels over the segmented body, attempting to recompose its whole from the cropped and disparate views. The visual exploration of each distinct curve and plane invokes the parallel sensation of touch, of a hand moving over the body. The metaphor is made vividly tangible by the visible imprint of Degas' own fingers, whether in the monotype ink, the clay of his sculptures, or in smudges of oil, or pastel.

Anatomical distortions which flatten and fix the figure into a shallow pictorial space can be seen in *The Tub* (plate 7), *After the Bath* (1884, Hermitage Museum,

Leningrad, BR 82) and *Woman Bathing in a Shallow Tub* (fig. 38), all shown at the 1886 exhibition. In *The Tub*, the jutting right knee is angled to create a central vertical and, reiterating the vertical of the left arm, to flatten and squash the figure into a square within the rectangle of the format. However, the knee does not connect to the thigh – which is far wider – and the fudged right hand disguises the leg's failure to connect with the torso. Both arms (the left forearm is particularly short) are anatomical oddities, and connect awkwardly to the trunk; stark tonal changes at the shoulders emphasise this dislocation, and the left shoulder-blade is particularly problematic.

In *After the Bath* the figure is again placed left of centre, in a flattening, square format. In the torso, a slippage to the right at waist level is disguised by the positioning of the left hand and the towel. The legs are again anatomically problematic, artificially twisted to the right to echo the framing edge. Behind the right thigh, the left leg is 'broken', the foot emerging at an impossible angle. This figure, too, is flattened and pushed forwards, within a shallow space closed by striped wallpaper which runs parallel to the picture plane. In *Woman Bathing in a Shallow Tub* (fig. 38) the spectator's glimpse of the left breast is maximised by its anatomically incorrect positioning in the figure's armpit; the rib-cage is exceptionally narrow from front to back. The twist of the back and shoulders relates only haphazardly to the ambiguous position and direction of the right, extended arm. This ambiguity is heightened by the pale negative shape which draws the eye to the breast; it is in this void between breast and left forearm that the figure's right arm should reappear.

The distortions of the figure in *Woman Bathing in a Shallow Tub* show Degas' technique of combining several distinct viewpoints on figure and setting. The angle of vision on the head is not consistent with that on the buttocks; no harmonising twist at hip level – to angle the upper torso away from us – is introduced to give authenticity to the acute angle from which the buttocks are seen. Pulling back from close scrutiny of the figure to examine the overall composition, figure and setting are seen from two distinct viewpoints. A high eye-level is used for the setting, which conflicts with the lower viewpoint on the figure itself. It is in the feet, where these incompatible angles of vision meet, that the disjunction is particularly obvious. The feet are carefully positioned – and intentionally left unfinished – in order to disguise the disparity of the views on figure and tub. Here, too, the reason for elongating the right forearm becomes clear: the positioning of the right hand in the same ground-plane as the left foot helps mask the conflicting plane of the tub.

The spectator both crouches with the figure, as if participating in its physicality, and stands erect gazing down on the scene from above – the distancing, controlling viewpoint. Effectively, the two viewpoints are themselves gendered: the low position equates with the feminine, the upright with the masculine. The viewpoints also inscribe the duality of touch and gaze: the desire for the physical, the tactile, the sensual, encoded as unselfconscious, atavistic absorption in the bodily self; and the fear of that desire signified by the rational, controlling viewpoint. In Degas' work,

the tension between the gaze – the desire to contain female sexuality – and the touch, the fascination with that sexuality, surfaces quite literally in such ruptures within the pictorial syntax.[18] The tactile senses are made inseparable from the activity of the gaze not only in Degas' anatomical and spatial dislocation of his subject matter, but also in his use of the pastel medium.

Pastel is an intrinsically tactile medium. Degas primarily exploits it not as a painting, but as a drawing material – one in which the mark-making process remains firmly in evidence. In 1867, the art theorist Charles Blanc articulated a common assumption about line and colour when he gendered them: 'Drawing is the masculine sex in art, colour in it is the feminine sex.' The hierarchisation of art thus explicity embodied sexual codes of superiority/inferiority. The architectural drawing, Blanc argued, was a copy of the 'ideal' born of the architect's pure thought; it was 'the idea itself . . . rising up in the architect's mind'. In sculpture, too, drawing was everything; colour was so alien to the medium as to be 'dangerous', playing if any, an accessory role. Even in painting, where colour was essential, it came second in rank to drawing; Blanc's sexual analogy was explicit:

> The union of drawing and colour is necessary to engender painting, just as is the union of man and woman to engender humanity; but drawing must conserve its preponderance over colour. If it is otherwise, painting will run to ruin; it will be lost through colour as humanity was lost through Eve.[19]

Blanc appealed to the 'laws of nature' to confirm his thesis. 'She', that is, nature, wished objects to be known by their drawn and not their coloured properties, for where the colour of objects rendered them indistinguishable, no two forms were the same. Colour (the feminine) connoted formlessness, the lack of distinguishing *traits*; drawing (the masculine) connoted legibility, individuality. In Degas' use of pastel, colour is articulated through line: line *becomes* colour. The dangerous, uncharted, feminine terrain (Blanc likens it to a desert camouflaging a lion) is colonised, mastered by the authority of Degas' drawing.

In *After the Bath, Woman Drying Herself* (fig. 39), for example, Degas' touch controls colour and directs the gaze. Touch is used to construct a taut composition which contains the female figure and carries its ambivalent meanings. The rich colour and texture of the setting weaves a dense surface fabric into which the figure is inextricably bound. The left arm and elbow are stated and restated, both in terms of containing outline, and of pastel striations to suggest the modelling of the fleshy upper arm. Background merges into form and form overlaps background, each without obliterating the other. The strong vertical hatchings of orange-yellow pastel shift into pink from the upper arm across to the left shoulder blade, the marks often resisting any form-following role. On the back, this pink tint over smudged black can be read as the careful recording of empirically observed effects of warm, reflected light in shadow, and of water-reddened flesh. At the same time these striking hatch-

Fig. 40 Edgar Degas, *Femme a Son Lever*, called *La Boulangère*, 1885–6, pastel on paper mounted on cardboard, 67 × 52.1 cm, The Henry and Rose Pearlman Foundation, L 877.

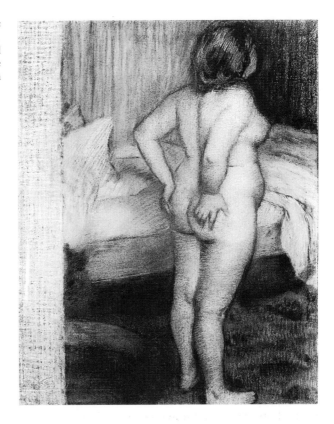

marks exist independently, linking to others of the same direction or colour across the composition.

 To the right of the torso, a late orange patch suggests reworking of the rib-cage contour, nipping in the waist and disguising alterations to the swelling hip-line. The orange stands out, refusing to lie in the background plane. It forces the eye to make a visual link with the prominent oranges elsewhere in the picture, particularly the touch representing body hair in the left armpit. This again draws attention to surface, to colour and texture resting on the picture plane, producing an oscillation between the readings of marked paper surface and described form in space. The taut interplay of line and colour, space and flatness, form and surface texture, are left unresolved, the figure held in a state of tense ambiguity. The *bricolage* of paper pieces which make up the support leave traces of the physical evolution of the work;[20] in this sense too, fragments and the whole achieve at best an uneasy co-existence. Fragments – the fractured, the broken, the dislocated – signify the feminine in the *Bathers* of Degas: 'a creature out of control';[21] the embattled fragments that are Degas resist the will to coherence.

 As Charles Blanc noted, pastel effects are characteristically light and airy in tone.[22] However, in Degas' *Bathers* the critics instead found monotonous bituminous tones

171

and a 'prejudice for darkness'. This was not merely a darkness of tone; it was a moral darkness signifying woman's 'sombre and gloomy nakedness', and 'taciturn indecency'. [23] A subtle sleight of hand here shifts the responsibility for signification from Degas/the critic, to the figured Woman. Ironically, in a society in which women had almost no public voice, and prostitutes were literally *déclassée* [24] and thus 'speechless', it is the Woman in Degas' work who is ascribed the power to signify: the 'taciturn indecency' is *hers*. Their impassioned partiality undisguised, Degas and his mediators nevertheless constitute themselves as disinterested observers.

Despite its 'dull, defective colour' the flesh (not the painting) was 'alive, becoming damp under the sponge, dry under the towel'. However, the pastels were 'too dark' and 'overdone'. [25] This is particularly apparent in *La Boulangère* (fig. 40), where the effort to hold the figure together, to *make it work*, involved numerous *reprises* which crushed the fragile pastel medium. The resulting deadness in the pastel surface is not immediately apparent even in colour reproductions, which impart a clarity and luminosity not present in the original. The overworked pastel surface elicited a reading of the 'flesh' itself as bruised and dead. Echoing the artist's touch, Desclozeaux's verbal exploration of the *Bathers* revealed that Degas 'brutally underlined the rough grain of the skin, the marks left by clothing, the traces of rouge and powder, the subtle tones of wet skin, the red marks caused by towelling'. To Geffroy, Degas revealed a tell-tale 'mottling and thickness' of the skin, with its connotations of sickness and disease. [26] The 'dead' pastel flesh thus signified the used flesh of the prostitute, as elaborated in the representations of prostitution in medical and sociological discourses. [27] Degas' unfamiliar handling (the term itself is telling) of this lean, opaque medium stands as a direct metaphor for the subject matter it constructed – 'the streetwalker's modern, swollen, pasty flesh'. [28] The anxiety which leaks from even the most enthusiastic reviews bears witness to the ambivalence between desire and revulsion – touch and gaze – constituted in Degas' 'distressing poem of the flesh'. [29]

V The *Bathers* and Personal Hygiene

Bourgeois interest in personal hygiene stemmed from a deep-rooted concern for public appearances and the visible signs of respectability. For this reason, cleanliness was associated less with personal ablutions, than with wearing clean clothes, particularly linen: white collars and cuffs were vital signs of status. Clean linen next to the skin was generally considered an adequate gesture towards personal hygiene. Its intimate contact with the flesh meant the fabric both scrubbed it, sloughing off old skin, and cleansed it, absorbing perspiration and odours. [30] The rapid expansion in the laundry trades was a direct result of the new consumer demand for clean linen; the habit of domestic bathing, which was consequently deemed less important, suffered a simultaneous decline. [31] Indeed, the bourgeoisie distrusted water and dampness. They continued to be linked not with hygiene, but with 'miasmas' – the source of disease in pre-Pasteurian beliefs – which were not easily relinquished.

The discourses of hygiene penetrated even the most intimate realms of the care

of the female body. However, attempts to encourage feminine hygiene were fraught with taboos. For the respectable woman, the most problematic aspect of bathing stemmed from the inculcated sense of shame which proscribed any contact, whether visual or physical, with her own body and in particular her genitals. One writer advised the woman to 'close her eyes' in order to be able to consummate the vital final stages of towelling herself dry.[32] Thus the simultaneous deployment of gaze and touch resulted, for woman, in a particularly dangerous – sexualised/ing – combination. In order to de-sensualise bathing, and to regulate female sexuality, gaze and touch had to be kept separate. For man, it was safe to look at the female body from a 'scientific' distance or via the *cordon sanitaire* of art. However, the separation of gaze and touch was problematised for the spectator of Degas' *Bathers*, where both materially (in terms of *facture*) and narratively, gaze and touch are simultaneously evoked.

Arguments for and against women washing their genitals were by no means clear cut. Religious moralists inveighed against the practice, on the grounds that it promoted indecent bodily self-awareness and masturbation. These destroyed that carefully fostered sense of shame through which habits of self-regulation were instilled in women. The ignorance promoted by clerics was directly opposed to the new, but equally intrusive, theories of lay medicine. In the latter, regular use of the bidet – particularly after menstruation – was advocated to prevent the harbouring and spread of disease. Other liberal thinkers decried this practice because it obliterated the intimate womanly smells considered so vital to the natural processes of voluptuousness and desire.[33]

Water was feared not simply because of its old association with disease. Writers both for and against intimate hygiene for women recognised the sensuality of water. They likened immersion in it and its intimate contact with every bodily crevice to the sexual act itself: water was perceived as a surrogate lover.[34] Water had always carried connotations of female sexuality, an image familiar from the iconography of the birth of Venus, where the goddess of carnal love emerges naked from the sea. Critics of the *Bathers* noted the implicit connection with this theme, emphasised in Degas' recurrent depiction of the flat bathing dish.[35] Rather more useful than affirming Degas' obvious interest in the classical tradition, it confirms that the critics viewed the *Bathers* as purveyors of carnal pleasure. In modernising the Venus theme to emphasise feminine hygiene, Degas reinforced this reading, for bathing was directly associated with lascivious sexual activity, in particular with prostitution; the corpulence popularly attributed to prostitutes was thought to result from an excess of bathing.

Just as the body of woman is fragmented in Degas' *Bathers*, so too is the discourse of female hygiene; separate washing of localised fragments of the body – face, hands, feet, genitals – were advocated as less compromising (less *sexual*) for woman, than complete immersion. She would not, therefore *visualise*, experience, her (bodily) self as whole: as wholly hers to *know*, and thus control, through her own gaze. A vision

fragmented and divorced from touch ensured woman's sexual ignorance, her partiality. Her body (her sexuality) would know no boundaries other than those imposed from *outside* from discourses dislocating the female body in order to relocate its meanings. The disturbing consequences of woman's transgression of her given boundaries emerges in a review which links the *Bathers* to Zola's fictional courtesan; *the unregulated body-care of the naked* woman marks the prelude to her sexual aggression: 'Nana bathing, washing herself with a sponge, taking care of herself, arming herself for the battle'.[36]

VI The *Bathers* and the Critics

From the *police des moeurs* to Perrier, to *eau de javel*, and from manuals on personal hygiene to Baron Haussmann's town planning, the bourgeiosie worked to eradicate the spectre of dirt and all it implied. Yet it was precisely this morbid fascination which fuelled the puritanical fires.

The same morbid fascination, this conflict between the desire to look and the fear of contamination, between gaze and touch, is discernible in Degas' *Bathers*, and in their meanings as constituted by his critics.[37] Fèvre wrote: 'In the ambiguous bedrooms of registered houses, where certain ladies fill the social and utilitarian role of great collectors of love, fat women wash themselves, brush themselves, soak themselves, and wipe themselves off in basins as big as troughs.' The fascination encoded in his verbal relish shifts to disgust in the final analogy with pigs, unequivocally connoting bestial filth. Ajalbert's phrasing also has bestiality foreclosing sensual pleasure: 'The water *slides over the skin* tensed from the strain of assuming simian positions.'[38]

Huysmans pictured Degas' *Bathers* as washing after the battle, rather than before. In levelling the activity of intimate bathing – 'regardless of [women's] . . . age, beauty, or status' – Huysmans gave his readers the 'unspeakable' reminder that it implicated the women of *their own class*: in doing so he assigned to *all* women the sexual status of prostitutes. For Huysmans continued, '. . . women must all at some time stoop . . . to remove filth from their bodies'.[39] 'Stooping' suggests washing the lower half of the body and thus the 'filth' was, by extension, overtly sexual in nature. It connotes both literal and moral filth: the filth of disease and that of the prostitutional 'seminal drain'.[40] The propagation, from 1885 on, of the modern theory of congenital syphilis charged the '. . . prostitute's image with new anxieties in learned discourse. The commercial woman henceforth threatens the genetic patrimony of the dominant classes.'[41] The spread of this hereditary disease through prostitution into the heart (sic) of the bourgeois family was experienced as a direct attack by the lowest classes: 'The virus incubated by the prostitutes sets in motion a process of *degeneration* that threatens to annihilate the bourgeoisie.'[42] The containment of this perceived female promiscuity was experienced as a battle for the very survival of bourgeois patriarchy. Huysmans' reading of the *Bathers'* activities mediated for the spectator Degas' pictorial constitution of this alarming discourse.

Thus for Huysmans, 'the significance of the action of bathing . . . was that it indicated the presence of filth'. While he could admire Degas' *artistic* mastery – the deviation from academic norms in the painter's oblique foreshortenings and radical elongation of anatomical segments – at the same time these distortions revulsed him. To him, they suggested '. . . degrading acts of self-mutilation on the part of the women'.[43] Huysmans' words connect the *Bathers'* actions with onanism. To contemporary readers, this was a clear reference to the popular theories of criminal anthropologists like César Lombroso, which categorised onanism as sexual deviancy. Masturbation, like other signs of physiological weakness disposing 'certain women' towards alcoholism, syphilis and indeed prostitution itself were all, to such theorists, evidence of a 'morbid heredity', an inbred biological degeneracy.[44] The social construction of woman as sexually degenerate, naturalised in the *Bathers* of Degas, had its discursive roots in the language of science. Sexual degeneracy was attributed to weaknesses in woman's *biological* constitution; the physical attributes which science codified as visible signs of those weaknesses were encoded in Degas' pictorial strategies.

As with Degas' handling of female anatomy, his depiction of flesh both attracted and repelled Huysmans. From admiring the beauty of the colour and the reflections on the skin, he shifted to seeing the pictures '. . . express a disgust for flesh as no artist has done since the Middle Ages'.[45] Here, in this reference to the Christian Gothic vision of the female body as the site of original sin, Degas' representation of female flesh again connotes the transgression of sexual (theological) boundaries, with its attendant guilt. The female body was deemed responsible for, and defiled by, sensual knowledge, and thus shame and humiliation were signified in the very *unselfconsciousness* of the *Bathers'* abandon to a world of purely physical sensation. In the light of this, and other critical references, to Gothic representations of the body, Degas' anatomical distortions take on a further layer of signification. His tortured twisting and dislocation of female anatomy suggest not only the pain of shame but its punishment.

Degas' *Bathers* were considered 'vulgar slatterns'; indeed, for Desclozeaux they were not even 'nudes' but a '. . . nakedness not enlivened by any touch of obscenity . . . a sad bestiality'.[46] For Mirbeau, too, the drawings did not inspire 'sensual desire . . . On the contrary, there is a ferocity that speaks of a disdain for women and a horror of love.'[47] Huysmans felt the drawings had strong *sexual* connotations, but this did not mean they spoke of pleasure or desire. The fractured female body spoke, rather, of woman's sexual objectification as a commodity in a system of cynical commercial exploitation. Of *La Boulangère* (fig. 40), Huysmans wrote: 'she is a creature whose vulgar form and coarse features invite continence and persuade to horror!'[48] Sensual desire, eroticism, even obscenity, then, would relieve for the male consumer this confrontation with Degas' relentless vision of the sexual atavism of woman. Yet it was in Degas' pictorial constitution of man's 'horror' – the making and the naming of it – in the face of this fantasised sexuality, that the cathartic function

of the work in allaying those fears lay.[49]

'Yet Degas had not imposed disgust on his subjects', Huysmans argued. Degas' pictures merely *revealed* the 'attitude of some women' towards 'the pleasures that they have provided.'[50] Again, the responsibility for signification was projected out on to the picture woman, rather than it being owned by Degas or his critics; the disgust was Huysmans'. This displacement was common to many of the critics: the line drawn between art and the fantasised reality was elusive. As one critic warned: 'Do not forget that the exhibition is only two steps from the street corner.'[51] The ambivalence between desire and revulsion is clear; admiration for Degas' skill and fascination with his images are frequently interspersed with horror. Disgust and fear sit uneasily beside repressed desire. Constituting the prostitute as culpable for the sexual needs of his class, Degas' images authorise the condemnation of the women whose bodies served those needs.

VII Bathing:
The Forbidden Sight and the Female Spectator

Javel's remarks on the 'excessive intimacy of [Degas'] subject', which he claimed not to find personally objectionable,[52] points to a crucial factor in the analysis of the *Bathers*: the social prohibition on observing personal ablutions. Injunctions to privacy in all matters relating to the sexual organs were innovations peculiar to nineteenth-century bourgeois society; recently imposed legal constraints on, for example, public urination and defecation, and river bathing for women, formed part of the broader project to impose throughout society a bourgeois sexual hegemony.[53] Although women bathing was available as a spectacle in prestigious brothels and amongst the *hautes courtisanes*, seeing a *Bourgeoise* was strictly proscribed even to the spouse in respectable bourgeois households. It was, however, vicariously accessible – and graphically described in titillating detail – in contemporary manuals of hygiene. In these manuals, bathing was a long and complicated ritual, at least among the few who could afford it. But even the inhabitant of the most modest apartment was advised to make space for a tub, which '. . . could be disguised behind a curtain'. The whole procedure had to be undertaken with the utmost secrecy, and with '. . . absolute certainty of not being disturbed'.[54] Such prohibitions contributed to the sexualisation of bathing.

Le cabinet de toilette of 1891 told the woman to 'make of her ''cabinet de toilette'' a sanctuary the threshold of which no one, not even a beloved husband, should cross when she threw herself into the practicalities of the cult of beauty'.[55] The intervention of hygienists was not restricted simply to washing. The injunction to constraint and privacy in the *toilette* was logically extended to matrimonial bed:

> Just as one shuts oneself in the water-closet to be screened from the gaze of others, so *hygiene* favours the conjugal bedroom with twin beds, set up to 'counter persistent nocturnal unions or the co-minglings of sweat and breath . . .'[56]

The fear of inhaling moisture-loving germs – those invisible, physical intruders – exacerbated the psychic terrors over securing personal boundaries. Here fears of contagion are linked to anxieties over promiscuity: 'persistent nocturnal unions'. The hygienists' discourse exploited genuine fears of disease in order to constitute sexual contact as co-extensive with contagion; the physical threat was used to contain the moral danger. Personal health became equated with personal privacy, with sexual restraint and, finally, with respectability. The ideological motivation is explicit: the regulation of hygiene is simultaneously a regulation of sexual practices. Inscribed in this quote as intrusive, tactile, the gaze is conflated with touch and, quite explicitly, with the physical contact between bodies in bed. The combination of gaze and touch is again problematised as overtly sexual, and the need to maintain a 'hygienic' separation between the two (as between man and woman), reiterated.

In reality, the sight of female bathing was available to the bourgeois male only through financial transactions, either with a prostitute, or between male artist and female model in the studio context.[57] Degas' *Bathers* signify on both levels. Since these pastels are clearly the product of a self-conscious studio set-up, they could feed into fantasies of the artist-model relationship, to which Degas thus gave the spectator privileged access. In fact, Degas' allusion to the artist-model relationship, and his 'exposure' not simply of bathing, but of prostitutes bathing, were made genuinely disturbing *only by their public context*.[58] In the art gallery setting, the female spectator – whose respectability depended upon ignorance of sexual matters – became implicated as a participant in the voyeuristic adultery of her male peers. Looking at Degas' *Bathers* was, for the *bourgeoise*, a transgression of the limits of feminine sexuality imposed by bourgeois ideology. This transgression threatened to disrupt the fragile boundaries of gender distinction by breaking the complicit silence surrounding the 'invisible' world of male libertinage and sexual commerce.

To my knowledge, none of Degas' critics refer to the problematic issue of female spectatorship. For the critics openly to acknowledge this threat in the discourse of art criticism would be literally to *publicise* it – to make it public – and thereby themselves break that complicit silence crucial to the maintenance of gender boundaries. Ironically, however, it did seem permissible to break the silence in *visual* criticism – for the female spectator does appear in caricatures.[59] In a page of cartoons lampooning the Fourth Independents' exhibition of 1879 (fig. 41), for example, most of the spectators depicted are in fact women. Within the conventions of pictorial caricature, it seems that denigration of the exhibited work, and dismissal of the seriousness of its intent, could more effectively be encoded in the female rather than the male spectator. The latter was thereby relieved of the responsibility of taking seriously novel work which might prove to be a humiliating jest. However, since gullibility and a lack of discerning judgement were attributed to woman, these could be unproblematically inscribed in the 'natural' emotional excesses of the female spectator.

Draner (Jules Renard) caricatures a variety of scenarios centred on the female

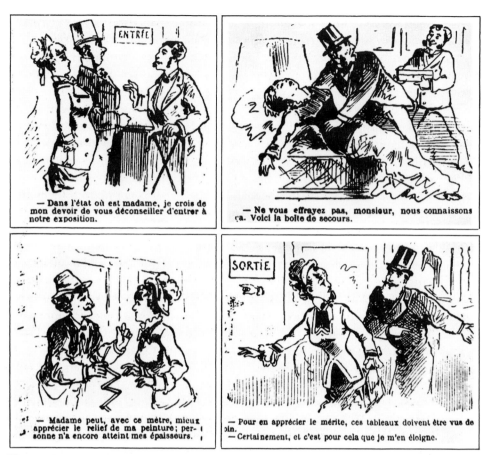

— Dans l'état où est madame, je crois de mon devoir de vous déconseiller d'entrer à notre exposition.

— Ne vous effrayez pas, monsieur, nous connaissons ça. Voici la boîte de secours.

— Madame peut, avec ce mètre, mieux apprécier le relief de ma peinture; personne n'a encore atteint mes épaisseurs.

— Pour en apprécier le mérite, ces tableaux doivent être vus de loin.
— Certainement, et c'est pour cela que je m'en éloigne.

Fig. 41 Draner (pseud. Jules Renard), 'Chez MM. les peintres indépendants', *Le Charivari*, 23 April 1879: caricatures of female spectators at the Fourth Impressionist Exhibition, 1879.

spectator. In each, woman is the protagonist on whom the meaning turns; man appears merely in supporting roles. The first image which strikes the reader, at the top left corner of the page, shows a woman accompanied by her husband – a respectable petit-bourgeois couple – at the entrance to the exhibition. She is visibly pregnant, and the caption speaks the words of the man (an artist?) on the gate, advising them against entering 'our' exhibition because of the woman's condition. The work would be such a shock to feminine sensibilities that a miscarriage might ensue. The female spectator's reaction was thus deemed to be physical – *sexual* – and not cerebral, as was man's. Since, in bourgeois ideology, woman was constituted in her reproductive function, the identification of the *womb* as the site of woman's responses is predictable. The womb connotes *hysteria*[60] – a popular diagnosis used to account for female 'neuroses', and designed to confine woman's transgression of the feminine within medical boundaries. Contractions of the womb pertain equally to childbirth and to orgasm, and thus, by inference, the female spectator's response

is explicitly sexual; art could provoke the resurgence of civilised, bourgeois woman's dark, libidinous nature and mark the onset of her atavistic degeneration. In this cartoon, Draner ascribes to the exhibition the power to dislodge the reproductive function as woman's 'natural' sexuality, and thus to destabilise society by undermining the bourgeois heterosexual norms and the nuclear family.

The second image on the top line shows a woman fainting from shock in the arms of her visibly alarmed husband; she is represented in a voluptuous attitude of display – emphasised by the solid black silhouette of her torso – which derives from fine art conventions of the female nude. The third figure in the cartoon carries a first-aid box, and the caption has him reassuring the husband that this is a familiar occurrence. Woman is again inscribed as being at the mercy of her physiological constitution: confronted with the shocking sight of this exhibition, her body takes over and she literally 'loses consciousness'. It is within the man's power to restore her to normalcy, thanks again to medical intervention.

Sexual innuendo is blatant in the image of a rather scruffy, disreputable artist engaged in an exchange with an unchaperoned *Parisienne*. He proffers his tape-measure for her to gauge the thickness of his *impastos*: '*personne n'a encore attient mes épaisseurs*' ('no one has yet matched my impastos'). The art, and the artist, are thus associated with corruption of the *ingénue*, and the spread of female promiscuity. The only other unchaperoned female included in the series is shown leaving the exhibition; her right hand reiterating the pictured hand which points to the exit, she hurriedly turns her back on the spectacle. A bearded and dandified artist-figure attempts to draw her back in with his opposing hand gestures, and in the caption he tells her the work needs viewing from a distance to be fully appreciated. Playing on the words *de loin* (from afar) and *je m'en éloigué* (I distance myself from it), the caption has her say that is why she *is* leaving – distancing herself from it. Woman (man?) is safe so long as she averts her gaze. Unlike caricatures of women *artists* in which masculine physiognomies are used to signify social and sexual deviancy via degeneration into a 'virile' atavism, the female spectator in these cartoons is the stereotypically pretty, feminine woman. It is, therefore, not *overtly* woman-as-sexual-rival who is represented here, but woman as the embodiment of respectability – the woman whose innocent gaze must be protected from corruption. However, beneath the coquettish charm, these figures embody the same discourse, aimed at neutralising the threat posed by female sexuality to male potency.

The discourse of Draner's 'text' centres on fears of female sexual transgression and its containment. His page of cartoons is laid out in a broadly narrative structure, the sequence beginning top left with entry to the exhibition and concluding, via two separate scenes of departure from the show, with a 'shot' of the publisher Dentu's window display. Significantly, the book titles are legible, and all carry double meanings. They play on words the ambivalence of which connotes both intellectual and sexual meanings; in them, the creative act is conflated with the sexual act. *De la sterilité* invites the reader to view the art of the *Indépendents* as creatively barren,

and the artists themselves as sexually sterile. *De L'impuissance* connotes both ineffectual art and impotent artists. *Conseils des hommes affaiblis* – advice to enfeebled men – refers to both sexual and intellectual weakness; *Les inutiles* means both the fruitless and the useless. The opening, *visual* constitution of modern art's impact on woman as aggressively sexual, is neutralised and foreclosed in the last cartoon: modern art is impotent (without *meaning*). It takes the power of the word – the published text – to render the art impotent, to contain the fantasy that woman's subjective visual experience might unleash her destructive sexual forces. In the first image, then, the terrifying, disruptive potential ascribed to woman's gaze is given its most explicit form, only to be returned, in the final image, to the safe confines of a 'scientific' discourse of impotence. Viewed from another angle, the pictorial narrative reveals its encoding of the feared consequences to man's potency of releasing the sexual appetites of woman. Here, even artists – those men mythically endowed with the greatest virility – can be rendered impotent by the Medusa-like gaze of woman. In this reading the images of woman again reveal themselves to be images *of man*. It also discloses the role of science as a discursive strategy designed to contain not woman, but man's fantasies.

These cartoons constitute the masculine view of the female spectator; they do not tell us anything of the real experience of women looking at the work, of a female subjectivity, a female sexuality. It is this subjectivity which constituted the threat to established gender boundaries and which was thus so vehemently excluded. The critics of Degas' *Bathers* in 1886 maintained this exclusion. They negotiated the danger by refusing it a public voice. However, giving voice now to this mute conflict helps not simply to explicate Degas' *Bathers*, or the ambivalence of his critics' reactions, but to articulate our own history, and the issues still at stake in women's struggle for speech.

Notes

1. Laura Mulvey, 'Visual Pleasure and Narrative Cinema', *Screen*, vol. 16, no. 3, 1975, p. 7, reprinted in Laura Mulvey, *Visual and Other Pleasures*, Macmillan, London, 1989. This important volume contains a number of essays relevant to the ideas discussed in the present paper.
2. Anthea Callen, *The Spectacular Body: Science, Sexuality and Difference in the Work of Degas*, London, Yale University Press (forthcoming).
3. 1 rue Laffitte, 15 May–15 June 1886; a facsimile of the Catalogue is reprinted in Charles S. Moffett, *The New Painting: Impressionism 1874–1886*, Oxford, Phaidon, 1986 (hereafter referred to as Moffett), pp. 443–7. Seven bather pastels have been identified as actually exhibited; Richard Thomson (*Degas: The Nudes*, London, Thames and Hudson, 1988, p. 131) gives six: Lemoisne 816, 872, Suppl. 113, 238, 822, 765. The catalogue *Degas* (Paris, 1988, p. 385) substitutes Suppl. 82 for L 738, and adds a pastel representing outdoor female bathers which is identified with L 1075, although the latter was substantially reworked by Degas

c. 1900, making any identification speculative. Further information will doubtless be available in Moffett's extended new edition based on *The New Painting*, to which I have not had access.

4. Robert Darnton, *The Great Cat Massacre*, Harmondsworth, Penguin Books, 1984, p. 193.

5. See Tag Gronberg, 'Femmes de brasserie', *Art History*, vol. 7, no. 3 (September 1984).

6. See Eunice Lipton, *Looking into Degas: Uneasy Images of Women and Modern Life*, Berkeley and Los Angeles, University of California Press, 1988; Alain Corbin, *Les filles de noce: misère sexuelle et prostitution (19ᵉ et 20ᵉ siècles)*, Paris, Aubier Montaigne, 1978, p. 90, refers to the use of shops selling luxury goods for women as fronts for brothels.

7. See Rachel Bowlby, *Just Looking: Consumer Culture in Dreiser, Gissing and Zola*, New York and London, Methuen, 1985.

8. Alex Potts, 'Dance, Politics and Sculpture', *Art History*, vol. 10, no. 1, (March 1987) p. 100.

9. Eunice Lipton, 'The Laundress in Late Nineteenth-century French Culture: Imagery, Ideology and Edgar Degas', *Art History*, vol. 3, no. 3 (September 1980), pp. 295–313, and Lipton (1988), op. cit., ch.3. See also Philippe Perrot, *Le Travail des apparences, ou le transformation du corps feminin XVIIIe–XIXe siècle*, Paris, Des Editiones du Seuil, 1984.

10. See A. Corbin, op. cit., especially Ch. 1.

11. See Alain Corbin on the impact of Pasteur's discoveries: *The Foul and the Fragrant. Odor and the French Social Imagination*, Leamington Spa, Berg Publishers, 1986; and 'Commercial Sexuality in Nineteenth-Century France: A System of Images and Regulations', in c. Gallagher and T. Laqueuer, *The Making of the Modern Body*, Berkeley and Los Angeles, Univ. of California Press, 1987, pp. 209–19; and 'L'Hérédosyphilis ou l'impossibile rédemption: Contribution à l'histoire de l'hérédité morbide', *Romantisme*, no. 31 (1981), pp. 131–49. See also Perrot, op. cit., p. 127ff.

12. P. Perrot, op. cit., pp. 111–12.

13. ibid., pp. 110.

14. On the transformation of Paris, see David Pinkney, *Napoleon II and the Rebuilding of Paris*, Princeton, New Jersey, Princeton University Press 1958, and H. Saalman, *Haussmann: Paris Transformed*, New York, Braziller, 1973; see also Marshall Berman, *All That is Solid Melts into Air*, London, Verso, 1985, esp. ch.3; on space/light, see P. Perrot, op. cit., p. 112.

15. Peter Stallybrass and Allon White, *The Politics and Poetics of Transgression*, London, Methuen, 1986, p. 135; and cf. M. Berman on Baudelaire, op. cit., p. 148ff.

16. See Carol Armstrong's discussion in 'Degas and the Representation of the Female Body', in Susan R. Suleiman (ed.), *The Female Body in Western Culture*, Cambridge, Mass., Harvard University Press, 1986, p. 234.

17. Feminist theorisations of this phenomenon – stemming from Freud's work on fetishism and explicating the constitution of woman as phallus, as the sign of male (fears of) castration – argue that representations of woman as *perfect*, effacing all sign of the 'wound' of castration, serve to confront man with an *other* in which lack can be disavowed. The female nude signifies not woman, but the phallus: '. . . it is her lack that produces the phallus as a symbolic presence, it is her desire to make good the lack that the phallus signifies' (L. Mulvey, 1975, p. 6). For Freud on 'Fetishism', see *The Standard Edition of the Complete Psychological Works of Sigmund Freud*, ed. James Strachey, London, The Hogarth Press and the Institute of Psycho-Analysis, vol. XXI (1927–31), 1961, pp. 152–7. See also, for example, Laura Mulvey, 'Fears, Fantasies and the Male Unconscious, or "You Don't Know What is Happening, Do You Mr Jones"', *Spare Rib*, 1973, reprinted in Mulvey, op. cit., 1989, pp. 6–13, and Griselda Pollock and Deborah Cherry, 'Woman as Sign: Psychoanalytic Readings', in G. Pollock, *Vision and Difference*, London, Routledge, 1988, pp. 120–54, and Jacqueline Rose, 'Sexuality in the Field of Vision' (1985), reprinted in her book of the same title, London, Verso, 1986, pp. 225–33. This approach is more fully developed in my book on Degas, see n.2, above. Although the very recent appearance of Charles Bernheimer's *Figures of Ill Repute: Representing Prostitution in Nineteenth-Century France*, Cambridge, Mass., Harvard University Press, 1989, has meant that I have not taken his discussion into account here, his chapter on 'Degas' Brothels: Voyeurism and Ideology' incorporates psychoanalytic approaches to Degas' monotypes. See also the Conference papers by Griselda Pollock and Heather Dawkins published in the present volume.

18. Carol Armstrong's essay, 'Degas and the Representation of the Female Body', in S. R. Suleiman (ed.), op. cit., pp. 223–42, offers a different reading of the gaze-touch problem in the *Bathers*.

19. Charles Blanc, *Grammaire des arts du dessin*, Paris, 1867, pp. 22–3.

20. See my technical analysis of this picture in Waldemar Januszczak (ed.), *Techniques of the World's Great Painters*, New Jersey, Chartwell Books, 1980, pp. 110–13.

21. Gustave Geffroy, in *La Justice*, 26 May 1886, paraphrased by Martha Ward in 'The Rhetoric of Independence and Innovation', in Moffett, op. cit., p. 433.

22. Charles Blanc, op. cit., p. 625.

23. Paul Adam, *La Revue Contemporaine, Littérature, Politique et Philosophique*, April 1886, quoted in Moffett, op. cit., p. 454; Jules Desciozeaux, *L'Opinion*, 27 May 1886, quoted in Moffett, op. cit., p. 453.

24. Registered prostitutes, according to Jill Harsin (*Policing Prostitution in Nineteenth-Century Paris*, Princeton, New Jersey, Princeton University Press, 1985), suffered two kinds of social marginality, the one economic – a commonplace – the other of administrative origin p. 206; since regulated prostitution was officially *tolerated*, but neither legal nor illegal, card-carrying prostitutes were literally outside the law p. 6. Inscription of the prostitute meant 'the transformation ipso facto of

a woman, enjoying until then all rights, into a woman *soumise*, following the consecrated expression, submitted to the administrative actions of the police, subject to certain police regulations, subject to corporal examination, and riveted by official patent to the most abject prostitution.' (Alfred Fournier, 'Prophylaxie publique de la syphilis', *Annales d'hygiène publique et de médecine légale*, 18, 3rd sér. [1887]; p. 74, quoted in Harsin, p. 212); see also pp. 234–7, and for their lack of rights before the medical profession, pp. 96, 120. A Corbin (1978), op. cit., stresses the government's deliberate 'marginalisation' of the prostitute. The unregistered prostitute – *insoumise* – did not even have the dubious benefit of being an officially recognised (card) number.

25. Jean Ajalbert, *La Revue Moderne* [Marseille], 20 June 1886, quoted in Moffett, op. cit., p. 454; Jules Christophe, *Le Journal des Artistes*, 13 June 1886, quoted in Moffett, op. cit., p. 453.

26. G. Geffroy, op. cit., quoted in Moffett, op. cit., p. 453.

27. On the literal and discursive links between prostitution, abattoirs and anatomical dissection see, in particular, A. Corbin, 'Commercial Sexuality in Nineteenth-Century France: A System of Images and Regulations', op. cit.; see also J. Harsin, op. cit., p. 120.

28. Henry Fèvre, *La Revue de Demain*, May–June 1886, quoted in Moffett, op. cit., p. 453.

29. G. Geffroy, op. cit., quoted in Moffett, op. cit., p. 453.

30. P. Perrot, op. cit., p. 115.

31. ibid., p. 108.

32. ibid., p. 117 and n.47.

33. See P. Perrot, op. cit., pp. 119–20. On the history of bourgeois sexuality, see Michel Foucault, *The History of Sexuality*, vol. 1, Harmondsworth, Penguin Books, 1979; for a case study of sexuality and medicine in England, see Frank Mort, *Dangerous Sexualities: Medico-Moral Politics in England since 1830*, London, Routledge and Kegan Paul, 1987. This work is also one of a number of recent contributions which argue important historical parallels between the regulatory discourses on sexuality and disease with regard to syphilis, and to AIDS.

34. P. Perrot, op. cit., pp. 116–17; he also notes that excessive bathing for men was considered *effeminizing*, partly because it was evidence of self-indulgence, p. 117.

35. For example, J. M. Michel, *La Petite Gazette*, 18 May 1886, quoted in Moffett, op. cit., p. 453; Félix Fénéon refers to the tubs as shells – 'la coque des tubs', in 'les impressionnistes', *La Vogue*, 13–20 June 1886, reprinted in *Au-delà de l'impressionisme*, Paris, Hermann, 1966, p. 58.

36. J. M. Michel, op. cit., quoted in Moffett, p. 453; P. Perrot, op. cit., p. 118, refers to fragmented, fragmentary bathing. On woman's 'partiality' as a sign of her 'lack', which highlights the link between my argument here and theories of woman as phallus (see n.17, above), see Kaja Silverman, *The Acoustic Mirror: The Female Voice in Psychoanalysis and Cinema*, Bloomington and Indianapolis, Indiana

University Press, 1988, p. 31. I am grateful to Griselda Pollock for bringing this book to my attention.

37. Regardless of the critical position of the reviewer, what artist and critics all had in common was the viewpoint of their gender and their *intelligenzia* class.

38. Fèvre, op. cit., quoted in Moffett, op. cit., p. 453; Ajalbert, op. cit., quoted in Moffett, op. cit., p. 454.

39. Joris-Karl Huysmans, 'Certains', *Oeuvres complètes*, no. 10, pp. 20–5, Paris, 1929, paraphrased by Martha Ward, op. cit., in Moffett, op. cit., p. 431.

40. See A. Corbin, particularly his 'Commercial Sexuality in Nineteenth-Century France . . .', in C. Gallagher and T. Laqueur (ed.), op. cit., p. 211.

41. ibid., p. 212.

42. ibid.

43. Huysmans, op. cit., Ward paraphrasing in op. cit., in Moffett, op. cit., p.431.

44. See Caesar Lombroso, *The Criminal in Relation to Anthropology Jurisprudence and Psychiatry*, London, 1876 and, in particular, Caesar Lombroso and William Perrero, *The Female Offender*, London, 1893, pp. 28, 101–2, 112–13.

45. Huysmans, op. cit., quoted in Ward, op. cit., in Moffett, op. cit., p. 431.

46. Desclozeaux, op. cit., quoted in Moffett, op. cit., p. 453.

47. Octave Mirbeau, *La France*, 21 May 1886, quoted in Moffett, op. cit., p. 453.

48. Huysmans, op. cit., quoted in Moffett, op. cit., p. 454.

49. On the fetishism and man's disavowal of 'woman's wound' – the fears of castration, see Freud's essay on 'Fetishism', op. cit., and Laura Mulvey, 'Fears, Fantasies and the Male Unconscious . . .' in op. cit., (1989); see also n.17, above.

50. Huysmans, quoted in Ward, op. cit., in Moffett, op. cit., p. 431.

51. Michel, op. cit., quoted in Moffett, op. cit., p. 453.

52. Firmin Javel, *L'Evénement*, 16 May 1886, quoted in Moffett, op. cit., p. 453.

53. See for example, P. Perrot, op. cit., pp. 108–13, and especially pp. 130–3, 252, n.150; in this volume, Heather Dawkins refers to the regulation of river bathing for women (see pp. 202–17).

54. Comtesse de Tramar, *A la conquète de la bonheur*, Paris, 1912, p. 69, quoted in P. Perrot, op. cit., p. 134.

55. Baronne Staffe, *Le Cabinet de toilette*, Paris, 1891, pp. 4–5, quoted in P. Perrot, op. cit., p. 253, n.162.

56. P. Perrot, op. cit., p. 134, and quoting Dr Degoix, *Hygiène de la toilette*, p. 144.

57. Heather Dawkins refers to a connection, made by one of Degas' critics, between the *Bathers* and Turkish baths; citing contemporary evidence on the latter, she argues that the *Bathers* may indeed represent 'unsuspecting' *bourgeoises*, since 'clandestine' peep-holes were a feature of female Turkish baths. Although it has not been possible for me to follow up this interesting lead, it is, however, clear from the anatomical characteristics of the figures Degas constructs (and from the critics' readings), that these bodies connote *work* – i.e. petit-bourgeoise or a lower class – since there is no anatomical evidence of tight corsets.

58. I am indebted to Griselda Pollock's discussion of this important issue in 'Modernity and the Spaces of Femininity', in op. cit., pp. 60–90.

59. For further discussion of representations of the female spectator of art in later nineteenth-century caricature, see Anthea Callen, 'An (Im)Material View: Images of the Female Spectator of Art in 1879', in Brian Rigby (ed.), *French Literature and Culture in the Nineteenth Century: A Material World*, London, Macmillan (forthcoming), and for an extended analysis of representations of the female spectator of art, see Anthea Callen, *The Spectacular Body: Science, Sexuality and Difference in the Work of Degas*, London, Yale University Press (forthcoming), chs. 'Anatomy of the Female Spectator' and 'Gendered Rights: Degas, Cassatt and the Female Spectator'.

60. See, for example, Elaine Showalter, *The Female Malady*, London, Virago, 1987, ch.6. For Freud on hysteria, see Joseph Breuer and Sigmund Freud, *Studies on Hysteria*, in J. Strachey (ed.), op. cit., vol. II (1893–5), London, 1955. For an interesting analysis of Charcot's photographs of hysterics, and of Freud's work on Hysteria with Charcot in Paris, see Joan Copjec, 'Flavit et Dissipati Sunt'. In A. Michelson, R. Krauss, D. Crimp and J. Copjec (eds.), *October: The First Decade, 1976–1986*, Cambridge, Mass., MIT and October Magazine, 1987, pp. 296–316. See also Jan Goldstein, 'The Hysteria Diagnosis and the Politics of Anticlericalism in Late Nineteenth-Century France', in *Journal of Modern History*, no. 54, June 1989; and Ann-Louise Shapiro, 'Disorderly Bodies/Disorderly Acts: Medical Discourse and the Female Criminal in Late Nineteenth-Century France', in *Genders*, no. 4, Spring 1989.

Signs and Non-Signs: Degas' Changing Strategies of Representation

Richard Kendall

Amongst the many debates surrounding Degas' images of women, surprisingly few have been concerned with the visual structures of the pictures themselves and the ways in which they constrain or direct the viewer's response to the subject. [1] Whilst the analysis of pictorial language is still a contested and ill-defined procedure, there is every reason to believe that it should be part of any approach to Degas' imagery. His own contemporaries repeatedly singled out the mechanisms of Degas' pictures for comment, hinting that the asymmetrical compositions, discontinuous spaces, curiosities of focus and oddities of pose were signs of a new sensibility, or of a changing dialogue between subject and spectator. There is also evidence that the artist himself had an unusually deliberate approach to such matters and that some of these signs and structures were adopted, and subsequently discarded, as part of a self-conscious strategy of representation. [2] Though we are not entitled to assume that these structures had uncomplicated meanings for either the artist or his contemporaries, or that such an analysis will grant a privileged access to a modern audience, there remains an urgent need to identify, scrutinise and evaluate them. The tendency to discuss subject-matter without reference to pictorial organisation; to gather Degas' work into undifferentiated groupings, such as the brothel monotypes or pastels of the female nude, regardless of their discontinuities; to shy away from contact with original works of art and to neglect considerations of scale, composition and technique; and to disregard the developmental nature of Degas' pictorial syntax, can all vitiate what might otherwise be productive speculation.

An analysis of a group of Degas' images of women from the 1870s helps to establish some of the visual procedures which characterised his work at the beginning of his public career. The *Dance Class* (fig. 42), one of the artist's pioneering ballet pictures, was executed in 1871 and exhibited at the First Impressionist Exhibition in 1874. The space depicted is both broad and deep, with a clear demarcation between foreground, middle distance and background. The room itself is precisely described, from its high doors and tall mirrors to the bare expanse of its rehearsal floor and

unadorned walls. Within this spacious and articulate arena, the artist has introduced a number of relatively small figures and a generous array of properties. Nine ballet-dancers (and their attendant reflections) are carefully differentiated from each other in pose, costume and hair-colouring, whilst an elderly musician presides over a sombre still-life of piano, watering-can, top hat and violin case. Throughout this unusually small painting, detail is sharply focused, as if the artist aimed to concentrate the maximum amount of visual information into its modest confines.

A few days before the *Dance Class* was put on show in 1874, Degas wrote to his friend James Tissot to persuade him to participate in the forthcoming exhibition. Though Degas and his colleagues had yet to decide on a name for themselves or their exhibition, the letter to Tissot makes Degas' perception of the event very clear. He wrote; 'The Realist movement no longer needs to fight with the others, it already *is*, it *exists*, it must show itself as *something distinct*, there must be a *salon of realists*.'[3] While Degas never defined what 'realism' meant to him, the *Dance Class* and the nine other pictures he exhibited in 1874 provide a number of clues. Each of the subjects chosen (four scenes of the ballet, three of the race-track, two of laundresses and one *après le bain*) is conspicuously urban and contemporary, and each stresses the informal nature of the action depicted.[4] Most of the pictures show wide, panoramic vistas and, like the *Dance Class,* incorporate a number of small figures in a deep and minutely

Fig. 42 Edgar Degas, *Dance Class*, 1871, oil on panel, 19.7 × 27 cm, Metropolitan Museum of Art, New York (Havemeyer Collection), L 297.

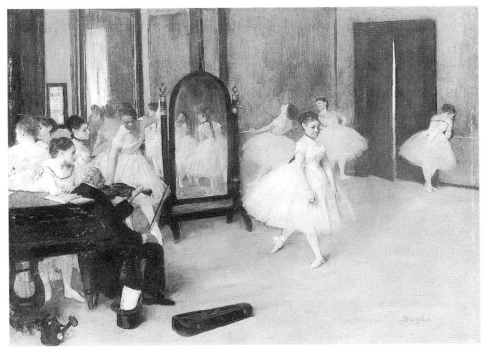

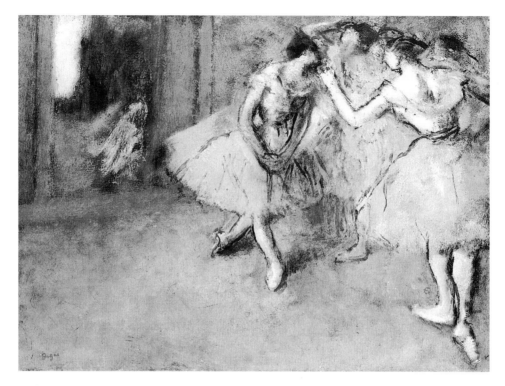

Fig. 43 Edgar Degas, *Group of Dancers, c.* 1898, oil on canvas, 46 × 61 cm, National Gallery of Scotland, Edinburgh, L 770.

described space. Visual definition is sharp and continuous, with costumes, furnishings and paraphernalia carefully documented and rooms or landscape settings crisply focused. So insistent was the visual documentation that some critics noted in adversely; even Emile Zola, the champion of descriptive Realism in the novel, suggested that Degas spoiled his pictures by an excessive attention to detail.[5]

By the time of the Second Impressionist Exhibition of 1876, Degas had met and befriended one of Zola's admirers, the novelist and critic Edmond Duranty. In his essay *La Nouvelle Peinture*, published in 1876 soon after the opening of the exhibition, Duranty quoted with approval Zola's claim that 'Science requires solid foundations, and it has returned to the precise observation of facts. And this thrust occurs not only in the scientific realm but in all fields of knowledge'.[6] In the field of the visual arts, this 'precise observation of facts' had a number of important implications. Duranty himself wrote that:

> . . . we will no longer separate the figure from the background of an apartment or street. In actuality, a person never appears against neutral or vague backgrounds. Instead, surrounding him and behind him are the furniture, fireplaces, curtains and walls that indicate his financial position, class and

profession. The individual will be at a piano, examining a sample of cotton in an office, or waiting in the wings for the moment to go onstage, or ironing on a makeshift table. [7]

It is clear that Duranty had Degas' own pictures in mind, both in this passage and in the wider argument of his essay. For both writer and artist, the description of 'backgrounds' helped to define the narrative and identify its protagonists. Deep space, clear lighting and a high degree of detail encouraged the 'precise observation of facts' and enabled the artist to characterize his subject through gesture, physiognomy and costume. Duranty went on to describe the other pictorial strategies appropriate to the New Painting, again echoing known pictures by Degas, 'the large expanse of ground or floor in the immediate foreground', the viewpoint that 'is sometimes . . . very high, sometimes very low' and the figure that 'is not shown whole, but often appears cut off at the knee or mid-torso, or cropped lengthwise'. [8] Here the emphasis is on the immediacy and informality of modern visual experience expressed through the structures of the painted image; the truncated figure and the dislocated viewpoint are, quite literally, signs of the times.

The significance of Degas' imagery in the 1870s becomes even more evident when it is compared with his work from subsequent decades. His *Group of Dancers* (fig. 43) was painted more than twenty years after the *Dance Class*, but its principal subject is effectively the same. The central ballerina is a direct descendant of the corresponding figure in the 1874 painting, while the lateral group of dancers, the asymmetrical composition and the mirror or doorway all recall the earlier work. As visual structures, however, the two images differ radically. In the *Group of Dancers*, as so often in his

Fig. 44 Edgar Degas, *Beach Scene*, 1877, oil on paper, 47 × 82 cm, National Gallery, London, L 406.

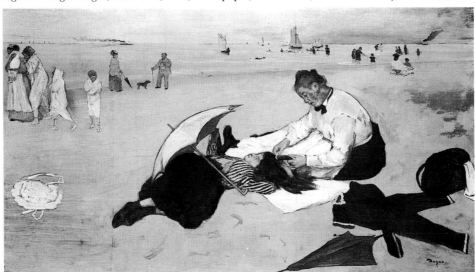

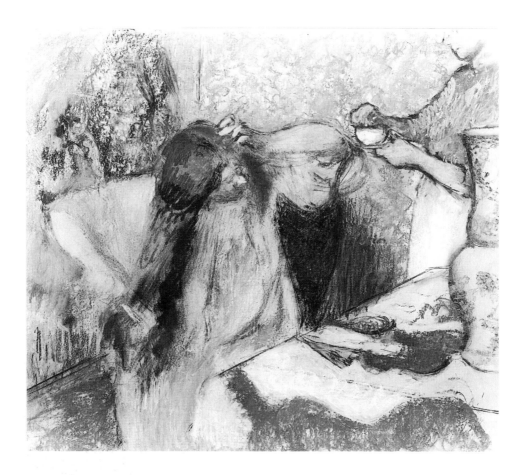

later work, Degas has moved closer to his subject, allowing the figures to fill the frame and confining them to a shallow foreground space. As a direct consequence, the room itself is largely excluded from the picture rectangle, along with the furniture, accessories and supporting cast so much in evidence in the *Dance Class*. Not only have such crucial indicators been removed, but the little that remains is so lacking in definition that its significance is far from clear. The depicted dancers might be engaged in exercise, in relaxation or even in dancing, but they lack facial features and all other signs of individuality; even the ominous void to their right is only recognisable as a mirror by comparison with earlier versions of the scene.[9] In place of the 'precise observation of facts' we have ambiguity and inference, set against one of those 'neutral and vague backgrounds' that Duranty had earlier deplored.

The tendency for Degas' images of dancers to become less informative and less historically specific is paralleled in many of his other female subjects.[10] While Degas' art is not entirely consistent in its development, and important exceptions to this tendency can be found, other themes show a similar progression from the inclusion of signs of narrative and identity towards their exclusion. *Beach Scene* (fig. 44), shown

by Degas in the Third Impressionist Exhibition in 1877, has the deep space, panoramic sweep and sharp focus already identified in the slightly earlier *Dance Class*. Like that picture, background and accessories are used to define the protagonists, though in *Beach Scene* the figures themselves are both more prominent and more informative. Not only are their costumes, limbs and deportment more expressive of their roles, but their faces are particularised and suggestive. The maid's weather-beaten complexion contrasts with the paleness of the child's, while the older woman's heavy features, which reflect a stereotypical view of working-class appearance, accentuate the delicacy and refinement of her *protégée*. Such attention to physiognomy is conspicuous in Degas' work during the 1870s and early 1880s, but becomes noticeably less common in subsequent years. A comparable scene from the 1890s, *Woman at her Toilette* (fig. 45), shows a later variant of the hair-combing motif. Once again, the artist has moved closer to his subject, confining the figures to a shallow space and excluding all but the most rudimentary information about the room and its contents. While the picture is at least as complex in its implications as the earlier

Fig. 45 *Left* Edgar Degas, *Woman at her Toilette*, c. 1894–1900, pastel, 95.6 × 109.9 cm, Tate Gallery, London, L 1161.

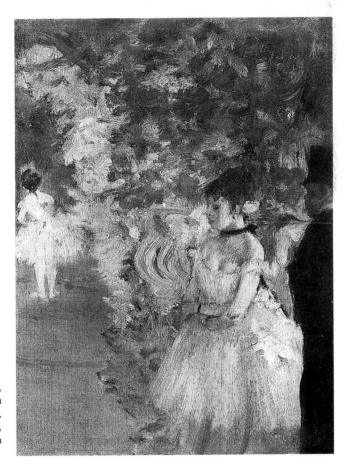

Fig. 46 *Right* Edgar Degas, *Dancers Backstage*, c. 1877, oil on canvas, 24.2 × 18.8 cm, National Gallery of Art, Washington DC (Ailsa Mellon Bruce Collection), L 1024.

191

Beach Scene, our attention is here concentrated on the rhythmic movement of the seated figure and the contrasting immobility of her maid. More remarkably, both women are effectively featureless, the maid's head cropped by the edge of the picture and the face of her mistress averted and lost in a blur of pastel. Though their class identities are still mutely signalled through costume and posture, these two women, like the figures in *Group of Dancers* and many of the artist's later works, have been rendered anonymous. By removing the definitive sign of their individuality, Degas has turned his models into representatives of their sex rather than particular idiosyncratic human beings.

A third picture from Degas' early years introduces another of his standard female subjects and a further example of his pictorial sign-language at work. *Dancers Backstage* (fig. 46) shows two ballerinas dressed in their finery, standing in the wings at the theatre and waiting for the performance to begin. The delicate pinks of their *tutus* harmonize with the complementary greens of the scenery, while the soft lighting might suggest a relaxed and innocent moment before the rigours of the dance. Crucial to the meaning of the picture, however, is the dark vertical form at the right-hand edge, a virtual silhouette that can just be identified as a male figure in top-hat and evening dress. This figure would have been instantly recognisable to Degas' contemporaries as an *abonné*, or regular subscriber to the theatre, who could go behind the stage and watch the proceedings from the wings, and could also mingle with the dancers before and after performances. It was widely known that such encounters were more sexual than cultural in intention, and that these backstage areas had become a virtual market-place for transactions between wealthy *abonnés* and under-paid dancers.[11] The inclusion of the male figure in *Dancers Backstage* and his suggestive proximity to the foreground dancer, explicitly places the scene in such a context, just as the hypothetical exclusion of this figure would, at the very least, have reduced the possibility of such a reading. This same dark-suited figure appears frequently in Degas' ballet pictures of the period, sometimes alone and sometimes in predatory flocks, but its emblematic role as a sexual indicator is never in doubt. In contrast to the colourful and diaphanous dancers, the male figure is often rendered as a black vertical smudge, as if to reduce it to an anonymous and abstract sign of masculinity. Beyond the subject of the ballet, and in even less ambiguous circumstances, Degas used the same stereotype in his brothel monotypes, where a number of male customers are pared down to sinister attenuated shadows.[12]

The figure of the lurking *abonné*, with all its connotations of sexual commerce, is conspicuous by its absence in Degas' later work. Though the subject of dancers posed in the wings remained amongst Degas' favourites, the dark-suited male spectator effectively disappears after the mid–1880s.[13] A pastel such as *The Red Ballet Skirts* (fig. 47) executed in the late 1890s, is characteristic of many hundreds of such studies, ostensibly showing a moment of respite off-stage during or after a performance. Attention is centred on the figures of the dancers as they lean against the scenery, stretch their tired limbs and adjust their clothing, and on the brilliant

Fig. 47 Edgar Degas, *The Red Ballet Skirts*, *c.* 1895--1900, pastel, 18.3 × 62.2 cm, Burrell Collection, Glasgow Museums and Art Galleries, L 1372.

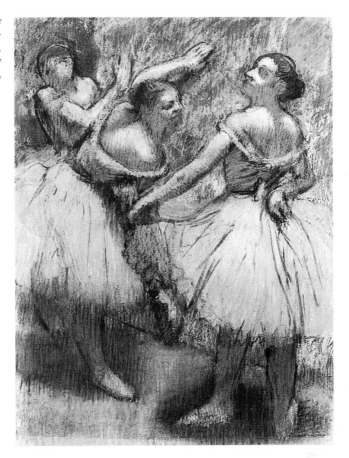

colours of their costumes. Not only have the accessories and incidentals of backstage life been excluded but there are no references of any kind to male figures, whether predatory or otherwise. While it can be argued that the furtive male observer is still present in the person of the artist, Degas' elimination of the *abonné* figure inevitably redefines the sexual climate of his late work. It has not often been noticed that these works are also free of the male musicians, *répétiteurs* and sundry theatrical dignitaries who populate such pictures as the early *Dance Class*. While the significance of the male figures may range from the rapacious to the bland, the artist's decision to banish them from his pictorial repertoire is part of a wider rejection of images of sexual confrontation and an inclination towards gender-specific subjects. The overt sexual aggression of Degas' early history paintings, and even the juxtaposition of the sexes in portraits and genre pictures such as *Interior* (plate 2), have almost no parallels in the final decades of Degas' career. [14]

The Red Ballet Skirts may be seen as a vivid summary of many of Degas' pictorial strategies in his later images of women. The virtual absence of a visible background reduces the specificity of the scene, while the broad handling of the pastel precludes

193

'the precise description of facts' advocated by Zola and Duranty. The faces of the dancers are powerfully modelled, but include few details or evidence of individuality. Throughout the picture, signs of identity, context and narrative have been stripped away, leaving only the figures and costumes of the women and the expressive structure of the composition to animate the subject. A number of commentators have seen such images as a progression towards 'abstraction', though the works themselves and the circumstances of their production hardly support such a view.[15] It is known, for example, that amongst his many and varied working practices, Degas continued to pose models for his drawings and sculptures until the last years of his career.[16] While the two principal dancers in *The Red Ballet Skirts* may both have been based on a single model, each suggests the gravity and particularity of a human figure carefully scrutinised. The muscular shoulders of the foreground dancer and the awkward but finely studied pose of her companion are the product of a continuing dialogue with observed reality. Though the physiognomy of his models is often generalised or concealed, it can be argued that Degas' responsiveness to the nuances and brute facts of the human body increased with its own advancing age.[17]

The marked tendency towards the elimination of precise visual indicators in his later work has other consequences for Degas' images of women. By suppressing the background and reducing the incidental detail of a picture, Degas consistently heightens the role of the figures themselves and draws our attention to the articulation of their bodies, the gestures of their limbs and the colours and textures of hair, skin and fabric. In effect, the depicted female figure is called upon to define its own identity. While this identity may be highly specific as far as physique and deportment are concerned, the woman's activity is often allowed to remain unclear. There is evidence that this lack of clarity, or even a wilful pursuit of obscurity, became part of Degas' later artistic programme. In some of the preparatory drawings for *The Bath, Woman Seen from Behind* (fig. 34), for example, the woman's raised arm is shown rubbing her leg with a towel, but the removal of the towel from the finished canvas has left her gesture suspended and unexplained.[18] In a number of late works, such calculated ambiguity results in poses that are tantalising but inscrutable, proportions and spatial relationships that are contradictory, and even distinctions between subjects that have become blurred; certain of Degas' later drawings, for example, appear to show ballerinas who are entirely naked, while some of his sculptures have been identified as both nudes and dancers.[19]

The deliberate construction of ambiguity in much of Degas' later work may be related to a wide variety of factors, ranging from his changing technical concerns to the shifts in his social and political attitudes. In common with many of his former Impressionist colleagues, Degas had gradually moved away from the documentation of urban life towards an art that was more studio-based, tradition-conscious and self-referential. Socially-specific themes, such as the Milliner's Shop, the Café-Concert, the Circus and the Laundry, were effectively abandoned after the mid-1880s and the subject of the female figure, posed either as a nude or as a dancer,

194

dominated Degas' later imagery. Along with many artists in their maturity, Degas also evolved a broader, less descriptive handling of line and colour, sometimes dissolving the detail of his pictures in a haze of pastel or oil-paint. While the documented decline of his eyesight may have contributed to this and other features of the artist's late work, there has been a tendency to use this explanation inexactly or uncritically. [20] Degas' relationship to the Symbolist movement is another little understood aspect of these years, but his recorded admiration for artists such as Gauguin, Redon and Carrière may indicate a shared interest in veiled subject-matter and suggestive form. Most tellingly of all, the artist who had once urged his friend Tissot to join the 'Salon of Realists' now openly criticized his own former position. On a number of occasions in later life Degas mocked the naturalism of Zola's novels and distanced himself from pedantic realism in painting; [21] he told the artist Georges Jeanniot:

> At the moment, it is fashionable to paint pictures where you can see what time it is, like on a sundial. I don't like that at all. A painting requires a little mystery, some vagueness, some fantasy. When you always make your meaning perfectly plain you end up by boring people. [22]

A comparison of Degas' pictorial strategy in the 1870s with that of the 1890s has suggested that this reluctance towards 'making his meaning perfectly clear' was a progressive and perhaps calculated feature of the artist's developing imagery. It might also be expected that this tendency would begin to show itself in the intervening decade, the 1880s, when Degas' work passed through a number of transitional phases, perhaps even crises. [23] In this decade, one of the most public manifestations of Degas' art was the group of pastels of the female nude shown at the final Impressionist Exhibition in 1886. Since their first appearance, these pastels have provoked widespread debate, much of it centred on their subject-matter and the identities of the women depicted. Degas himself listed them in the 1886 catalogue as 'Women bathing, washing themselves, drying themselves, wiping themselves, combing their hair or having it combed', but it has subsequently been argued that the artist specifically intended these women to be seen as prostitutes. [24] A number of contemporary critical responses to the pastels have been analyzed, but there have been few attempts to understand the pictures in terms of Degas' own established visual syntax.

Recent research into the 1886 pastels has suggested that *The Tub* (plate 7), *Woman Bathing in a Shallow Tub* (fig. 38), *La Boulangère (Femme à son Lever)* (fig. 40) and *After the Bath* (1884, Hermitage Museum, Leningrad, BR 82) were amongst the six or seven pictures originally shown. [25] While there are important differences of size, format and technique within the group of pastels, there are also a number of pictorial strategies that are common to them all. In each picture, an unusually closer view-point has been adopted, allowing the woman's body to dominate the composition

and even to project beyond the picture rectangle. The room itself, as a consequence, is largely excluded from our view, and we see little beyond a patch of carpet or an area of wall, with one or two glimpses of furniture or generalised accessories. Though the poses of the women vary remarkably, each of them averts or conceals her face, while their state of undress necessarily excludes some of the standard indicators of class and social identity. [26] Surprisingly, only one of the pastels includes discarded clothing, a device often used to convey information in such scenes, and in that example the garments are too vague to be instructive. [27] All of the scenes portray solitary women and none of them incorporates a reference to another human presence, either male or female.

Within the terms that Duranty had laid down a decade earlier, the 1886 pastels are remarkable for their lack of socially specific or pictorially informative detail. In *The Tub*, for example, which is arguably the most radical composition of the series, the vertiginous viewpoint excludes the 'background' entirely, and we are provided with no indication of the woman's location, status or identity. Other pastels in the group are almost as reticent, offering only ill-defined spaces and a minimal inventory of props and accessories. In this sense, the pictures contrast sharply with Degas' work in the 1870s and appear to associate themselves with the 'vagueness' and imprecision of his later career. This absence of clear and consistent visual indicators has encouraged a wide variety of contradictory readings of the works, not least amongst the critics who first reviewed them in 1886. While one writer found a 'delicious harmony' [28] in the pastels, another described them as 'a distressing poem of the flesh' [29]; some critics remarked on the 'ugliness' [30] and the 'frog-like aspects' [31] of the women depicted, while Octave Mirbeau found in them 'the loveliness and power of a gothic statue'; [32] two or three commentators implied that the figures were prostitutes, [33] in contrast to one who identified a model as a 'fat bourgeoise', [34] another who saw a 'poor working woman, deformed by the toil of modern days' [35] and a third who decided that they were all 'decidedly chaste'. [36] As if to summarise their confusion, Maurice Hermel responded to claims that Degas was a misogynist by suggesting that, on the contrary, 'he is a feminist'. [37]

These extraordinary contradictions go well beyond the range of reactions to be expected in such circumstances and point to a fundamental disruption in the process of looking at, and writing about, Degas' images of women. A number of other features in the critics' responses are also significant. First, in the absence of informative 'backgrounds', the writers were obliged to identify the subject-matter of these pictures largely through a study of the figures themselves. The assumption by some critics that these 'fat, pot-bellied' [38] or 'simian' [39] models belonged to the lower orders tells us a great deal about the confusion of contemporary class attitudes, but raises as many questions as it answers. [40] Secondly, the exhibited pastel which most explicitly refuted the identification with prostitution was (and has remained) the least discussed by Degas' critics. In *Girl Drying Herself* (National Gallery of Art, Washington, BR 113), the model is posed against grass and trees, in a rural setting at the opposite

extreme to the 'ambiguous bedrooms' mentioned by one of the 1886 critics.[41] This pastel cannot be reconciled with the more simplistic interpretations of the nudes and has, perhaps, been overlooked for that reason. It also draws attention to the complex and sometimes teasing nature of Degas' imagery and to his wilful manipulation of its signs and structures. By introducing a distant tree-stump, which is little more than a city-dweller's hieroglyph for the countryside, Degas transformed the possible readings of this picture; similarly, by excluding all such devices, as in *The Tub*, the artist could opt for the unmapped and uncertain pictorial territory that has so confounded his critics. This puzzle-like quality in Degas' work was even singled out by some of his more astute contemporaries, one of whom listed the signs and indicators that had been *removed* from the artist's pictures of nudes.[42]

It has been argued recently that the 1886 pastels were the outcome of an evolution in Degas' work that began with the monotypes of the late 1870s.[43] Technically, thematically and visually, the pastels developed certain features of these prints, while emphatically rejecting others. The monotypes include specific scenes of brothel life and studies of individual prostitutes, most of them represented in the kind of descriptive detail that characterized Degas' work in this earlier decade. In these scenes, the women's faces are clearly defined, their gestures are explicit and a legible narrative is established between the prostitutes and their often conspicuous male customers. Even on the small scale of the monotype, the mirrors, gas-lights and banquettes of the *Salle d'atteinte*, and the more modest furnishings of the bedrooms, are clearly described, while the prostitutes are identified by their striped stockings, elaborate *coiffures* and scanty *négligées*.[44] In this context, Degas was evidently content to use the standard notation of the brothel, and to define the identities of his characters and the nature of their commerce. While these monotypes refer to a specific category of brothel and were intended for a selective and private audience, it is clear that the inclusion of such conventional signs was part of a deliberate strategy, to be modified or manipulated at will. By the same token, the suppression of these conventional signs in a later group of monotypes,[45] and their omission from the 1886 pastels, points to a shift in the artist's strategy. In rejecting the stereotypical signs and structures of prostitution, Degas neutralized the standard responses of his audience and offered in their place imprecision and ambiguity. In this sense, the panic of Degas' contemporaries and the confusion of later generations have been the controlled outcome of his pictorial manoeuvering. The critic who discovered a 'fat bourgeoise' was neither nearer or further from the image than the one who saw the 'streetwalker's . . . pasty flesh.';[46] both of these allusions, as well as those to 'a young cat'[47] or even 'a kneeling Venus',[48] are made possible and perhaps encouraged by the 1886 pastels, while none of them is allowed to become definitive.

It is this capacity for the knowing manipulation of visual language, and for the modification of that language in the context of differing subject-matter, that has so often been overlooked and misunderstood in the study of Degas' female imagery. The orchestration of spaces, settings and physiognomy was often calculated for specific

197

ends, just as the suppression or elimination of these factors might be preferred in other circumstances. As writers like Duranty understood well, the character of an image could be established both by inclusion and by exclusion, by radical intervention or by the subtlest of visual inflections. In his earlier female subjects, Degas' commitment to social documentation was reflected in a number of pictorial devices that accentuate detail, identity and social behaviour. In the 1880s, his pictures began to be less descriptive and more broadly executed, often using pastel to create an image that was both dense and richly allusive. During the last decades of his career, Degas virtually eliminated the deep spaces, 'backgrounds' and tokens of direct sexual confrontation found in his earlier work, actively promoting the dislocation and ambiguity of his subject-matter. These late drawings, pastels and paintings of women are, by intention and design, highly resistant to description and it is no coincidence that they remain amongst the least discussed of Degas' works. By confronting these pictures, however, and by considering them alongside Degas' earlier and more celebrated female imagery, it is possible to identify some of the patterns and significances within his visual syntax. While none of these patterns is unproblematic and while all of them have their inconsistencies, together they offer the possibility of a more informed and particularized, if perhaps less convenient, characterization of Degas' images of women.

Notes

1. Exceptions are Anthea Callen, 'Degas' technique: pictorial space and the construction of gender', in Richard Kendall (ed.), *Degas 1834–1984*, Manchester, 1985, pp. 42–52; Eunice Lipton, *Looking Into Degas*, Berkeley and Los Angeles, 1987; and Richard Kendall, 'Degas' discriminating gaze' in *Degas: Images of Women*, Tate Gallery Liverpool, 1989, pp. 6–9.
2. For the evidence of Degas' own practice, see Richard Kendall, 'Degas and the contingency of vision', *Burlington Magazine*, Vol. CXXX, No. 1020, March 1988, pp. 180–97.
3. Marcel Guérin (ed.), *Degas, Letters*, Oxford, 1947, p. 39.
4. For Degas' submissions see Charles Moffett, *The New Painting*, Geneva, 1986, p. 120.
5. Emile Zola, *Le Bon Combat*, Paris, 1974, pp. 185 and 214.
6. Moffett, op. cit., p. 47.
7. ibid., p. 44.
8. ibid., p. 45.
9. See Paul-André Lemoisne, *Degas et son oeuvre*, Paris, 1946–49, nos. 768 and 769.
10. While a limited number of late ballet pictures show a broad expanse of stage, few depict deep space, detailed scenery or props.
11. See Lipton, op. cit., chapter 2.
12. For example, nos. 83 and 84 in Eugenia Parry Janis, *Degas Monotypes*, Cambridge, 1968.

13. Two exceptions, both of which are reworkings of earlier compositions, are *Dancers, Pink and Green*, Metropolitan Museum of Art, New York, Lemoisne no. 1013 and *Danseuses (Les Coulisses de l'Opera)*, private collection, Lemoisne no. 880; both may be dated *c.* 1890.

14. The portraits of M. and Mme. Louis Rouart (Lemoisne nos. 1437–44), *c.* 1904, are amongst the few exceptions to this pattern.

15. See George Shackleford, *Degas: The Dancers*, Washington, 1984, p. 107, and Jean Sutherland Boggs, 'Edgar Degas in old age', in *Oberlin College Bulletin*, no. 1–2, 1977–78, p. 59, amongst others.

16. A number of models and visitors to Degas' studio recorded this practice; the most celebrated account is that of Alice Michel, 'Degas et son modèle', *Mercure de France*, CXXXI, 16 February 1919, pp. 457–78 and 623–39.

17. This argument is indebted to Jean Sutherland Boggs, 'The late years', in Jean Sutherland Boggs *et al.*, *Degas*, Paris, Ottawa and New York, 1988–89, pp. 481–607.

18. The preparatory studies in question are Lemoisne nos. 1106 and 1106 *quater*. For a discussion of this painting see Kendall, 1989, op. cit., p. 64.

19. See Kendall, 1989, op. cit., p. 58.

20. See Kendall, 1988, op. cit.

21. See, for example, George Moore, *Impressions and Opinions*, London, 1891, p. 319.

22. Georges Jeanniot, 'Souvenirs sur Degas', *Revue Universelle*, LV, no. 15, 1 November 1933, pp. 280–81.

23. A radical shift in Degas' art towards the mid-1880s has been identified in Gary Tinterow, 'The 1880s: synthesis and change', in Boggs *et al.*, op. cit., p. 366. A number of the artist's letters, written in 1884 at the time of his fiftieth birthday, also suggest a personal and professional crisis; see Guérin, op. cit., pp. 80 and 81.

24. The exhibition is described in Martha Ward, 'The rhetoric of independence and innovation', in Moffett, op. cit., pp. 421–47. The argument that Degas' models were intended to represent prostitutes was first developed in Eunice Lipton, 'Degas' bathers: the case for realism', *Arts Magazine*, no. 54, May 1980, pp. 94–97. Lipton, however, uses the fact that some of Degas' monotypes make highly specific reference to brothels to argue that the pastels should be seen in the same way; the argument in this present paper suggests that it is the *lack* of such references in the pastels that separates them from the visual language of the monotypes.

25. See Richard Thomson, 'Degas' nudes at the 1886 Impressionist Exhibition', *Gazette des Beaux Arts*, November 1986, pp. 187–90; Gary Tinterow, 'Synthesis and change' in Boggs *et al.*, op. cit., p. 385; Richard Thomson, *Degas: the Nudes*, London 1988, pp. 130–32.

26. In contrast, several of Degas' closest followers, such as Forain and Zandomeneghi, persisted in spelling out the nature of the model's clothing and accessories in their own contemporary studies of the nude; see for example Forain's *The Tub*, Tate Gallery, *c.* 1886–7 and Zandomeneghi's *Woman Stretching*, Milan, private

collection, 1886.

27. *Girl Drying Herself*, National Gallery of Art, Washington.

28. Maurice Hermel, *La France Libre*, 27 May 1886; quoted in Moffett, op. cit., p. 452.

29. Gustave Geffroy, *La Justice*, 26 May 1886; quoted in Moffett, op. cit., p. 453.

30. Alfred Paulet, *Paris*, 5 June 1886; quoted in Moffett, op. cit., p. 453.

31. Geffroy, op. cit., p. 453.

32. Octave Mirbeau, 'Exposition de peinture', *La France*, 21 May 1886, p. 1.

33. For example, Henri Fevre, 'L'exposition des impressionistes', *La Revue de Domain*, May–June 1886, p. 154.

34. Paul Adam, 'Peintres impressionistes', *La Revue Contemporaine Littéraire, Politique et Philosophique*, 4 April 1886, p. 545.

35. Anon. [George Moore?], *Bat*, 25 May 1886, p. 185; quoted in Kate Flint, *Impressionists in England*, London, 1984, p. 70.

36. Joris-Karl Huysmans, *Certains*, Paris, 1889, p. 24.

37. Maurice Hermel, *La France Libre*, 27 May 1886; quoted in Martha Ward, 'The Rhetoric of Independence and Innovation', in Moffett, op. cit., p. 433.

38. Joris-Karl Huysmans, op. cit., p. 24.

39. Jean Ajalbert, *La Revue Moderne*, 20 June 1886; quoted in Moffett, op. cit., p. 454.

40. The association of ugliness with working-class figures was widespread amongst certain writers, but it co-existed with a view expressed by some Realist novelists that, beneath their finery, all classes were identical. See Guy de Maupassant, *A Woman's Life*, London, 1965, p. 151, where a peasant points out that the dead bodies of two high-born lovers show that we are 'all the same, all equal!'; and Emile Zola, *Nana*, London, 1972, p. 358, where the heroine insists that her grandest customers are as squalid beneath their clothes as her humblest.

41. Fevre, op. cit., p. 154.

42. Gustave Geffroy, *La Vie Artistique*, Paris, 1894, p. 167; quoted in Boggs *et al.*, op. cit., p. 368. The confusion amongst the critics responses to the 1886 exhibition has been noted in Martha Ward, 'The rhetoric of independence and innovation', in Moffett, op. cit., pp. 431–33 and Thomson 1988, op. cit., p. 139, though neither author presents this confusion as the deliberate consequence of Degas' visual strategies.

43. See Gary Tinterow, 'The 1880s: synthesis and change', in Boggs *et al.*, op. cit., p. 411.

44. Charles Bernheimer's essay 'Degas's brothels: voyeurism and ideology', in R. Howard Bloch and Frances Ferguson (eds), *Misogyny, Misandry and Misanthropy*, London, 1989, pp. 156–86, is based on the erroneous assertion that the brothel monotypes are characterised by 'crude, scribbled, smudged, murky forms' (p. 164). A first-hand examination of the monotypes shows, on the contrary, that while a small number incorporate chance effects and suggestive areas of shadow, the majority are remarkable for their incisive lines, fine detail and controlled facture.

45. See Janis op. cit., nos. 121, 123, 125, 127, 129, 131, etc.
46. Fevre, op. cit., p. 154.
47. Octave Maus, 'Les vingtistes parisiens', *L'Art Moderne* (Brussels), 27 June 1886, p. 201.
48. George Moore, *Confessions of a Young Man*, London, 1918.

Frogs, Monkeys and Women:
A History of Identifications
Across a Phantastic Body

Heather Dawkins

In a 1930s publication an artist remembers Degas saying:

> It is all very well to copy what one sees, but it is much better to draw what
> one remembers. A transformation results in which imagination collaborates
> with memory. You will reproduce only what is striking, which is to say, only
> what is necessary. That way, your memories and your fantasies are liberated
> from the tyranny of nature. [1]

With uncanny accuracy this recollection pinpoints what is at issue in Degas' series
of pastels of women bathing.

Flipping through the latter half of the catalogue for the 1988 retrospective exhibition
of Degas in Ottawa, Paris and New York can be a dizzying experience. The repeated
poses of bathers become insistent, the peculiarities of Degas' vision relentless. The
changes from image to image are noticable but inexplicable. And yet this is only
the viewer's perspective. The problem is more emphatic when one considers how
difficult it was for Degas to finish work, how reluctant he was to part with it and
how often images and especially sculptures were interminably worked and reworked.
The process of making, for Degas, was no desultory affair, however unfinished his
work may have looked to some. A process like this, re-engaged continually over
decades, testifies to a massive artistic and psychological investment, an untiring need
to re-encounter the same psychic and social materials, but without an even vaguely
defined goal that would call a halt to the process and propose, however temporarily,
of a resolution to the problem.

One of these social materials, prostitution, is discussed with the strange ambivalence
current in art historical work. In the Degas literature, prostitution has been made
to bear the questions of sexuality and has focused those questions in specific ways
– on women's identities (as prostitutes or not) and on occasional masculine sexual
and monetary practices. This focus has exempted masculine heterosexuality from

analysis, just as it has limited compulsive peering and repulsion, shifting its object from the feminine body to the prostitutional body. It is the compulsive peering and repulsion, that underlies the ambivalence of the discussion of prostitution in art history.

A case in point would be Richard Thomson's book on the nudes. He refers to an 'injudicious and dogmatic assertion' on the part of Eunice Lipton, that all Degas bathers are prostitutes. [2] He is speaking of an article that suggested that if one considers the customs of bathing in the later nineteenth century and the similarities between Degas' brothel monotypes and the bather images, the latter's relationship to prostitution is explicit. [3] Thomson dismisses Lipton's work as an exaggeration, pointing out, even making too much and too little of the way that the 1886 critics do not show consensus on the identities of these women. But there is something odd in the manner in which he dismisses the possibility that these images could be unreservedly implicated in prostitution, for in doing so he ignores the fact that Eunice Lipton's text itself is unable to retain the prostitute after setting her up as the subject of the series, that far from being dogmatic, Lipton undermines her own text (and this is true of the later book as much as the article of 1980).

What does it mean that Lipton's text is unable to maintain the argument that these are pictures of prostitutes? And likewise, what does it mean that Thomson's text seizes a contradictory argument as dogmatic and injudicious, and then, in countering it, argues that Degas' work refers ambiguously and complexly to a variety of contemporary meanings, of which prostitution is one? [4] As in so many texts on Degas, the relation between Degas' work and prostitution is both compelling and intolerable; the argument must be presented but then forced into a more nuanced and ambiguous state. The historical relevance of prostitution is rarely doubted, but the extent to which this phenomena could be implicated in Degas work is firmly limited. Despite the declared differences, these authors do have in common an inability to come to terms with the obsessiveness of Degas' production of women's bodies and arguments that have oddly contradictory trajectories.

Why do Thomson's and Lipton's arguments double back on themselves? Why are they, like so many art historians, unable to come to terms with Degas' obsessive production of women's bodies, and the restricted number of variations that takes? An examination of their texts show that such a discussion would disrupt two things. In Thomson's book, Degas' interest in women is described as a curiosity, while his interest in forms in movement is described as an artistic obsession. [5] The psychoanalytic term is here carefully reserved for something that tries not to, and seems not to, speak directly of sexuality, while a rather mundane term, curiosity, is employed for what might actually qualify as a sexual obsession.

The text details at length elements of the artistic obsession, and to a lesser extent the curiosity about women. Thomson's text produces Degas as a curious bachelor whose attitudes were determined by, and consistent with, the 'orthodox preconceptions and prejudices of a man of his class and upbringing'. [6] Degas'

imagination is mostly 'mischievous', 'uninsistently patronising', 'playful', 'unmalicious' or 'matter of fact'[7] in its search to mould women's bodies 'into challenges for his draughtsman's preoccupations'[8] while creating 'an ambiguous complex of contemporary meanings'.[9] Only occasionally do the nudes evidence 'ribald fantasy', an 'actively scabrous curiousity', a 'purposeful fantasy of the male in rut', or a 'coarse turn of mind'[10] as Degas 'applied the public patois of sexual commerce sparingly, [and] obliquely'.[11] On the other hand, the brothel monotypes convey disgust, representing a bestial race beyond the bounds of decency[12] that earlier in the text Degas is said to have visited 'as a convenient outlet for a fragile sexuality without risk of humiliation'.[13]

None of these aspects of sexuality seriously impinge on the cultural project that is Degas. This is a version of sexuality devoid of the resurgence of Oedipal conflicts around woman and the confusing coincidence of hate and love, repulsion and fascination, that marks it. It is as psychically unconflicted as Thomson's understanding of the feminine body of masculine looking. Neither can he come to terms with what was special about Degas who, though structured by masculinity in ways presumably common to others of his class and upbringing, was the only man to be so intensely involved in repetitiously producing a highly specific range of bather images.[14] Nineteenth-century critics who discussed the bathers as a sign of misogyny or of a horror of women are, according to Thomson, projecting their own psychosexual problems on them.[15] Presumably avoiding a discussion of Degas' obsession with women's bodies is to prevent a similar twentieth-century projection. But projections are not unleashed by just anything, and one must ask what was it about Degas and his pictures that triggered those very specific projections which could be understood in horrified ways in 1886? The pictures exhibited were not the most extreme of his *oeuvre* and they met a varied, if all-male, critical public which means that they were encountered by subjectivities with vulnerabilities particular to the historical and psychic moment. This is no less true of the reviewers who seemed in control of their responses, than for those who seem excessive. Those seemingly excessive reviewers indicate the possibility of a continuity across Degas' nudes, a kind of psychic violence or conflict that renders separations of the 'playful', the 'matter of fact' and the 'coarse', irrelevant.

Unlike the obsession, conflict and violence of the psychic and the sexual that are skirted by Richard Thomson's text, pleasure seems to be threatened in Eunice Lipton's essay where quite a different process takes place. Two things risk being unsettled by prostitution – the pleasure of looking at the images, and an imagined narcissistic pleasure that the women in the images experience. Thus where Thomson risks losing an artistic obsession with forms in movement to a masculine heterosexual obsession with women, Lipton risks losing the pleasures of women's bodies to one of the explicitly sexual and debased social forms of heterorsexuality. What is at stake is a gender specific identification for each writer, for though Thomson can look at 'Degas' he can only look at a kind of culturally viable project like his own, a study

of the multiple meanings and references in Degas' bathers, in which prostitution is but one unproblematic part since he and Degas are masculine. This culturally viable project is emphatically not to be confused with something as uncultured or driven as an obsessive pursuit of women's bodies, something which may indeed raise questions about his own project.

For Lipton on the other hand, the problem of identification is one which cannot be achieved, a gendered dis-identification in short – she finds it impossible to sustain visual pleasure in a prostitutional matrix of masculine sex, money and power, and in this dis-identification, the masculinity on which viewing these pictures is predicated is thrown into relief. Having disowned that gaze and conscious that she is still looking, Lipton offers herself and some spectators/readers a way out to an emphatic, narcissistic and pleasurable looking in which the viewer recognises the bather's experience of herself. The prostitutional argument disappears, and Lipton writes that the pictures short circuit the prostitutional 'narrative' and invite 'the contemplation of sensation'. She continues:

> That sensation is of mixed minds, however. For some, it reverberates with the paid spectator's response and is both lascivious and contemptuous; for others, to the contrary, the images invite empathy and the contemplation of narcissism. These contradictions are built into the paintings and into the different historic milieus represented by the late 1880s and today. [16]

Now this brief and unpretentious paragraph merits close attention. It attempts to divide the viewing of Degas' pictures between a prostitutional viewing and an empathetic experiential viewing, a division built into the pictures, into a hundred-year historical contrast, and suggestively into groups of viewers, some of which see one way and some of which see another. It would make sense to divide these viewing groups between those who are likely to be clients of prostitutes (men) and others (women). But the frontier of this multi-layered division proves fickle – first the historian confounds the discrete historical separation by re-presenting the 1880s prostitutional context. And secondly, divisions of masculine and feminine have an awkward way of being undermined or transgressed, even when one might find their neat division both appealing and secure. For listen again to the first sentence-and-a-half: 'That sensation is of mixed minds, however. For some, it reverberates with the *paid spectator*'s response and is both lascivious and contemptuous.' What is, in this case, a paid spectator? In one fell slip the structure of this argument collapses in the worst way. For where we have had women prostitutes and the often disparaging masculine gaze of a client and viewer we now have what can only be a riotous moment in which who is paid and who looks unite: the spectator as paid *and* looking, in others words as prostitute, as masculine and feminine? For this is all that the unfortunate expression 'paid spectator' implies. [17] These are the most immediate meanings, a repressed fantasy of being looked at and paid and looking and paying; a confusion

that is the otherwise unspoken basis for an identification with these women and our claim on behalf of ourselves and Degas to 'present her as she saw and experienced herself'. [18]

These are only two examples of the processes of identification I have been able to isolate in the Degas literature, a literature that is full of twists and turns in what I have called the 'managing' of Degas. [19] As Eunice Lipton's work indicates, women's relationships to these paintings tend to be more difficult than men's; fraught by particular tendencies inherent in our psychic, social and sexual positioning, women problematise the looking so readily assumed by the masculine heterosexual subject. This management of looking (whether by men or women), and the various defensive and strategic movements and meanings it involves, testifies to a threat in the Degas *oeuvre*, a threat we may not be able to locate a single strand of meaning for, considering that it is to be found not only in the images but also varying forms from text to text. I want to refocus these issues here, less in terms of defining the threats or their management, and more in terms of tracing some aspects of Degas' fantasy across these images. I then want to step to one side of that fantasy to analyse one of the truly exceptional publications on Degas, one in which the look of the bathers is returned to Degas.

Degas and Fantasy

How can we get 'at' the fantasy in the Degas *oeuvre*? Perhaps first of all by looking at the bathers as a whole and experiencing that point in repetition where meaning and familiarity becomes enigma and strangeness. But secondly I think, by discussing the construction of a fantasy in a way that breaks down its enigmatic character so that rather than a global enigma (for which Woman has been made so well to qualify) we find our way through the component parts. Here the psycho-analytic writings on fantasy are quite helpful, suggesting that the difficulty of understanding fantasy is that it refers simultaneously to the three different temporal spaces which I have discussed in 'Managing Degas', and to which in Degas' case I think we can add a fourth. [20]

I have so far used the term 'fantasy' to denote an individual's imaginary scene that is shared – historic and cultural – a group fantasy in other words. That fantasy, produced in collective and individual history, has an aspect more deeply embedded in or repressed to the unconscious. In adopting the term 'phantastic body', I am indicating that the fourth level of fantasy is perhaps the most difficult to consider, less accessible to cultural resolution. We are used to thinking of the body as a thing, an almost discrete entity which one possesses or inhabits. The kind of body which I am going to refer to and which is so important to an analysis of Degas' work, is the body as a memorable space.

Degas and the Phantastic Body

It has often been remarked that the bodies Degas depicted were anatomical contortions, that they seemed tortured and deformed by the stress of their poses.

206

Fig. 48 Edgar Degas, Notebook 11, p. 56, *c.* 1857–8, 12.6 × 8.3 cm, Bibliothèque Nationale, Paris.

I want to suggest that more than the study of muscles and limbs under tension, these works register a psychic projection. It is psycho-analysis that provides ways of thinking about the memorable body in relation to Degas' *oeuvre* and working practices. For as we know from Freud and Lacan, people come to inhabit their bodies through a contradictory and difficult process, a process which is neither completely achieved nor perfectly repressed. There are various ways that Degas' bodies can be read as specific kinds of projections from the masculine subject to the feminine as a phantastic body, a projection which tries to preserve the coherence of the masculine subject at its body, but which, in Degas' case, seems to have been turned back on itself. Now this may sound vague, but let us consider on a general scale the way that Degas' pictures are constructed. First of all, as the 1886 published criticisms emphasised, when it came to flesh, Degas was no colourist, and it was the lack of fresh perfection of this flesh that spoke of prostitution. Then as the 1988 catalogue so lovingly details with the help of modern technology, many of the limbs in Degas pictures were repositioned several times before he was able to arrive at a finished pose or picture. In addition, as many have noticed, Degas' sense of the body, especially from the 1870s, was very tenuous: anatomies under *tutus* are

207

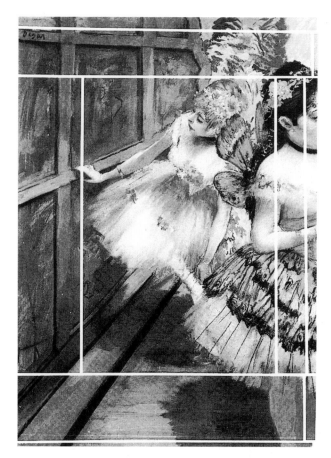

Fig. 49 Edgar Degas, *Dancers in the Wings*, 1878, pastel and distemper, 66.7 × 47.3 cm, Norton Simon Art Foundation, Pasadena, L 585. The white lines indicate the piece-by-piece construction of the picture plane.

implausible, legs join to torsos problematically, women stepping in or out of baths threaten to split up the middle, and so on. [21] A close examination of later work confirms these difficulties which have been attributed to a lack of representational skill rather than a psychic pressure or knot. Similarly, but on a different level of manufacture, the compositional page was often added to, built up with pieces of paper in a way that echoes the disjointed process of arriving at a pose or body (fig. 49). Add to this Degas' choice of subjects or poses – we can consider here not only the bathers' anatomies which were described as tortured or deformed, as seen by the sharp look of a surgeon but this choice of the ballet as a subject. This was one of the interstitial spaces of cross-class sexual exchange, as Griselda Pollock has argued. [22] Further, they evidence a sustained 'interest' in a particular type of body, a body the coherence of which is constantly challenged by anatomies which, in Degas' pictures, either threaten to disintegrate or precariously achieve integration – even if one does not consider numerous arms or legs concealed by the finished surface (plate 6). [23] But this remarkable process is even more pronounced in Degas' sculptures, sculptures that were more often than not abandoned rather than finished and left to disintegrate

in the studio. Degas constantly frustrated himself, undermining the sculptured body from within by placing pieces of cork in the torso – cork which eventually protruded from the soft plasticine mass around it, ruining his efforts which were already complicated by often intricate poses. [24] And so, added to poses in which limbs were vulnerable and balance precarious, was another threat of physical and material fragmentation (fig. 50).

I am here trying to summarise the salient points of a body and a practice which I believe to be symptomatic of what is in effect a very ordinary process, one that speaks of what is left over from psychically constructing a coherent body – fragmented perceptions of the body that cannot cohere. It is completely normal for these disquieting processes to be projected outward, to be lived in displaced form from where they may return at times to plague the subject. Degas' work was constituted on that process of projection and through conflicts of gender, class and sexuality.

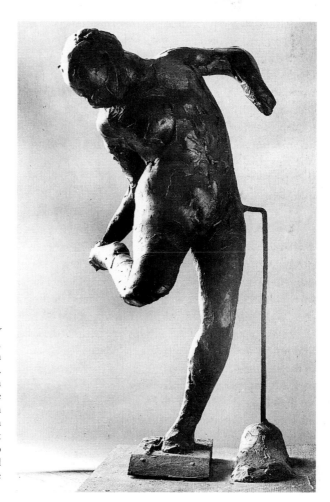

Fig. 50 Edgar Degas, *Dancer Looking at the Sole of Her Right Foot*, 1895–1910, green wax, 46 cm high, Musée d'Orsay, Paris. A precarious balance, a broken arm . . . Degas worked on this pose over a period of fifteen years. In Alice Michel's article both Pauline and the model who left employment with Degas to become a sculptor, are employed to enact it (neither women were dancers).

209

One of the characteristics of projection is precisely that the relationship between the subject and the object is marked by phobic avoidance; this goes a long way to explain why Degas found it so difficult to finish work, why at certain points in an unfinished work the model for it was not formally dismissed from further employment but was left to figure out her dismissal for herself through Degas' socially awkward behaviour. [25] The necessity for a constant deferral of gratification in fantasy was met in part by the necessary phobic avoidance of the object in projection.

What is unusual in reading this archive is the intensity with which this fantasy and projection find form; what is ironic is that it occurs simultaneously with the faltering of the author's vision. Degas' incapacity to see well has been found suspiciously unconvincing by his friends, and by historians. I am not concerned with finding the truth about Degas' eyesight, the possible physiological basis for his optical vagaries or the reasons for inconsistencies of his behaviour around vision, but with a recognition of this failing in the context of a reading of his work that is attentive to the psychic formation of identity and history. For in comparison with the body and all other senses, sight is peculiar to the extent to which we can control it by simply opening or shutting our eyes. (Not looking, at least, can be absolute.) Degas apparently lived in a traumatised relationship to this visual control of the world after 1870, the time that his image-making moved away from his immediate class and familial situations. Seeing was an absolutely primary component of his identification as an artist, yet looking was profoundly troubled. Simultaneously as he traumatised women's bodies in projecting and protecting himself against his 'memorable' body, that trauma returned to him, undermining the coherence of the organ of projection, traumatising the process of being an artist as much as being man who looks.

Alice Michel Returning the Look: Reading as a Model

The reviews of Degas' bathers in 1886 are the most extensive writings on Degas produced during his lifetime. After his death, various people were called upon to publish their memories and fantasies of Degas, in an attempt to fill out an author for an *oeuvre*. Much of the writing produced in the gap is curiously fragmented and thin, a strange mixture of attempts to come to grips with his work and attempts to remember things of significance; not to speak of forgetting and insignificance, and not to make too much of Degas' unpleasant character. There is one exception to the strangely disjointed literature. In 1919 a woman who used to model for Degas took advantage of the publishing opportunities opened up by his death and published an article in the *Mercure de France*. This article qualifies as the least noted writing on Degas in the literature for reasons that will become obvious. Alice Michel has some rather unpleasant things to say about the artist who employed her, making this text welcome reading to anyone who is not worried about protecting the genius of Degas or his works. But beyond that, Alice Michel's text merits a close reading; for feminists the opportunities posed by a text written by a model and a woman

is unparalleled in a frustratingly masculinist literature. This is an opportunity that cannot be recognised from within the structures of the masculinist culture of art history. Thus when Richard Kendall excerpted and translated parts of the text for his book, *Degas by Himself*, he used the text to get at a particular version of Degas, rather than Pauline, the model who appears in the text. In doing so he cut the text in a way that made it conform to the disjointedness of the other memory texts, though this was not a random editing. The excerpts' overall pattern produces the effect of spontaneous conversation between Degas and Pauline. Almost exclusively the conversations are initiated by Degas and censor the reflections that, in Alice Michel's text, Pauline censors from Degas. The exceptions to this pattern are noteworthy – a conversation that Richard Kendall permits Pauline to initiate could have easily been patterned along the lines of the other conversations but this would have resulted in opening with Degas saying that though he was not excessive about having wild times in his youth (in other words that he had been normally promiscuous but not debauched) he did have venereal disease.[26] The other exception is similar to this one, a conversation that opens with Pauline reminding Degas of the first time she modelled for him, a reminder which elicits from Degas the memory that her shirt had to be torn off her, and that she looked so chaste it was charming.[27]

What is clear in the original text of 1919 is that conversations between Pauline and Degas – rather than being spontaneous – are tediously familiar to Pauline, and that this reminiscing is calculated to pry Degas away from launching on one of his despairing monologues, monologues that evoke her anger and pity at the same time that she is compelled to try to cheer him up.[28] Both of Kendall's exceptions to conversations initiated by Degas serve to place sexuality as a conversational topic on the side of the model rather than the artist. This is indicative of the kind of 'Degas' that is produced in the translated and edited text, a sexually respectable and melancholic artist, blighted by old age and failing vision, and absolutely unlike the 'Degas' produced by Alice Michel's uncensored text.

For as well as editing out Pauline's thoughts and opinions, Kendall edits out all that is offensive in Degas – rabid anti-semitism demanding the enclosure of Jews in ghettos or the complete destruction of the race;[29] his incomprehensible ramblings about, for example, a tiger (which is also a term for a ballet dancer, one up from the 'rats' [young ballet dancers] he so often painted) adorned with a jock strap who pees along the ramparts of art;[30] his mean spirited control over money;[31] his personal and studio filth;[32] his naïve and youthful bout with pubic lice;[33] his abusive relationships to the women around him; his emotional and practical dependence on them; his aggressively verbal sexuality.[34]

Significantly, Alice Michel's text ends with the sentence, 'This was the last time she saw the old artist,'[35] a sentence which comes across as a statement of fact and no great loss in its context. The three things that Pauline wants from Degas – regular employment, stories about celebrities and a representation of her beauty – have already been taken from her through Degas' refusal to tell the stories she solicits

211

from him, his block on portraying any of his model's features and by his eventual avoidance of both her and the statue he was making of her. [36] Pauline's' matter-of-fact last view of Degas is paralleled, we could say circumvented, in Kendall's text by another kind of separation in which 'seeing' figures. His text ends, of course, by producing the melancholic artist once again. The last line is Degas' lamentation, 'Ah no, I will never see my studio again.' [37] The melancholic Degas terminated by Kendall is, in Alice Michel's text, immediately cheered up and lives on. [38] Thus a text whose merits are twofold, that is, first failing not only to mourn the loss of but also failing to produce an artistic genius, and secondly daring to return looking, thinking and representation to women, Richard Kendall's text compulsively restores the masculine look and a 'tragic' artistic loss.

It should now be clear why art historians have not been able to read, much less identify, with this text, for it subverts the production of a masculine genius, indeed the text renders such overvaluation incomprehensible. The political implications of identifications should be obvious. I want to conclude by drawing out the potential of another reading and another identification, both foreign to the Degas literature; to make some main points that are independent of the desire to identify with Degas through this text, and that might enable a reading of, and identification with, Alice Michel's text.

First of all, 'Degas and his model' produces a model who strains under the effort to control and maintain certain poses (fig. 50). Like Zoé Closier, Degas' maid, she is subject to the artist's rather childish and unreasonable will, and to whom the artist is predictable in his moods, tantrums and opinions and so whose ego can be managed, though not necessarily understood and only rarely empathised with. Tellingly, the exceptional moment of empathy is the only point in the text where Pauline refers to him as 'father Degas': 'Pauline who fundamentally was fond of "father Degas" despite his brusk manners and retrograde ideas, was alarmed to see him in such a sad state.' [39] The text is not without moments of sexual drama – Pauline narrowly escapes the marks of the sculpting compass which are the marks of a sado-masochistic threat; [40] she is introduced to public nudity by force; and she is subjected to an aggressively verbal sexuality. But there is no trace of the fantasy we found in Lipton's text, only the dreadful boredom and effort of modelling sessions (and the hope that Degas will be in a good enough mood to help time pass as quickly as possible):

> For the fifth time the model took up the pose. Boredom and fatigue made the morning seem interminably long.
>
> She resented the old artist's grouchiness and also his mania for giving only tiring poses.
>
> Never, even when his eyesight permitted him to make drawings or pastels, did he give his models an easy movement. Always, it was a pose full of action where one had to arch one's back or tighten one's muscles to the tips of one's

fingers. The sight of a round back or a hand stretched nonchalantly could make him scream with anger . . .

Pauline thought how bizarre was this aversion for gracious movement and this constant research for poses expressing vigorous movement.

He wasn't however, insensitive to a harmony of lines, the beauty of forms because rather often he went into raptures before the body of his model, praising her beautiful legs, her arms with their charming roundness, her delicate shoulders/groin/wrists and ankles . . .[41]

Pauline's investment in modelling is more than one of earning a living, but her second investment is doomed to non-fruition, for her desire to see her beauty in material form can only be frustrated with Degas who was scarcely able to finish work, and only able to make women ugly and ungracious. (Pauline and Mary Cassatt were not the only women to share this opinion of Degas' work.)

Encountering this text in our own cultural and subjective moment and liberated from the compulsions to read in the masculine, these are just a few of the things we might read, but what might persons of the feminine persuasion identify with?

The text offers more than one possibility. Alice Michel tells the story of a model who is willing to engage with Degas for as long as he helps her earn a living. Pauline

Fig. 51 Edgar Degas and his servant Zoé Closier, photograph, Bibliothèque Nationale, Paris.

does her best to make that time tolerable, and shares this effort with Zoé, Degas' maid, and this forms the basis for their moments of solidarity, just as the experience of modelling provides moments of solidarity with Suzon and Juliette, two other models (fig. 51). As Pauline is finishing her bout of 'managing Degas', Juliette begins her time in the endless chain of phantastic bodies sought by him.

Though the text replaces Pauline by Juliette, and eventually by Yvonne in the studio, there are also two breaks in the chain of models on which Degas's fantasy is figured. One is briefly mentioned – a model who leaves employment with Degas in order to take up sculpture. [42] The other is Suzon who is at lunch with Juliette and Pauline and reveals that she modelled for Degas twice. And that was enough. Though she allows that Pauline and Juliette must have courage, her opinion of Degas is unambigious, he is a 'crackpot' and an 'old maniac'. Being dismissed at the beginning of her third session with him is an obvious relief, and in the words of the text, she 'couldn't care less about him and his exhausting poses.' [43]

As I have said, Pauline leaves Degas behind less expressively than Suzon, rather matter of factly, but this is only fictionally, for she reappears beyond that fiction as Alice Michel, the author who is an effect of that fiction. In so doing she avenges working-class literacy against Degas' belief that she and those of her class should be illiterate and uncultured. She breaks with constraints on the fictional Pauline, that is, the necessity to hide her literacy in order to keep her job and to censor her thoughts about how contradictory these beliefs were coming from a man who required his maid to read to him and became angry if she read poorly. She takes literacy beyond service to an employer, indeed she uses it against him, revealing not only the unpleasant and even idiotic aspects of his character, but the criticisms, disagreements and refusals masked by a professional, that is, paid silence. [44] It is Pauline's knowledge of Huysmans' infamous text on Degas that provokes Degas' anti-literacy tirade; the conversation thus aborted is continued across her text, and with a bearing to Huysmans' text. A focused instance of the running disagreement on working-class literacy that informs the text looks like this:

'But you used to exhibit works yourself', said Pauline. 'The other day I read a pamphlet by Huysmans where he was saying a lot about you.'

'Huysmans?' said Degas contemptuously. 'He's a stupid s__. What was he doing talking about painting? He knew nothing about it! All these writers think they can sit down and become an art critic as if painting weren't the least accessible form of all.'

He got up and stood gesticulating in front of the young girl.

'What age is this that we are living in, Lord God! Everybody, even you models, come and talk to you about art, painting, literature, as if all they needed to know was how to read and write . . . In days gone by weren't the common people more content without all this useless instruction they're given in schools? . . . One of Zoé's brothers is a butcher and the other a carter; neither of them

can read or write, but they're none the worse off for that.'

His voice grew more and more strident:

'Nowadays they want to popularize everything: teaching, and even art . . . All people talk about now is popular art . . . What criminal folly it is! As if artists themselves didn't have enough trouble learning what art is! . . . But all this comes from these ideas of equality . . . How infamous it is to talk equality, since there will always be rich and poor! In the old days everyone stayed in his place and dressed according to his station; now the most insignificant grocer's boy reads his paper and dresses up like a gentleman . . . What an infamous century this is . . .'[45]

He got so angry he spluttered and gasped while he glared at Pauline who was standing before him, immobile, head lowered.

She resented having provoked this explosion of fury. However, she was long familiar with the ideas of the old artist and knew that it was even forbidden for Zoë to sweep any corner of the studio other than the little zone permitted just as it was forbidden to models to encroach upon the artistic terrain. Already several times she saw herself soundly rebuffed for an escaped reflection or even for not having hidden the book or newspaper she brought with her.

Often she felt like retaliating that if Zoë was illiterate like her brothers, she wouldn't be able to read him his letters and or newspapers and as for models, they were often encouraged by the artists themselves to take an interest in painting or sculpture.

But she had never expressed out loud what she thought to herself, convinced that a discussion could only result in her dismissal. She kept quiet like so many other times, cursing her carelessness which was going to have the consequence of a morning passed in glacial silence.

Which is what happened.[46]

Suzon's break with Degas is as definitive as the unnamed model who leaves to take up sculpture herself; Pauline does her time with Degas and matter of factly leaves it behind. But as Pauline/Alice Michel, she does her time and writes about it, returning the look and occupying for a moment the terrain of representation, crossing a frontier strictly policed by Degas in his studio. With understated brilliance she produces a woman's historical moment, a complex moment of feminine agency so repressed in the culture of which the Degas literature is one part.

Her text thus offers exemplary and welcome opportunities for identification: Suzon's disparaging comments and dismissal of a crackpot employer; the anonymous model who seems to take Degas' ability to finish work with her when she leaves to begin her own art practice; Pauline's professional conflicts and silences, her experiences of gendered and classed power and her awkward redundancy. Encompassing these, dismantling artistic genius and the phantastic body, and avenging working-class literacy is a final and textually intricate opportunity for

identification: the voice-in-print-and-history of a woman, Pauline/Alice Michel's settling of accounts and enunciation of a feminine working-class position.

Acknowledgement

Grateful acknowledgement is made to the Social Sciences Humanities Research Council of Canada Doctoral Fellowships for funding my research.

Notes

1. Georges Jeanniot, quoted in Jean Sutherland Boggs, *et al.* (eds.), *Degas*, Paris, Editions de la Réunion des Musées Nationaux, Ottawa, National Gallery of Canada and New York, the Metropolitan Museum of Art, 1988, p. 369.
2. Richard Thomson, *Degas: The Nudes*, London, Thames and Hudson, 1988, p. 139.
3. Eunice Lipton, 'Degas' bathers: the case for realism', *Arts Magazine*, no. 54, May 1980, pp. 93–7.
4. Thomson, op. cit., p. 139.
5. ibid., p. 165.
6. ibid., p. 117.
7. These descriptions run through the third chapter, 'Pastel, pose and pun', of Richard Thomson's book.
8. ibid., p. 164.
9. ibid., p. 139.
10. ibid., pp. 82, 87, 164, 146–7, respectively.
11. ibid., p. 165.
12. ibid., p. 117.
13. ibid., p. 101.
14. I am indebted to Griselda Pollock for his point. Jean-Jacques Henner's work may have been as repetitious, but comparing their images emphasises the peculiarity of Degas' work.
15. ibid., p. 162.
16. Lipton, op. cit., p. 96.
17. The related expression 'paying spectator' would not have had nearly the same effect and would have maintained the structure of the argument.
18. ibid., p. 97.
19. See Heather Dawkins, 'Managing Degas' in this volume (pp. 133–45), which is revised from an article published in *Vanguard*, vol. 18, no. 1, February/March, 1989.
20. The three temporal spaces outlined in 'Managing Degas' are Degas' past, his present (the historical present debated by historians), and his future (the impossible promise of gratification).
21. See, for example, Thomson, op. cit., p. 119.
22. Griselda Pollock, 'Modernity and the spaces of femininity', in *Vision and Difference*, London, Routledge, 1988, pp. 50–90.

23. The 1988 catalogue, *Degas: Images of Women*, traces these working methods which involve additions of paper and revisions to the body.

24. Alice Michel, 'Degas et son modèle', in the *Mercure de France*, CXXXI 16, February 1919, pp. 472–3.

25. ibid., pp. 638–9.

26. See Richard Kendall, *Degas by Himself*, London, McDonald Orbis, 1987, p. 314; or Alice Michel, op. cit., pp. 470–1.

27. See Richard Kendall, op. cit., p. 316; or Alice Michel, op. cit., p. 634.

28. Alice Michel, op. cit., p. 473.

29. ibid., p. 475.

30. ibid., p. 469.

31. ibid., p. 462.

32. ibid., pp. 458–9; 466.

33. ibid., p. 474.

34. ibid., p. 471.

35. ibid., p. 639.

36. ibid., pp. 474; 476.

37. Richard Kendall, op. cit., p. 317.

38. Alice Michel, op. cit., p. 637.

39. ibid., p. 636.

40. ibid., p. 460.

41. ibid., p. 627.

42. ibid., p. 628. According to the text, the sculpture Degas was then working on was the last he was able to cast (i.e. finish) – it was as if the model's entry into his field symbolically and seriously threatens his own command of it.

43. ibid., p. 630.

44. ibid., p. 476.

45. Richard Kendall, op. cit., pp. 316–16. Kendall ends his quotation here but the original text continues.

46. ibid., pp. 624–5.

Notes on Contributors

Deborah Bershad is the Director of Archives and Photographic Collection at the New York City Art Commission. She writes on photography, urban design and visual theory, and is currently at work on a directory of governmental agencies responsible for urban design review in the United States.

Anthea Callen trained as a painter before becoming an art historian. She held her first one-woman show in 1990 at the University of Warwick, where she is a lecturer in the History of Art. Her Doctoral thesis at the Courtauld Institute of Art, London, was published as *Techniques of the Impressionists* (Octopus, 1982). Other published work includes *Angel in the Studio: Women in the Arts and Craft Movement 1870–1914* (Astrgal/Viking, 1979). Her forthcoming book on Degas, *The Spectacular Body*, is being published by Yale University Press. Anthea Callen is married to James Barrett, an analytical psychotherapist, and has two children, Phoebe and Tom.

Hollis Clayson teaches art history at Northwestern University in Evanston, Illinois, USA. Her first book, *Painted Love: Prostitution in French Art of the Impressionist Era*, is published by Yale University Press. Her current research focuses upon art made during and in the aftermath of the Paris Commune.

Heather Dawkins is Cultural Historian and Theorist at Simon Fraser University in Vancouver, Canada. She did her Ph.D. at the University of Leeds, England. Her doctoral thesis is on the work of Edgar Degas and on questions of women, history and writing.

John House is Reader in the History of Art at the Courtauld Institute and has published extensively on the art of the Impressionists. He was one of the organisers of the *Post-Impressionism* exhibition at the Royal Academy in 1979 and the *Renoir* retrospective at the Hayward Gallery in 1985. His most recent publication is *Monet: Nature into Art*.

Richard Kendall selected the exhibition *Degas: Images of Women* at the Tate Gallery Liverpool in 1988, and initiated the symposium of the same title that forms the basis for many of the essays in *Dealing with Degas*. Formerly a Senior Lecturer in the Department of History of Art and Design at Manchester Polytechnic, he is now a freelance art historian and writer who specializes in the work of Degas and his contemporaries. His other publications include works on Degas, Cézanne and Monet, and the catalogue, *Van Gogh to Picasso: The Berggruen Collection at the National Gallery*.

Linda Nochlin is a professor of Art History at Yale University. She is the author of several books and many articles on nineteenth-century art, including *Realism*, and most recently, *Women, Art and Power* and *The Politics of Vision*.

Griselda Pollock is Professor of the Social and Critical Histories of Art at the University of Leeds. She is also Director of the Centre for Cultural Studies. Co-author of *Old Mistresses* (Pandora, 1981) and *Framing Feminism* (Pandora, 1987), she has also written *Vision and Difference* (Routledge, 1988) as well as monographs on nineteenth-century art and a range of critical and theoretical writing on contemporary art and art history. She juggles her commitments to feminist theory and practice, writing and teaching with domestic responsibilities and passion for two children, Benjamin and Hester.

Richard Thomson is the author of several books and articles on the Impressionists and their contemporaries, and was the curator of the exhibition *The Private Degas* shown in Manchester and Cambridge in 1987. He is a Senior Lecturer in the History of Art Department at Manchester University, and has recently published a study of one of the principal themes of Degas' art, *Degas: The Nudes*.

Index

(Italicised figures refer to illustrations.)